Pedro Jarque Krebs

fragile

Pedro Jarque Krebs

fragile

To Cristina, my everything

teNeues **YellowKorner**
éditions

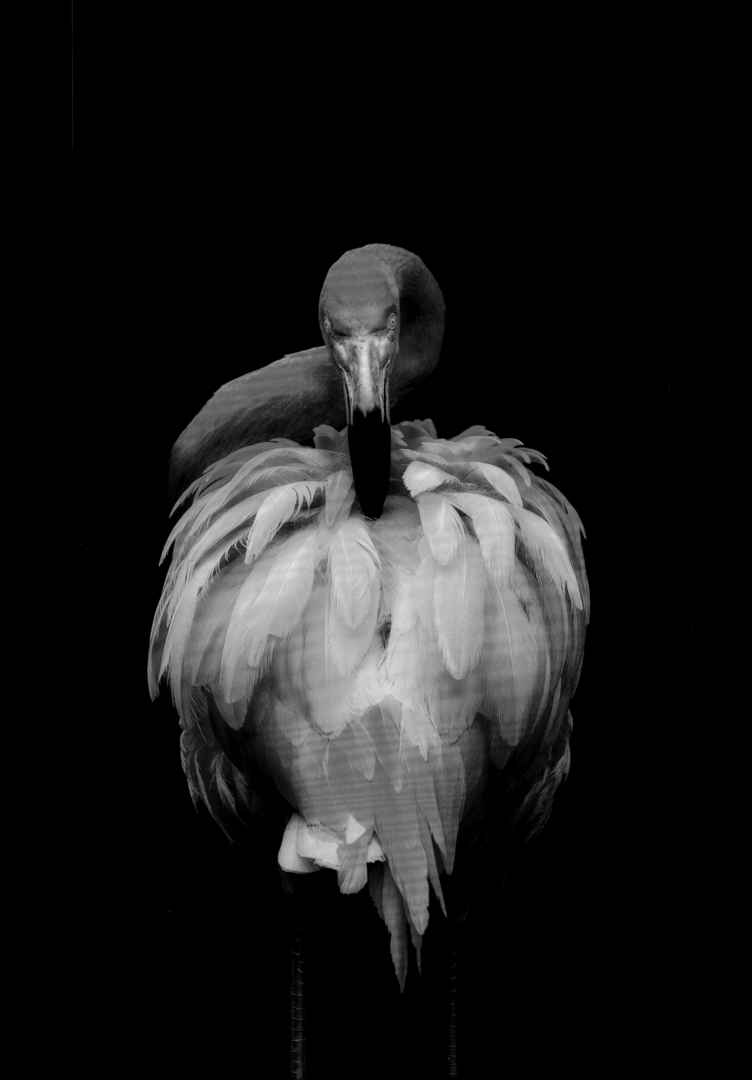

Introduction

Introduction

Nobody can deny the fact that we humans have many problems to solve as a species, and that our societies have a long way to go in order to achieve the justice and equality for which we yearn. However, preoccupying or concerning ourselves with the world of animals, far from being seen as trivial, has become an overriding issue that is directly related to our survival. And it is not simply a case of losing diversity and beauty, but one of imbalance in our ecosystem. Our expansion has meant the loss of thousands of living species.

According to the most recent reckoning, there are some 8.7 million living species on the planet. But we only know 1.3 million of them. More than 86 percent of terrestrial species and 91 percent of marine species are unknown. Nevertheless, given the level of the threats facing most of them as a consequence of human expansion, many of these species will disappear from the world before we even become aware of them.

ALL, OR ALMOST ALL, OF US LOVE
ANIMALS. THEY SHARE WITH US THE
MYSTERY OF LIFE, OF CONSCIOUSNESS,
AND OF BEING.

But beyond all philosophical, ethical, or even aesthetic considerations (which are also relevant), the question of the state of extreme fragility in which many living species find themselves has a significance that exceeds that of any debate, the very existence of humanity. Put into simple terms, if the animals disappear from the planet, we humans will also disappear.

According to the latest World Wildlife Fund report on the state of biodiversity, it is estimated that almost 60 percent of vertebrate animals have become extinct in the last 40 years. Since 1970, the number of nonhuman terrestrial animals has decreased by 38 percent, that of amphibians by 81 percent, and that of fish by 36 percent. Scientists refer to this as "biological annihilation." Every day we hear in the media about the threats faced by the most popular species that we know and love most, such as rhinoceroses, polar bears, tigers, whales, elephants, and orangutans. But they are merely the tip of the iceberg of what is a much more serious problem, the imbalance of the entire ecosystem. There is much debate about the exact scale of the problem, but the scientific community is unanimous in its belief that the current rate of extinctions is not only alarming, but catastrophic. There is already talk of a sixth mass extinction.

What are the causes of this drama? Habitat loss, the illegal wildlife trade, climate change and their effects on ecosystems and different species, poaching, and pollution are some of them. But they all have a common denominator—human dominion over the planet and its expansion. Today there are more than seven billion of us (the most numerous vertebrate animals on the planet, just ahead of rats). And in order to feed a population of this size, we are indiscriminately and irresponsibly squandering the planet's resources. We slaughter more than 56 billion animals each year for our consumption (eight times the number of humans), not counting marine animals, our consumption of which is estimated at more than 170 million metric tonnes. By 2050 we will be approaching 10 billion people and the current rate of consumption will have doubled. If drastic changes are not made to our way of consuming resources, the entire ecosystem will collapse.

It is true that the world is designed in such a way that living beings eat one another. In order to subsist, all living things need to consume other living beings. We have no choice. All living beings fight bitterly against others to survive in this world whose design seems to be exquisitely perverse. Even so, perverse or not, everything had held its course as part of the very balance of nature until the emergence of humans, with their more sophisticated intellectual development, who introduced an additional factor of destruction. This factor has multiplied the natural rate of species extinction by more than a thousand.

IT IS ESTIMATED THAT A SPECIES ON
THE PLANET BECOMES EXTINCT EVERY
TEN MINUTES AS A DIRECT RESULT OF
HUMAN ACTIVITY.

So, what are the alternatives? Above all, we must be aware that this problem is an extremely urgent one and that we cannot continue to ignore it. Although we have never been so exposed to a disaster of this nature, we are also witnessing a collective awakening of awareness about the problem, and there is still hope that we can act in time. Action must be taken on all levels, from that of the individual to that of the group, by way of political decisions, scientific research to find alternative solutions, and the adaptation of economic activities to responsible and sustainable forms of consumption. However, the most important thing is not to lose hope, because it is the only way we can turn back this process of destruction in which we are immersed.

Einleitung

Zweifellos steht die Spezies Mensch vor einer ganzen Reihe von ungelösten Problemen, und in puncto Gleichheit und Gerechtigkeit haben wir in unseren Gesellschaften noch lange nicht die ersehnten Ziele erreicht. Doch die Sorge um den Erhalt und Schutz der Tierwelt ist deswegen kein oberflächliches Unterfangen, denn es geht dabei um nichts Geringeres als auch um unser Überleben. Nicht nur, dass Schönheit und Artenvielfalt verloren gehen: Unser gesamtes Ökosystem gerät mit dem Verlust von Arten aus den Fugen. Die weltweite Expansion des Menschen hatte bereits die Ausrottung Tausender lebender Arten zur Folge.

Laut aktuellen Schätzungen existieren auf der Erde etwa 8,7 Millionen lebende Arten. Von diesen kennen wir aber nur 1,3 Millionen. Mehr als 86 Prozent der auf der Erde und 91 Prozent der im Meer lebenden Arten sind bislang unbekannt. Durch das massive Artensterben, ausgelöst durch die Tatsache, dass der Mensch immer mehr Raum fordert, werden unzählige Spezies von der Erde verschwinden, ohne dass wir sie je kennengelernt haben.

WIR ALLE – ODER ZUMINDEST FAST
ALLE – LIEBEN TIERE. SIE TEILEN MIT
UNS DAS GEHEIMNIS DES LEBENS,
DES BEWUSSTSEINS UND DES SEINS.

Aber über alle philosophischen, ethischen und (nicht minder relevanten) ästhetischen Betrachtungen hinaus ist die extreme Gefährdung vieler Tierarten von immenser Bedeutung: Die Existenz der Menschheit steht auf dem Spiel. Einfach ausgedrückt: Wenn die Tiere von der Erde verschwinden, verschwinden auch wir Menschen.

Laut dem letzten Bericht des World Wild Fund For Nature (WWF) zur Lage der Biodiversität sind in den letzten 40 Jahren fast 60 Prozent der Wirbeltiere ausgestorben. Seit 1970 hat der Bestand an Landtieren um 38 Prozent abgenommen, der an Amphibien um 81 Prozent und der an Fischen um 36 Prozent. Die Wissenschaftler sprechen von »biologischer Vernichtung«. Jeden Tag wird in den Medien darüber berichtet, wie bedroht allseits bekannte und beliebte Arten sind, darunter beispielsweise Rhinozeros, Eisbär, Tiger, Wal, Elefant oder Orang-Utan. Dabei sind sie nur die Spitze des Eisbergs – das weitaus größere Problem ist das aus dem Gleichgewicht geratene Ökosystem. Es gibt viele unterschiedliche Meinungen darüber, wie groß das Ausmaß dieses Problems tatsächlich ist, aber in der Wissenschaft besteht Konsens darüber, dass die jährliche Aussterberate nicht nur alarmierend ist, sondern geradezu katastrophal. Man spricht bereits von einem sechsten Massensterben.

Was aber sind die Ursachen des Dramas? Die Vernichtung von Lebensräumen, der illegale Handel mit geschützten Arten, der Klimawandel und seine Auswirkungen auf das Ökosystem und die einzelnen Arten, die Wilderei, die Umweltverschmutzung und einiges mehr. All diese Ursachen haben einen gemeinsamen Nenner: die zunehmende Herrschaft des Menschen über die Erde. Aktuell sind wir mehr als sieben Milliarden – die zahlreichsten Lebewesen auf dem Planeten übrigens, dicht gefolgt von den Ratten. Um eine Bevölkerung dieser Größenordnung zu ernähren, verschwenden wir verantwortungslos die Ressourcen unseres Planeten, als gäbe es kein Morgen. Jedes Jahr töten wir mehr als 56 Milliarden Tiere für unseren Verzehr (das Achtfache der Weltbevölkerung), die Meerestiere nicht eingerechnet, deren Verzehr auf über 170 Millionen Tonnen jährlich geschätzt wird. Im Jahr 2050 wird sich die Bevölkerung der Zehn-Milliarden-Marke nähern, und der aktuelle Konsum wird sich verdoppeln. Wenn wir unseren Konsum nicht drastisch verändern, wird das gesamte Ökosystem kollabieren.

Natürlich ist die Welt so konzipiert, dass einer den anderen frisst. Um überleben zu können, müssen zahlreiche Lebewesen andere verzehren. Wir haben keine andere Wahl. Alle Lebewesen kämpfen erbittert um das Überleben in dieser Welt, deren Konzeption geradezu pervers anmutet. Doch innerhalb des Gleichgewichts der Natur war alles auf Kurs, bis der intellektuell höher entwickelte Mensch auftauchte und einen zusätzlichen Faktor der Zerstörung einbrachte. Und dieser Faktor hat die Geschwindigkeit des natürlichen Artensterbens um mehr als das Tausendfache erhöht.

SCHÄTZUNGEN ZUFOLGE WIRD ALLE
ZEHN MINUTEN EINE ART DURCH
DIREKTEN EINFLUSS DES
MENSCHEN AUSGELÖSCHT.

Was gibt es für Alternativen? Wir müssen begreifen, dass das Thema keinen Aufschub duldet und wir nicht länger die Augen davor verschließen dürfen. Auch wenn wir vor dem größten Desaster der Menschheitsgeschichte stehen, gibt es doch ein steigendes kollektives Problembewusstsein. Es besteht Hoffnung, dass wir noch rechtzeitig eingreifen können. Handeln ist angesagt – von jedem Einzelnen und von der Gemeinschaft. Wir brauchen richtungsweisende politische Entscheidungen, alternative Lösungsvorschläge aus der Wissenschaft und eine Korrektur des wirtschaftlichen Verhaltens hin zu einem verantwortungsvollen und nachhaltigen Konsum. Entscheidend ist, dass wir die Hoffnung nicht aufgeben dürfen, denn das ist die einzige Möglichkeit, den Zerstörungsprozess noch aufzuhalten.

Introducción

No cabe duda de que los humanos tenemos muchos problemas que resolver como especie, y que nuestras sociedades distan mucho de haber alcanzado la justicia e igualdad que anhelamos, pero ocuparse, o preocuparse, por el mundo animal, lejos de ser una simple frivolidad, se ha convertido en una cuestión de gran magnitud que atañe directamente a nuestra supervivencia. Ya no se trata solo de la pérdida de diversidad y de belleza, sino del desequilibrio de todo nuestro ecosistema. Nuestra expansión ha significado la desaparición de miles de especies vivas.

Según los cálculos más recientes, existirían aproximadamente 8,7 millones de especies vivas en el planeta. Pero solo conocemos 1,3 millones de ellas. Más del 86 % de las especies terrestres y el 91 % de las marinas son desconocidas. Sin embargo, dado el grado de extinción al que se enfrentan la mayoría de ellas debido a la expansión del dominio humano, muchas de estas especies desaparecerán de la tierra antes de que hayamos tenido conocimiento de ellas.

> TODOS, O CASI TODOS, AMAMOS A LOS
> ANIMALES. ELLOS COMPARTEN CON
> NOSOTROS EL MISTERIO DE LA VIDA,
> DE LA CONCIENCIA Y DEL SER.

Pero más allá de consideraciones filosóficas, éticas o incluso estéticas (que también son relevantes), la cuestión del estado de extrema fragilidad en el que se encuentran muchas especies vivas tiene un significado e importancia que superan cualquier debate: la subsistencia misma de la especie humana. Dicho de forma simple, si desaparecen los animales del planeta, también desaparecemos nosotros, los humanos.

Según el último informe del World Wide Fund For Nature (WWF) sobre el estado de la biodiversidad, se estima que en los últimos cuarenta años han desaparecido casi el 60 % de los animales vertebrados. Desde 1970, la población de animales terrestres no humanos disminuyó un 38 %, la de anfibios un 81 % y la de peces un 36 %. Los científicos lo denominan «aniquilación biológica». Todos los días se escuchan en los medios las amenazas que sufren las especies más populares y que más queremos y conocemos, como los rinocerontes, los osos polares, los tigres, las ballenas, los elefantes o los orangutanes. Pero ellos solo son la punta del iceberg de un problema mucho mayor, que es el desequilibrio de todo el ecosistema. Existen muchas discrepancias sobre la magnitud exacta del problema, pero la comunidad científica es unánime ante el hecho de que la tasa de extinción actual no solo es alarmante, sino catastrófica. Se habla ya de la sexta extinción masiva.

¿Y cuáles son las causas de este drama? La reducción de los hábitats, el comercio ilegal de especies, el cambio climático y sus efectos en los ecosistemas y en las distintas especies, la caza furtiva o la contaminación son algunas de ellas. Pero todas tienen un denominador común: la expansión del dominio humano en el planeta. Hoy en día somos más de siete mil millones de seres humanos (los animales vertebrados más numerosos del planeta, justo por encima de las ratas). Y para alimentar una población de esta magnitud estamos dilapidando los recursos del planeta de forma indiscriminada e irresponsable. Cada año matamos más de cincuenta y seis mil millones de animales para nuestro consumo (ocho veces la población total de seres humanos), sin contar los animales acuáticos, cuyo consumo se calcula en más de 170 millones de toneladas al año. Para el año 2050 nos estaremos acercando a los diez mil millones de personas y el ritmo actual de consumo se duplicará. Si no se aplican cambios drásticos en nuestra forma de consumo, todo el ecosistema colapsará.

Es verdad que el mundo está diseñado para que los seres vivos nos comamos los unos a los otros. Para poder subsistir, todos los seres vivos necesitamos consumir a otro ser vivo. No tenemos alternativa, y todos los seres vivos luchan encarnizadamente entre sí para sobrevivir en este mundo cuyo diseño se antoja exquisitamente perverso. Aún así, todo había mantenido su curso, perverso o no, dentro del equilibrio propio de la naturaleza, hasta que surgió el ser humano, con un desarrollo intelectual más sofisticado, que ha venido a introducir un factor destructivo adicional. Un factor destructivo que ha multiplicado por más de mil la velocidad de extinción natural de las especies.

> SE ESTIMA QUE CADA DIEZ MINUTOS
> SE EXTINGUE UNA ESPECIE VIVA DEL
> PLANETA POR LA ACCIÓN DIRECTA
> DEL SER HUMANO.

¿Cuáles son las alternativas entonces? Ante todo, tomar conciencia de que este problema es impostergable y de que no podemos seguir ignorándolo. Aunque nunca antes habíamos estado tan expuestos a un desastre de este tipo, también es cierto que asistimos a un despertar colectivo de la conciencia sobre el problema y que existe la esperanza de poder actuar a tiempo. Las acciones tienen que realizarse en todos los niveles, desde el individual hasta el colectivo, pasando por las decisiones políticas, la investigación científica para buscar soluciones alternativas y la adaptación de las actividades económicas hacia un consumo responsable y sostenible. Pero lo más importante es no renunciar a la esperanza, porque es la única manera de poder revertir el proceso destructivo en el que nos encontramos inmersos.

Introduction

Il ne fait aucun doute que nous autres, humains, avons de nombreux problèmes à résoudre en tant qu'espèce et que nos sociétés sont loin d'être les havres de justice et d'égalité auxquels nous aspirons. Aujourd'hui, se préoccuper du monde animal n'est pas une simple frivolité, mais une question cruciale qui pose la question de notre propre survie : il ne s'agit plus seulement de se soucier de la perte de diversité et de beauté, mais du déséquilibre de tout notre écosystème puisque notre développement a incontestablement entraîné la disparition de milliers d'espèces vivantes.

Selon des estimations récentes, environ 8,7 millions d'espèces vivantes cohabiteraient sur la planète, mais nous n'en connaissons que 1,3 million. Cela signifie que plus de 86 % des espèces terrestres et 91 % des espèces marines nous sont encore inconnues. Étant donné le degré d'extinction auquel la plupart d'entre elles sont confrontées en raison de l'expansion humaine, il est probable que des espèces disparaissent avant même que nous les ayons découvertes.

TOUT LE MONDE, OU PRESQUE, AIME LES ANIMAUX. ILS PARTAGENT AVEC NOUS LE MYSTÈRE DE LA VIE, DE LA CONSCIENCE ET DE L'ÊTRE.

Mais au-delà de considérations philosophiques, éthiques, voire esthétiques – pertinentes au demeurant –, la question de l'état d'extrême fragilité dans lequel se trouvent de nombreuses espèces vivantes revêt un sens et une importance au-delà de tout débat : la survie de l'espèce humaine. En d'autres termes, si les animaux venaient à disparaître de la planète, il en serait de même pour les humains.

Le dernier rapport du Fonds mondial pour la nature (WWF) sur l'état de la biodiversité estime que près de 60 % des animaux vertébrés ont disparu au cours des quarante dernières années. Depuis 1970, la population des animaux terrestres non humains a diminué de 38 %, celle des amphibiens de 81 % et celle des poissons de 36 %. Les scientifiques parlent d'un « anéantissement biologique ». Chaque jour, les médias relaient les menaces qui pèsent sur les espèces les plus populaires que nous apprécions et que nous connaissons, comme les rhinocéros, les ours polaires, les tigres, les baleines, les éléphants ou encore les orangs-outans. Mais ces menaces ne représentent qu'une infime partie d'un problème beaucoup plus vaste : le déséquilibre de l'écosystème tout entier. Bien que l'ampleur exacte du problème fasse l'objet de débats, la communauté scientifique est unanime sur le fait que le taux d'extinction actuel est alarmant, voire catastrophique. On parle déjà de la sixième extinction massive.

Quelles sont les causes de ce drame ? La réduction de l'habitat naturel des animaux, le commerce illégal, le changement climatique et ses effets sur les écosystèmes et les espèces, le braconnage et la pollution sont quelques-unes des principales raisons. Toutes ont comme dénominateur commun la croissance continue de la population et son emprise sur la planète. Aujourd'hui, nous sommes plus de sept milliards d'êtres humains, le plus grand nombre de vertébrés au monde, juste au-dessus des rats. Pour nourrir une population de cette ampleur, nous gaspillons les ressources de la planète sans aucun discernement et sans aucune conscience. Chaque année, nous tuons plus de cinquante-six milliards d'animaux pour notre consommation (l'équivalent de huit fois la population humaine mondiale), sans compter les animaux aquatiques dont la consommation est estimée à plus de 170 millions de tonnes par an. D'ici 2050, nous approcherons les dix milliards d'habitants et la consommation actuelle doublera. Si nous ne changeons pas radicalement notre façon de vivre, l'écosystème tout entier s'effondrera.

Il est vrai que le monde est conçu pour que les êtres vivants se mangent entre eux pour survivre. Nous n'avons pas d'alternative, et tous les êtres vivants luttent les uns contre les autres pour subsister dans ce monde dont la conception semble d'une perversité exquise. Pourtant, la vie suivait son cours, pervers ou non, au sein de l'équilibre propre à la nature, jusqu'à l'arrivée de l'être humain. Doté d'un développement intellectuel plus sophistiqué, il a introduit un facteur destructeur supplémentaire qui a multiplié par plus de mille la vitesse à laquelle les espèces disparaissent.

ON ESTIME QUE TOUTES LES DIX MINUTES, UNE ESPÈCE DISPARAÎT DE LA PLANÈTE DU FAIT DE L'ACTION DIRECTE DE L'HOMME.

Mais quelles sont les alternatives ? Nous devons avant tout être conscients du fait que ce problème ne peut plus être ignoré ni remis à plus tard. Bien que nous n'ayons jamais été aussi exposés à une telle catastrophe, il est également vrai que nous assistons à une prise de conscience collective du problème, qui laisse entrevoir l'espoir d'agir à temps. Des actions doivent être menées à tous les niveaux, par l'individu et par la collectivité, et des mesures doivent être prises au niveau politique et scientifique pour développer des alternatives et adapter les activités économiques à une consommation responsable et durable. Le plus important est de ne pas perdre espoir, car c'est le seul moyen d'inverser le processus destructeur dans lequel nous sommes engagés.

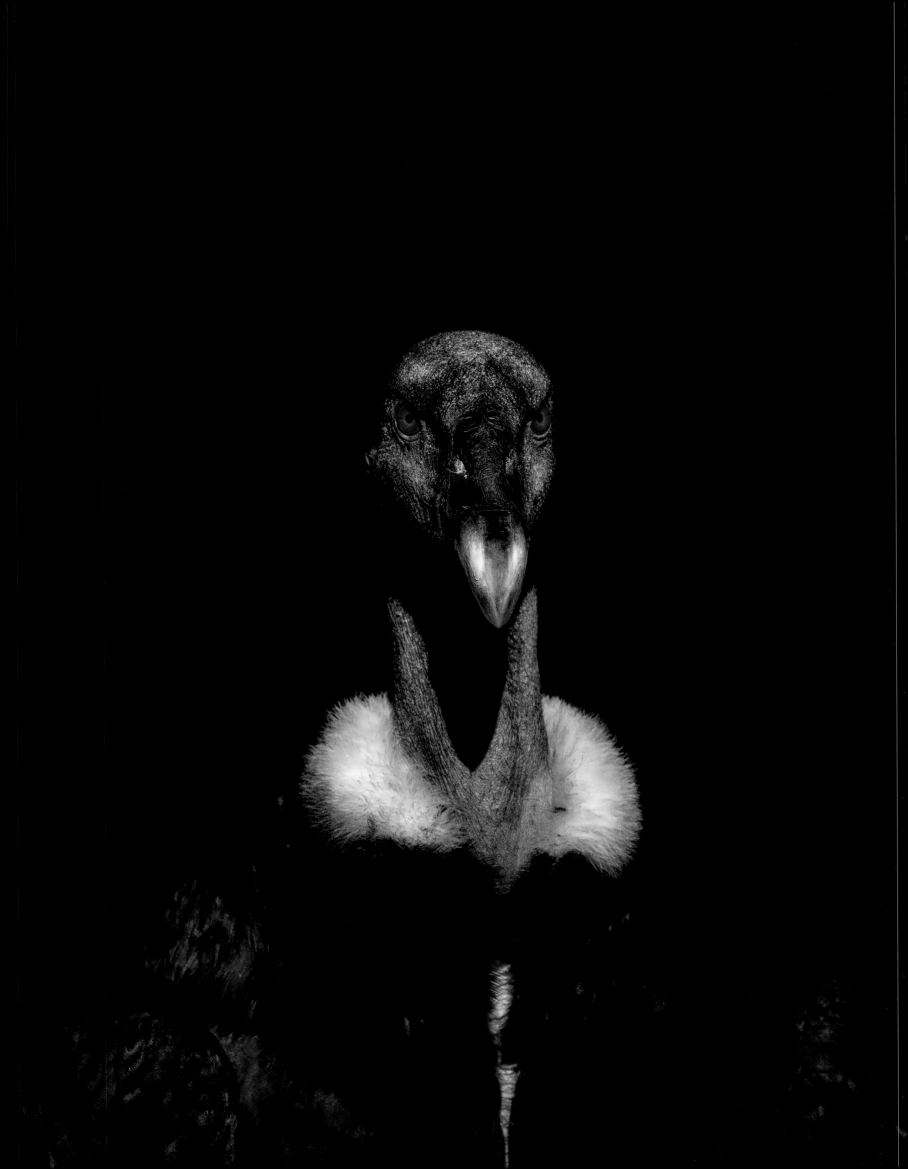

Photographs

Blue-and-yellow macaw

Ara ararauna, 1758

In 2012, a group of renowned scientists published the Cambridge Declaration on Consciousness, which explained that most animals, including birds, possess near human-like levels of consciousness. Although they lack a neocortex, their neural networks allow them to manifest conscious behaviors, such as pain, pleasure, and fear, and even to recognize themselves in a mirror and to dream.

Im Jahr 2012 veröffentlichte eine Gruppe anerkannter Wissenschaftler die *Cambridge Declaration of Consciousness.* Darin erklären sie, dass die Mehrzahl der Tiere, Vögel eingeschlossen, ein Bewusstsein besitzt, das dem des Menschen sehr ähnlich ist. Auch ohne Großhirnrinde verfügen Tiere über neurologische Anlagen, die es ihnen ermöglichen, Empfindungen wie Schmerz, Lust oder Angst auszudrücken, sich im Spiegel zu erkennen oder zu träumen.

En 2012 un grupo de reconocidos científicos publicó la Declaración de Cambridge, en la que explicaban que la mayoría de los animales, incluidas las aves, poseen una conciencia muy parecida a la humana. Aunque carezcan de neocórtex, sus redes cerebrales les permiten manifestar comportamientos conscientes como el dolor, el placer o el miedo e incluso reconocerse en un espejo o soñar.

En 2012, un groupe international de scientifiques a publié la Déclaration de Cambridge sur la conscience chez les animaux. On y apprend que la plupart d'entre eux, y compris les oiseaux, ont une conscience très semblable à celle des humains. Bien qu'ils n'aient pas de néocortex, des connexions cérébrales leur permettent de manifester des comportements conscients : la douleur, le plaisir, la peur, le fait de se reconnaître dans un miroir ou de rêver.

fragile

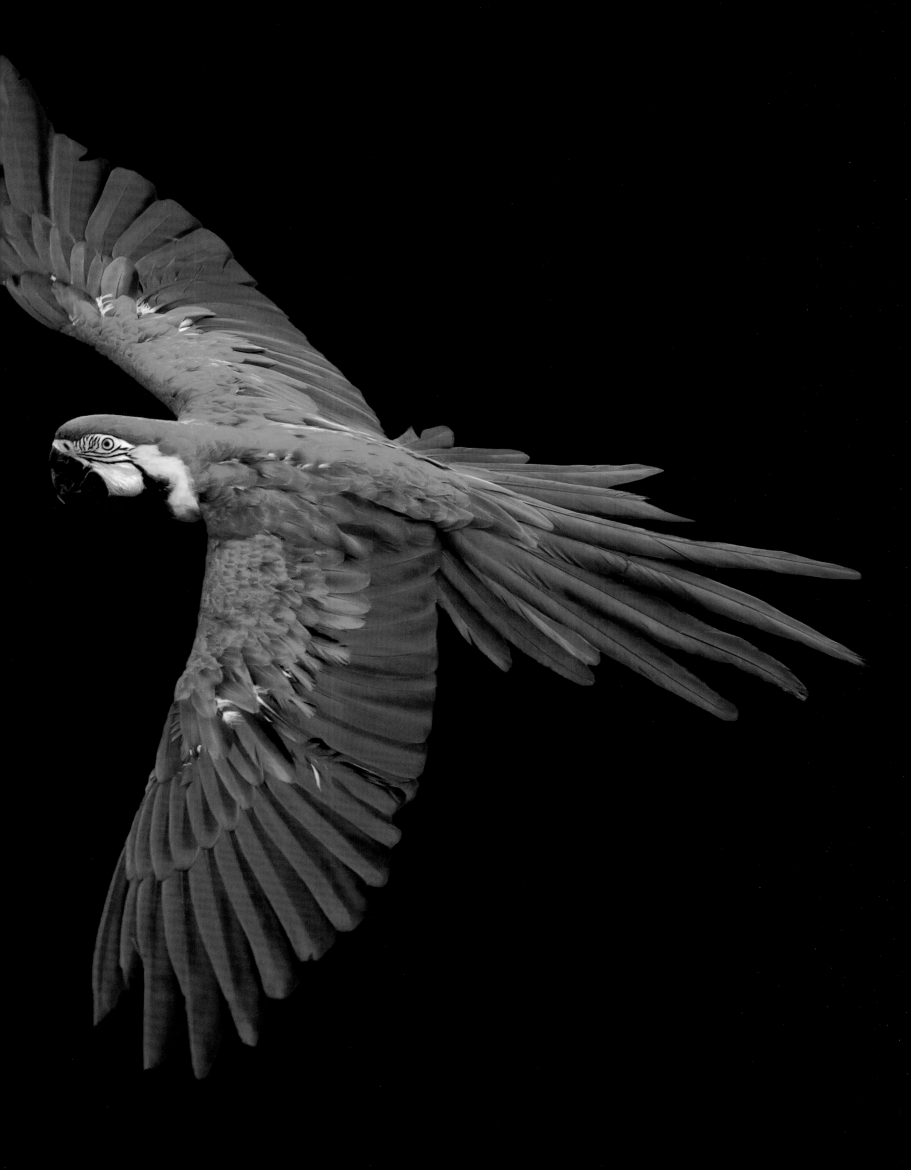

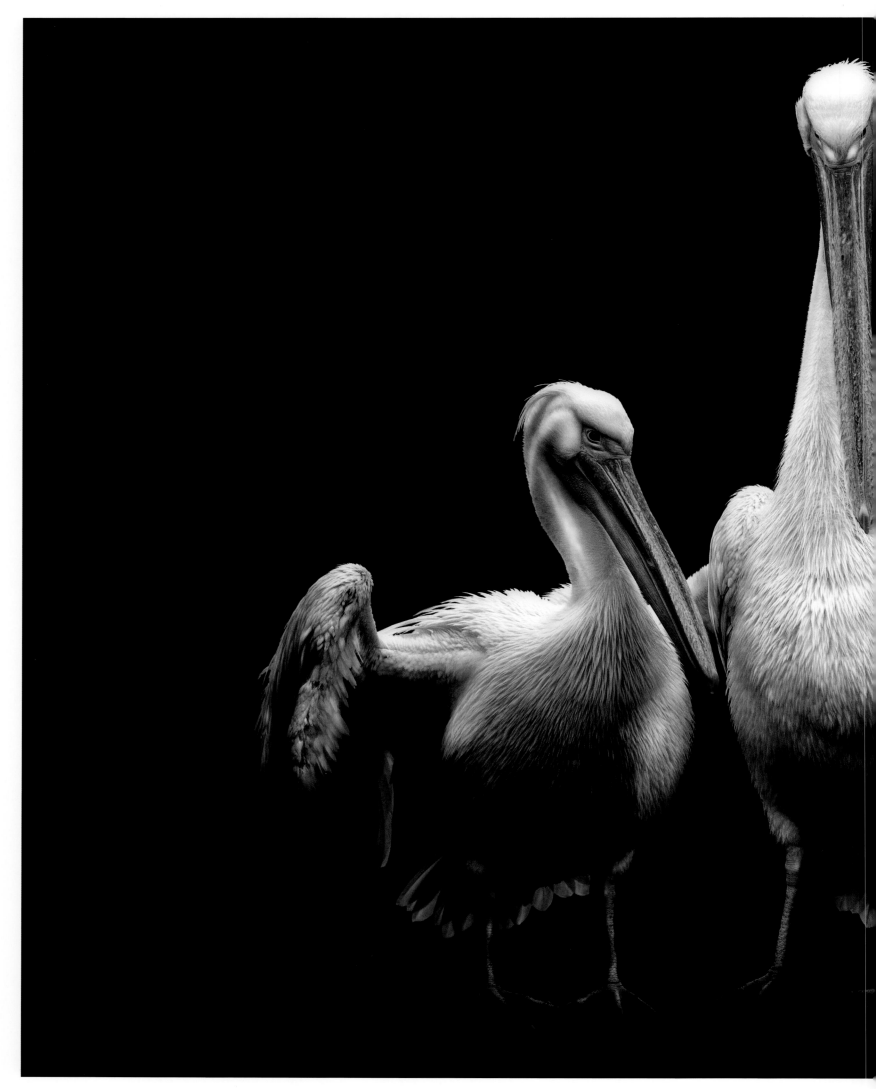

fragile

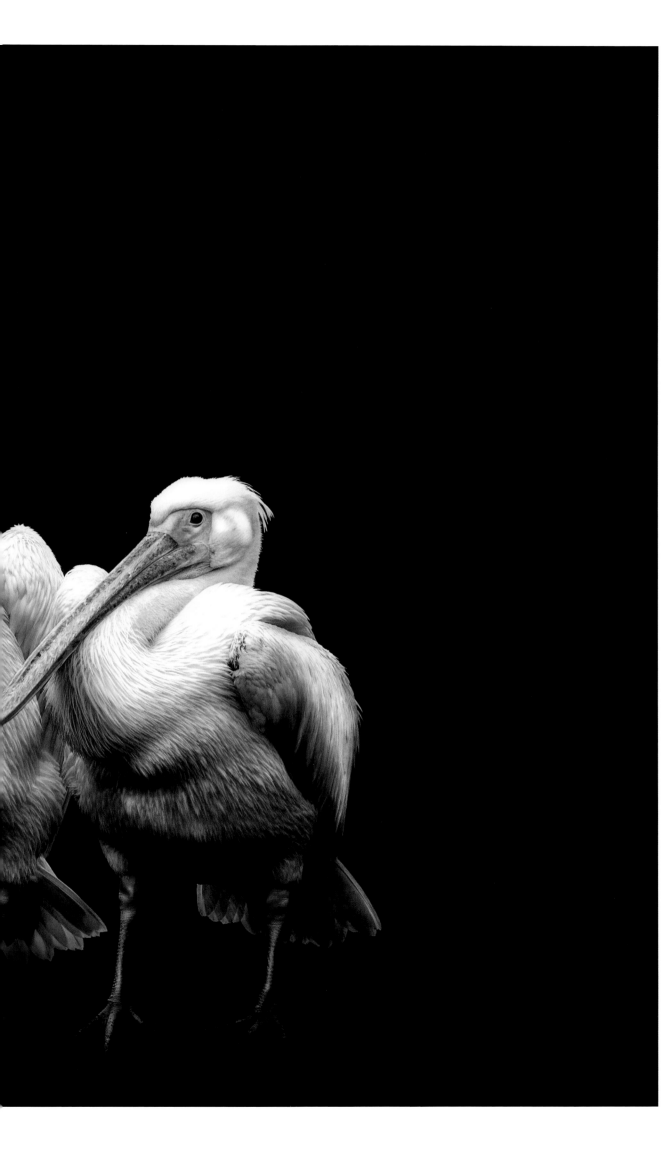

Great white pelican
Pelecanus onocrotalus, 1758

The French philosopher René Descartes maintained that animals were mere machines that lacked consciousness. Today, however, it is known that the areas of the brain that distinguish humans from other animals are not the ones responsible for consciousness. Paradoxically, although we now recognize consciousness in animals, we continue to treat them as simple goods to eat and trade.

Der französische Philosoph René Descartes war der Ansicht, Tiere seien reine Maschinen ohne Bewusstsein. Doch heute weiß man, dass die Hirnareale, die die Menschen von den anderen Tieren unterscheiden, nicht die sind, in denen das Bewusstsein entsteht. Paradoxerweise gestehen wir heute den Tieren zwar ein Bewusstsein zu, aber wir behandeln sie nach wie vor als Ware für Handel und Konsum.

El filósofo francés René Descartes consideraba que los animales eran meras máquinas desprovistas de conciencia. Pero hoy se sabe que las áreas cerebrales que distinguen a los humanos de otros animales no son las que producen la conciencia. Paradójicamente, aunque ahora reconocemos una conciencia en los animales, los seguimos tratando como simple materia para el consumo y el comercio.

René Descartes soutenait la thèse selon laquelle les animaux étaient de simples machines, sans conscience. On sait aujourd'hui que les zones du cerveau qui distinguent les humains des animaux ne sont pas celles qui abritent la conscience. Et pourtant, le fait de reconnaître cette faculté ne nous empêche pas de traiter les animaux comme de simples produits de consommation et de commerce.

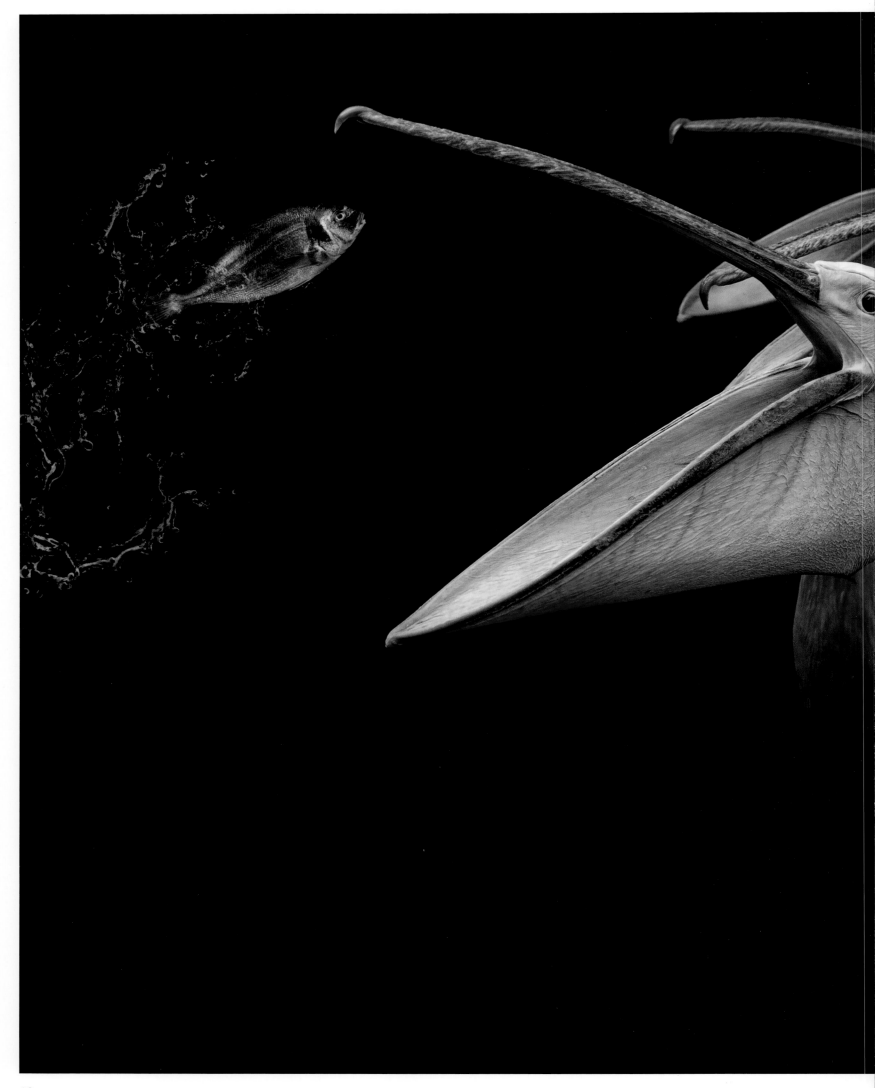

fragile

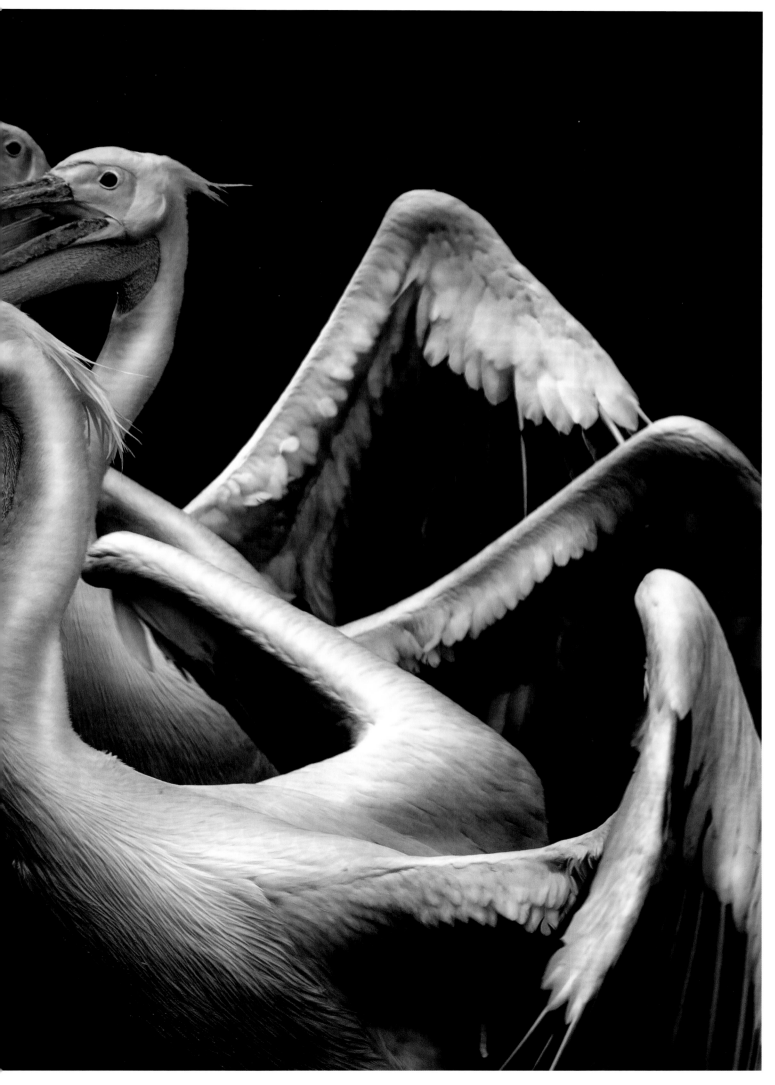

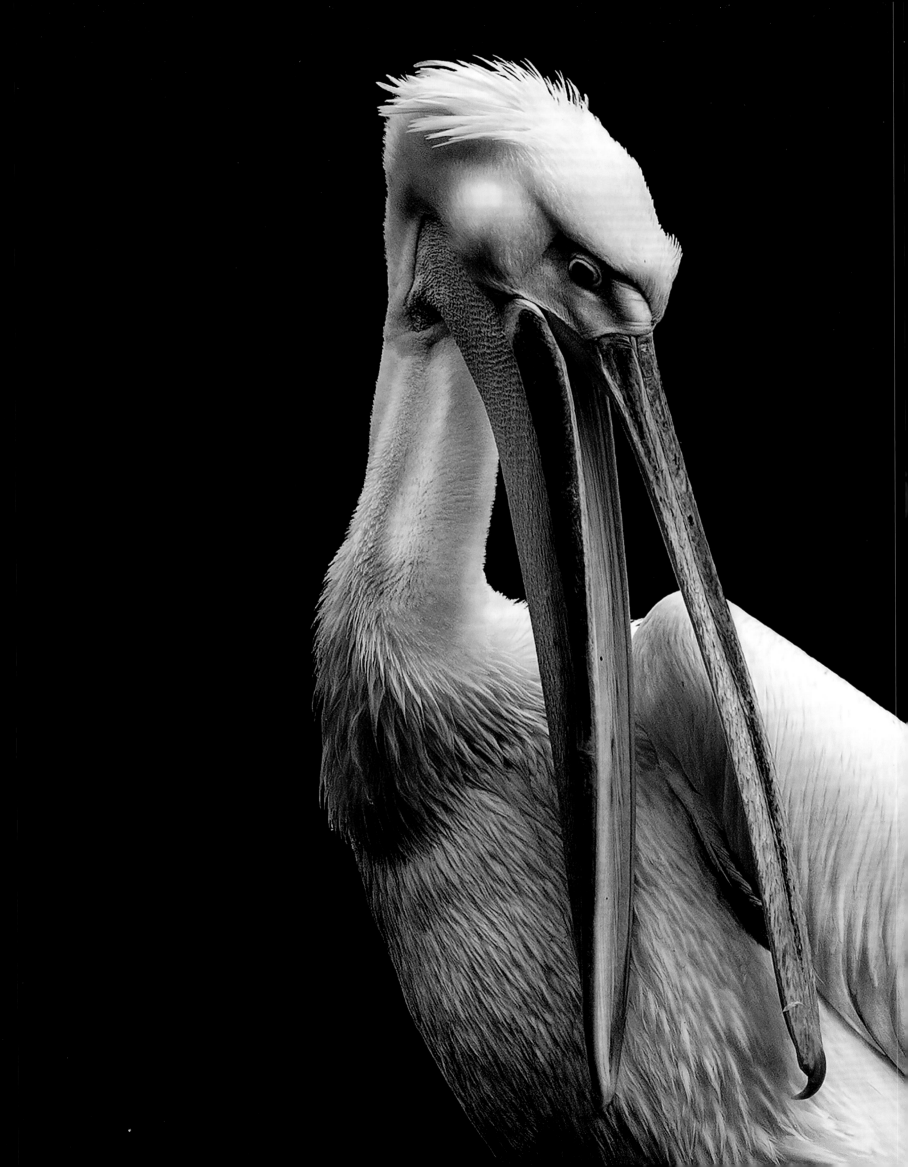

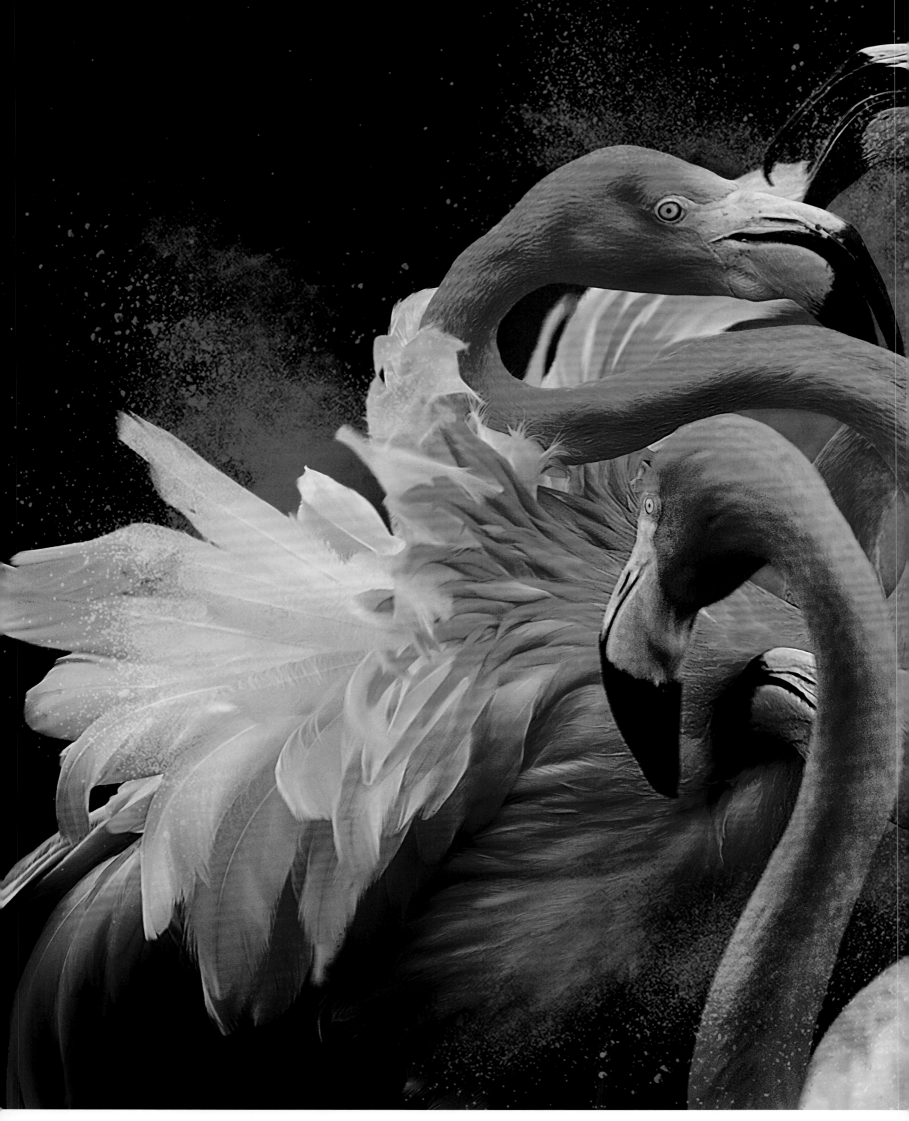

fragile

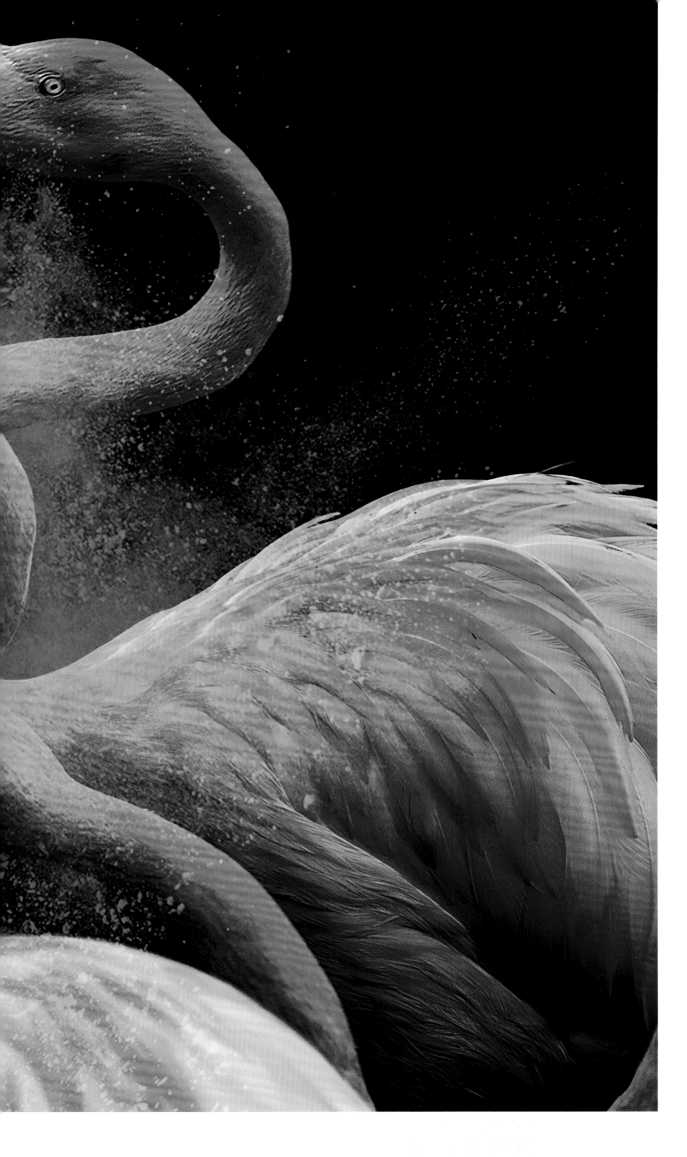

American flamingo
Phoenicopterus ruber, 1758

Even though the eyes of flamingos are bigger than their brains, this does not make them animals lacking in consciousness. They have excellent sight, and despite a limited ability to interpret what they see, the way in which they form groups enables them to develop a collective consciousness in order to cope with their environment. Climate change is increasingly affecting their habitats.

Auch wenn die Augen der Flamingos größer sind als ihr Hirn, heißt das nicht, dass sie kein Bewusstsein besitzen. Sie haben ein weites Gesichtsfeld, und obwohl ihre Fähigkeit, das Gesehene zu interpretieren, begrenzt ist, entwickeln sie durch die Bildung von Gruppen ein kollektives Bewusstsein, mit dem sie auf die Umwelt reagieren. Ihr Lebensraum wird zunehmend durch den Klimawandel beeinträchtigt.

Aunque los flamencos tienen los ojos más grandes que el cerebro, esto no los convierte en animales desprovistos de conciencia. Poseen una gran visión, y a pesar de que su capacidad para interpretar lo que ven es limitada, su forma de asociarse en grupos les permite desarrollar una conciencia colectiva para enfrentarse a su entorno. El cambio climático está afectando a sus hábitats de manera creciente.

Bien que les flamants roses aient les yeux plus gros que le cerveau, ils ne sont pas pour autant dépourvus de conscience. L'interprétation de ce qu'ils voient est limitée par rapport à leur grande capacité visuelle. Mais grâce à leur mode de vie en groupe, ils ont développé une conscience collective qui leur permet de s'adapter à leur environnement. Le changement climatique bouleverse par contre de plus en plus leurs habitats.

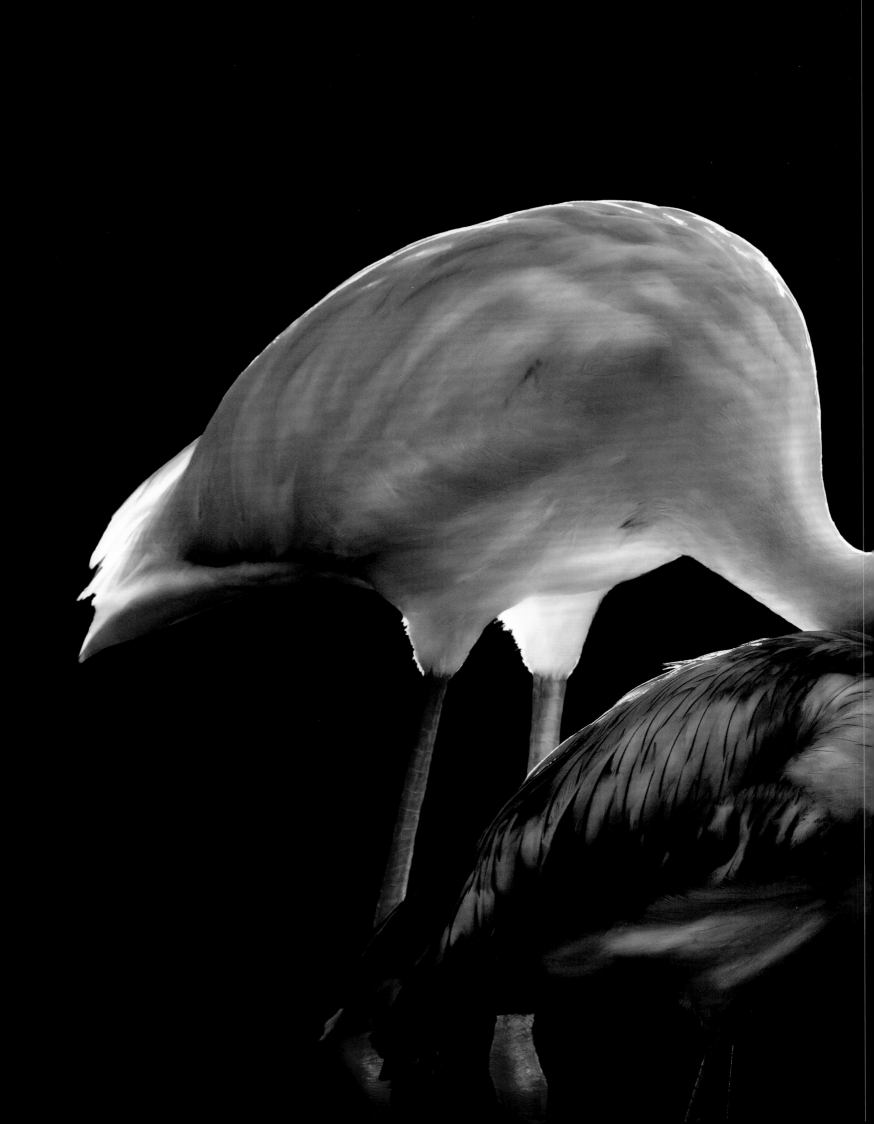

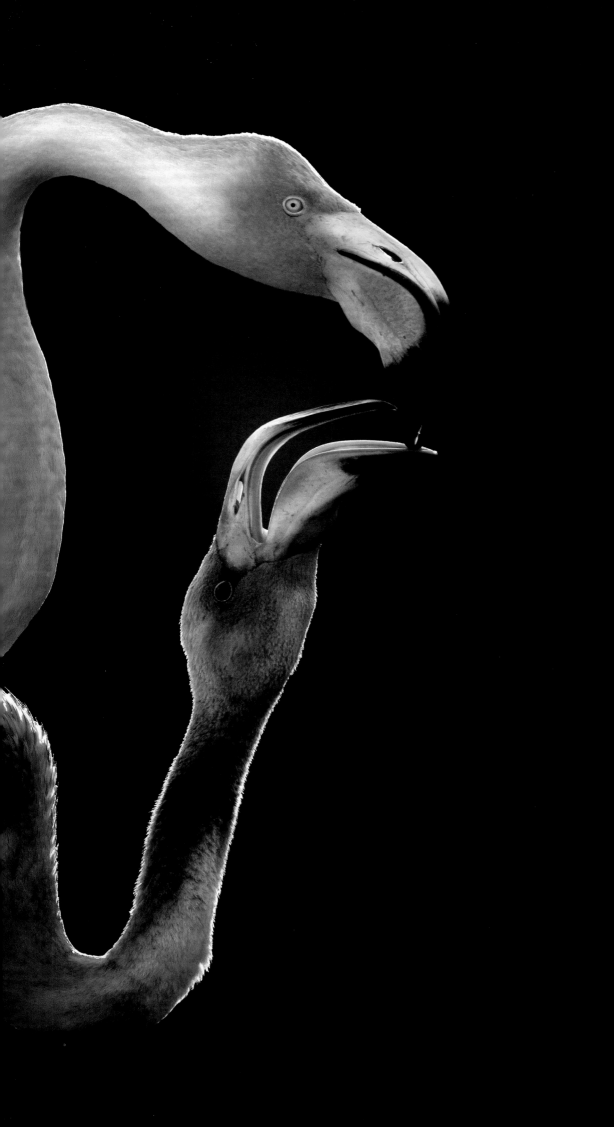

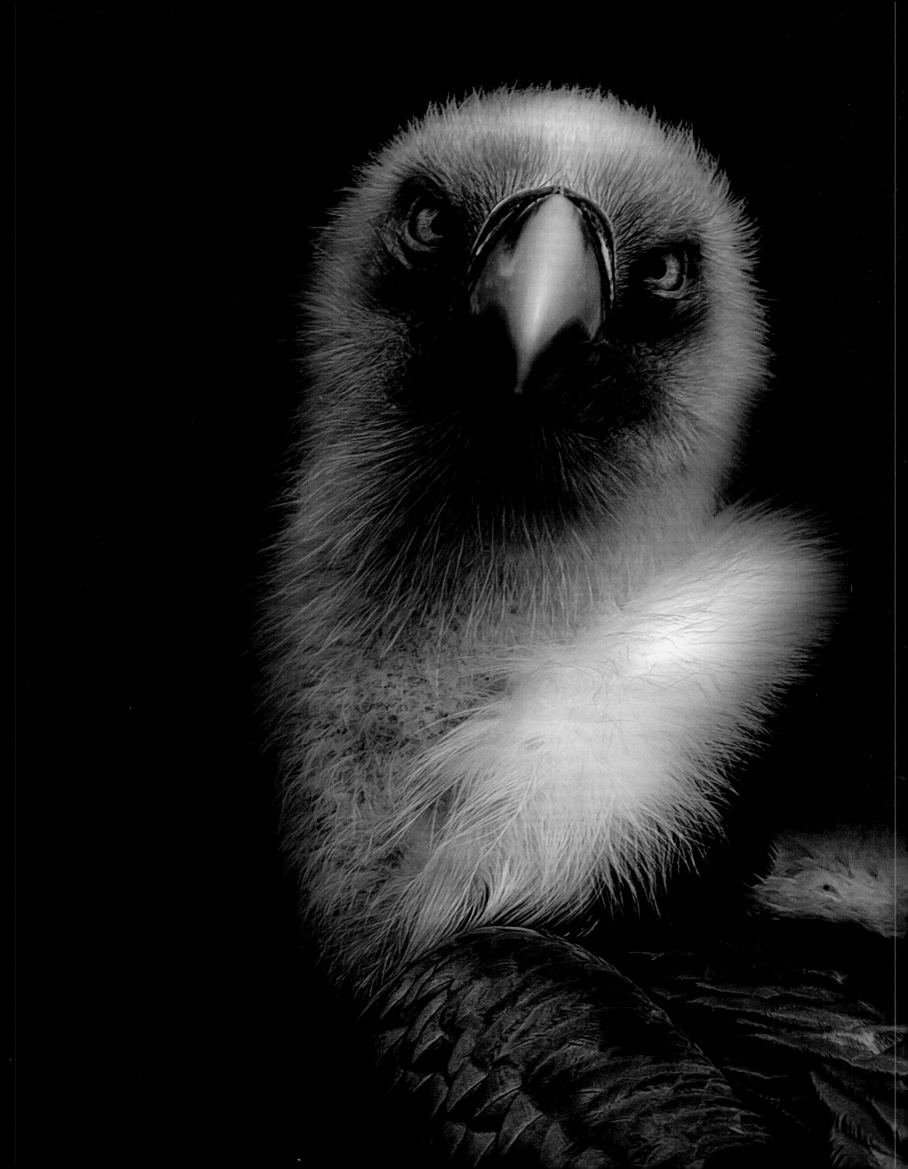

Griffon vulture
Gyps fulvus, 1783

Despite its poor reputation, the vulture plays an essential role in the ecosystem because by eating dead animals, they prevent the spread of disease. However, the numbers of some vulture subspecies have fallen by nearly 95 percent in a very short time owing to the use of diclofenac with livestock. This drug is present in the carrion they eat, affecting their kidneys and causing their death.

Trotz seines schlechten Rufs ist der Geier für das Ökosystem unverzichtbar: Da er sich von toten Tieren ernährt, verhindert er die Verbreitung von Krankheiten. Doch bei einigen Unterarten ist die Population durch die Verwendung des Medikaments Diclofenac in der Viehwirtschaft binnen wenigen Jahren um nahezu 95 Prozent gesunken. Die Geier nehmen das Medikament, das bei ihnen tödliche Nierenschäden verursacht, mit dem Aas auf.

A pesar de su mala fama, el buitre es un animal indispensable para el ecosistema ya que al alimentarse de animales muertos evita la propagación de enfermedades. Sin embargo en algunas subespecies su población ha caído casi en un 95 % en pocos años debido al uso del diclofenaco en el ganado. Este fármaco está presente en la carroña que consumen y les afecta a los riñones causándoles la muerte.

Malgré sa mauvaise réputation, le vautour est essentiel à l'écosystème, car en se nourrissant des animaux morts, il évite la propagation de maladies. Mais en quelques années, la population de certaines sous-espèces a décliné de près de 95 % à cause du diclofénac, un anti-inflammatoire utilisé dans l'élevage du bétail. Ce médicament est encore présent dans les carcasses que les vautours consomment : il provoque une insuffisance rénale qui entraîne leur mort.

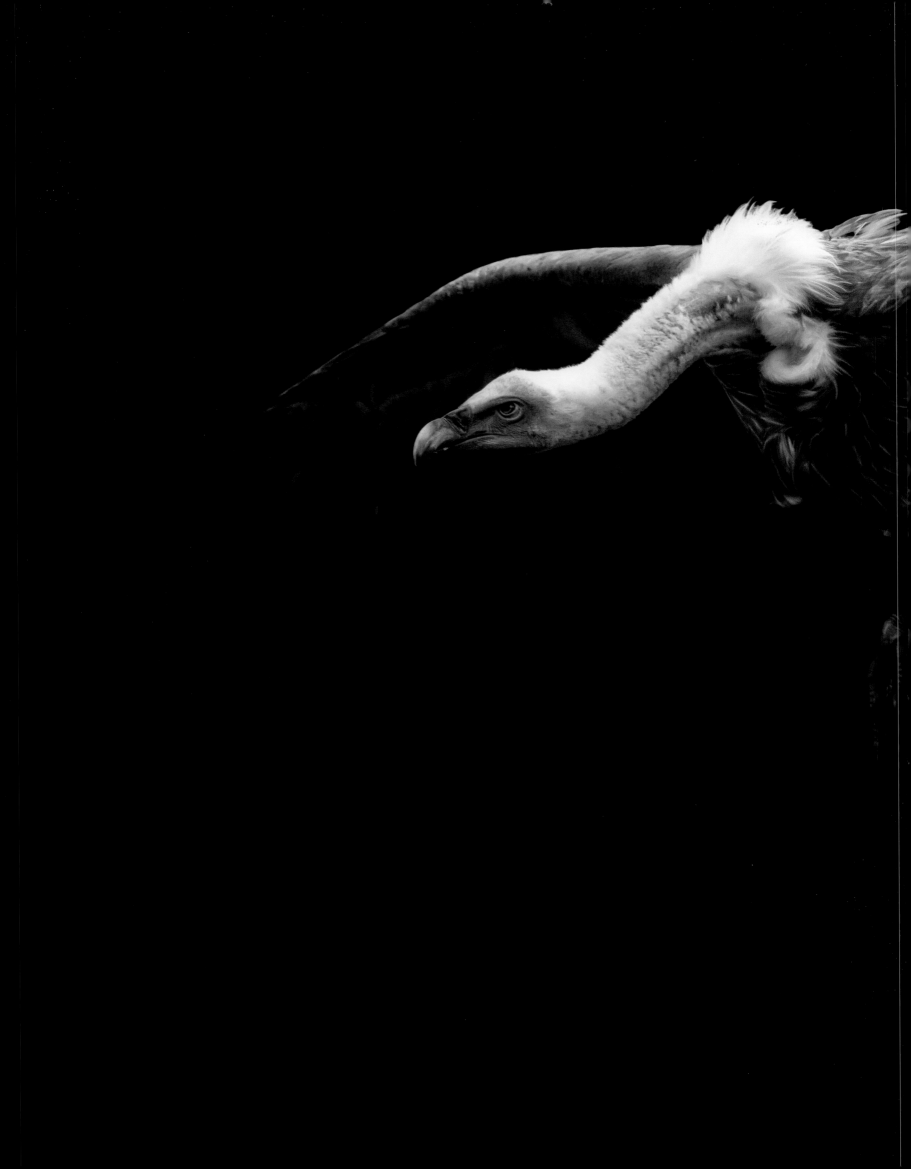

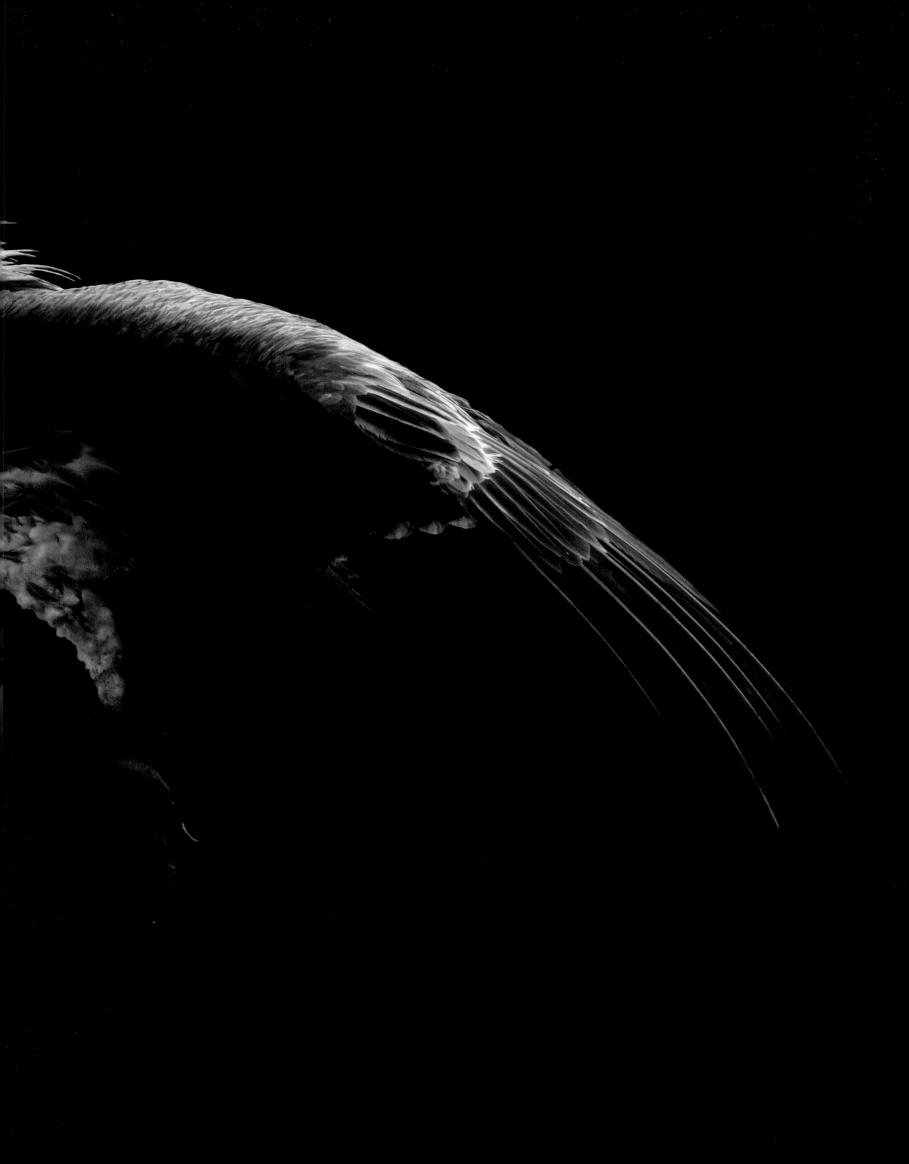

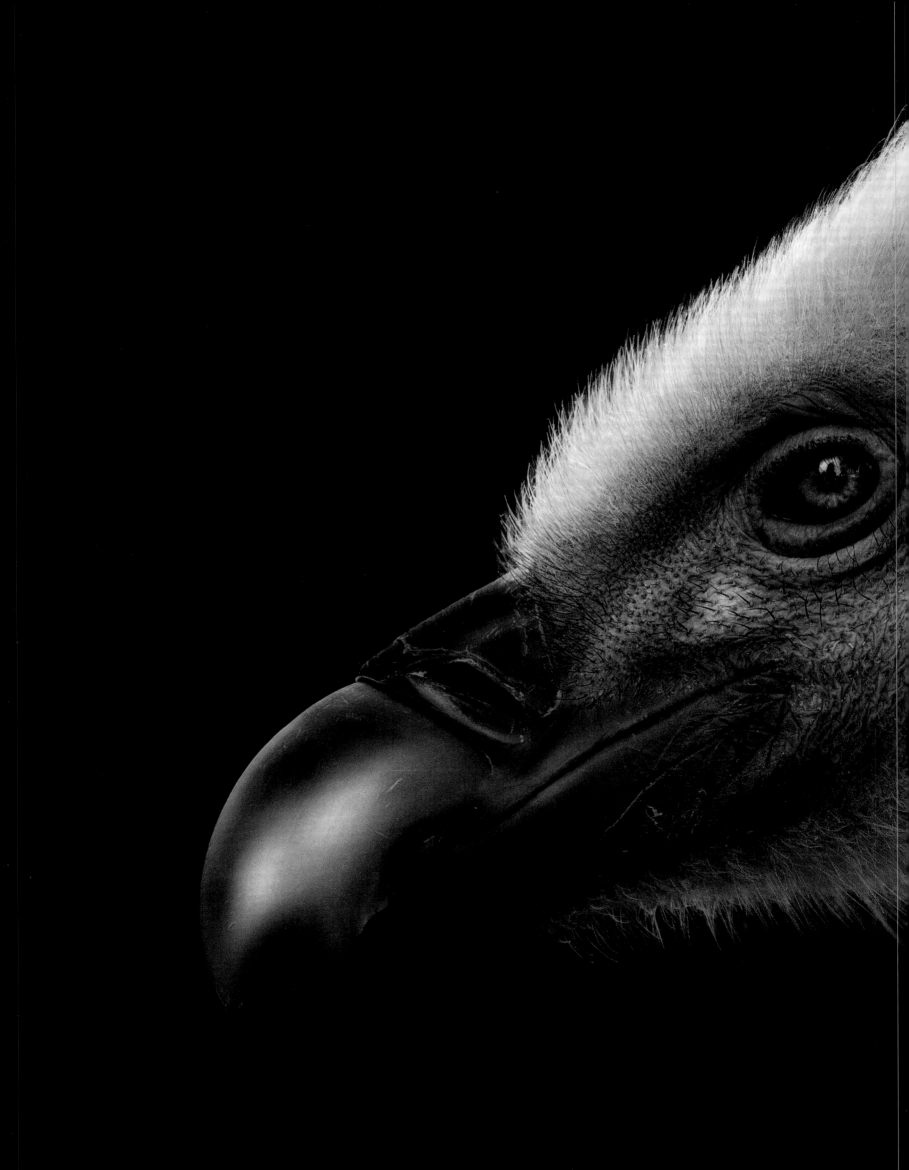

Steller's sea eagle

Haliaeetus pelagicus, 1811

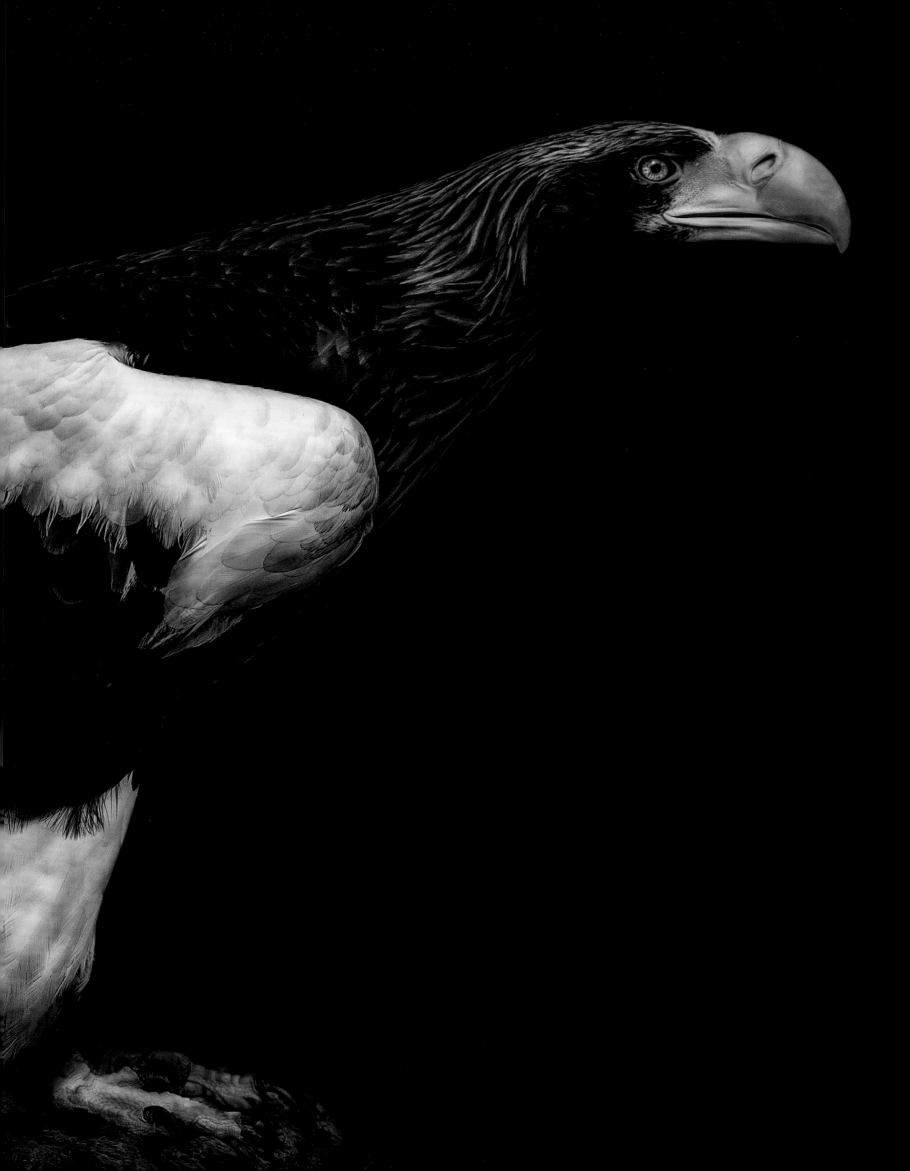

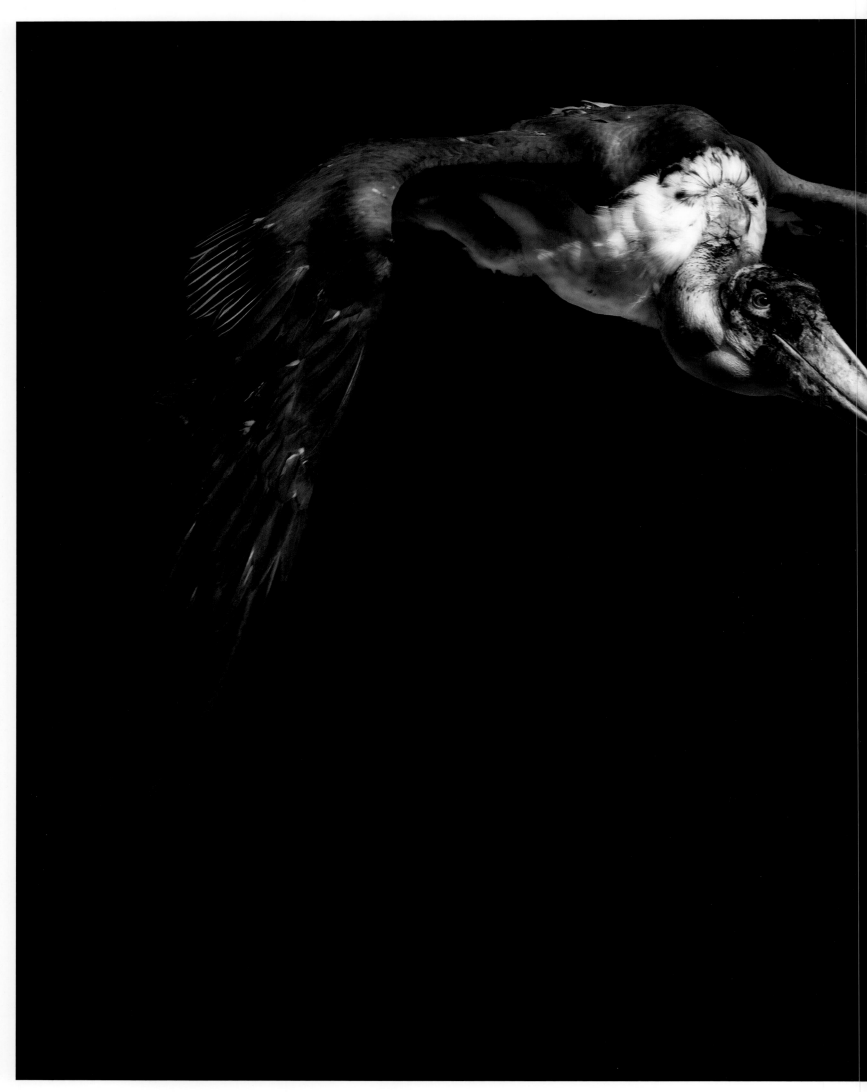

fragile

Marabou stork
Leptoptilos crumeniferus, 1831

One in every eight species of birds is endangered. The main causes are unsustainable agricultural practices, deforestation, invasive species, hunting, climate change, and pollution, among others. Marine birds are the most fragile, with more than 77 percent of species endangered, mainly the result of overfishing. Other very well-known species, such as the sparrow, have seen their numbers decline. However, as the direct threat is human activity, the damage can be reversed, and in some cases the decline has been halted.

Eine von acht Vogelarten ist vom Aussterben bedroht. Hauptgründe sind vor allem nicht nachhaltige Landwirtschaft, Abholzung von Wäldern, invasive Arten, Klimawandel und Umweltverschmutzung. Für die Seevögel ist die Lage am brisantesten: Mehr als 77 Prozent der Spezies sind bedroht, hauptsächlich durch Überfischung. Aber auch die Bestände anderer weitverbreiteter Arten wie des Feldsperlings sind geschrumpft. Da die Bedrohung in diesem Fall direkt auf das menschliche Handeln zurückzuführen ist, lässt sich der Schaden korrigieren. In einigen Fällen hat man der Ausrottung Einhalt gebieten können.

Una de cada ocho especies de aves está en peligro de extinción. Las principales causas son la práctica de una agricultura insostenible, la tala de árboles, las especies invasoras, la caza, el cambio climático y la contaminación, entre otras. Las aves marinas son las más frágiles, con más del 77 % de especies amenazadas debido, principalmente, a la sobrepesca. Otras especies muy conocidas como el gorrión común, también han visto mermadas sus poblaciones. Sin embargo, como la amenaza es directamente la acción humana, el daño es reversible y en algunos casos se ha podido frenar el declive.

Une espèce d'oiseau sur huit est menacée d'extinction. Les principales causes sont l'agriculture non durable, la déforestation, les espèces envahissantes, la chasse, le changement climatique et la pollution. Les oiseaux de mer sont les plus fragiles, avec plus de 77 % des espèces menacées, principalement victimes de la surpêche. D'autres espèces bien connues, comme le moineau domestique, ont également vu leurs populations diminuer. Cependant, comme la menace est directement liée à l'activité humaine, il est possible de freiner les dégâts, dans certains cas, leur déclin a pu être endigué.

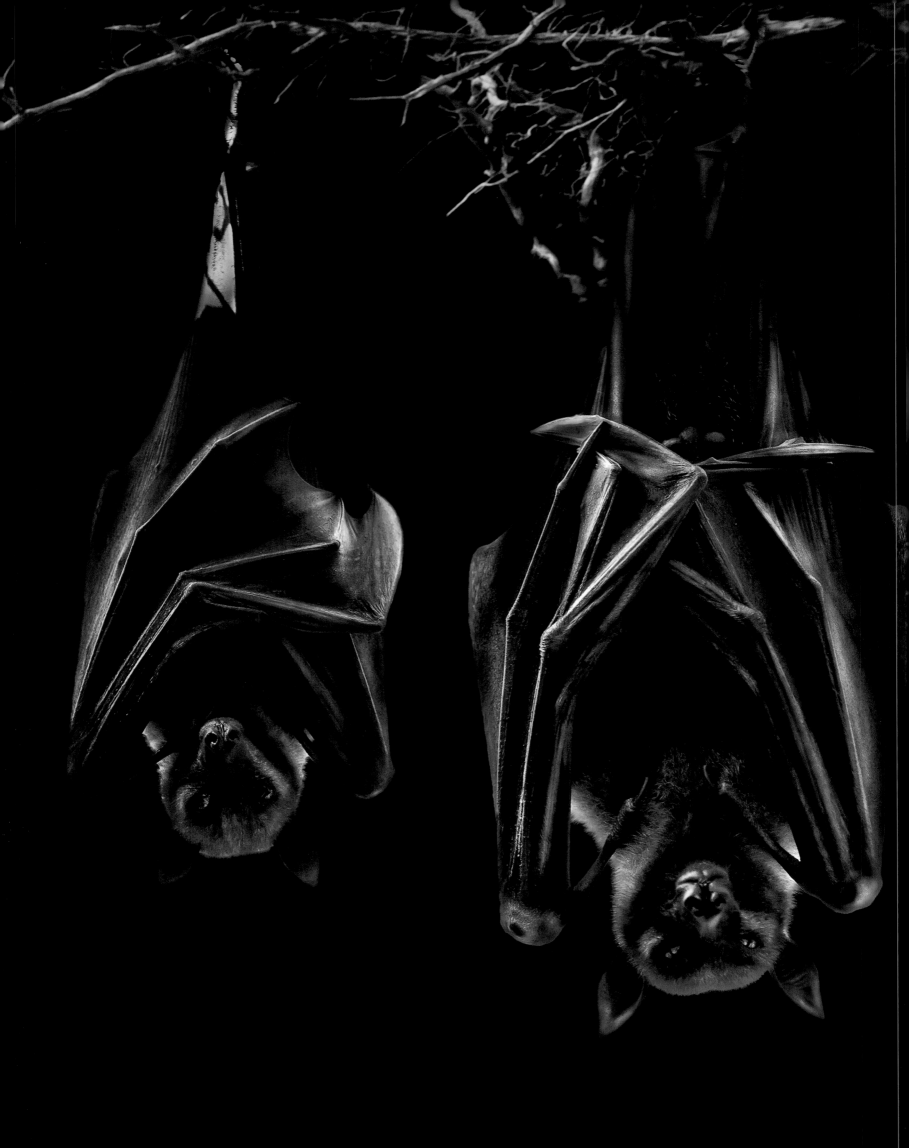

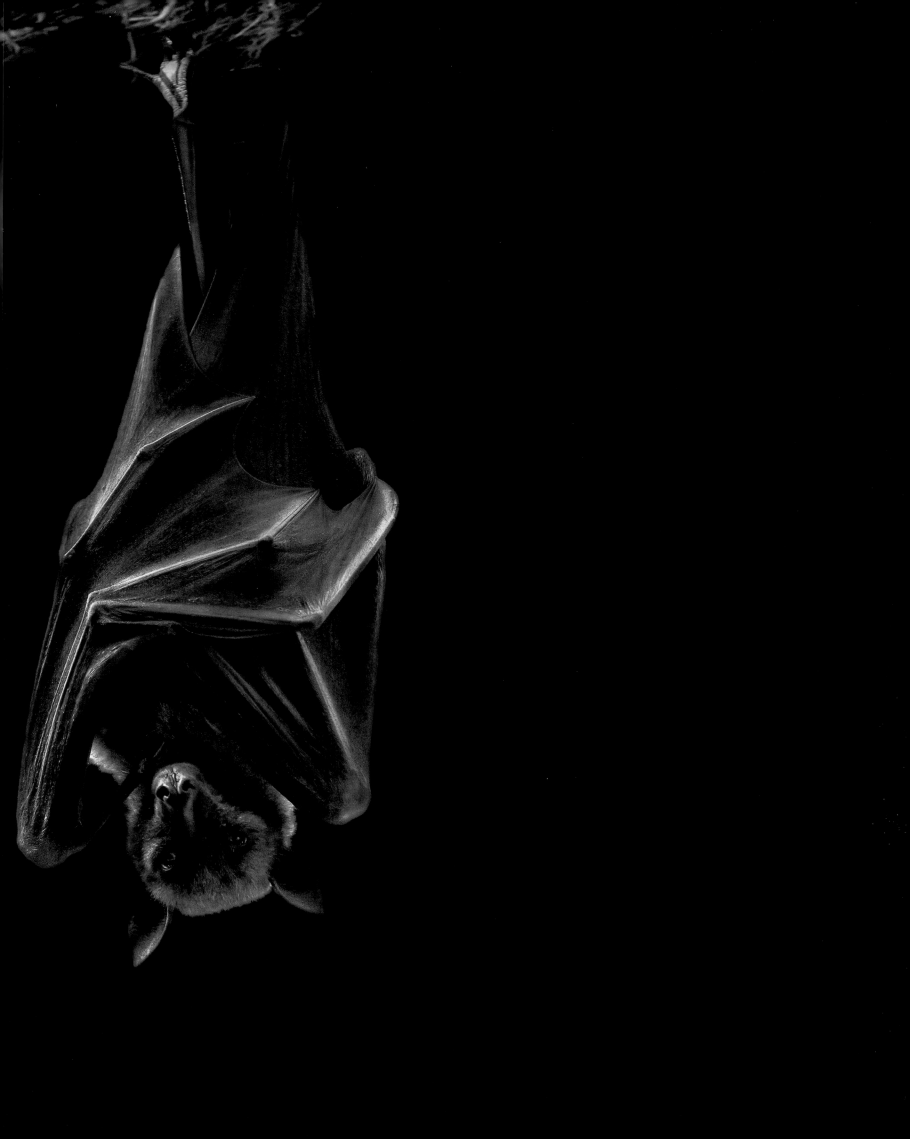

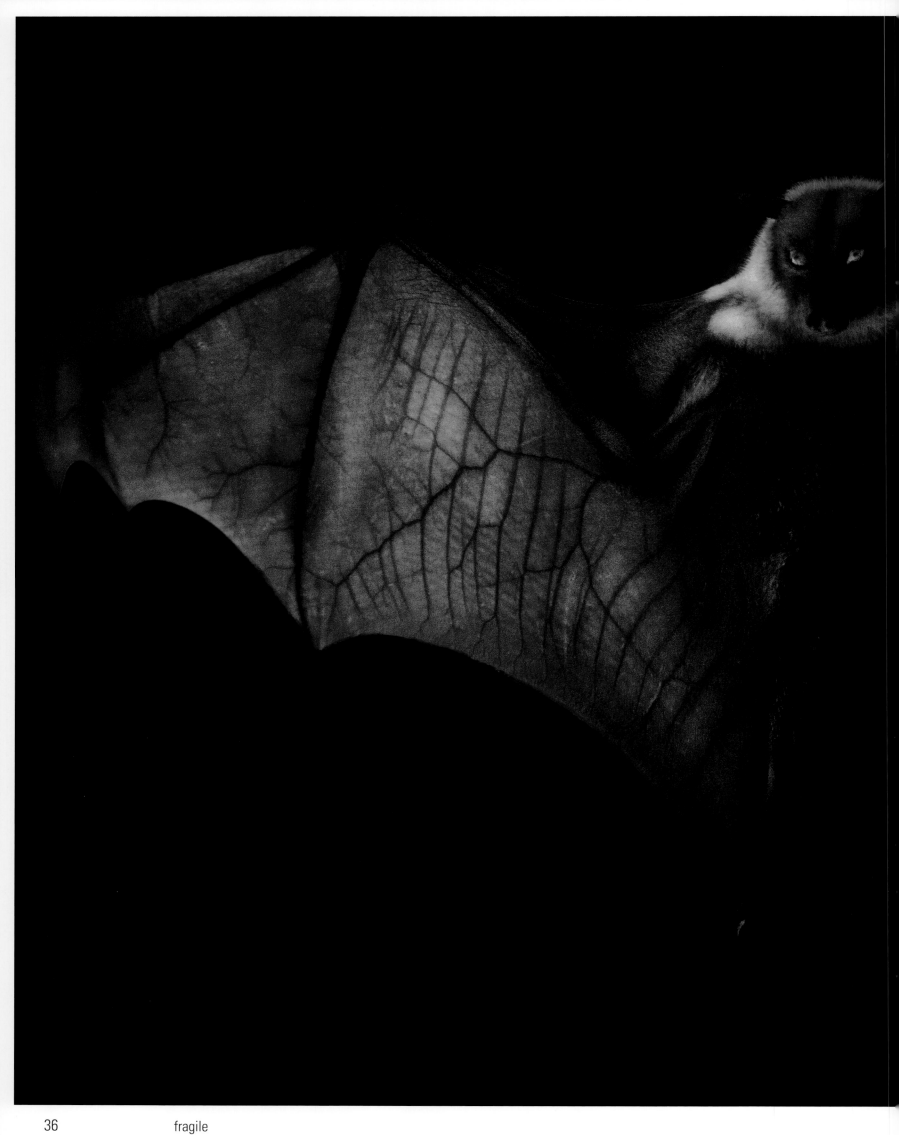

fragile

Large flying fox
Pteropus vampyrus, 1758

The large flying fox is another rare and endangered species. Its habitat is restricted to the Philippines. Feeding mainly on fruit, it assists in the process of pollination and of plant dispersal by spitting out seeds. It is the victim of poaching and deforestation, and the lack of interest in its preservation has led to a worrying fall in numbers.

Der Flughund ist eine weitere vom Aussterben bedrohte Art, die nur auf den Philippinen vorkommt. Er ernährt sich im Wesentlichen von Obst. Indem er die Früchte vom Baum pflückt und deren Samen ausspuckt, leistet er einen wertvollen Beitrag zur Bestäubung und Verbreitung der Pflanzen. Er ist ein Opfer der Wilderei und Abholzung. Das fehlende Interesse an seinem Erhalt hat mittlerweile zu einer besorgniserregenden Dezimierung seiner Population geführt.

El zorro volador es otra especie rara en peligro de extinción cuyo hábitat natural está restringido a Filipinas. Se alimenta fundamentalmente de frutas y al escupir las semillas colabora en el proceso de polinización y diseminación. Es víctima de los cazadores furtivos y de la deforestación, y la falta de interés por su conservación ha llevado a una preocupante disminución de su población.

Le grand renard volant ou roussette de Malaisie est une espèce rare menacée de disparition et dont l'habitat naturel se limite aux Philippines. Cette chauve-souris se nourrit principalement de fruits et participe, en recrachant les graines, au processus de pollinisation et de dissémination. Victime de braconnage et de la déforestation, le manque d'intérêt pour sa conservation a entraîné un déclin inquiétant de sa population.

Indian eagle-owl
Bubo bengalensis, 1831

The eyes of owls capture light one hundred times better than our own, but are practically unable to move. To compensate, owls can rotate their heads 135 degrees in any direction, giving them a 270-degree total field of vision. They are a vital link in the food chain, and their numbers have also been affected by habitat loss, and even poisoning through pesticide use.

Die Augen des Bengalenuhus erfassen das Licht hundertmal besser als unsere Augen, sind aber praktisch bewegungsunfähig. Doch der Uhu kann seinen Kopf zu jeder Seite um 135 Grad drehen – und so verfügt er über ein Gesichtsfeld von insgesamt 270 Grad. In ihrer Heimat stehen die Vögel an der Spitze der Nahrungskette, aber auch ihr Bestand wird zunehmend durch die Vernichtung von Lebensräumen und den Pestizideinsatz dezimiert.

Los ojos de los búhos captan la luz cien veces mejor que los nuestros, pero carecen casi de movilidad y por eso son capaces de rotar la cabeza 135 grados en cualquier dirección alcanzando un campo de visión total de 270 grados. Son parte fundamental de la cadena alimentaria y su población también se ha visto afectada por la disminución de sus hábitats o incluso por envenenamiento debido al uso de pesticidas.

Les yeux des hiboux captent la lumière cent fois mieux que les nôtres, mais ils sont pratiquement immobiles. Pour compenser, ces oiseaux peuvent tourner la tête à 135 degrés dans toutes les directions, ce qui leur donne un champ de vision total de 270 degrés. Ils jouent un rôle central dans la chaîne alimentaire et leur population a décliné en raison de la dégradation de leur habitat et de l'utilisation massive de pesticides.

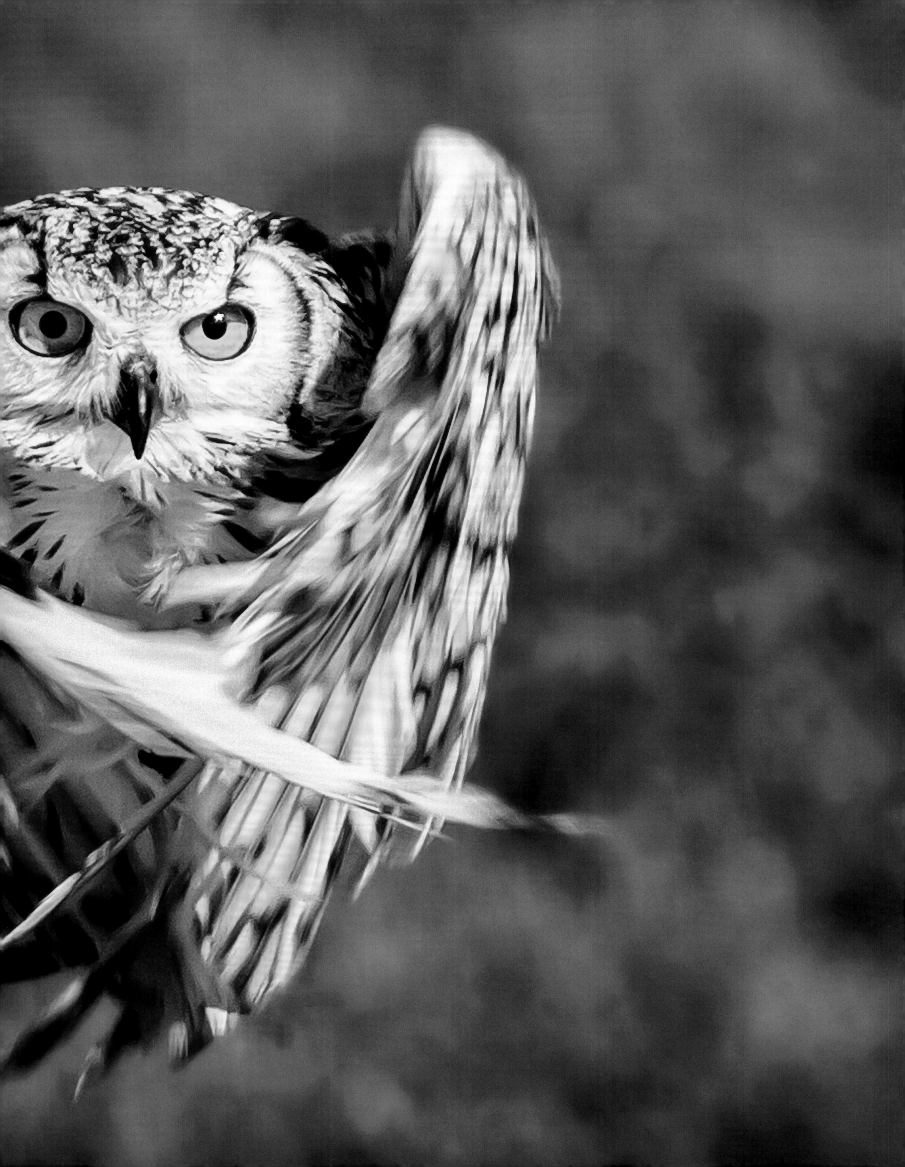

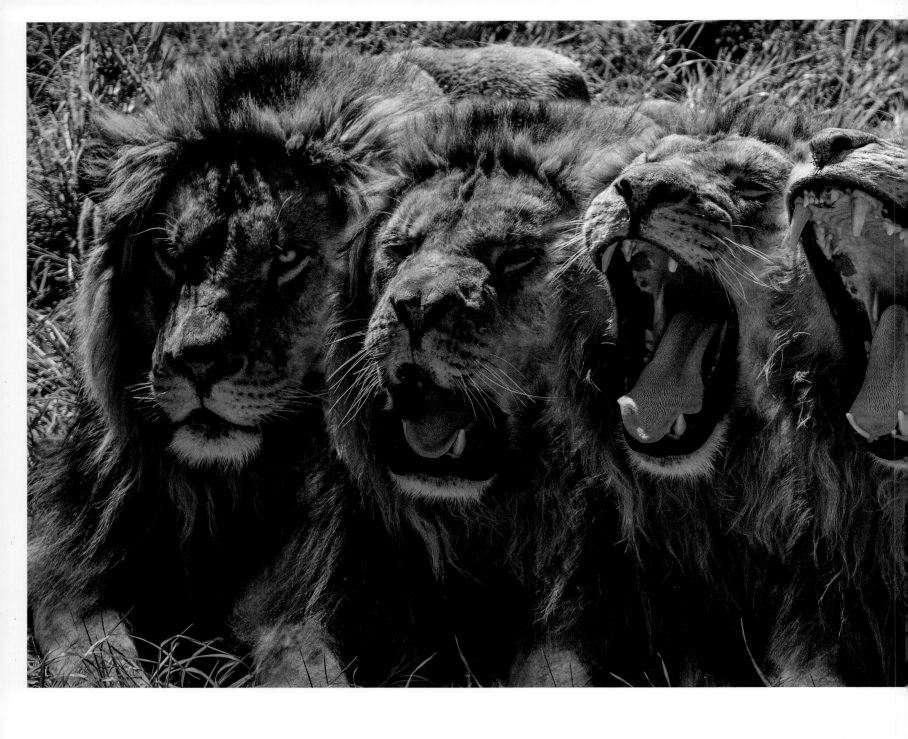

Lion

Panthera leo, 1758

fragile

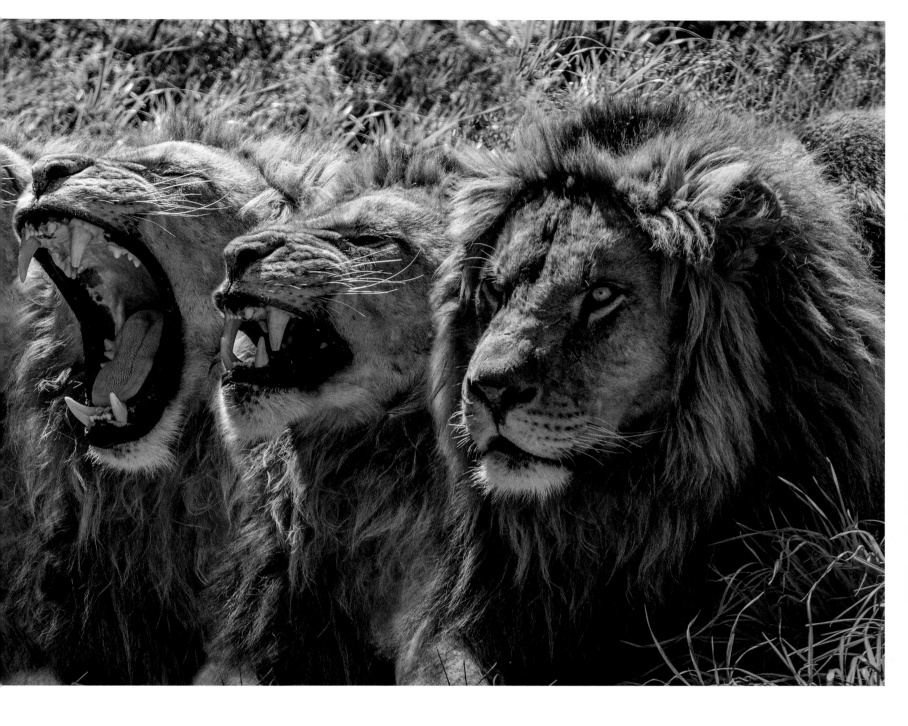

Every year around 18,000 hunters travel to Africa, where they pay between 20,000 and 40,000 dollars, or even more, to hunt lions reared on special farms for this purpose. This sport is known as "canned hunting." Some 8,000 lions are bred in captivity for this practice, which is still legal in certain African countries. Defenders of the practice assert that this business is a source of income for the local population. There are more than 200 such farms for lions and other species in South Africa alone, and many initiatives now exist to stop these activities.

Jedes Jahr reisen etwa 18 000 Jäger nach Afrika. Sie zahlen zwischen 20 000 und 40 000 Dollar oder sogar mehr, um einen Löwen zu jagen, der auf einer Farm eigens zu diesem Zweck gezüchtet wurde. Der Sport ist unter dem Namen »canned hunting« bekannt. Etwa 8000 Löwen werden in Gefangenschaft gezüchtet und zum Abschuss freigegeben. In einigen afrikanischen Staaten ist das immer noch legal. Die Verteidiger dieser Praxis argumentieren, das Geschäft sei eine Einnahmequelle für die lokale Bevölkerung. In Südafrika existieren 200 von diesen Farmen. Doch es gibt inzwischen viele Initiativen, die dieser Praxis Einhalt gebieten wollen.

Cada año unos 18 000 cazadores viajan a África y pagan entre 20 000 y 40 000 dólares, o incluso mucho más, por cazar a un león criado en granjas especiales para este fin. A este deporte se le conoce como «caza enlatada». Unos 8000 leones son criados en cautividad y se destinan a estas prácticas que aún son legales en algunos países africanos. Sus defensores alegan que este negocio es una fuente de ingresos para las poblaciones locales. En Sudáfrica existen unas 200 de estas granjas de leones y otras especies y ya hay muchas iniciativas para el cese de estas actividades.

Chaque année, quelques 18 000 chasseurs se rendent en Afrique et paient de 20 000 à 40 000 dollars, voire davantage, pour chasser un lion élevé en enclos. Cette pratique est connue sous le nom de « chasse en boîte ». Environ 8 000 lions sont ainsi élevés en captivité et destinés à ces pratiques encore légales dans certains pays africains. Ses partisans affirment que ce commerce est une source de revenus pour les populations locales. En Afrique du Sud, on compte environ 200 élevages de lions et d'autres espèces. De nombreuses initiatives ont vu le jour pour mettre un terme à ces activités.

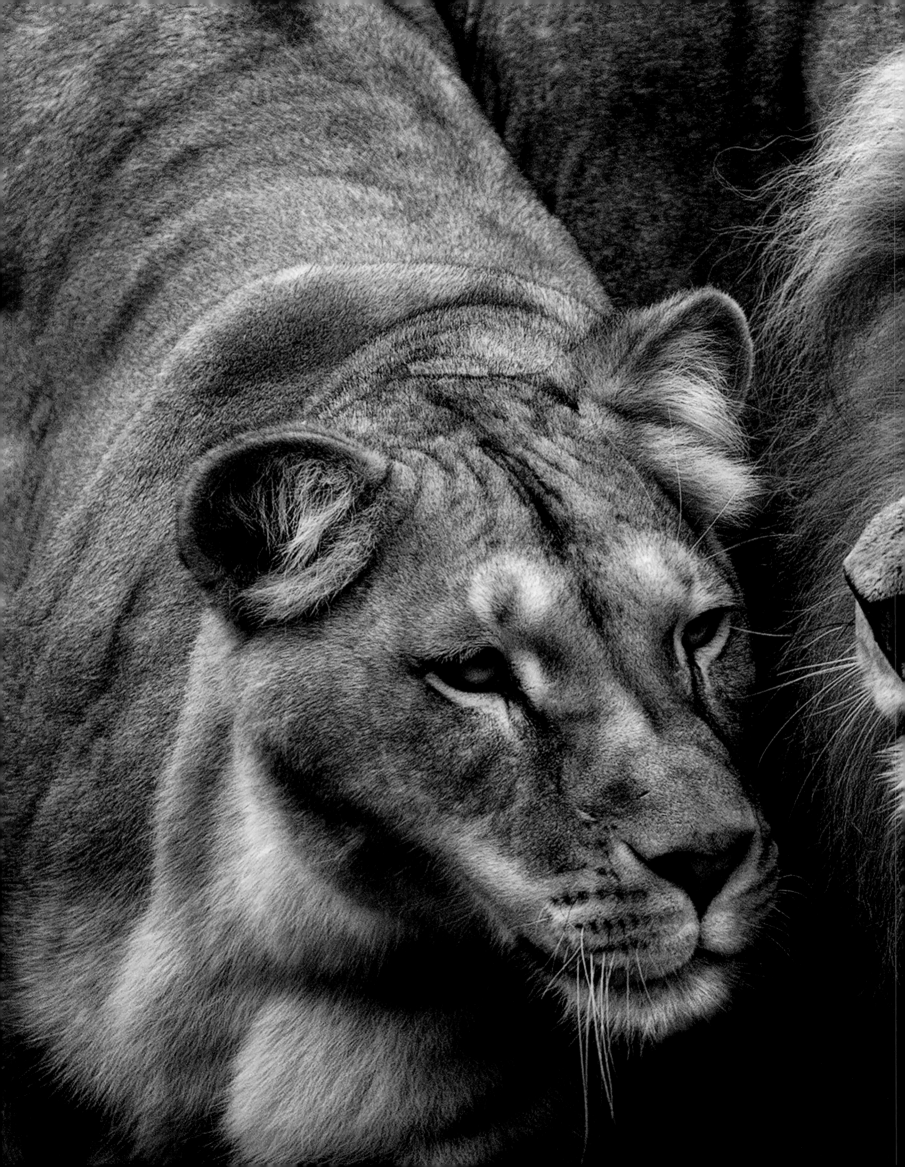

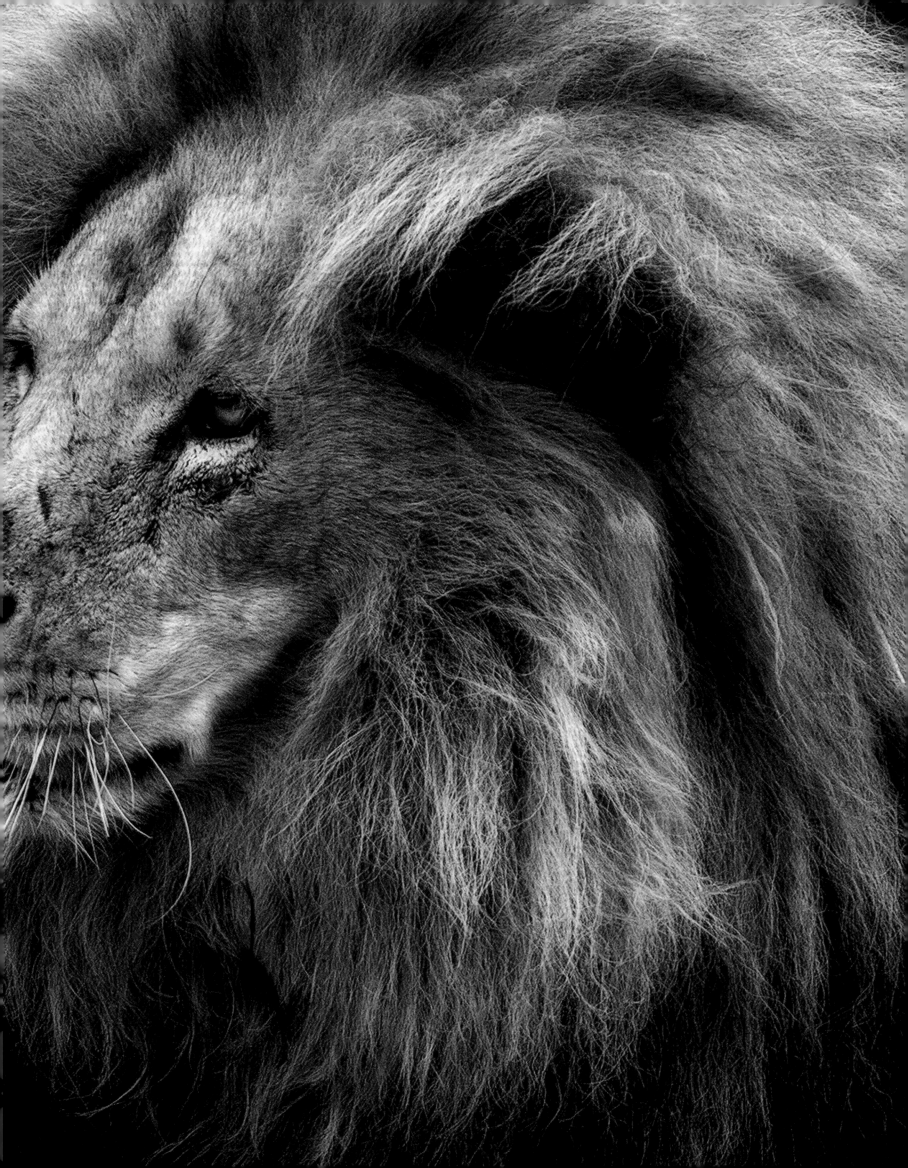

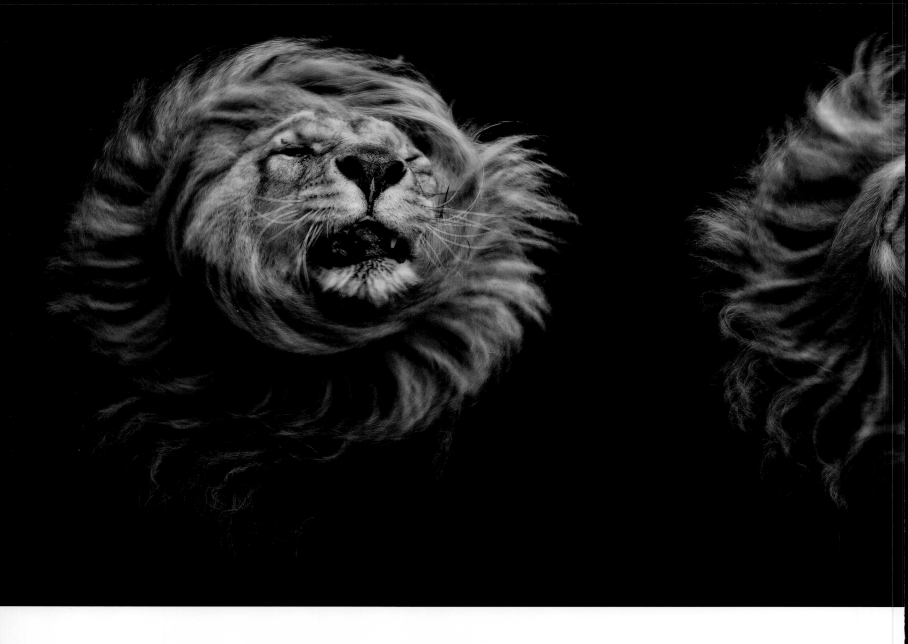

fragile

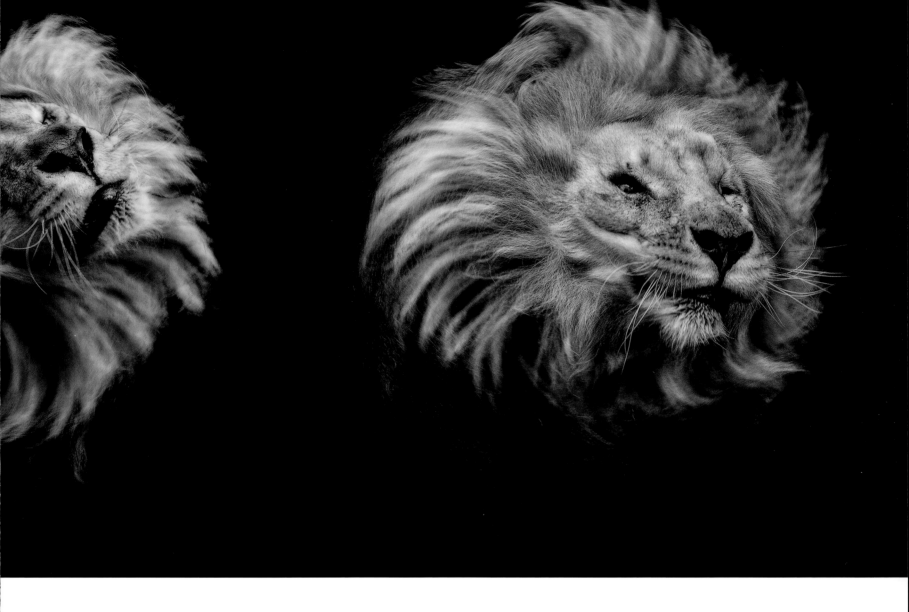

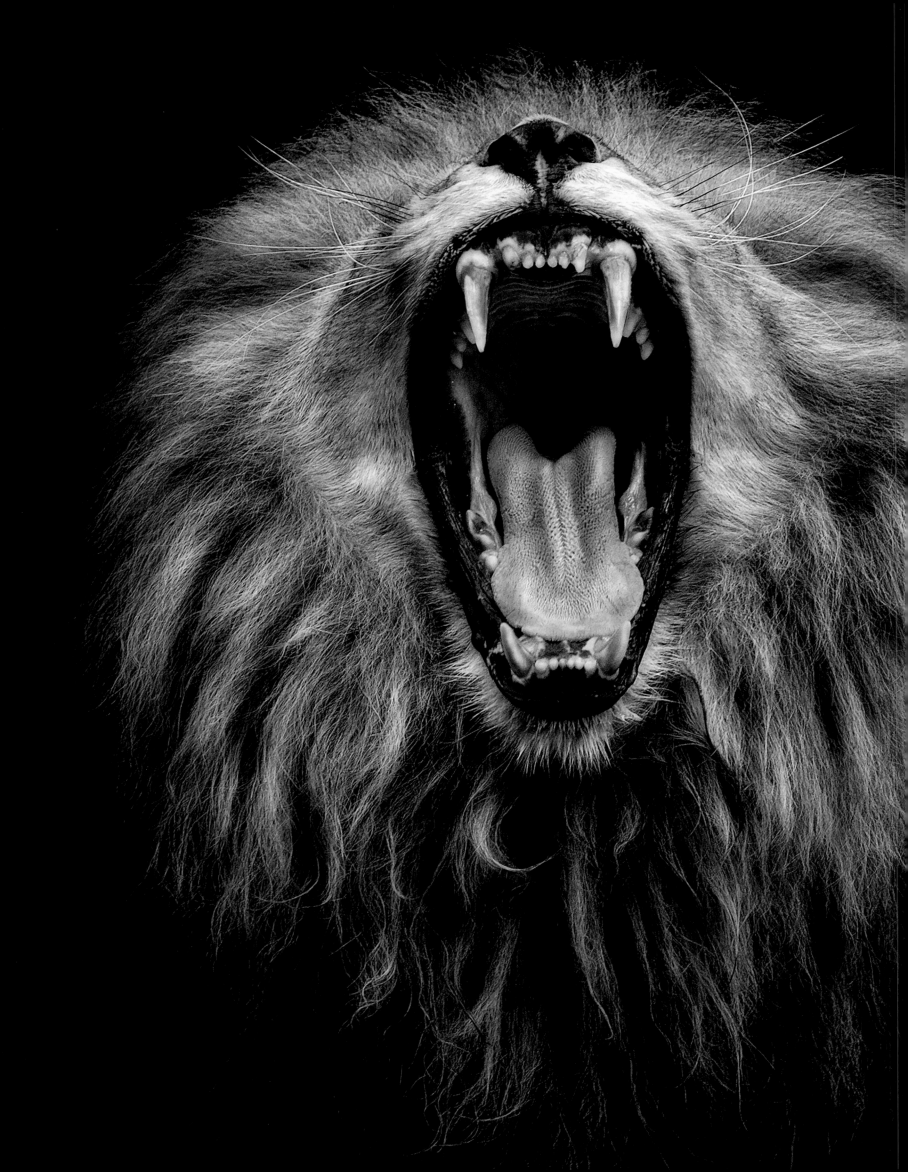

There are more lion statues in the world than there are living lions. There are only between 16,000 and 30,000 lions left in the wild, when there were around 300,000 only a century ago. Habitat loss and legal and illegal hunting activities are their main threats. Their territories are increasingly shrinking as a result of growing human settlements, making confrontation unavoidable. The future is uncertain for many of these species as the human population continues to grow. The day may come when they are no longer found in the wild and only a few specimens remain in zoos.

En el mundo existen más estatuas de leones que leones vivos. Solo quedan entre 16 000 y 30 000 leones salvajes, cuando hace un siglo eran unos 300 000. La reducción de sus hábitats y la cacería legal e ilegal son sus principales amenazas. Sus territorios se ven cada vez más restringidos por el crecimiento del hábitat humano, de manera que el enfrentamiento es inevitable. El futuro es incierto para muchas de estas especies conforme la población humana siga creciendo, y podrían acabar desapareciendo en estado salvaje y quedar tan solo algunos ejemplares en zoológicos.

Es gibt auf der Welt mehr Löwenstatuen als lebende Löwen. Von den 300 000, die es vor hundert Jahren noch gab, sind noch 16 000 bis 30 000 Löwen in freier Wildbahn übrig. Die Zerstörung ihrer Lebensräume sowie legale und illegale Jagd sind die Hauptbedrohungen. Die Löwenreviere werden immer kleiner, da der Mensch sich mehr und mehr ausbreitet. So ist der Konflikt unvermeidlich. Die Zukunft vieler Arten mit ähnlichem Schicksal ist angesichts des Bevölkerungswachstums ungewiss. Vielleicht kann man am Ende nur noch einige wenige Exemplare in Zoos bewundern.

Il existe plus de statues de lions dans le monde qu'il n'y a de lions vivants. Il ne reste que 16 000 à 30 000 lions sauvages contre 300 000 il y a un siècle. La réduction de leurs habitats et la chasse, qu'elle soit légale ou non, sont à l'origine de leur disparition. Leurs territoires étant de plus en plus restreints par la croissance de l'habitat humain, la confrontation est inévitable. L'avenir est incertain pour beaucoup de ces espèces, car la population humaine ne cesse de croître. Elles pourraient finir par disparaître du monde sauvage et seuls quelques-uns survivraient dans les zoos.

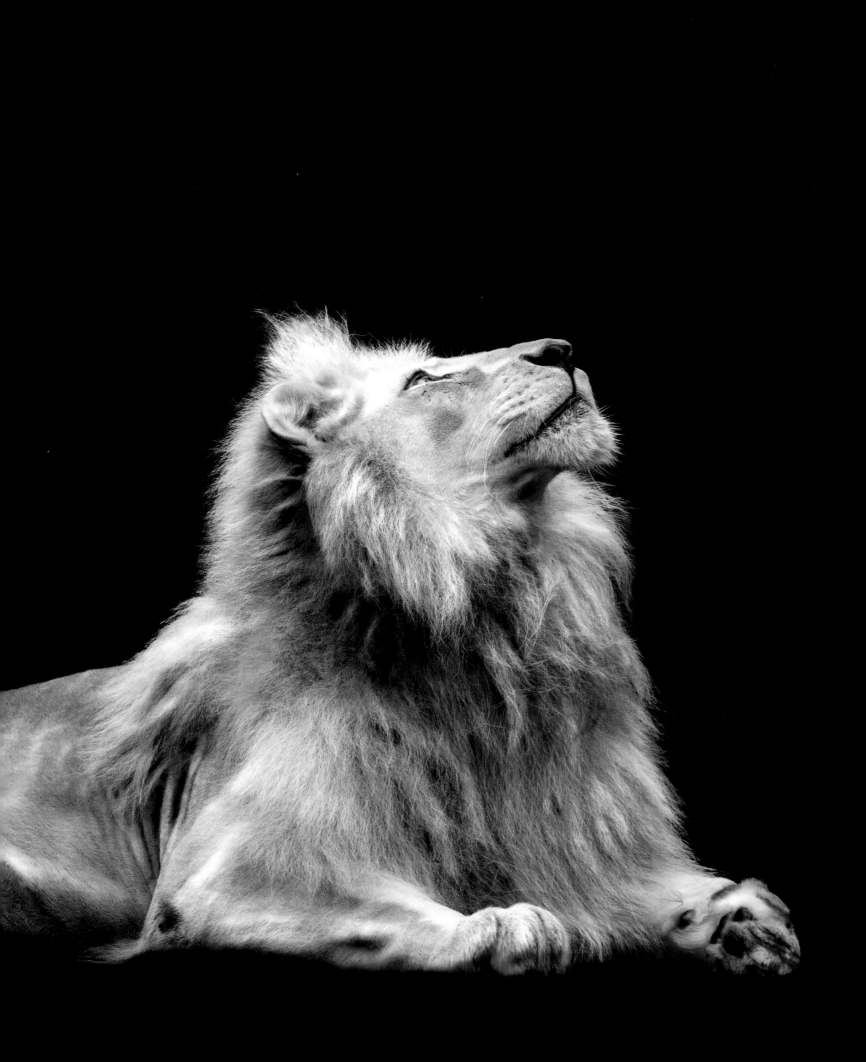

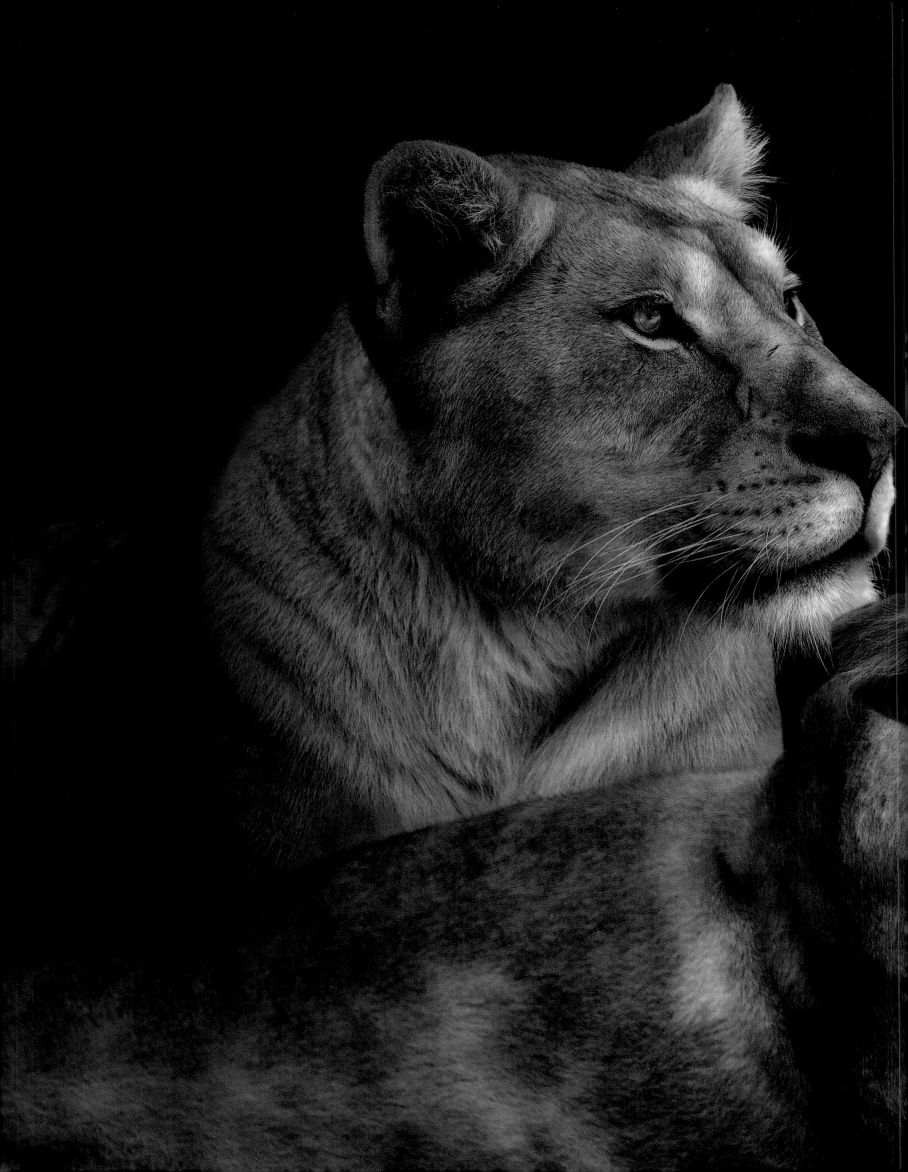

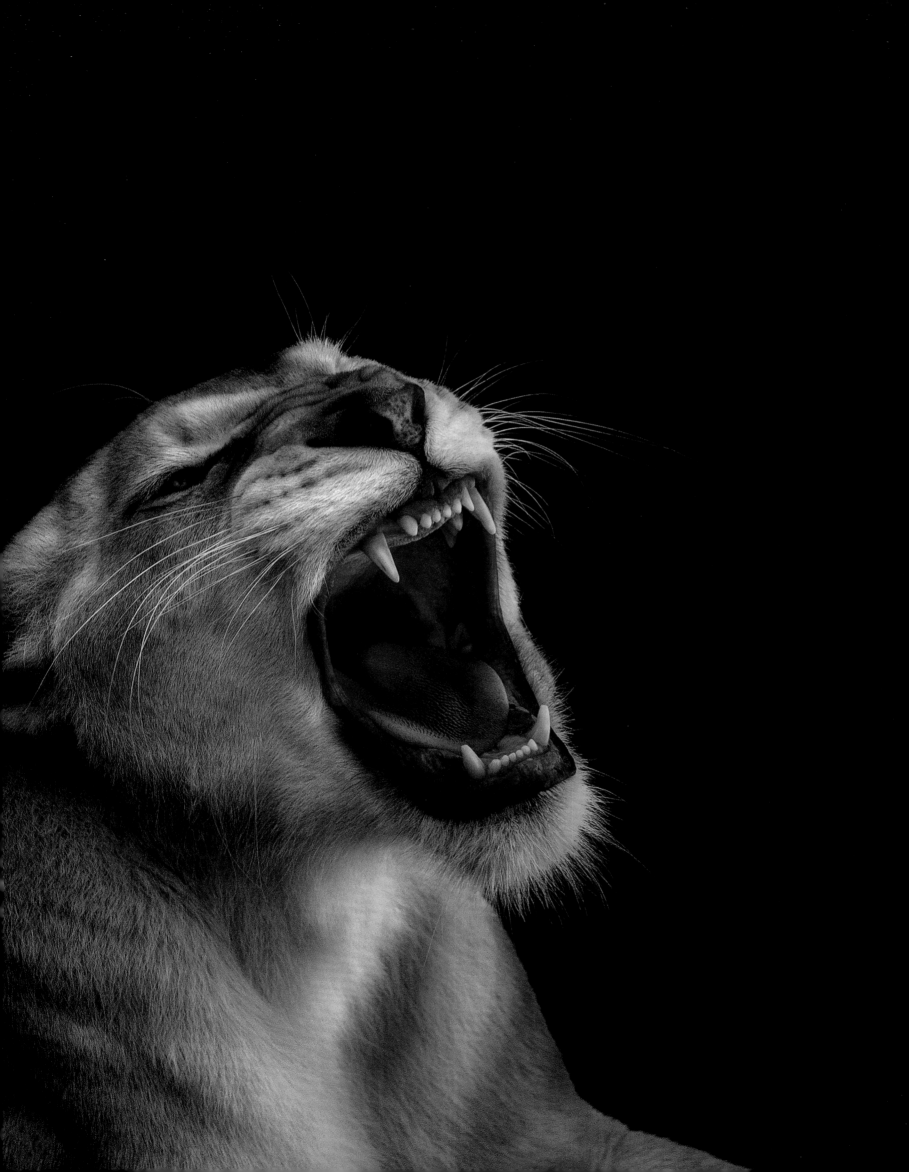

Bengal tiger
Panthera tigris tigris, 1758

The tiger is the largest of the felines and is also a quintessentially totemic animal, considered the spirit and guardian of the forest. When Dersu Uzala (in the film of the same name by Akira Kurosawa) wounds one, he becomes increasingly despondent for having offended it. An expression of a human-animal relationship that is unthinkable today, and one that has almost been completely lost in an extremely materialistic world.

Der Tiger ist die größte Katze und das Totemtier schlechthin. Er ist Geist und Hüter des Waldes. Als Dersu Usala in *Uzala, der Kirgise,* einem Film von Akira Kurosawa, einen Tiger verwundet, zieht er sich tieftraurig in den Wald zurück. Er ist überzeugt, verflucht zu sein, weil er den Geist des Waldes verletzt hat. Eine besondere Beziehung zwischen Mensch und Tier, die in unserer heutigen extrem materialistischen Welt gar nicht mehr vorstellbar ist.

El tigre es el felino más grande y es, además, el animal totémico por excelencia. Espíritu y guardián del bosque, cuando Dersu Uzala (en la película de Akira Kurosawa) lo hiere, este se hunde en una profunda depresión por haber ofendido a ese espíritu del bosque. Una expresión de la relación hombre-animal hoy impensable y que ya se ha perdido por completo en un mundo en extremo materialista.

Le tigre, le plus grand félin du monde, est aussi l'animal totémique par excellence. Esprit et gardien de la forêt, lorsque Dersou Ouzala le blesse, dans le film d'Akira Kurosawa, il sombre dans une profonde dépression pour avoir offensé cet esprit de la forêt. Cette scène illustre une relation homme-animal inimaginable aujourd'hui et qui s'est déjà complètement perdue dans un monde très matérialiste.

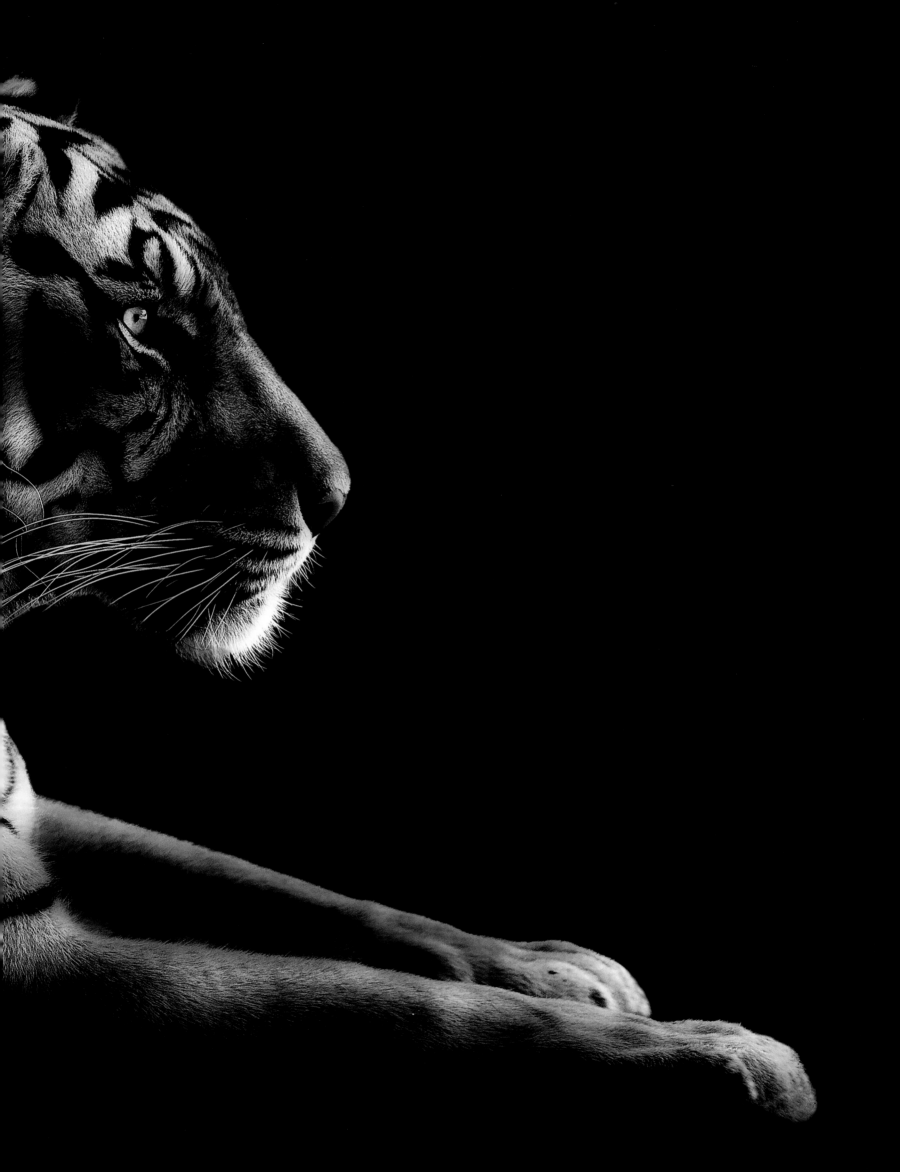

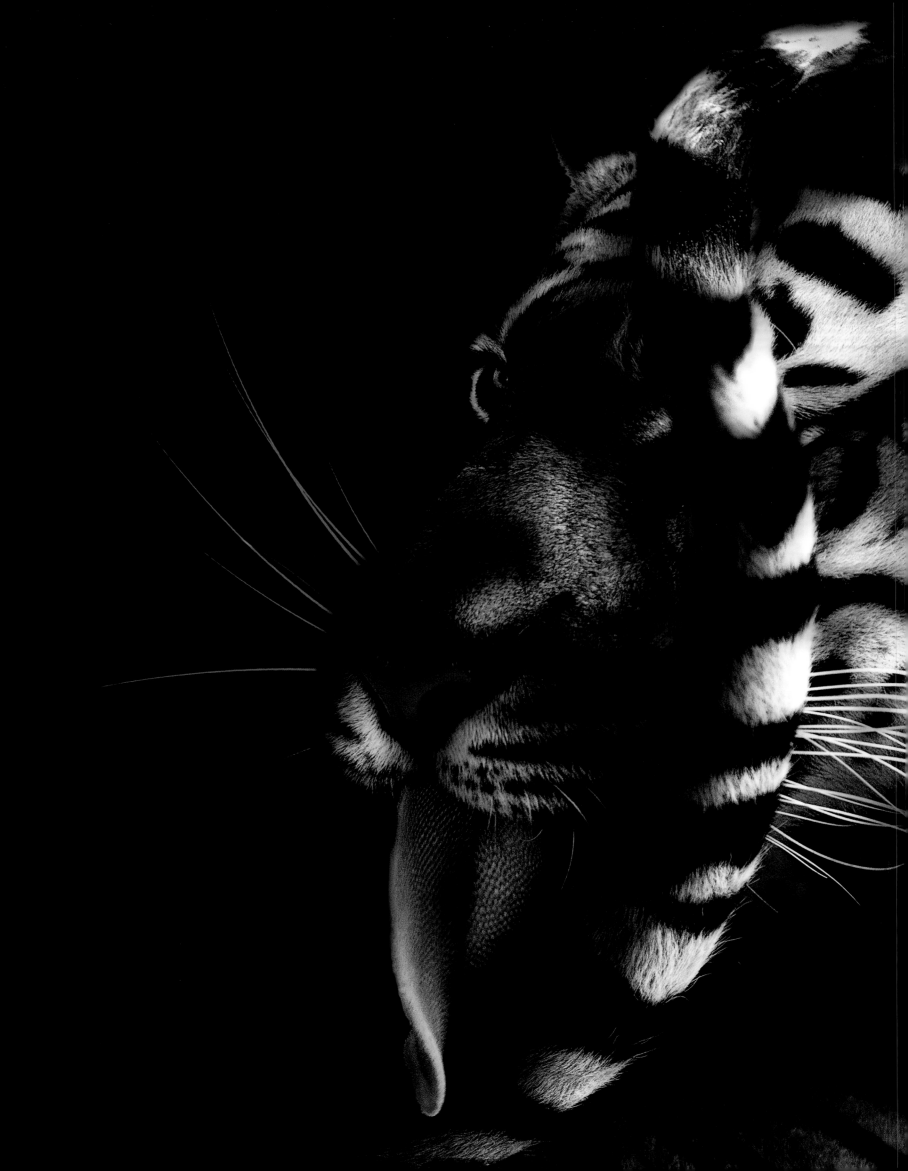

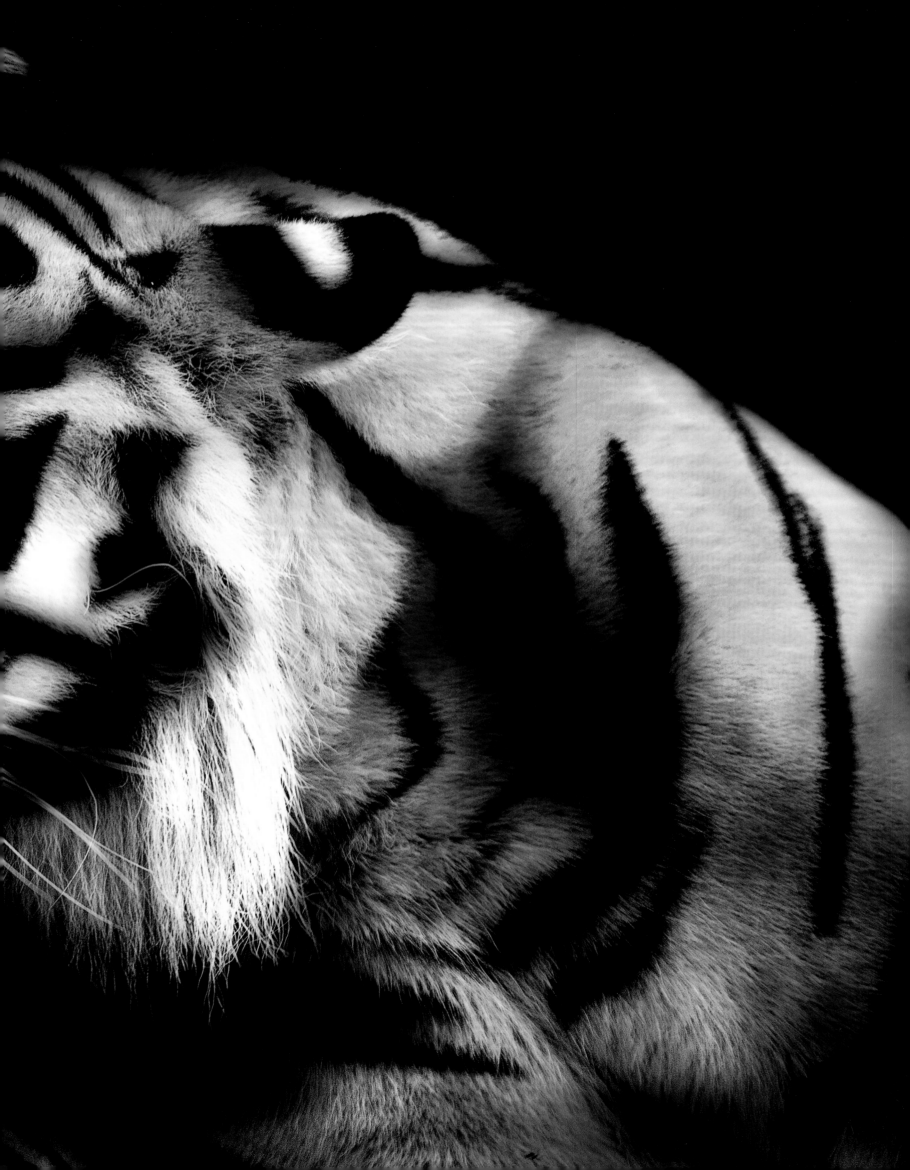

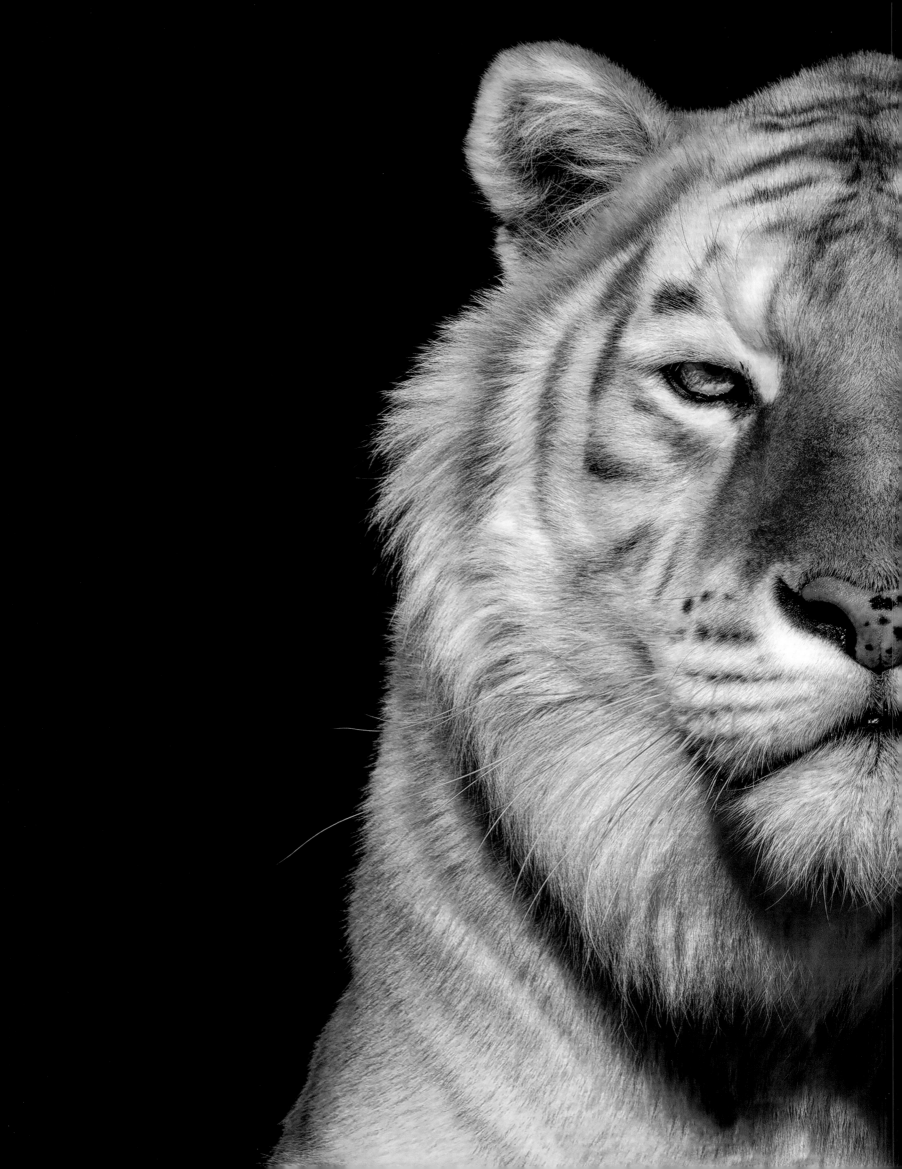

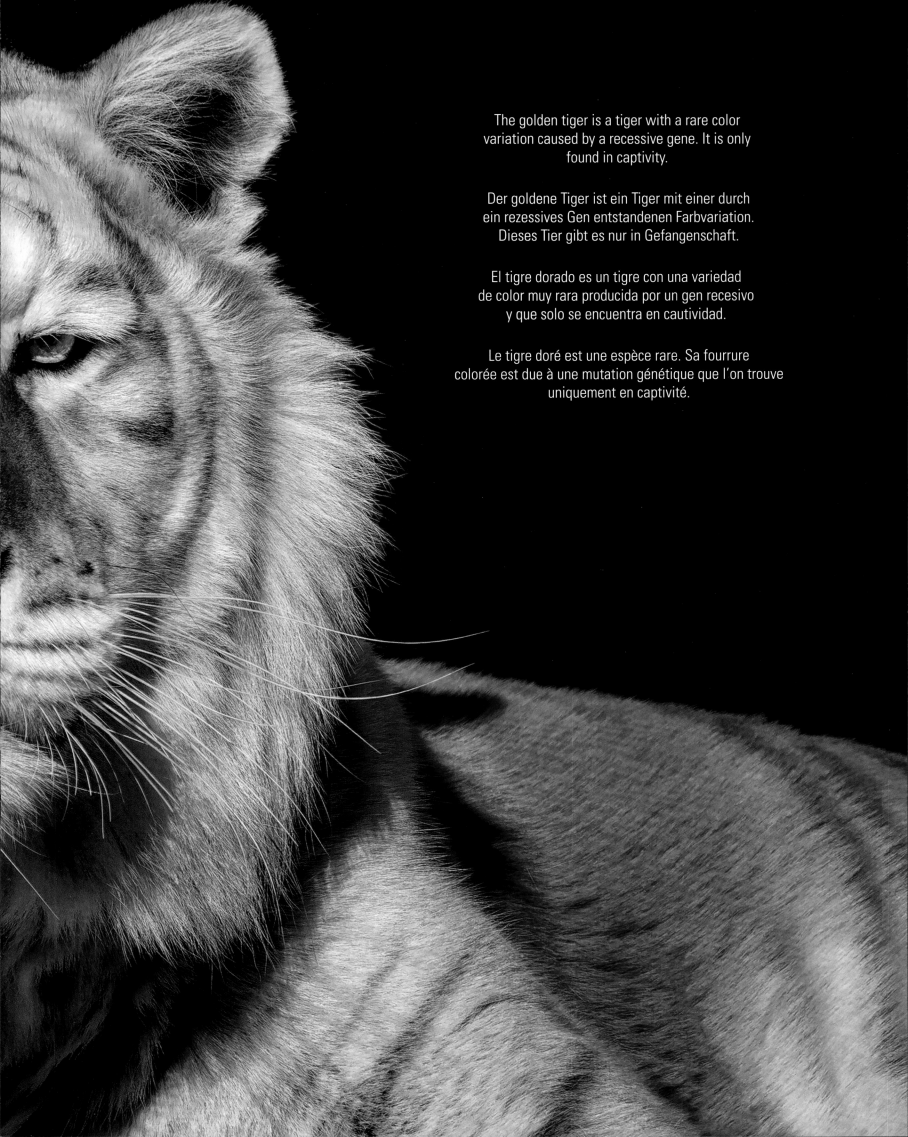

The golden tiger is a tiger with a rare color variation caused by a recessive gene. It is only found in captivity.

Der goldene Tiger ist ein Tiger mit einer durch ein rezessives Gen entstandenen Farbvariation. Dieses Tier gibt es nur in Gefangenschaft.

El tigre dorado es un tigre con una variedad de color muy rara producida por un gen recesivo y que solo se encuentra en cautividad.

Le tigre doré est une espèce rare. Sa fourrure colorée est due à une mutation génétique que l'on trouve uniquement en captivité.

Jaguar
Panthera onca, 1758

The black panther is actually a leopard or jaguar with excess black pigmentation that hides its markings. Like most of the wild cats, it is also endangered as a result of habitat loss and hunting for its skin, also because of the threat it poses to livestock and conflict with human populations.

Der weithin bekannte schwarze Panther ist eigentlich ein Leopard oder ein Jaguar, bei dem die charakteristischen Flecken durch übermäßige Pigmentierung überdeckt werden. Wie die Mehrzahl der wild lebenden Großkatzen ist auch er vom Aussterben bedroht. Die Gründe dafür sind das anhaltende Schrumpfen seines Lebensraums, die Jagd für den Pelzhandel sowie Konflikte mit den Menschen, etwa weil die Raubkatzen Herdentiere erbeuten.

La pantera negra es en realidad un leopardo o un jaguar con un exceso de pigmentación que oculta sus manchas. Al igual que la mayoría de los felinos salvajes también se encuentra amenazada y en peligro de extinción por la reducción de su hábitat y la caza para el comercio de pieles o por la amenaza que representan para los rebaños y los conflictos con las poblaciones humanas.

La panthère noire est en réalité un léopard ou un jaguar dont les taches sont dissimulées par un excès de pigmentation. Comme la plupart des félins, sa survie est menacée par la réduction de son habitat naturel, le commerce de sa fourrure et les conflits avec les hommes car la panthère représente une menace pour les troupeaux.

fragile

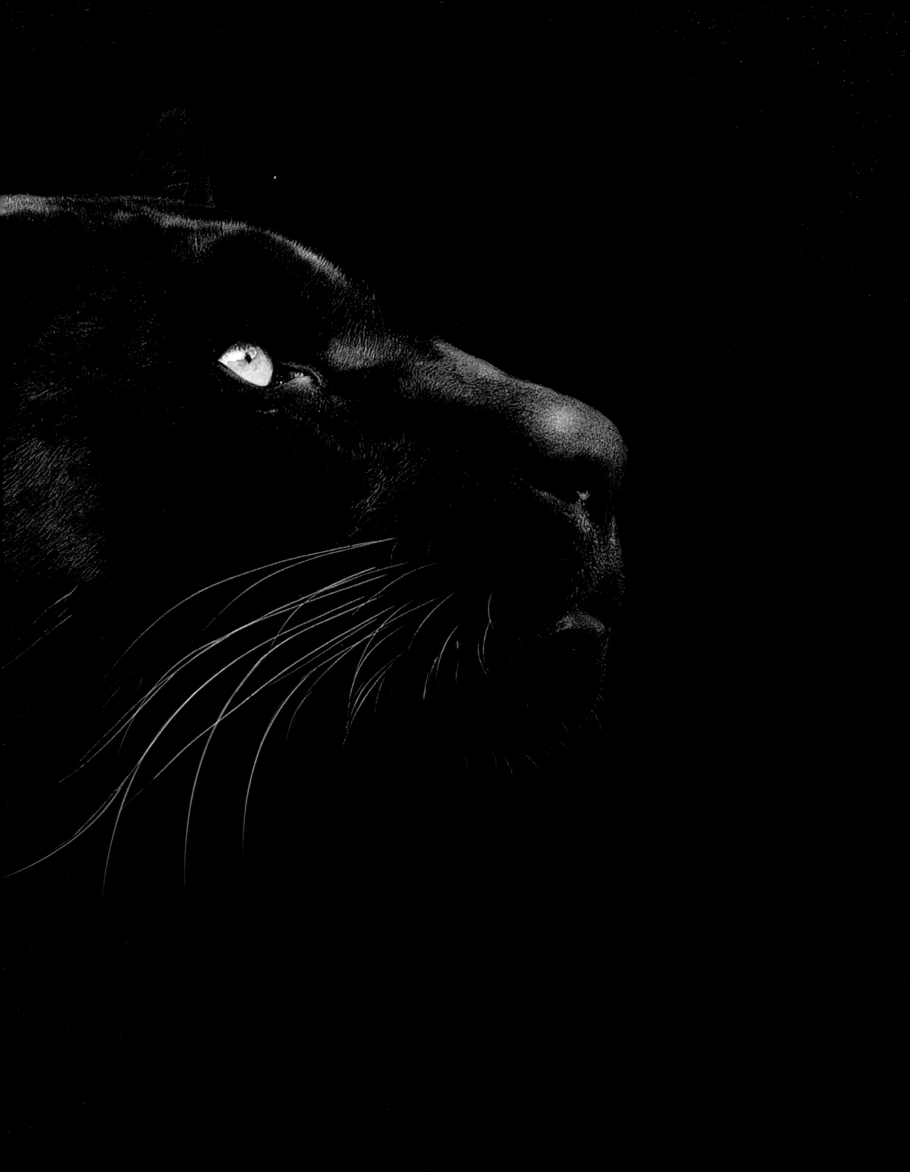

From their origins as places of entertainment for commercial purposes, zoos have taken on an educational role. Today they are seen as a new Noah's Ark for many species whose only, and perhaps last, chance of survival is in their hands. It is often thought that animals should be set free, but unfortunately for many, their natural habitats no longer exist, or their freedom would be equivalent to a death sentence. Contact with these otherwise inaccessible animals also brings awareness of their fragility.

La concepción original de los zoológicos ha pasado del mero entretenimiento con fines comerciales a la función educativa. Hoy en día se están convirtiendo en verdaderas arcas de Noé para muchas especies cuya única oportunidad de supervivencia, y quizás la última, se encuentra en sus manos. Frecuentemente se piensa que los animales deberían ser puestos en libertad, pero, por desgracia, para muchos de ellos su hábitat natural ya no existe o su libertad significaría su condena. El contacto con estos animales, inaccesibles de otro modo, ayuda además a crear conciencia sobre su fragilidad.

Das Konzept des Zoos als Ort reiner Unterhaltung zu kommerziellen Zwecken hat sich gewandelt: Heute kommt ihm eine Bildungsfunktion zu. Für viele Arten wird er zu einer Arche Noah – zur einzigen, vielleicht letzten Überlebenschance. Häufig wird die Freilassung der Tiere gefordert, doch leider haben viele längst keinen natürlichen Lebensraum mehr, oder die Freiheit wäre ihr Todesurteil. Der Kontakt mit diesen Tieren, den es ohne Zoo nicht gäbe, trägt außerdem dazu bei, ein Bewusstsein für ihre fragile Existenz und damit auch ihren Schutz zu schaffen.

Les zoos ne sont plus uniquement des lieux de divertissement à des fins commerciales, ils ont également une fonction éducative. Aujourd'hui, ce sont de véritables arches de Noé qui permettent de préserver de nombreuses espèces. On pense souvent que les animaux devraient être relâchés en pleine nature. Malheureusement pour beaucoup d'entre eux, leur habitat naturel n'existe plus et les libérer les condamnerait. Le contact avec ces animaux autrement inaccessibles contribue également à la prise de conscience de leur fragilité.

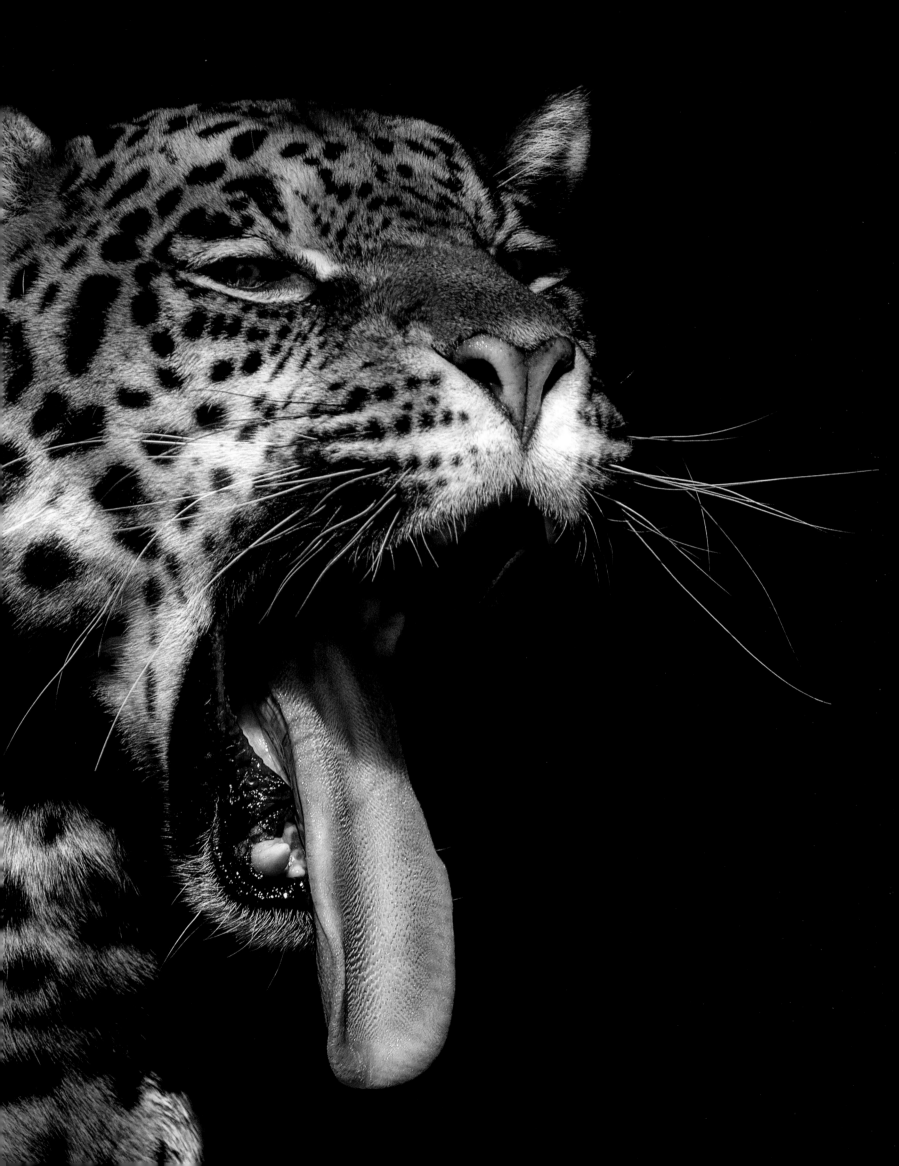

fragile

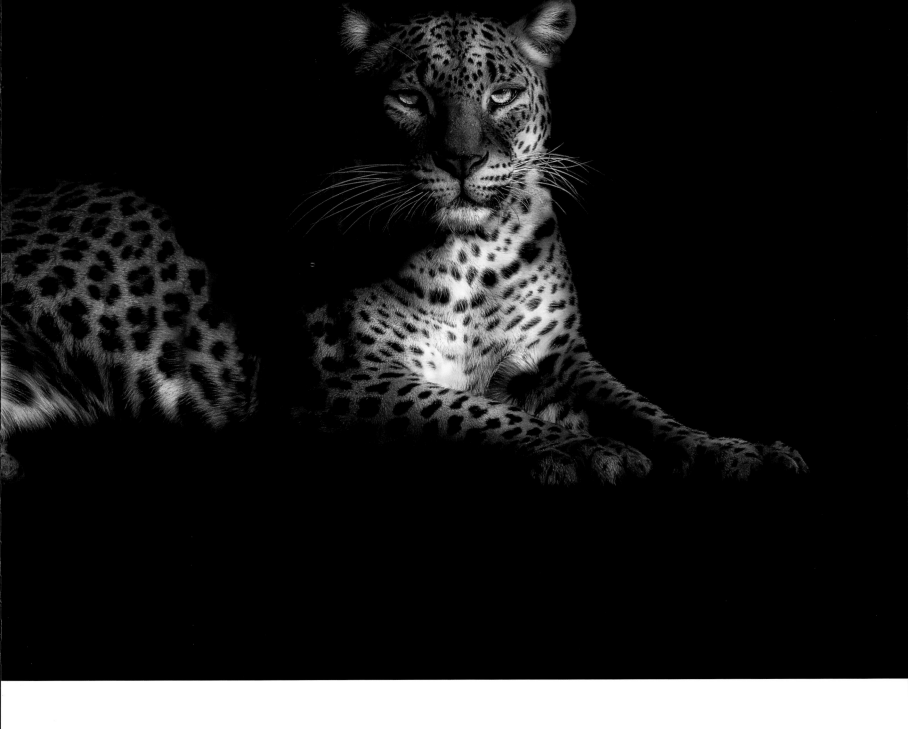

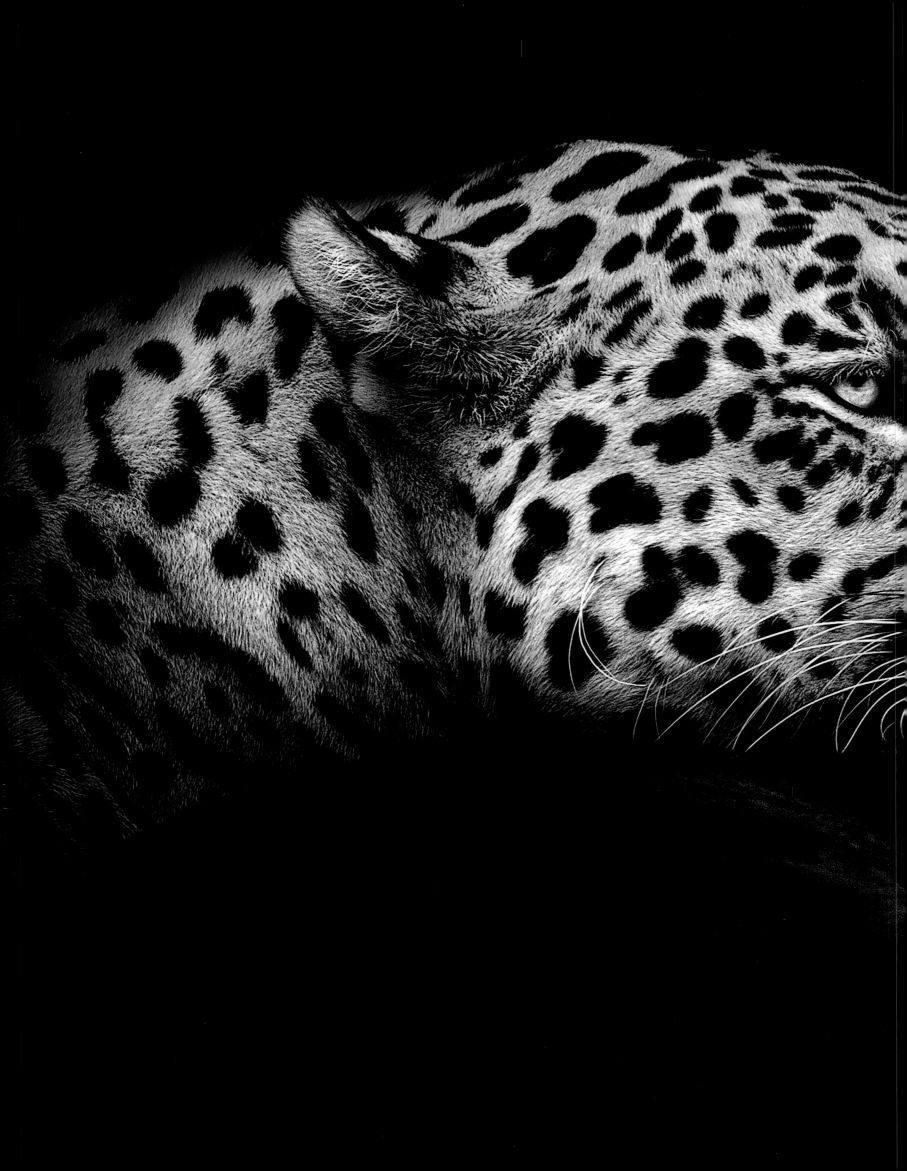

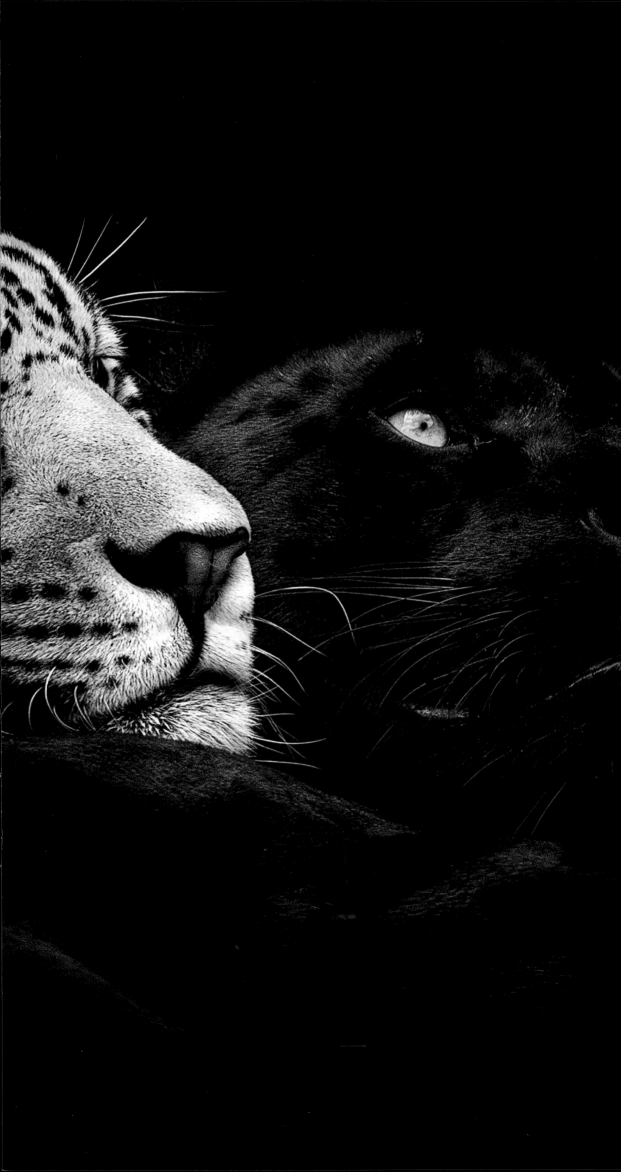

fragile

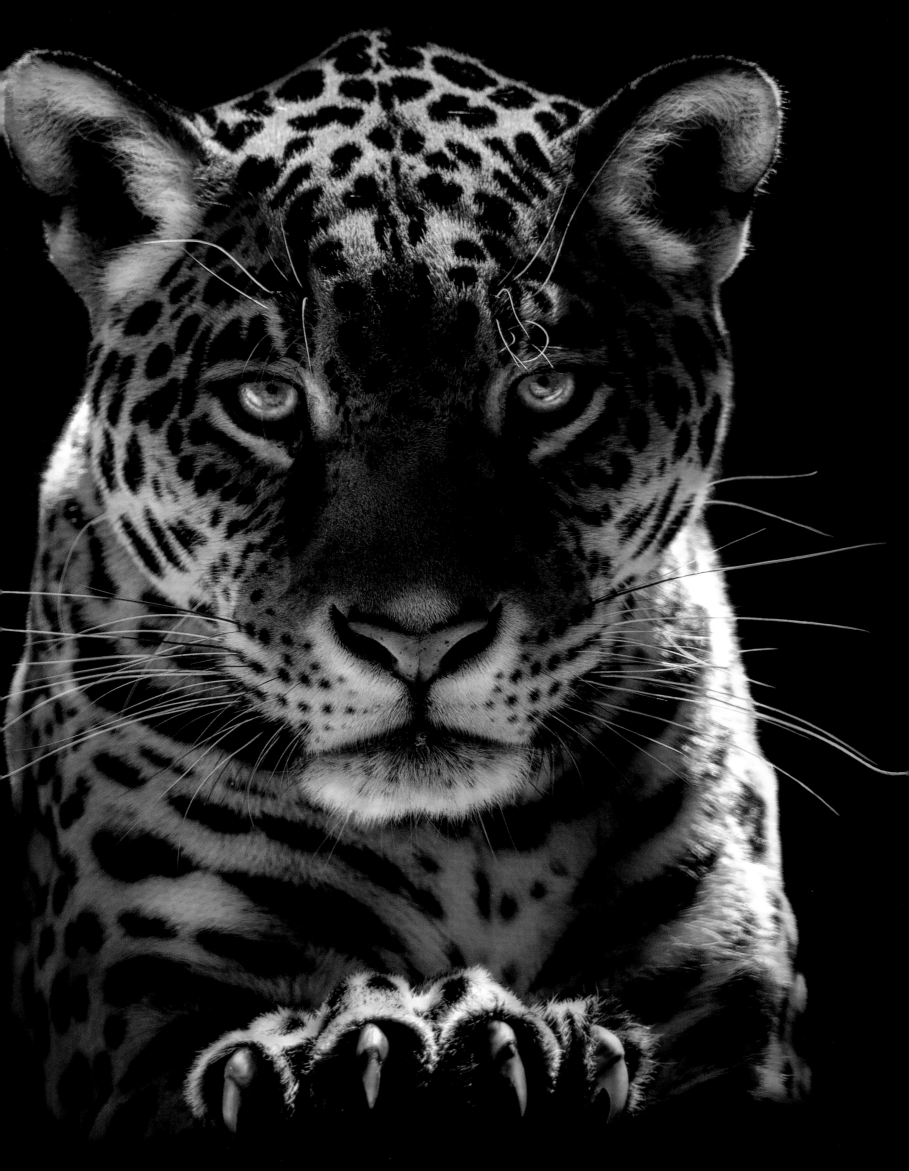

Cheetah
Acinonyx jubatus, 1775

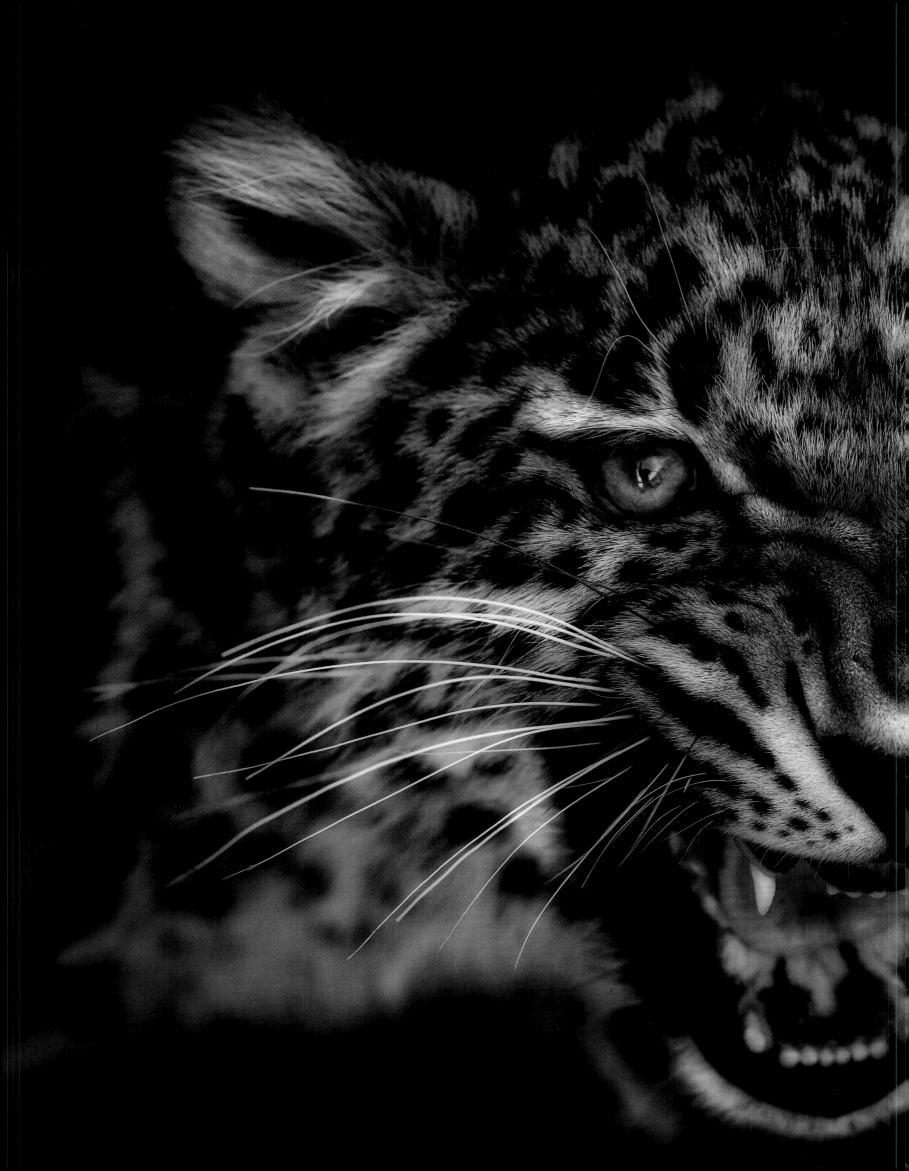

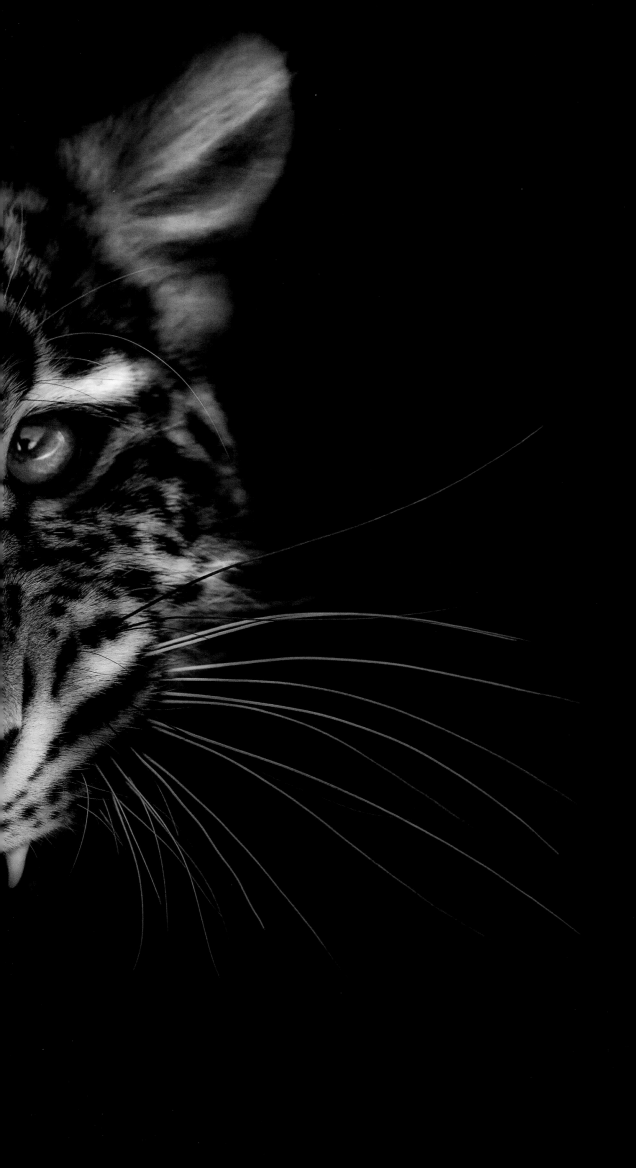

Leopard
Panthera pardus, 1758

The majority of wild cat species are endangered, and the leopard is one of the most at risk. Some subspecies, such as the Amur leopard, are critically endangered with fewer than one hundred specimens left. While it is mainly hunted for its fur, it is also pursued because of the threat it poses to the livestock in populated areas that overlap with its natural habitat.

Die Mehrzahl der wild lebenden Großkatzen ist vom Aussterben bedroht. Der Leopard zählt dabei zu den bedrohtesten Arten. Bei einigen Unterarten wie beim Amurleoparden ist die Lage ausgesprochen kritisch, es gibt nur noch weniger als hundert Exemplare. Die herrlichen Katzen werden hauptsächlich wegen ihres Fells gejagt, aber auch, weil sie in Lebensräumen, die sich mit denen des Menschen überlappen, eine Gefahr für die Herden darstellen.

La mayoría de los felinos salvajes están en peligro de extinción y el leopardo es uno de los más amenazados. Algunas subespecies como el leopardo de Amur se encuentran en una situación crítica y solo quedan menos de cien ejemplares. Cazado principalmente por su piel, también es perseguido por representar una amenaza para el ganado en poblaciones que se solapan con sus hábitats naturales.

La plupart des félins sauvages sont en danger d'extinction. Le léopard est l'un des plus menacés. Certaines sous-espèces comme le léopard de l'Amour connaissent une situation critique : on ne compte plus qu'une centaine de spécimens à travers le monde. Surtout prisé pour sa fourrure, il est aussi chassé, car il représente une menace pour le bétail qui pâture dans son habitat naturel.

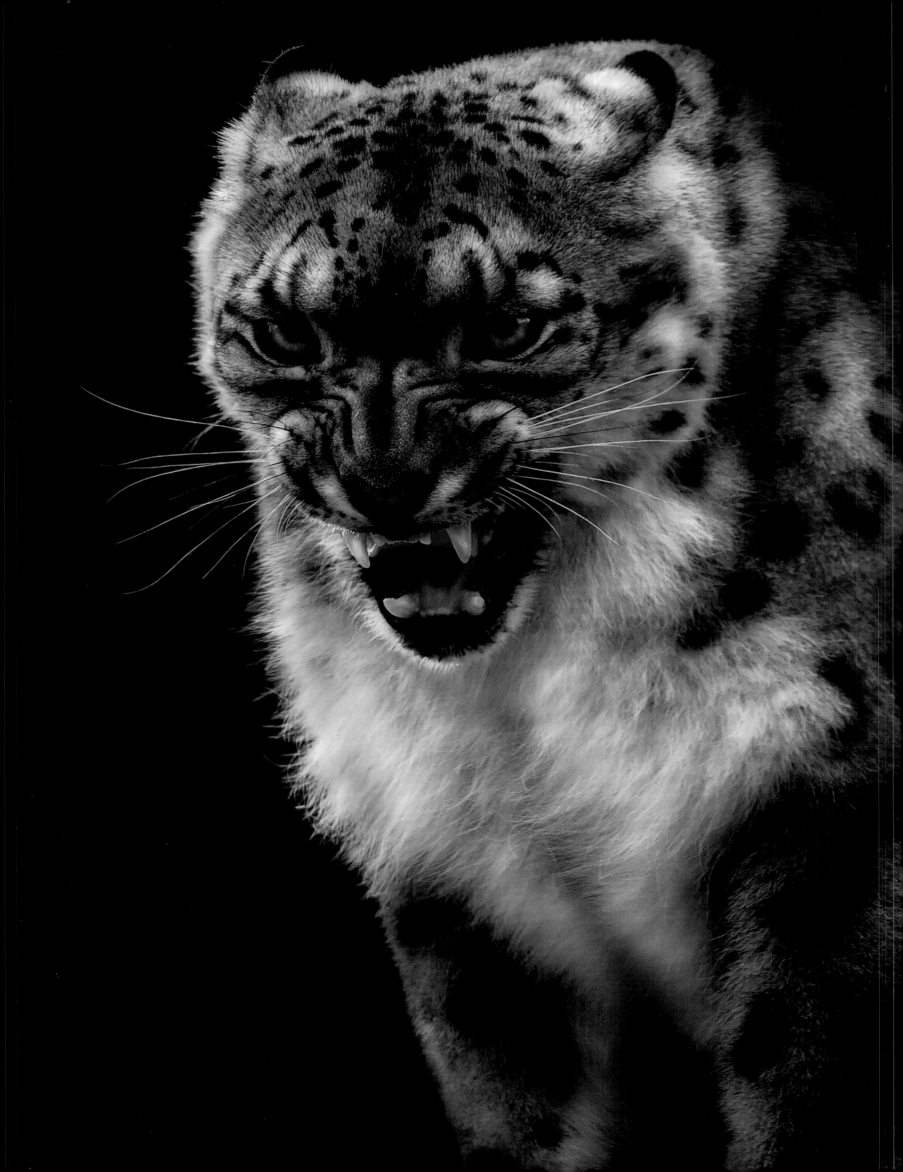

Snow leopard
Panthera uncia, 1775

For the inhabitants of the Himalayas, the snow leopard is a mystical creature, a sacred totem with the power to remove sins from the past lives of people who are fortunate enough to see one. They also believe that killing a snow leopard restores all these past sins to the killer's present life. It is a very elusive and solitary animal that inhabits remote parts of the Himalayas, and very few people have ever seen one in the wild. It is also considered the guardian of all sacred animals and a link between the material and spirit worlds.

En la mitología de los pueblos del Himalaya el leopardo o pantera de las nieves es un tótem sagrado que tiene la facultad de absorber los pecados de las vidas pasadas de aquellas personas que logran tener un encuentro visual con él. Pero aquel que lo mate recibe por transferencia todos los pecados absorbidos por el leopardo. Es un animal muy esquivo y solitario que habita en lugares remotos del Himalaya y son pocas las personas que lo han podido ver en estado salvaje. También es considerado el guardián de todos los animales sagrados y un enlace entre el mundo material y el espiritual.

In der Mythologie der Himalaya-Völker ist der Schneeleopard ein heiliges Tier. Demnach hat er die Fähigkeit, die Sünden vergangener Leben all jener Menschen aufzunehmen, die Blickkontakt mit ihm haben. Aber wehe dem, der ihn tötet! Auf ihn übertragen sich alle Sünden, die der Leopard aufgenommen hatte. Er ist ein scheuer Einzelgänger, der in den abgelegensten Gebieten des Himalaya lebt. Nur wenige Menschen haben ihn je in freier Wildbahn gesehen. Er gilt auch als Wächter aller heiligen Tiere und als Bindeglied zwischen der materiellen und der geistigen Welt.

Dans la mythologie des peuples de l'Himalaya, le léopard ou panthère des neiges est sacré. Il a la faculté d'absorber les péchés des vies passées de ceux qui croisent son chemin. Et celui qui le tue reçoit par transfert tous les péchés gardés par le léopard. Cet animal insaisissable et solitaire vit dans des endroits reculés de l'Himalaya et peu de personnes ont pu l'apercevoir à l'état sauvage. Il est également considéré comme le gardien de tous les animaux sacrés qui relie le monde matériel au monde spirituel.

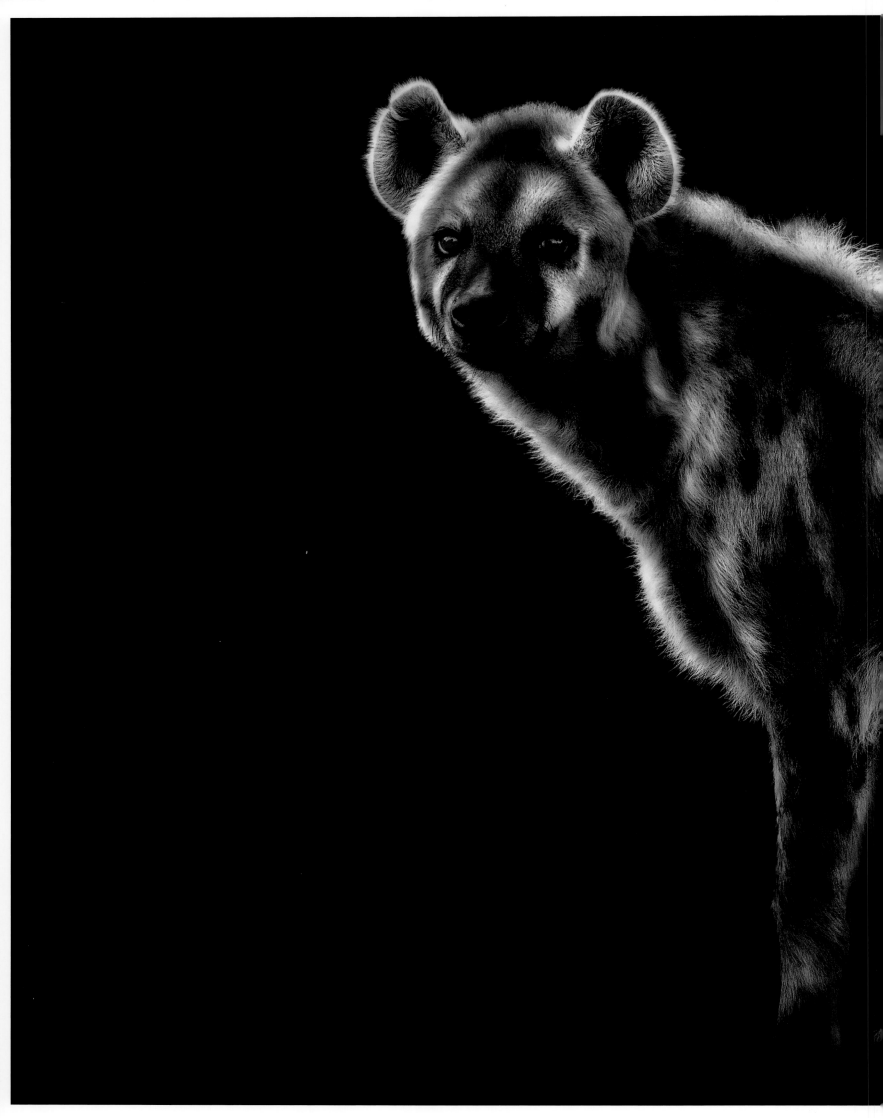

fragile

Spotted hyena
Crocuta crocuta, 1777

Arctic wolf

Canis lupus arctos, 1935

The Arctic wolf is one of the largest of the known wolf species. It lives in very remote and icy regions of Alaska and the north of North America, and is characterized by its white fur. Despite inhabiting regions little frequented by humans, it is also endangered, particularly as the result of climate change and habitat loss.

Der Polarwolf zählt zu den größten Exemplaren der Unterarten des Wolfes. Er besiedelt entlegene und kalte Gebiete in Nordamerika. Sein typisches Kennzeichen ist die weiße Fellfarbe. Obwohl er in Gegenden lebt, in denen Menschen nur selten anzutreffen sind, ist er vom Aussterben bedroht. Auch ihm setzen der Klimawandel und vor allem der zunehmende Verlust ungestörter Lebensräume zu.

El lobo ártico es uno de los lobos más grandes que se conoce. Esta especie, que vive en zonas muy aisladas y frías de Alaska y del norte de América, se caracteriza por su blanco pelaje. A pesar de vivir en áreas poco frecuentadas por humanos, también se encuentra en peligro de extinción debido sobre todo a los efectos del cambio climático y la reducción de sus hábitats.

Le loup arctique est l'un des plus grands loups connus. Caractérisée par sa fourrure blanche, cette espèce évolue dans des régions très isolées et froides de l'Alaska et de l'Amérique du Nord. Bien que vivant dans des zones peu fréquentées par l'homme, le loup arctique est en danger d'extinction notamment en raison du changement climatique et de la diminution de son habitat.

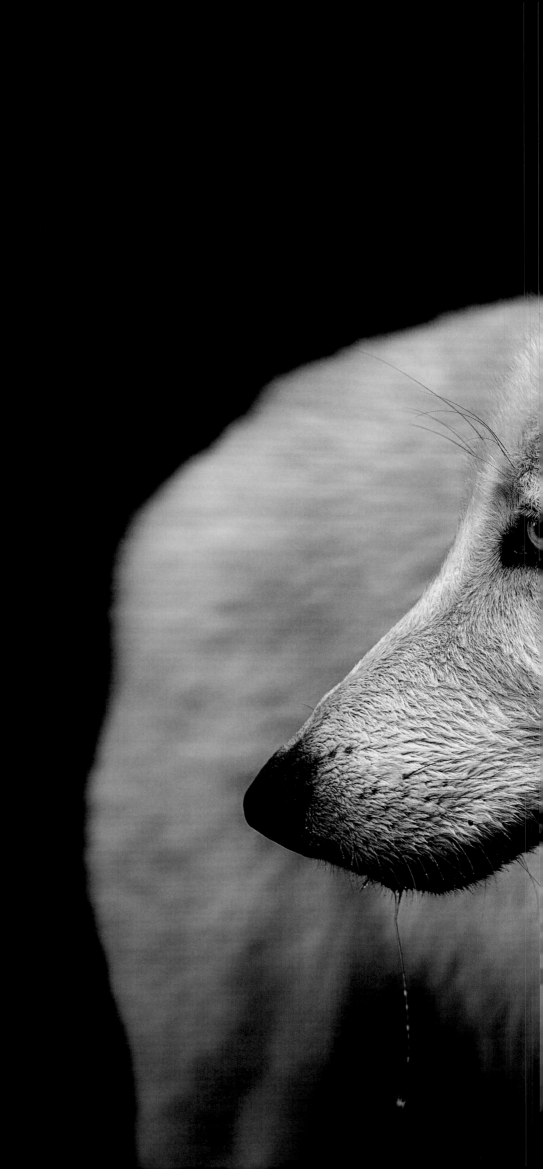

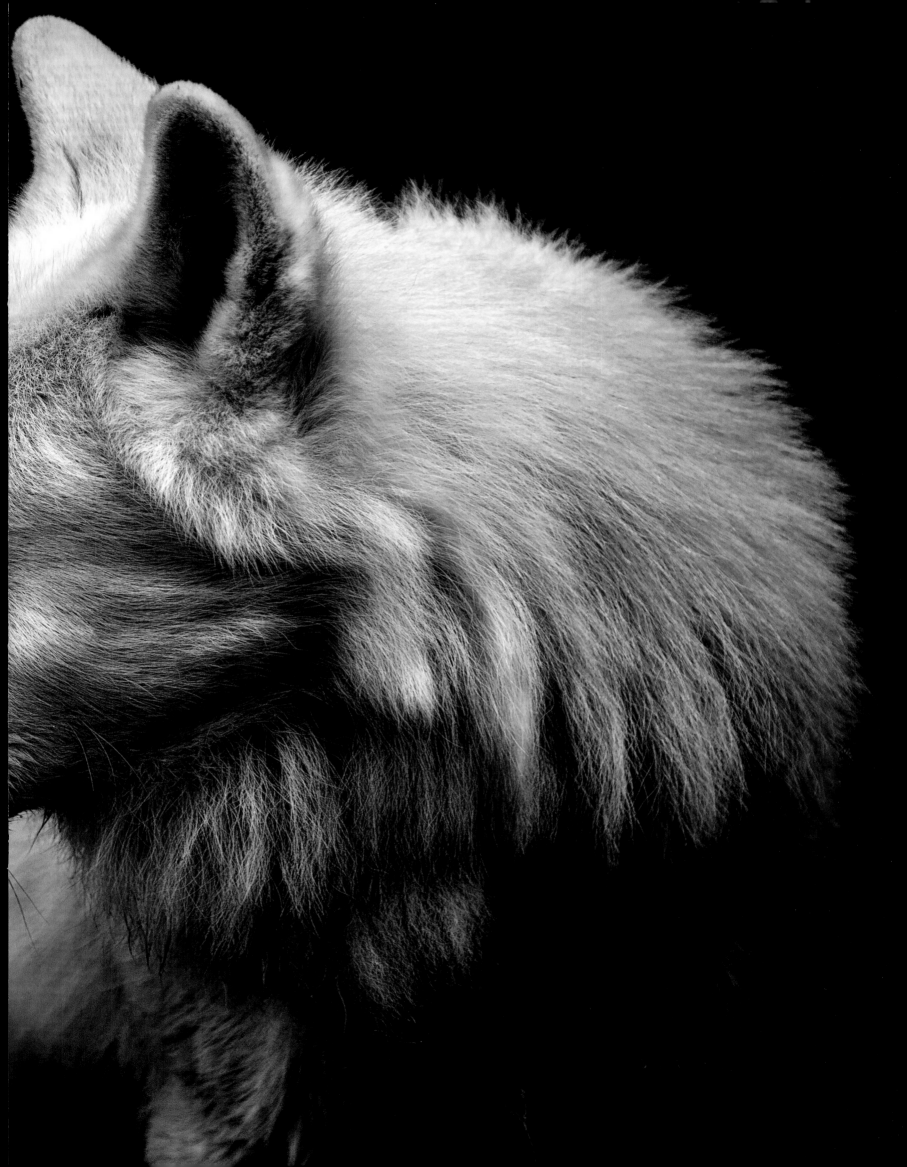

Iberian wolf
Canis lupus signatus, 1907

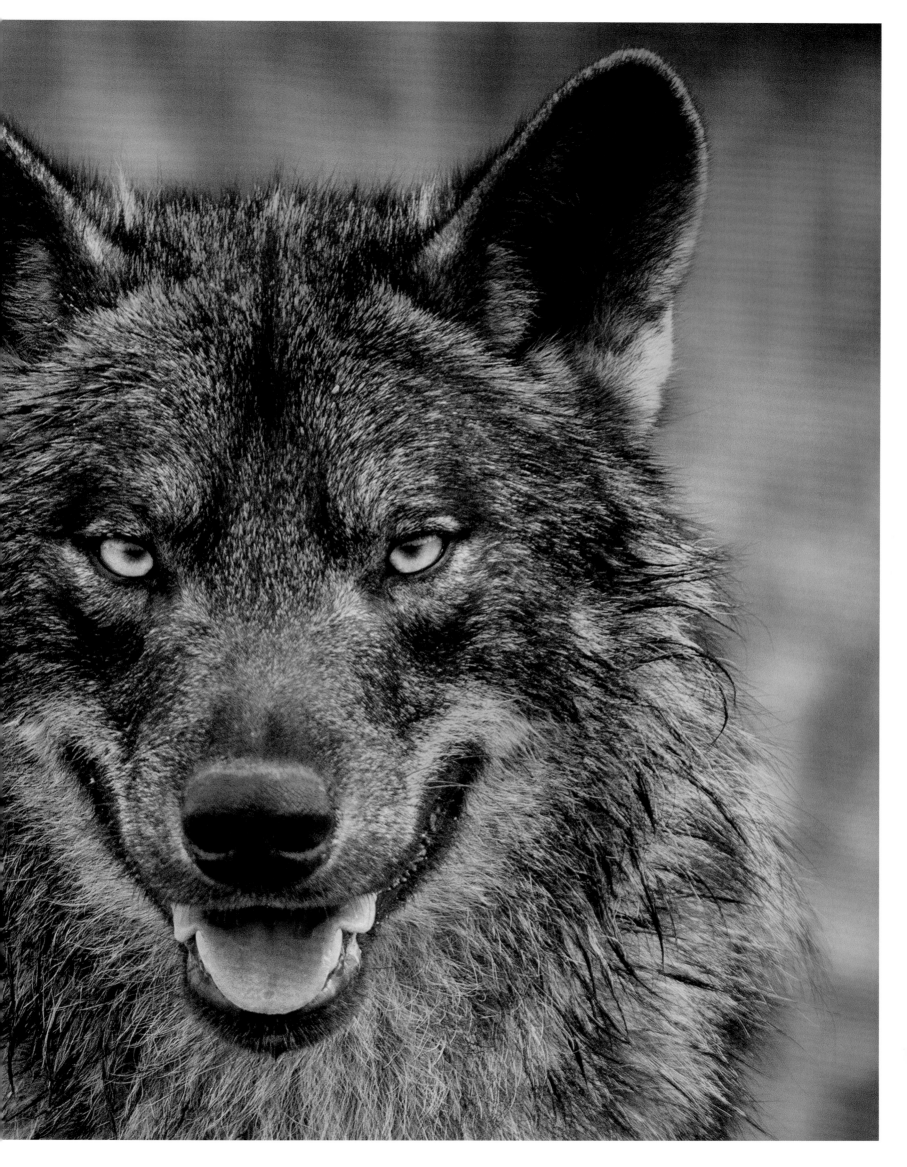

Lar gibbon
Hylobates lar, 1771

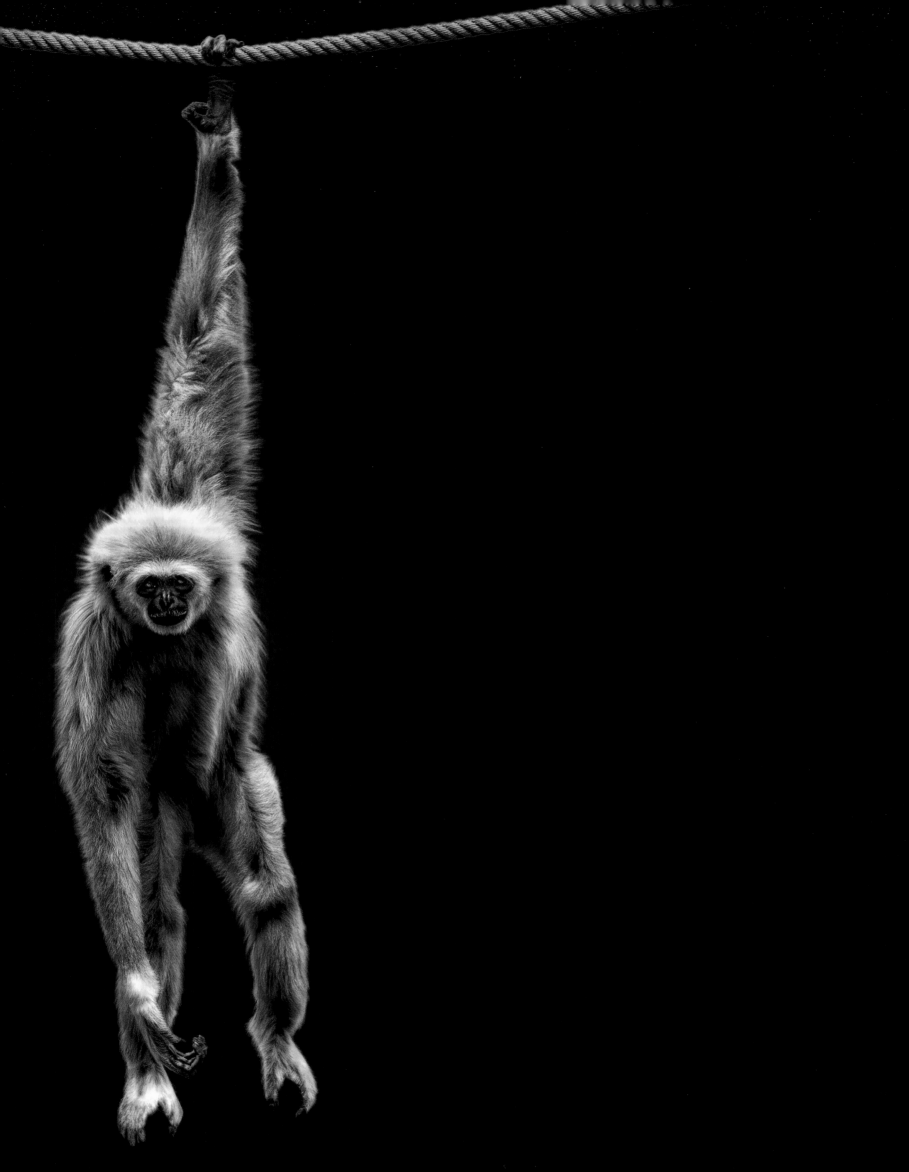

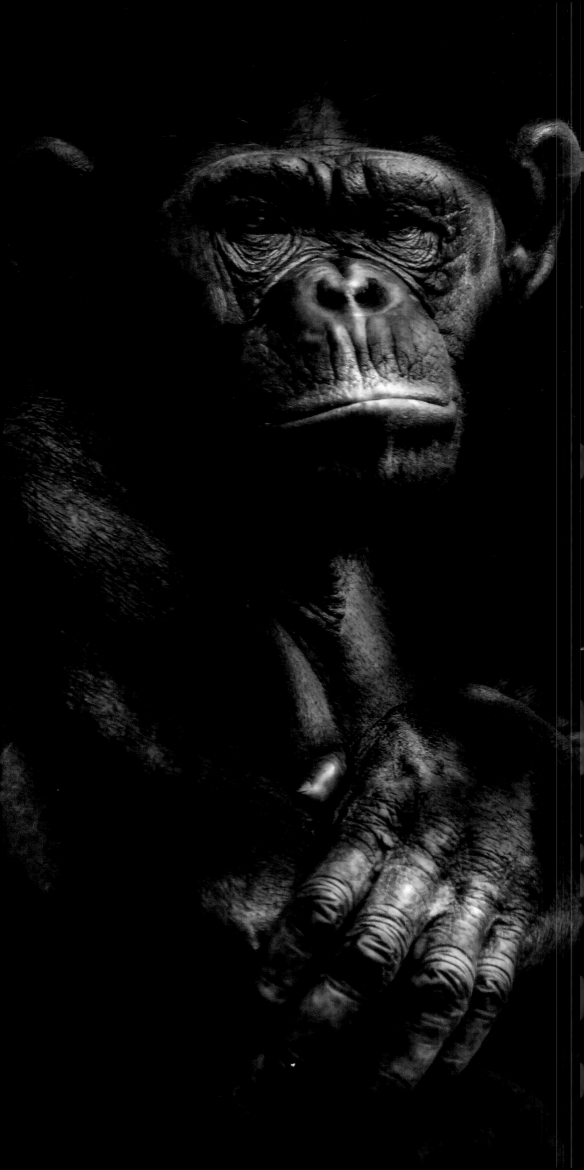

Chimpanzee
Pan troglodytes, 1775

A recent study has found that we share 99.4 percent of our DNA with chimpanzees, making them our nearest relatives. From a genetic perspective, this makes them almost identical to ourselves. There are researchers who propose to have them included in the genus *Homo*, i.e., humans, a source of great controversy for the scientific community.

Eine aktuelle Studie belegt, dass die DNA der Schimpansen zu 99,4 Prozent mit unserer übereinstimmt. Sie sind unsere nächsten lebenden Verwandten. Aus genetischer Sicht unterscheiden sich diese Primaten also kaum von uns. Manche Wissenschaftler fordern daher auch, die Schimpansen der Gattung *Homo* und der Familie der Hominiden zuzuordnen. Dies hat in der Wissenschaftsgemeinde eine kontroverse Diskussion ausgelöst.

Un estudio reciente ha determinado que compartimos el 99,4 % de nuestro ADN con los chimpancés, siendo nuestro pariente vivo más cercano. Esto hace que, desde el punto de vista genético, sean casi idénticos a nosotros, y hay investigadores que han propuesto incluirlos dentro del género *Homo*, es decir humanos, generando así gran controversia en la comunidad científica.

Une étude récente affirme que nous partageons 99,4 % de notre ADN avec les chimpanzés qui seraient notre plus proche parent vivant. D'un point de vue génétique, ce sont presque nos jumeaux. Certains chercheurs ont donc proposé de les inclure dans le genre *Homo*, c'est-à-dire les humains, soulevant un véritable tollé au sein de la communauté scientifique.

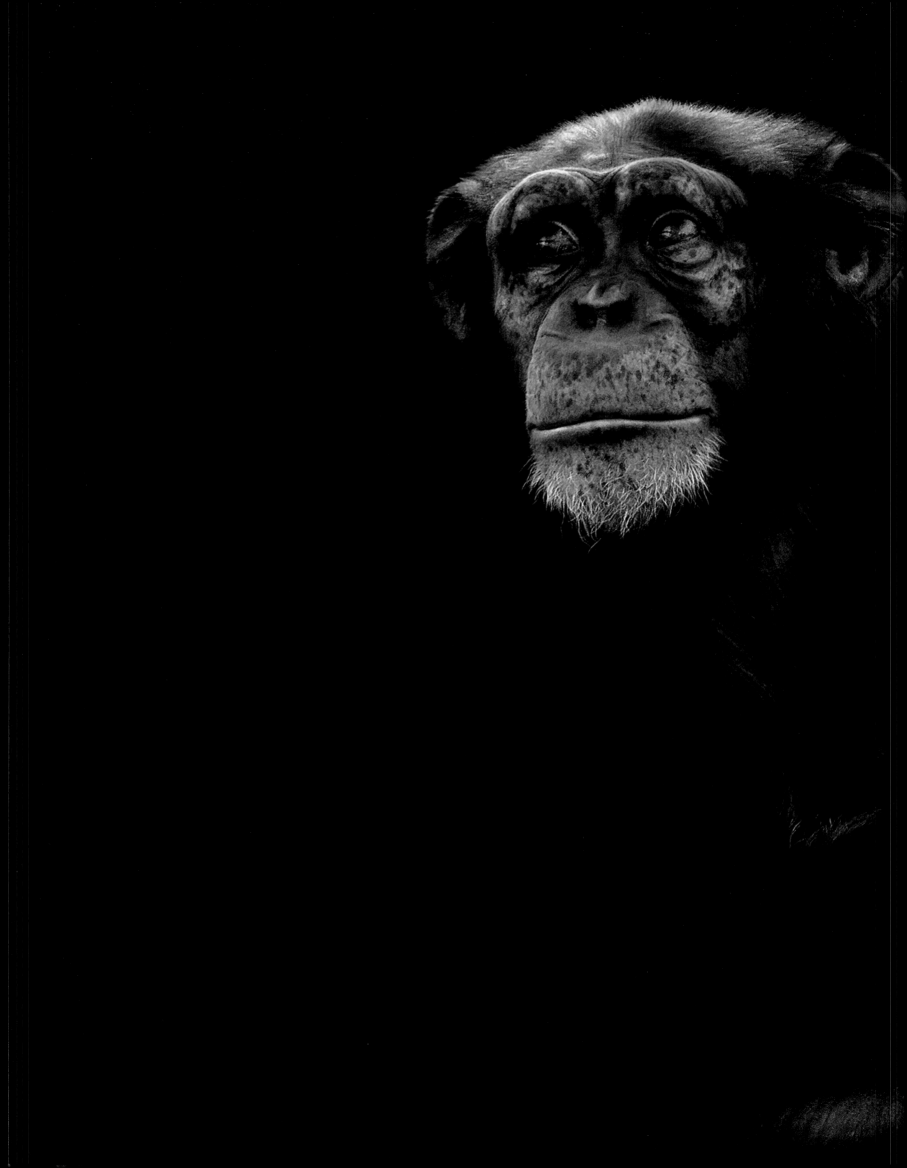

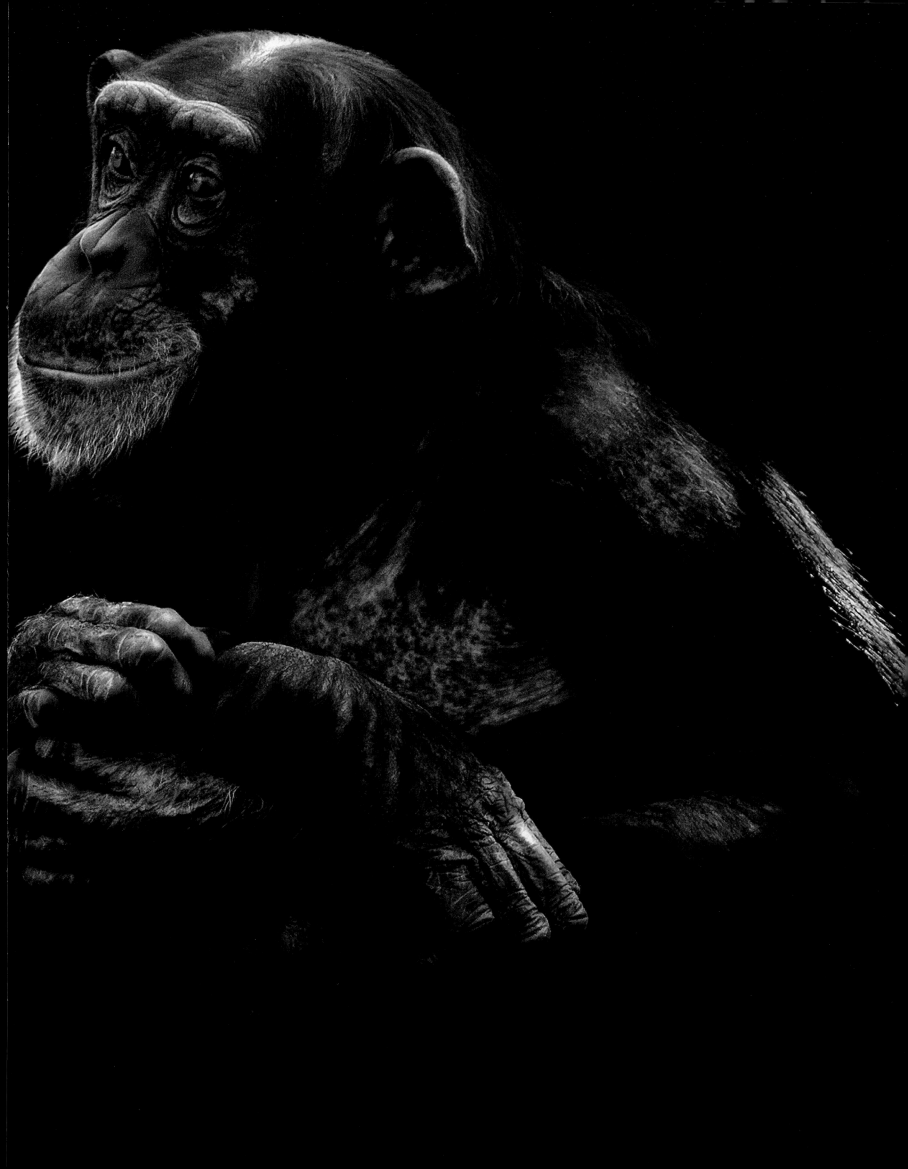

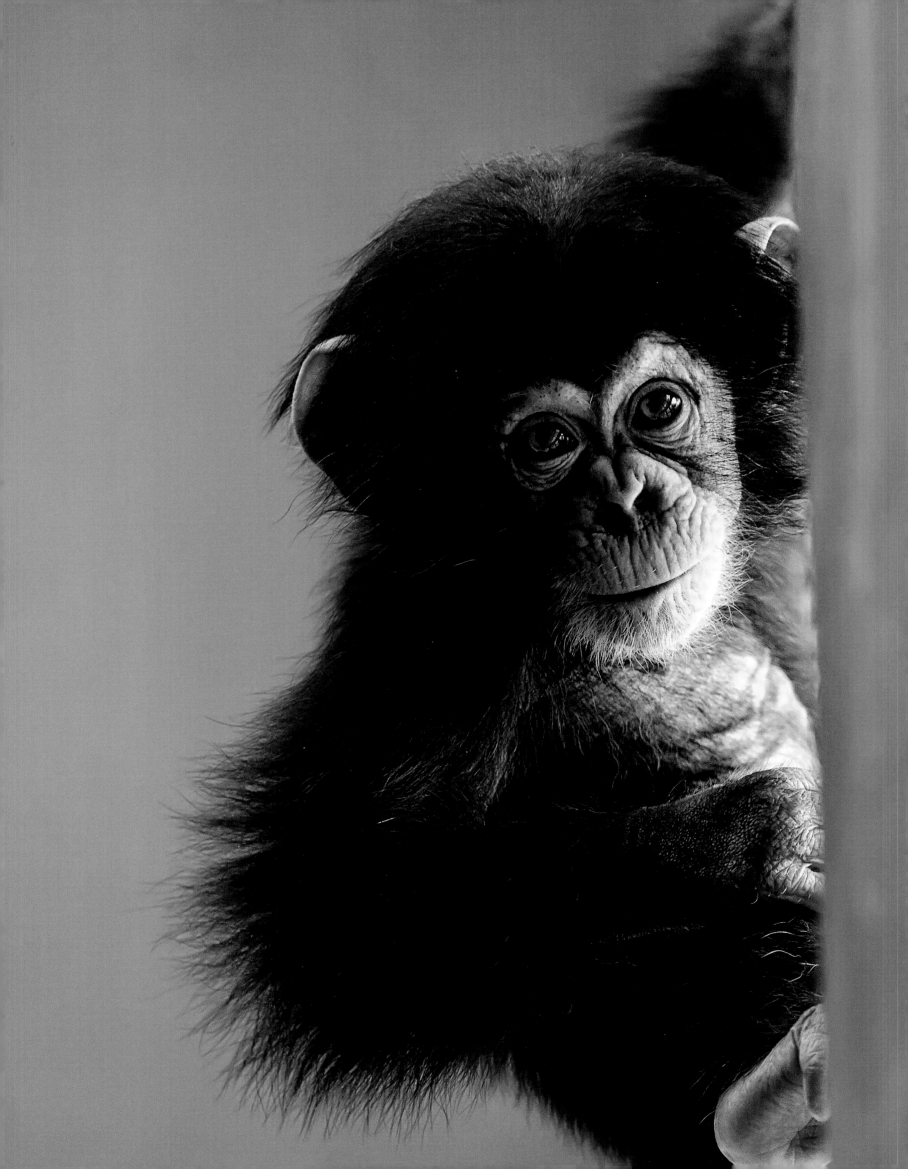

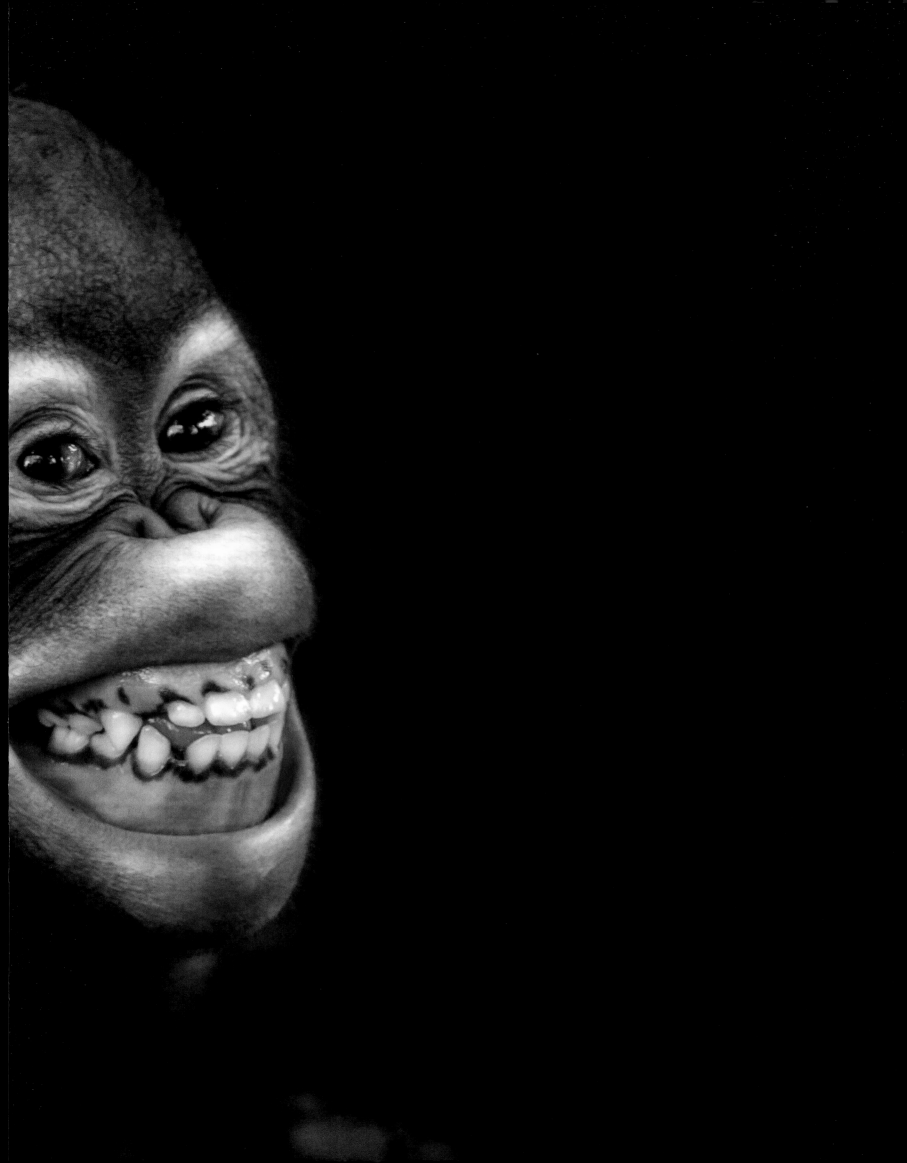

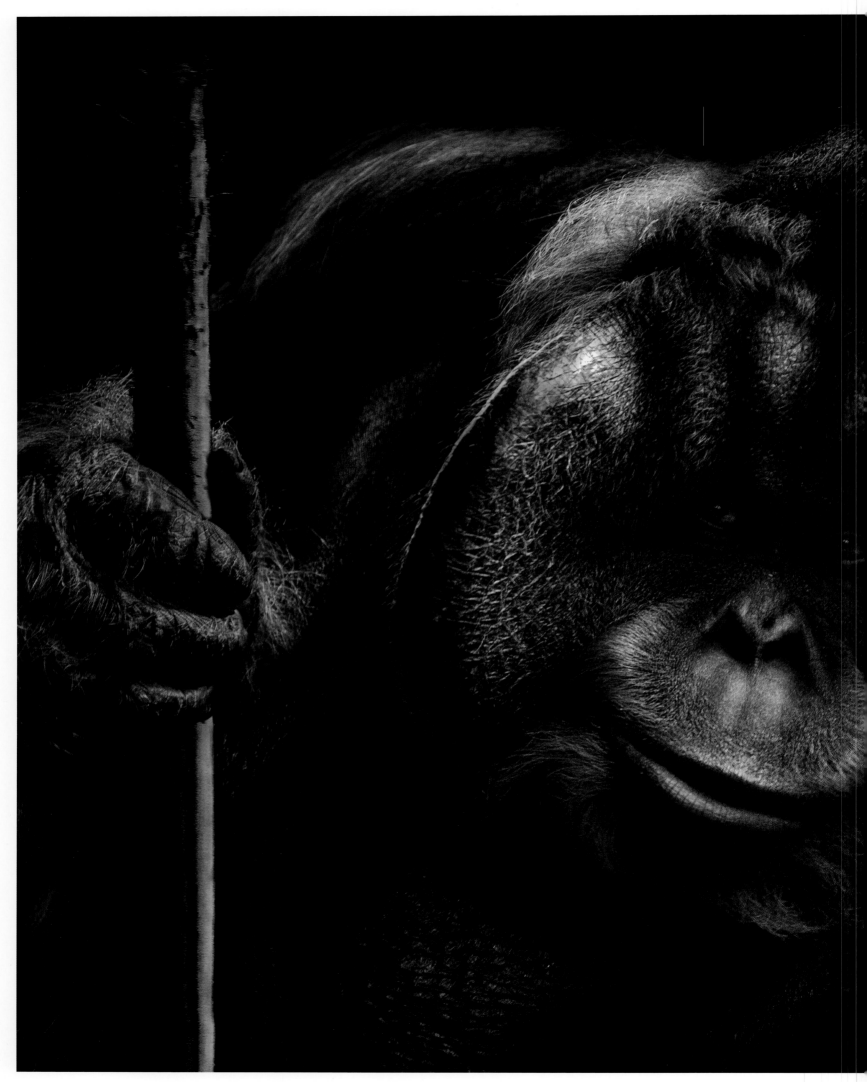

fragile

Bornean orangutan
Pongo pygmaeus, 1760

The orangutan (meaning "forest person") is one of the most endangered of species, mainly as a consequence of palm oil plantations, which are replacing the rainforests of Southeast Asia where they live. Orangutan numbers have fallen by more than 100,000 over the last 16 years, and fewer than 50,000 currently remain. Orangutans and humans share 97 percent of their genes.

Der Orang-Utan (was so viel bedeutet wie »Waldmensch«) gehört zu den am meisten bedrohten Arten weltweit. Der Grund ist die Ausbeutung des Palmöls. Ihr fallen die Wälder Südostasiens, in denen die Primaten beheimatet sind, zunehmend zum Opfer. In den letzten 16 Jahren ist der Bestand der Affen um 100 000 Exemplare auf unter 50 000 gesunken. Orang-Utans und Menschen haben zu 97 Prozent das gleiche Genom.

El orangután (que significa «persona del bosque») es una de las especies más amenazadas, principalmente por la explotación del aceite de palma que está arrasando las selvas del sudeste asiático donde habitan. Su población ha perdido más de 100 000 ejemplares en los últimos 16 años, y quedan menos de 50 000 en la actualidad. Orangutanes y humanos comparten el 97 % del genoma.

L'orang-outan (qui signifie «homme de la forêt») est l'une des espèces les plus menacées au monde, principalement en raison de la culture de l'huile de palme qui détruit son habitat : les forêts de l'Asie du Sud-Est. Plus de 100 000 individus ont ainsi disparu au cours des 16 dernières années, et il en reste aujourd'hui moins de 50 000. Les orangs-outans partagent 97 % de notre génome.

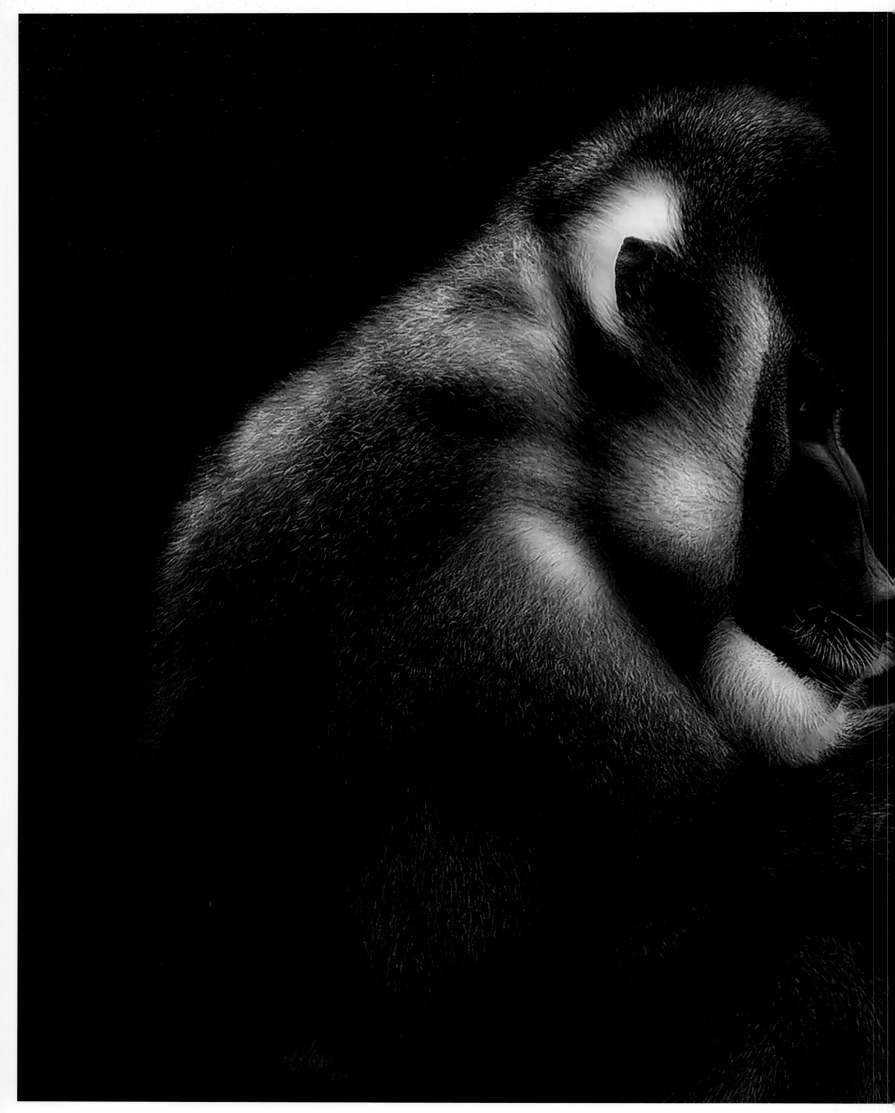

fragile

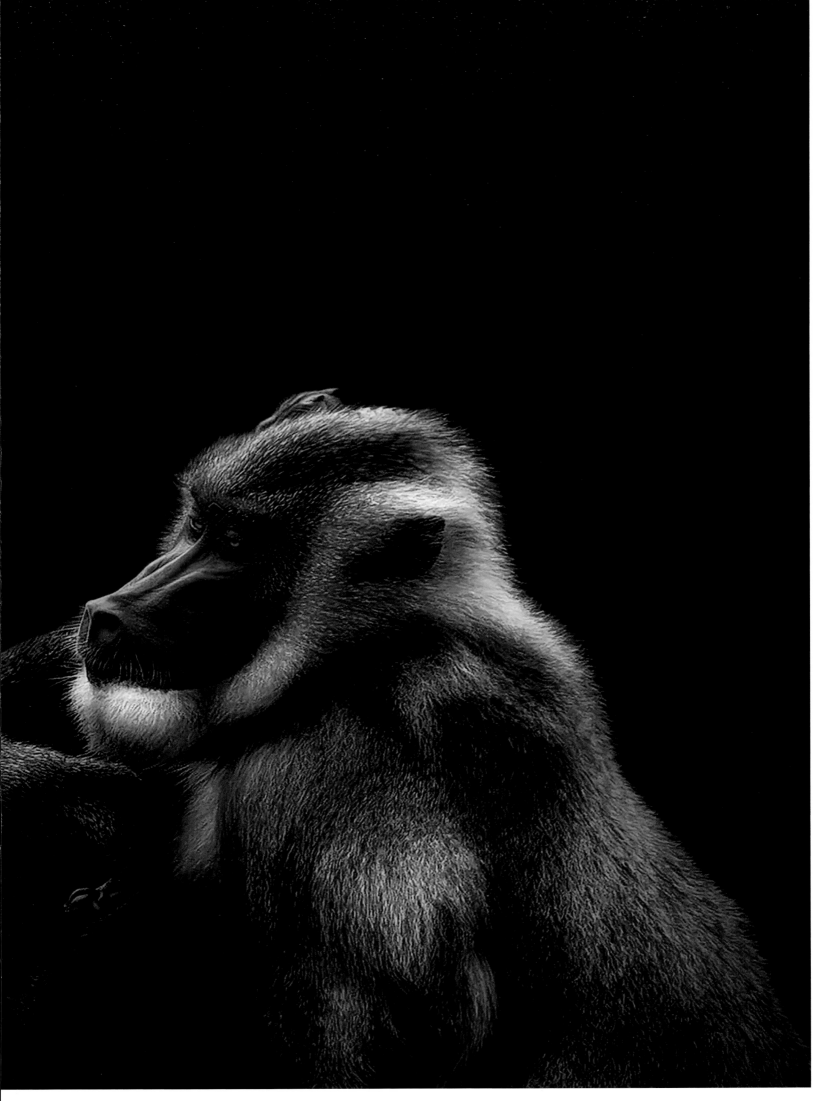

Drill

Mandrillus leucophaeus
1807

Drills have been included on the IUCN Red List of Threatened Species. Its meat is highly prized in certain African countries, and illegal trade and hunting are wiping out entire populations given that they live in very large groups, making it easier to kill many individuals at the same time. They raid crops for food, creating conflict with human populations.

Auch der Drill steht auf der Liste der bedrohten Arten. Sein Fleisch ist in einigen Ländern Afrikas sehr begehrt. Die Jagd nach diesen Affen und der illegale Handel mit ihnen löschen ganze Populationen aus. Drills leben in großen Rudeln. So ist es leicht, eine große Anzahl auf einmal zu töten. Da die Primaten die Felder und Plantagen der Landwirte häufig als Nahrungsquelle nutzen, sind Konflikte mit den dort lebenden Menschen unvermeidlich.

Los mandriles han entrado en la lista roja de especies amenazadas. Su carne, muy apreciada en ciertos países de África, y el comercio ilegal y la caza están acabando con poblaciones enteras ya que viven en grupos muy grandes y resulta más fácil exterminar a muchos individuos juntos. Aprovechan los cultivos para alimentarse, lo que crea conflictos con las poblaciones humanas.

Les drills sont inscrits sur la liste rouge mondiale des espèces menacées. Leur viande, très prisée dans certains pays africains, le commerce illégal et la chasse les déciment en masse. Les drills vivent en très grands groupes et il est très facile d'exterminer plusieurs individus ensemble. Ils se nourrissent beaucoup de fruits cultivés, ce qui génère des conflits avec les populations humaines locales.

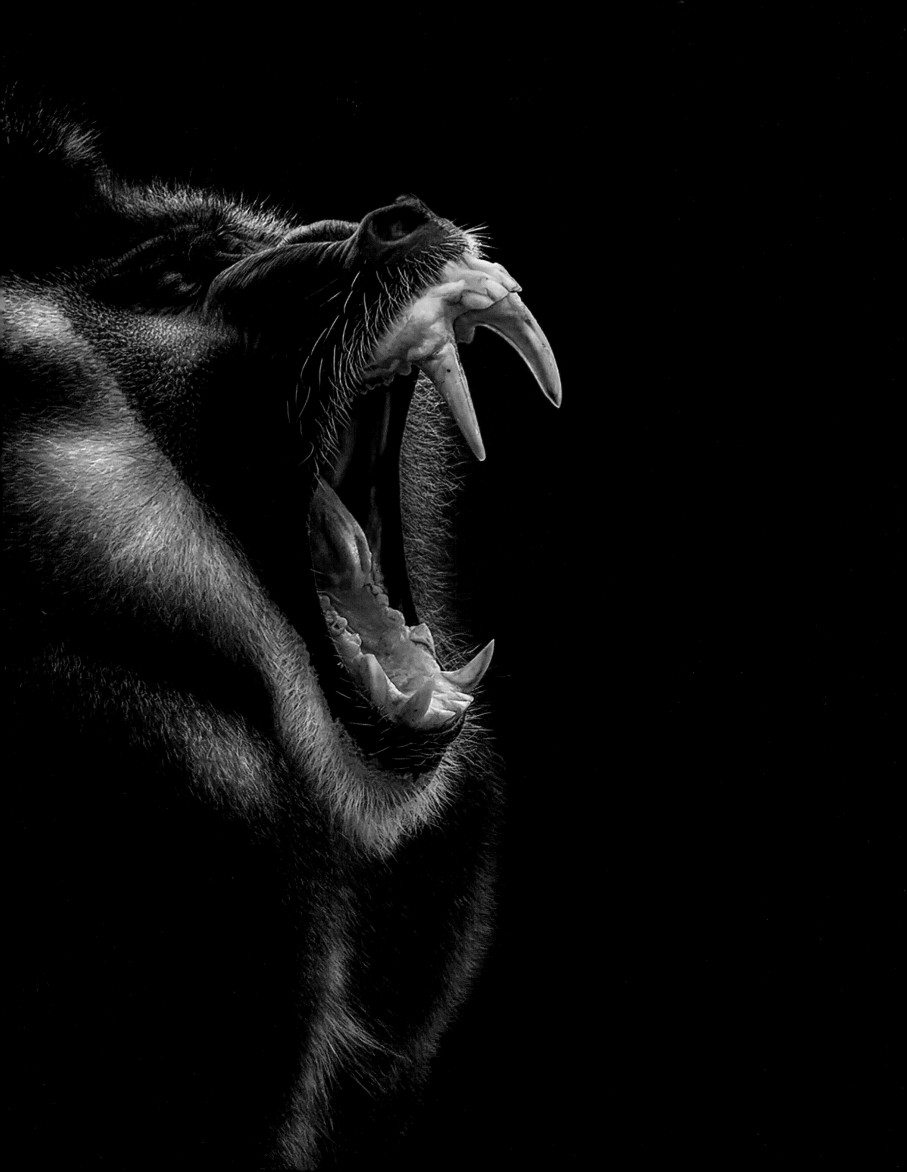

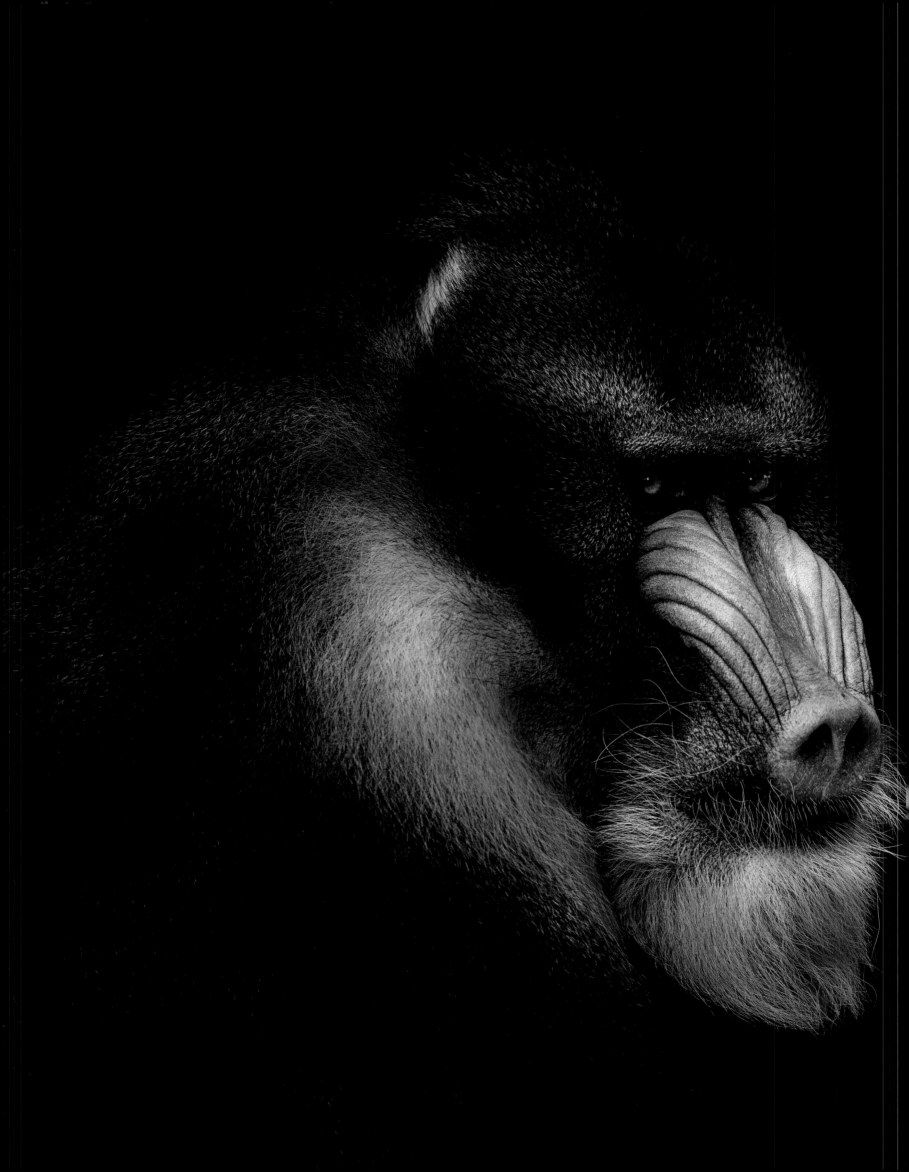

Mandrill
Mandrillus sphinx, 1758

As the human population expands at a dizzying rate, the world's last bastions of wilderness are being lost. Resource extraction, urban growth, and the demand for food are threatening to diminish the few wild spaces that remain. Seventy percent of these spaces are found in only five countries. If we add climate change to this situation, many of the known species will become extinct, including rhinoceroses, axolotls, pangolins, vultures, and gorillas, among others. The list is long, with only a few specimens to be found in zoos or wildlife rescue centers.

A medida que la población humana aumenta a un ritmo frenético, los últimos bastiones salvajes del mundo van decreciendo. La extracción de recursos, el crecimiento de las ciudades y la demanda de alimentos amenazan con reducir los pocos espacios salvajes que quedan. El 70 % de estos espacios se encuentran en tan solo cinco países. Si a esto añadimos el cambio climático, en los próximos veinte años se extinguirán muchas especies conocidas, entre ellas rinocerontes, ajolotes, pangolines, buitres, gorilas, etc. Y la lista es larga, quedando solamente algunos ejemplares en zoológicos o centros de preservación.

Durch das rasante Wachstum der Weltbevölkerung bröckeln die letzten Bastionen wild lebender Tiere auf der Erde. Der Abbau von Bodenschätzen, das Wachstum der Städte und die steigende Nachfrage nach Lebensmitteln führen zu einem stetigen Schrumpfen der verbleibenden Lebensräume. 70 Prozent dieser Räume verteilen sich auf gerade einmal fünf Länder. Wenn wir noch den Klimawandel hinzurechnen, werden in den nächsten 20 Jahren viele bekannte Arten aussterben, darunter Rhinozerosse, Axolotls, Schuppentiere, viele Geierarten und Gorillas etc.

Tandis que la population humaine augmente à un rythme effréné, les derniers sites sauvages du monde s'amenuisent. L'exploitation des ressources naturelles, la croissance des villes et la demande en denrées alimentaires menacent de réduire davantage les territoires vierges qui subsistent. Seulement cinq pays détiennent 70 % de ces espaces. À cela s'ajoute le changement climatique qui va entraîner la disparition de nombreuses espèces connues au cours des vingt prochaines années, notamment les rhinocéros, les axolotls, les pangolins, les vautours ou les gorilles. La liste est longue, ne laissant une chance de survie qu'aux spécimens présents dans les zoos ou dans des centres de conservation.

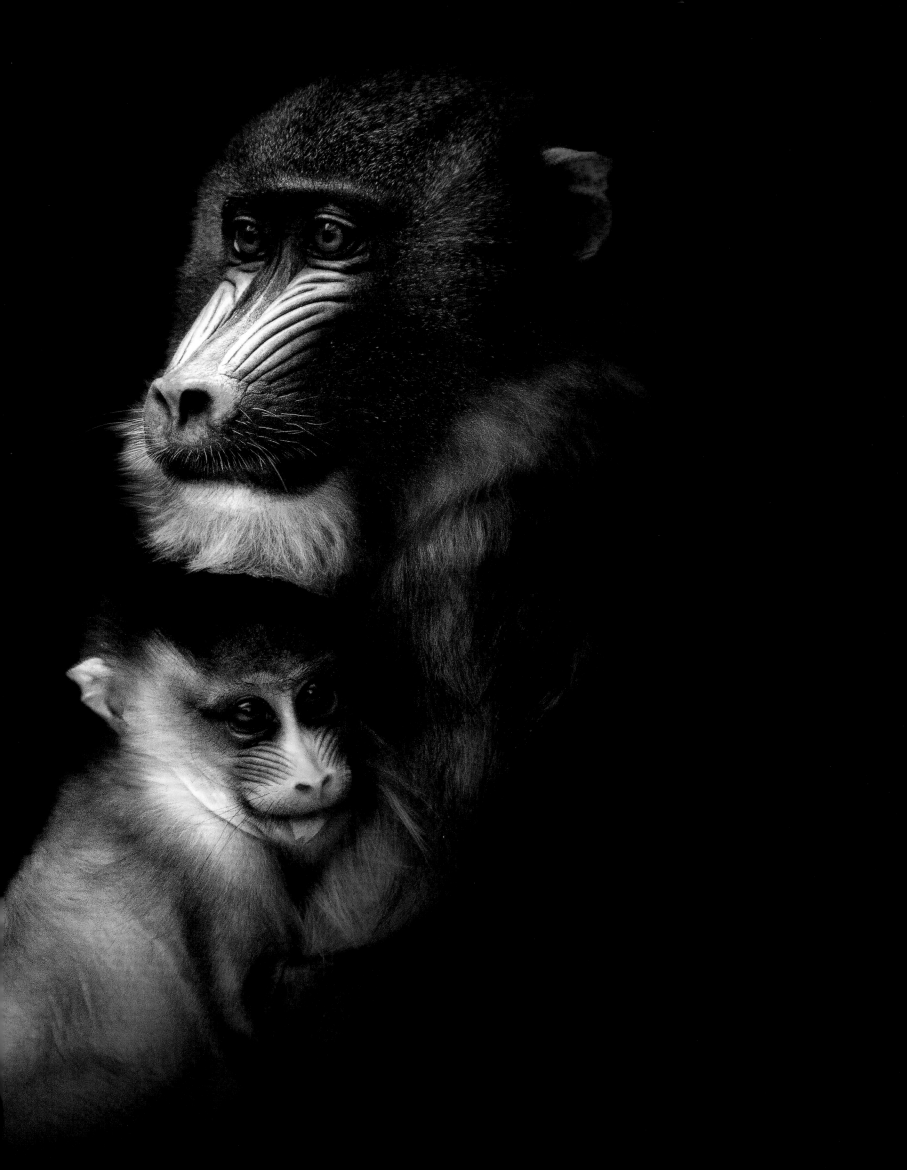

Western gorilla

Gorilla gorilla, 1847

fragile

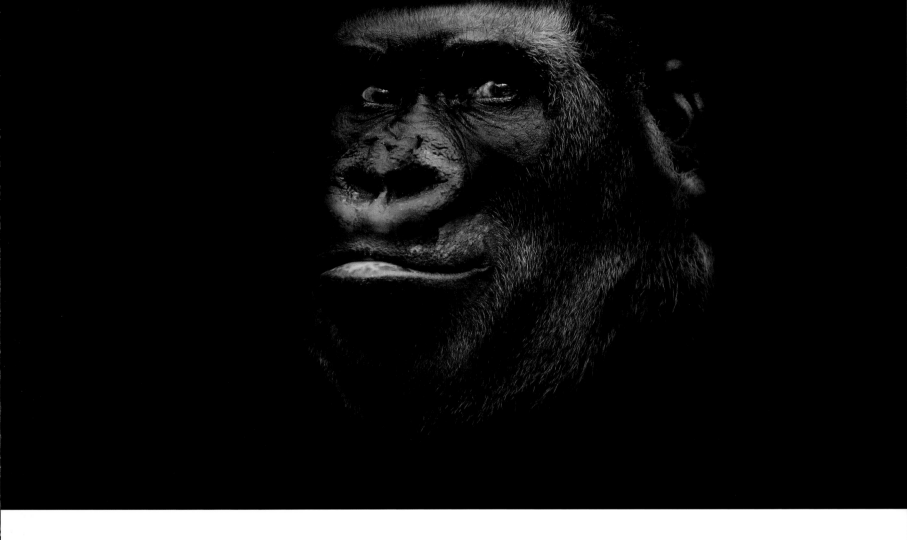

Gorillas, chimpanzees, and orangutans are the genetically closest animals to humans. But there is a paradox. Chimpanzees share 99.4 percent of our DNA, meaning that there is less than a one percent difference between us, but gorillas and humans share part of that one percent that differentiates us from chimpanzees. Scientists are therefore curious to find what exactly it is that makes us *Homo sapiens*. Is the thing that gives us reason and abstract thought really so genetically insignificant? The extinction of the gorilla may mean we will never know the secret.

Gorillas, Schimpansen und Orang-Utans stehen dem Menschen genetisch am nächsten. Erstaunlicherweise haben Schimpansen zu 99,4 Prozent dieselbe DNA wie wir, der Unterschied beträgt also weniger als ein Prozent. Der Gorilla und der Mensch haben wiederum einen Teil dieses einen Prozents gemein, das uns vom Schimpansen unterscheidet. Die Wissenschaftler fragen sich, worin der Schlüssel besteht. Was macht uns zum *Homo sapiens*? Ist das, was uns Vernunft und abstraktes Denken ermöglicht, auf genetischer Ebene tatsächlich so unbedeutend? Wenn der Gorilla ausstirbt, wird er dieses Geheimnis mit in sein Grab nehmen.

Gorilas, chimpancés y orangutanes son los animales genéticamente más cercanos al ser humano. Pero existe una paradoja. Los chimpancés comparten el 99,4 % de nuestro ADN y lo que nos diferencia de ellos es menos de un 1 %, pero el gorila y el humano tienen en común parte de ese 1 % que nos diferencia de los chimpancés. Los científicos se preguntan dónde reside entonces la clave de lo que nos convierte en *Homo sapiens*. ¿Es realmente tan insignificante, a nivel genético, lo que nos proporciona la razón y el pensamiento abstracto? La extinción del gorila podría llevarse este secreto para siempre.

Les gorilles, les chimpanzés et les orangs-outans sont les animaux les plus proches des humains d'un point de vue génétique. On observe cependant un paradoxe : les chimpanzés partagent 99,4 % de notre ADN et ne diffèrent des humains que de 1 %, mais le gorille et l'homme ont en commun ce fameux 1 % qui nous différencie des chimpanzés. Les scientifiques s'interrogent : où se trouve la clé de ce qui fait de nous des Homo sapiens ? Ce qui nous confère la raison et la pensée abstraite est-il vraiment si insignifiant au niveau génétique ? Le gorille, s'il venait à disparaître, pourrait bien emporter ce secret avec lui.

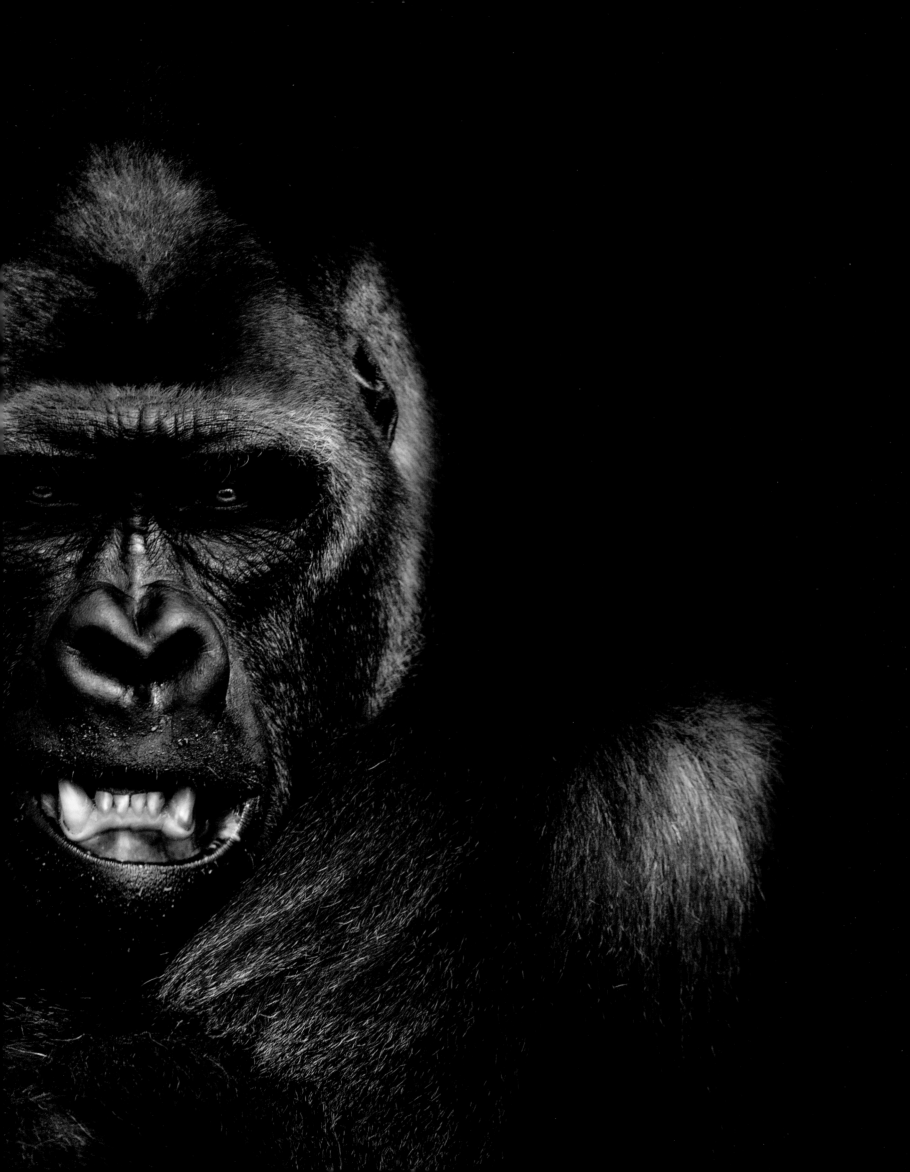

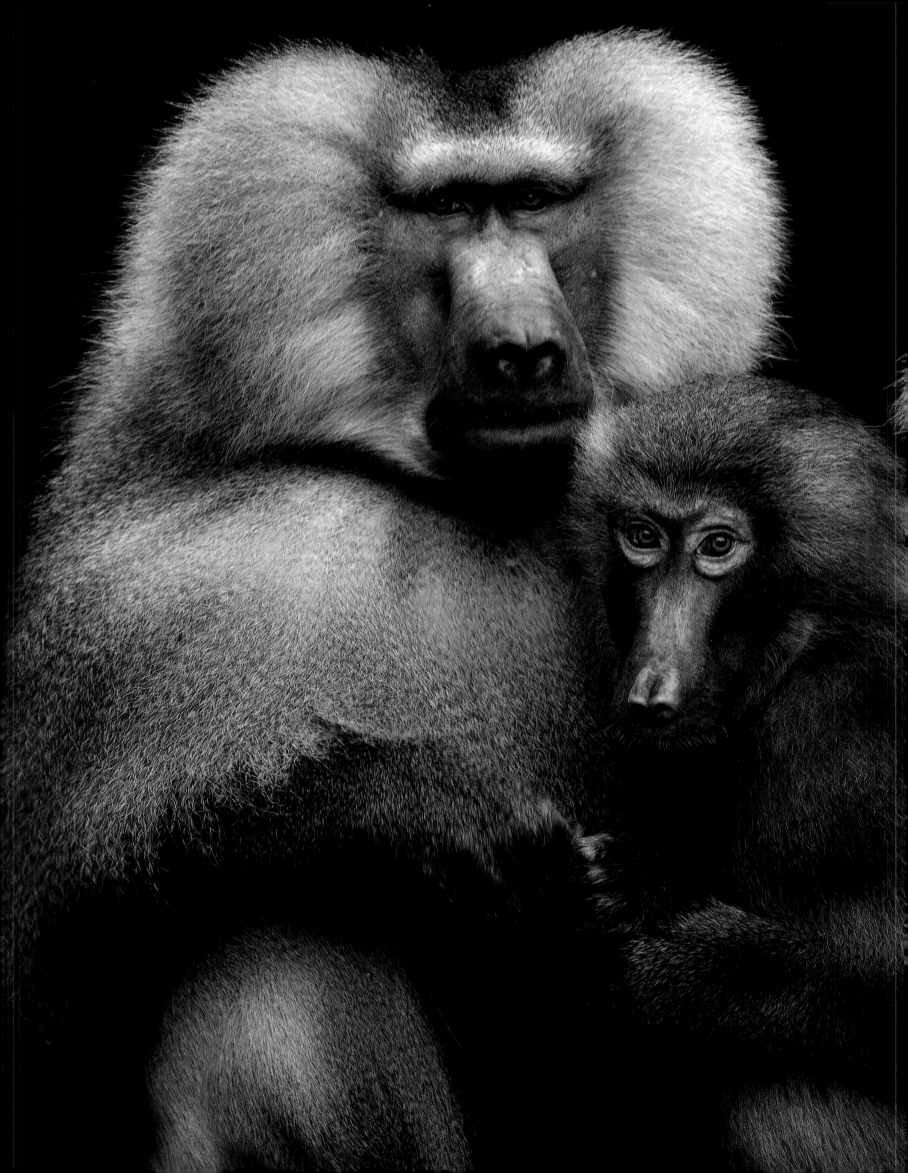

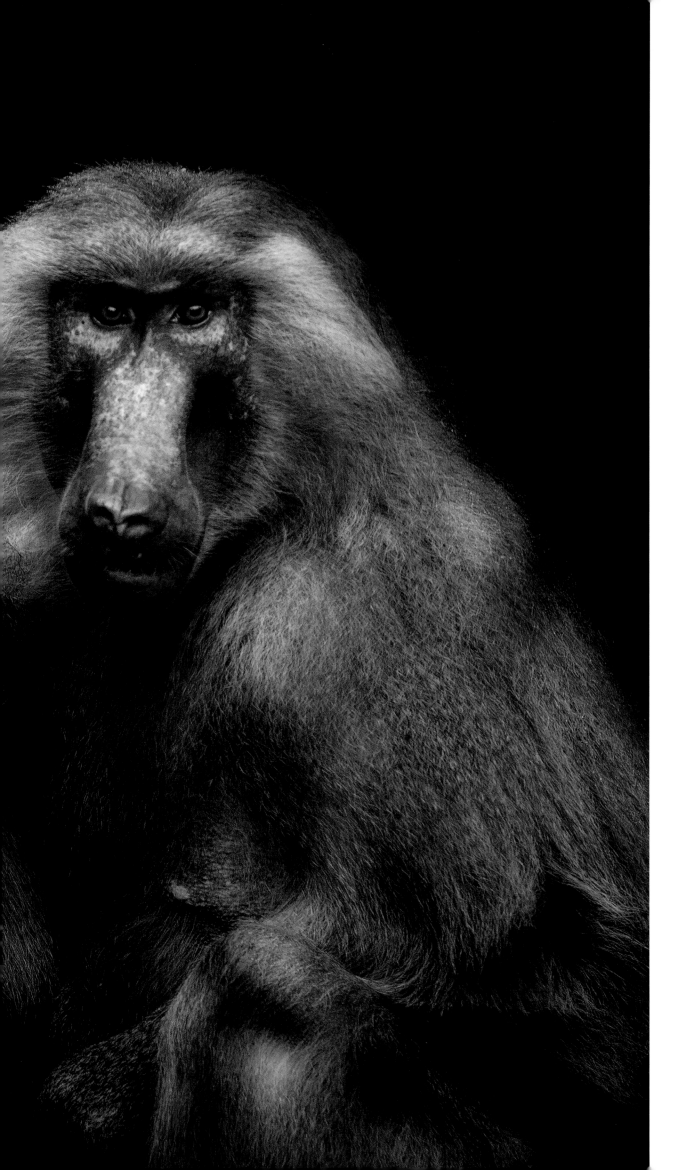

Hamadryas baboon
Papio hamadryas, 1758

Baboons are a species of primate with which we share 91 percent of our DNA and whose behavior is often quite similar to that of humans—gender violence, possessiveness and domination. They use more than ten different types of vocalizations and a large range of gestures to communicate with each other. They are some of the most aggressive animals in the world, and even lions hesitate to attack them. They were considered sacred animals by the ancient Egyptians.

Mit den Pavianen teilen wir 91 Prozent unserer DNA. Sie verhalten sich in vielen Punkten wie Menschen: So zeigen sie sexistische Gewalt, possessives Verhalten und Dominanzstreben. Zur Kommunikation verwenden sie mehr als zehn verschiedene Lautäußerungen und zahlreiche Gesten. Sie zählen zu den aggressivsten Tieren der Welt. Selbst Löwen überlegen es sich zweimal, ob sie sie angreifen. Im Alten Ägypten galten Paviane als heilig.

Los babuinos son una especie de mono con el cual compartimos el 91 % de ADN y cuyo comportamiento es similar al humano: violencia sexista, posesividad y dominación. Para comunicarse emplean más de diez tipos de vocalizaciones y muchos gestos. Son uno de los animales más agresivos del mundo, y hasta los leones dudan antes de atacarlos. En Egipto eran considerados animales sagrados.

Nous partageons 91 % de notre ADN avec les babouins et nos comportements ont des similitudes : violence sexiste, possessivité et domination. Ils utilisent plus de dix types de vocalisations et de nombreux gestes pour communiquer. C'est l'un des animaux les plus agressifs au monde ; même les lions hésitent à les attaquer. En Égypte, ils étaient considérés comme sacrés.

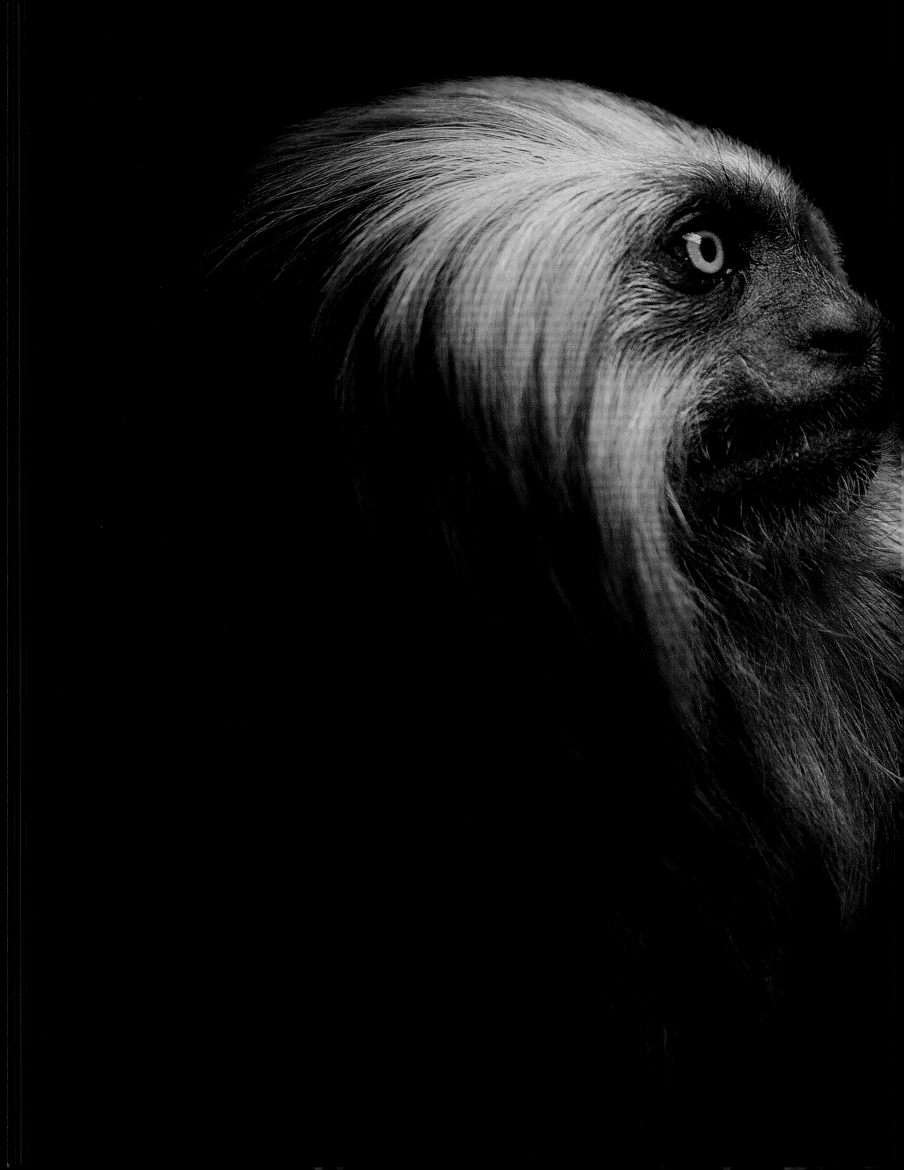

Golden Lion
tamarin
Leontopithecus rosalia, 1766

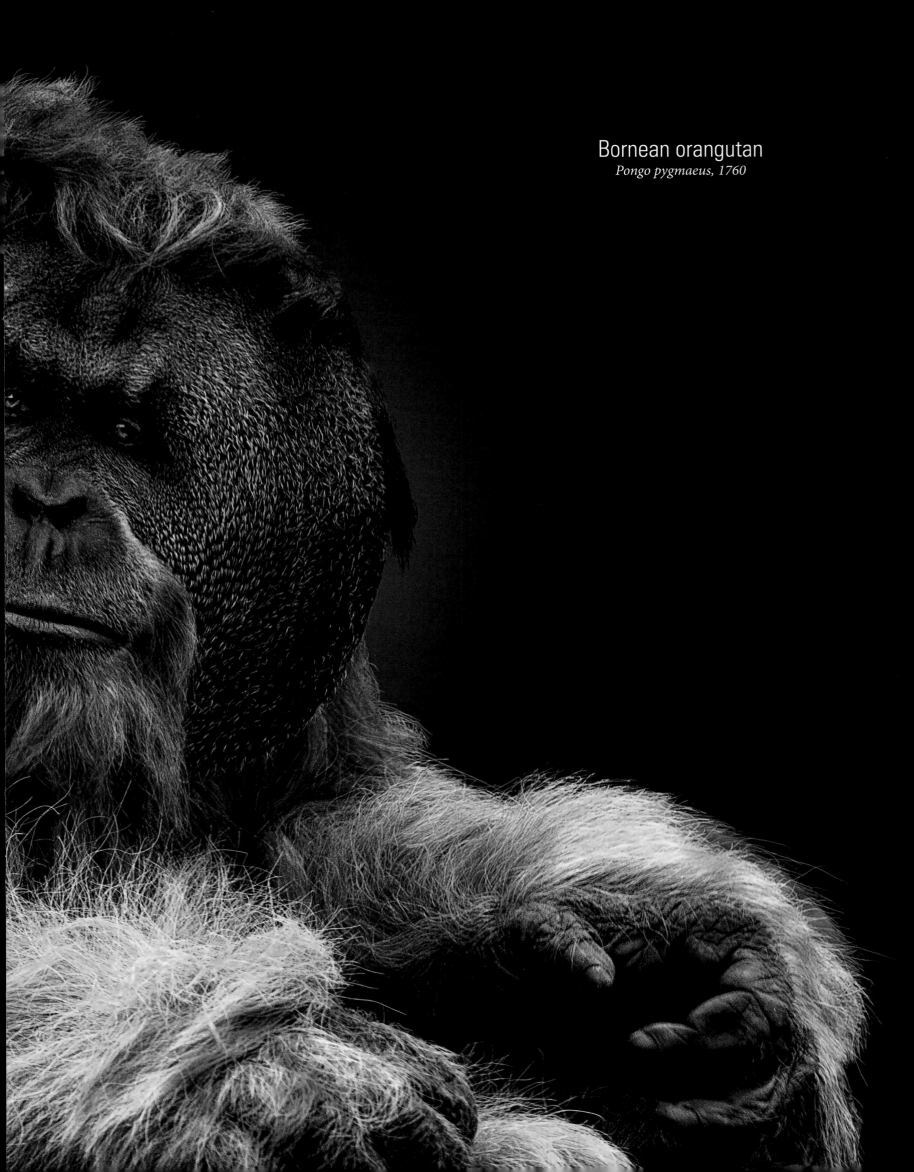

Bornean orangutan
Pongo pygmaeus, 1760

Giant panda

Ailuropoda melanoleuca, 1869

The particular charms of the giant panda have
managed to bring it back from the brink of extinction,
and major panda conservation programs have been set up.
In China, prison sentences of up to 20 years are the
penalty for people attempting to hunt them.

Das Aussehen des Pandabären hat ihn vor dem
Aussterben bewahrt. Es sind wichtige Programme zu seinem
Erhalt entwickelt worden. In China stehen bis zu 20 Jahre
Gefängnis auf die verbotene Jagd.

El particular encanto del oso panda lo ha
salvado *in extremis* de la desaparición, y se han
desarrollado importantes programas para su conservación.
En China hay penas de hasta veinte años de prisión
para quienes intenten cazarlos.

Le charme particulier du panda l'a sauvé
in extremis la disparition et d'importants programmes
de conservation ont été mis en place pour assurer sa survie.
En Chine, sa chasse est passible de peines
allant jusqu'à 20 ans de prison.

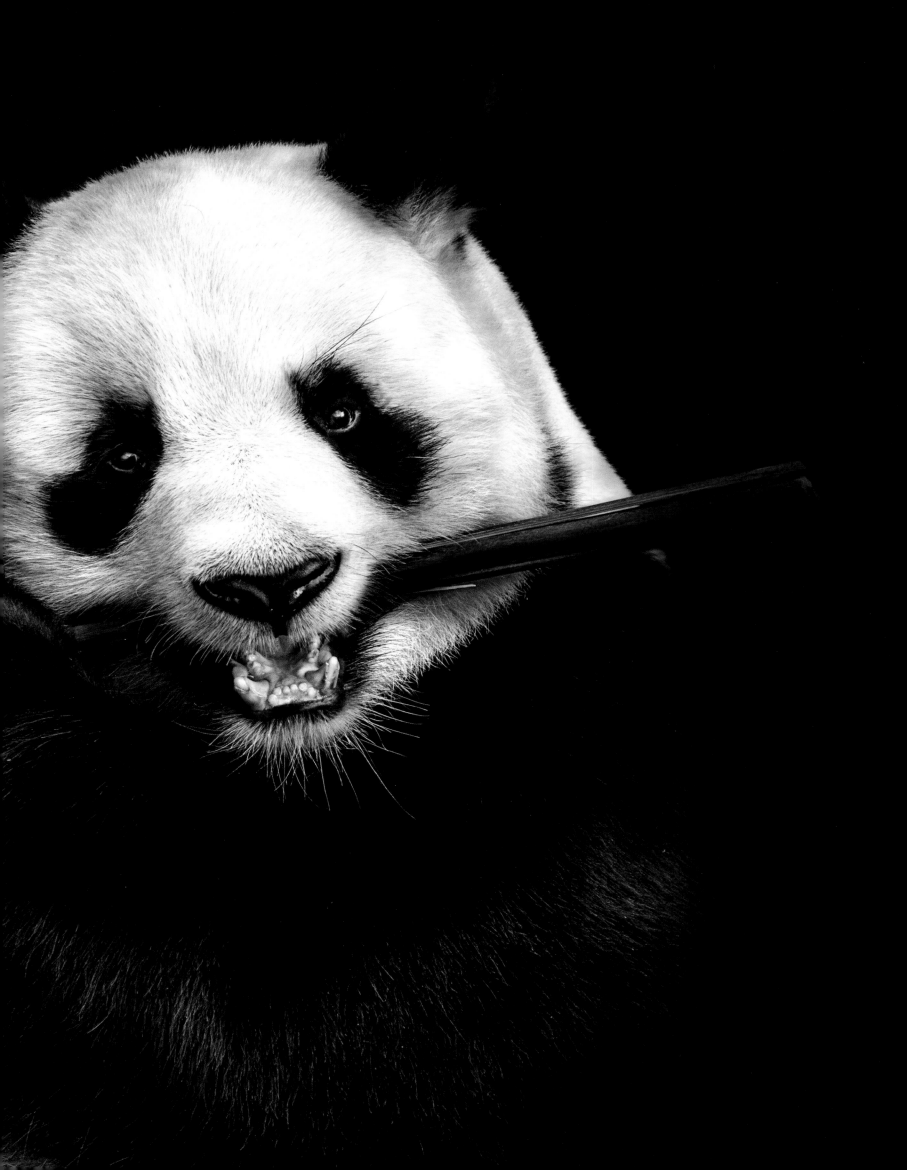

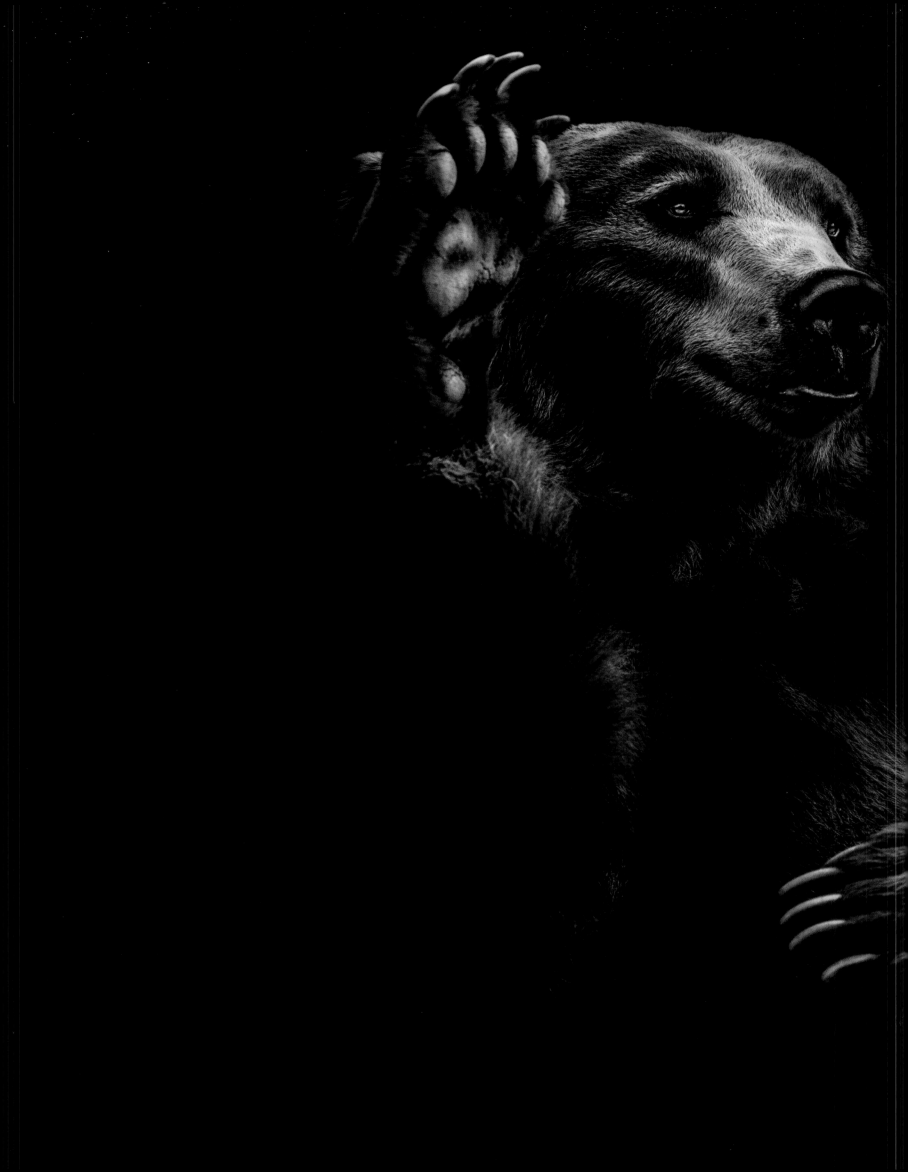

Brown bear
Ursus arctos, 1758

The brown bear has learned its lesson—to keep as far away as possible from humans. Its natural habitats have been restricted to the northern regions of North America and Europe as human populations have expanded over its former territories. Outside of these regions, in Europe, they inhabit very remote mountainous areas, and programs for their reintroduction have been put in place.

Der Braunbär hat seine Lektion gelernt: Er hält sich so weit wie möglich vom Menschen fern. Durch die Ausdehnung der menschlichen Siedlungen in seinen ursprünglichen Lebensraum wurde er in den Norden Nordamerikas und Europas zurückgedrängt. Man findet ihn nur in abgelegenen Bergregionen. Es wurden jedoch Programme entwickelt, ihn auch andernorts wieder anzusiedeln.

El oso pardo ya ha aprendido la lección: alejarse lo más posible del ser humano. Sus hábitats naturales se han ido restringiendo al norte de América y de Europa a medida que las poblaciones humanas se han extendido por sus antiguos territorios. Fuera de estas regiones se les encuentra, en Europa, en zonas montañosas muy aisladas y se han desarrollado programas para su reintroducción.

L'ours brun a bien retenu la leçon : toujours se tenir à bonne distance de l'homme. Ses habitats naturels se limitent à l'Amérique du Nord et à l'Europe où les populations humaines se sont installées sur leurs anciens territoires. Vivant dans des zones montagneuses très isolées en Europe, l'ours brun a fait l'objet de programmes de réintroduction.

fragile

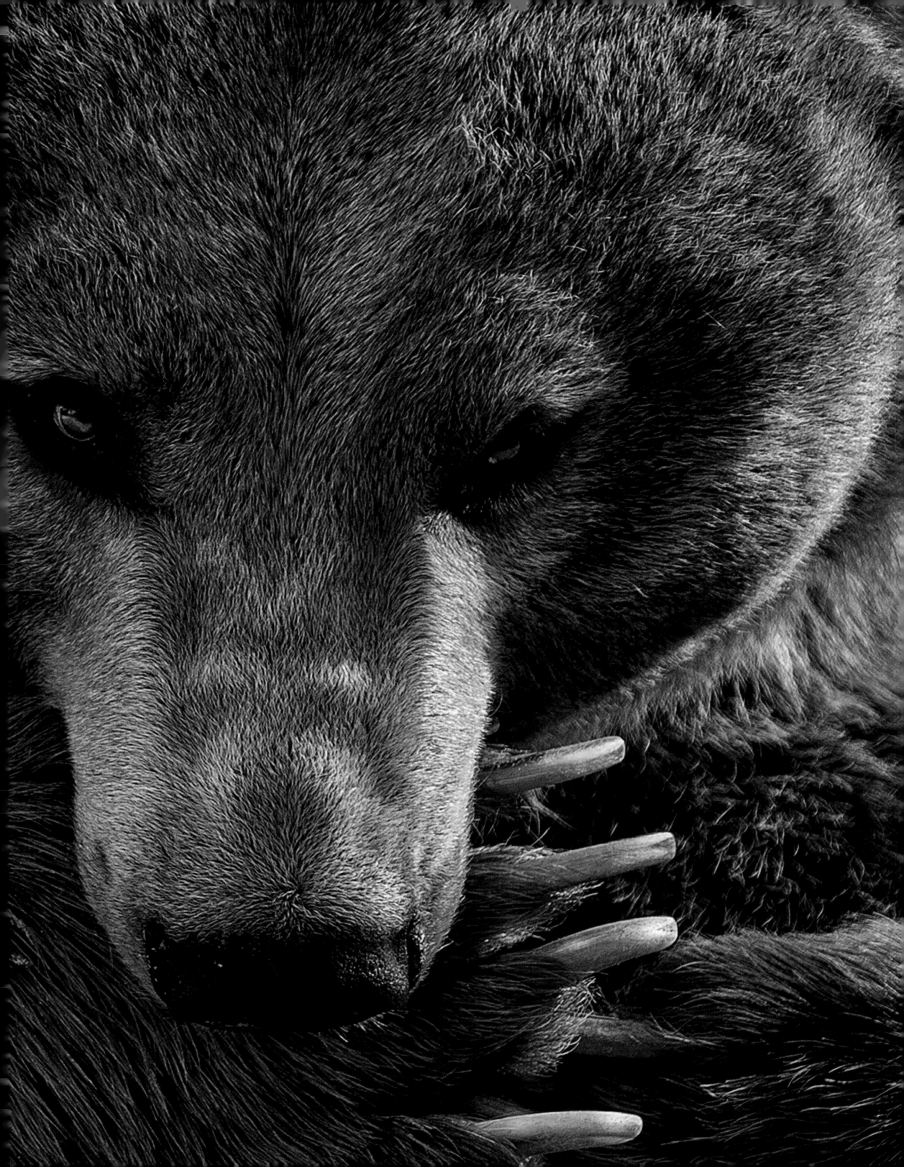

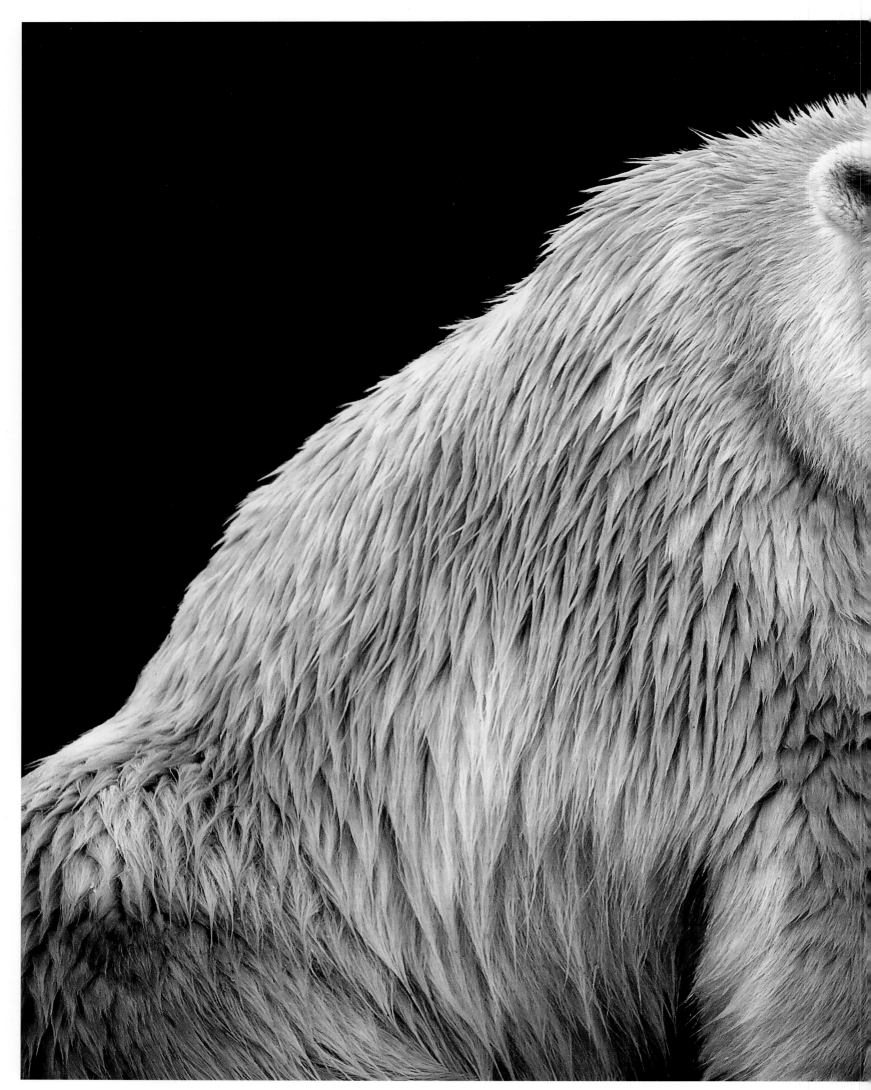

fragile

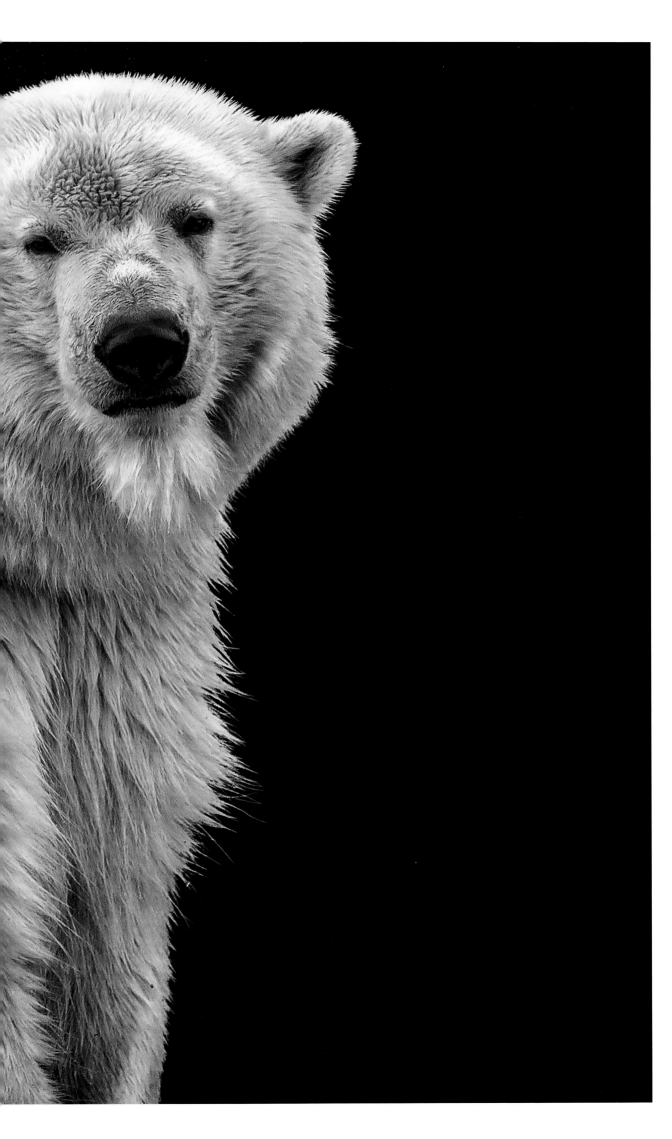

Polar bear
Ursus maritimus, 1774

Polar bears have become the quintessential symbol for climate change. The dramatic decline in its numbers as a result of melting polar ice could drive it to extinction from starvation in the coming decades. There are some 25,000 specimens left in the world, but their preservation depends almost exclusively on the measures taken to halt climate change.

Die Eisbären sind zum Symbol für den Klimawandel schlechthin geworden. Der dramatische Rückgang des Bestands durch das Abschmelzen der Pole kann in den nächsten Jahrzehnten zum Aussterben des größten Landraubtiers durch Nahrungsmangel führen. Es gibt aktuell noch 25 000 Eisbären auf der Welt. Ihr Erhalt hängt fast ausschließlich davon ab, ob es uns gelingt, mit geeigneten Maßnahmen den Klimawandel aufzuhalten.

Los osos polares se han convertido en el símbolo del cambio climático por excelencia. El dramático declive de su población debido al deshielo polar podría llevarlo a su extinción por inanición en las próximas décadas. Hoy quedan unos 25 000 ejemplares en el mundo, pero su conservación depende casi exclusivamente de las medidas que se tomen para frenar el cambio climático.

L'ours blanc est devenu le symbole du changement climatique. La population des ours polaires a enregistré un déclin notoire en raison de la fonte des glaciers qui pourrait conduire à son extinction par la famine dans les décennies à venir. Aujourd'hui, il reste environ 25 000 spécimens dans le monde, mais leur conservation dépend presque exclusivement des mesures qui sont prises pour enrayer le changement climatique.

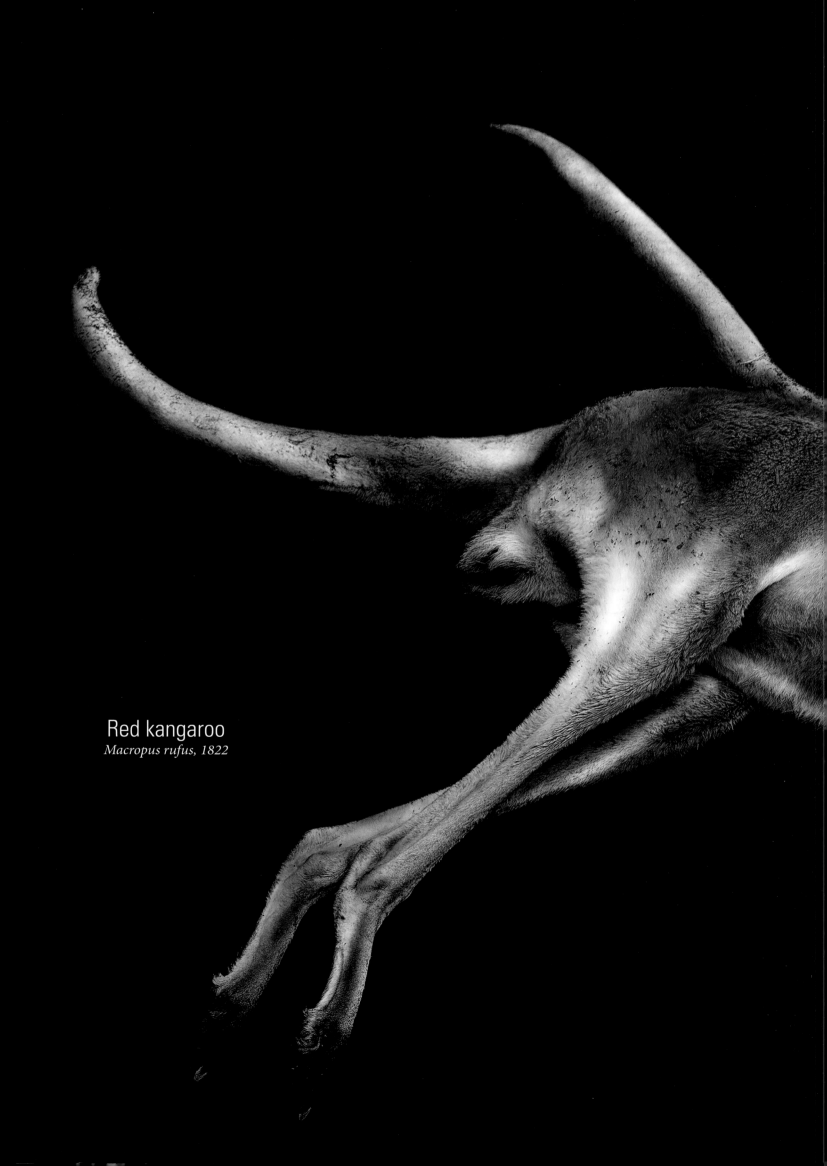

Red kangaroo
Macropus rufus, 1822

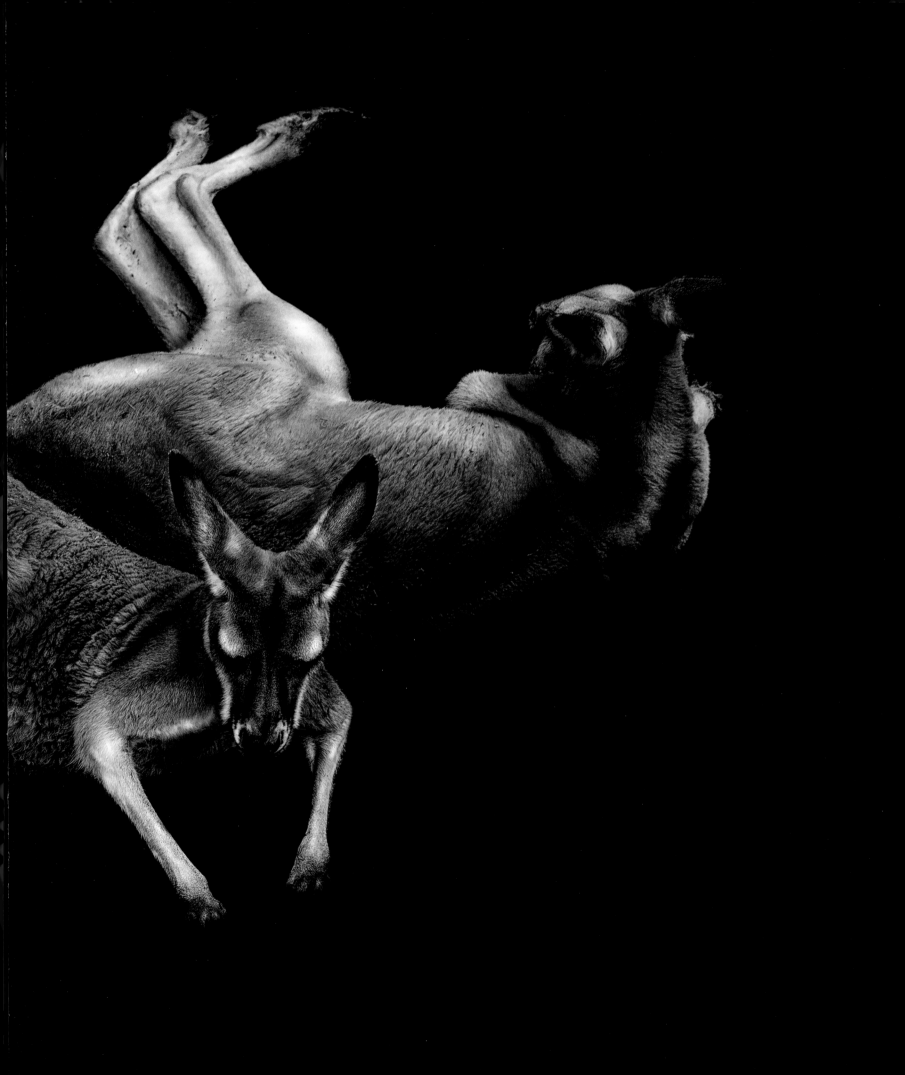

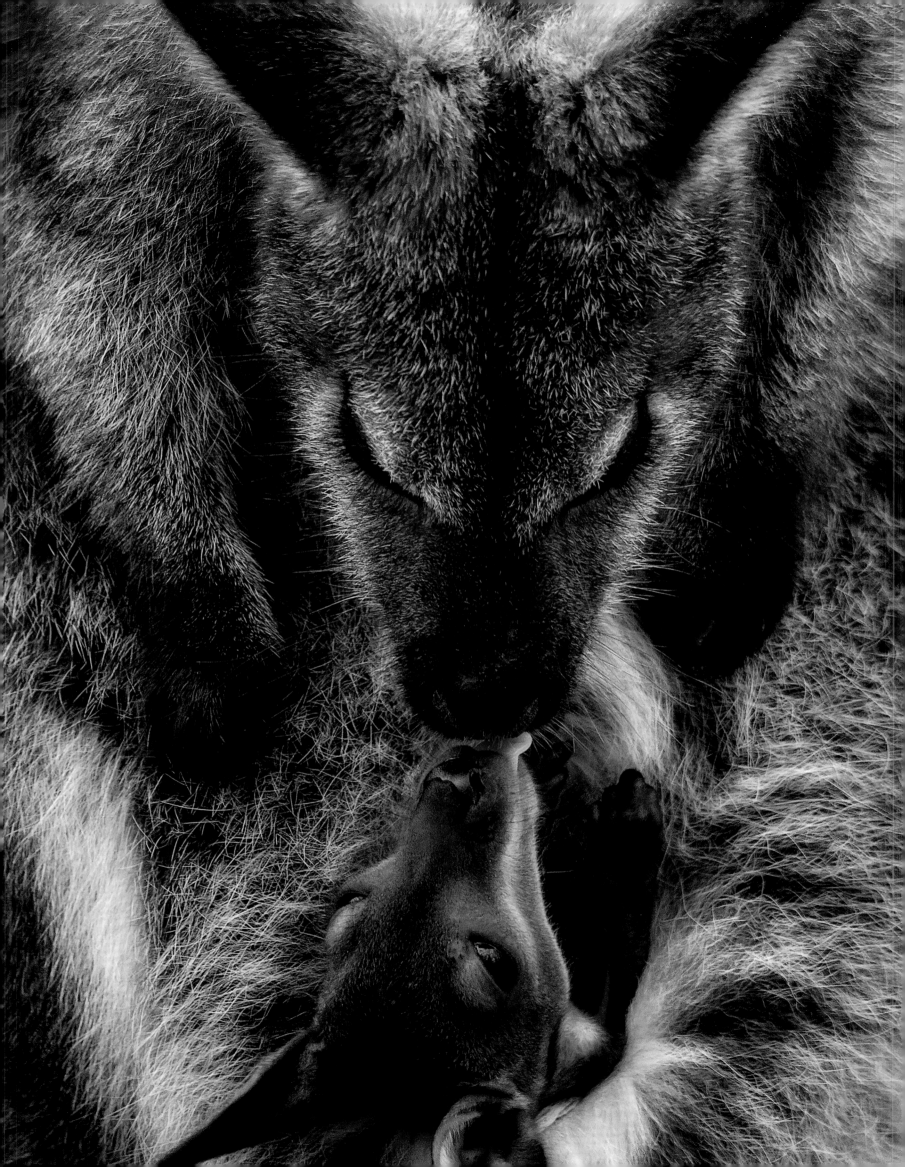

Wallaby

Macropus rufogriseus, 1817

Often mistaken for kangaroos, wallabies are a smaller species of marsupial. They are shy and curious, and like most marsupials, they only give birth to one offspring that is born at a very early stage of development, which will continue to develop inside its mother's pouch. It is born after four weeks of gestation and slowly crawls up towards the pouch following a trail of saliva left by its mother. There it will grow until almost fully developed. Wallabies are clearly able to express their emotions, such as their pain at losing a joey.

Die Wallabys werden gern mit den gewöhnlichen Kängurus verwechselt. Sie gehören zwar ebenfalls zu den Beuteltieren, sind aber kleiner. Sie bekommen nur ein einziges Jungtier, das bereits nach vier Wochen in einem sehr frühen Entwicklungsstadium auf die Welt kommt. Der Winzling kriecht auf einer Speichelspur, die seine Mutter zuvor angelegt hat, von der Geburtsöffnung in den Beutel. Dort wächst er weiter. Wallabys können ihre Empfindungen deutlich zum Ausdruck bringen.

Con frecuencia confundidos con los canguros, los ualabíes son una especie de marsupial más pequeño. Son tímidos y curiosos, y como la mayoría de los marsupiales tienen una sola cría que nace en un estado de desarrollo muy temprano, para terminar su crecimiento en el interior de la bolsa marsupial. A las cuatro semanas de gestación nacen y siguen lentamente un camino de saliva que la madre deja hasta la bolsa. Allí completarán la mayor parte de su desarrollo. Son capaces de manifestar sus emociones de manera explícita, como por ejemplo el dolor de perder a una cría.

Souvent confondus avec les kangourous, les wallabies sont une espèce de petits marsupiaux. Ces animaux timides et curieux n'ont qu'un petit qui naît à un stade de développement très précoce, pour terminer sa croissance à l'intérieur de la poche marsupiale. À quatre semaines de gestation, le petit naît et rejoint lentement la poche grâce à un chemin de salive laissé par la mère. C'est là qu'il achèvera la majeure partie de sa croissance. Les wallabies sont capables d'exprimer leurs émotions, comme la douleur de perdre un petit.

Meerkat
Suricata suricatta, 1776

Meerkats live in "mobs" comprising about 40 individuals, and they have clearly defined roles in the group. There are meerkat sentries responsible for alerting the rest of the mob to danger, and lookouts keep watch while standing on their rear legs. They emit different sounds for different predators and are immune to many toxins, which even allows them to eat scorpions.

Erdmännchen verbringen ihr Leben in Kolonien von etwa 40 Tieren. Es gibt eine klare Aufgabenteilung: Wachposten spähen nach Feinden aus, während andere, auf den Hinterbeinen sitzend, die Eingänge des Baus beaufsichtigen. Die Wächter warnen mit unterschiedlichen Lauten vor den verschiedenen Feinden. Gifte schrecken Erdmännchen nicht ab – sie fressen sogar Skorpione.

Los suricatos viven en manadas de unos cuarenta individuos y su función en el grupo está claramente definida. Hay suricatos centinela que se encargan de avisar al resto de la manada sobre algún peligro, y vigías que se ocupan de vigilar el entorno erguidos sobre sus patas. Emiten diferentes sonidos para distintos depredadores y son resistentes a muchos venenos pudiendo alimentarse incluso de escorpiones.

Les suricates vivent en troupeaux d'une quarantaine d'individus au sein desquels le rôle de chacun est clairement défini. Les sentinelles sont chargées d'avertir le reste du groupe de tout danger, et les gardiens se dressent sur leurs pattes arrière pour surveiller les alentours. Ils émettent des sons différents pour identifier les prédateurs, résistent à de nombreux poisons et peuvent même se nourrir de scorpions.

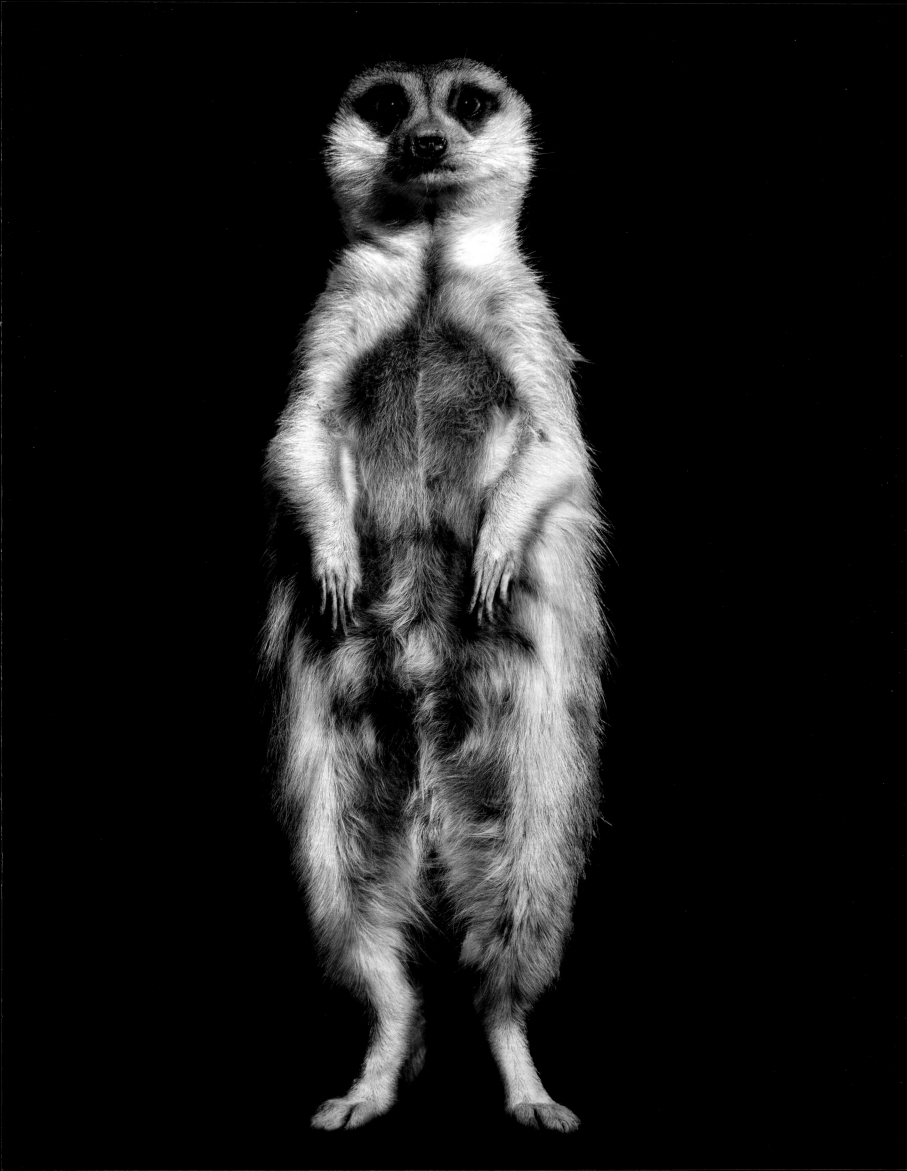

Lemur

Lemuroidea, 1821

The name lemur is derived from the Latin plural *lemures* meaning nocturnal specters or ghosts, in reference to the lemur's red eyes that glow in the dark, nocturnal habits, and the sounds it makes. The lemurs of Madagascar live in matriarchal societies where the females dominate the group and their place in the hierarchy is handed down from mothers to daughters. Since the arrival of man on the island, their habitat has gradually shrunk, and although they are found in many zoos given the ease with which they reproduce in captivity, lemurs are now endangered.

Der Name Lemur leitet sich vom lateinischen *lemures* ab, womit die Schattengeister der Verstorbenen bezeichnet wurden. Dieser Name ist wohl auf die rot glänzenden Augen, die nächtliche Lebensweise und die Laute zurückzuführen, die die Tiere ausstoßen. Die Lemuren von Madagaskar leben in matriarchalischen Gesellschaften, in denen die Weibchen die Herrschaft innehaben. Die Stellung in der Hierarchie wird von den Müttern an die Töchter weitergegeben. Seit der Mensch die Insel betreten hat, wurden ihre Lebensräume immer kleiner – und so sind auch die Lemuren vom Aussterben bedroht.

El nombre del lémur proviene del plural latino *lemures*, que se refería a los fantasmas o espectros nocturnos, debido a sus ojos rojos que brillan en la oscuridad, sus hábitos nocturnos y los ruidos que emiten. Los lémures de Madagascar viven en sociedades matriarcales donde las hembras ejercen el dominio del grupo y cuya jerarquía se transmite de madres a hijas. Desde la llegada del hombre a la isla, sus hábitats se han reducido y, aunque se encuentran en muchos zoológicos dada su facilidad de reproducción en cautividad, el lémur también está hoy en día en peligro de extinción.

Le nom du lémurien vient du pluriel du mot latin, *lemures* ou fantômes nocturnes en raison de leurs yeux rouges qui brillent dans le noir, de leur rythme de vie et des bruits qu'ils émettent. Les lémuriens de Madagascar vivent dans des sociétés matriarcales où les femmes sont à la tête du groupe et dont la hiérarchie se transmet de mère en fille. Depuis l'arrivée de l'homme sur l'île, leur habitat a été réduit et, bien qu'on le trouve dans de nombreux zoos en raison de sa facilité de reproduction en captivité, le lémurien est maintenant également menacé d'extinction.

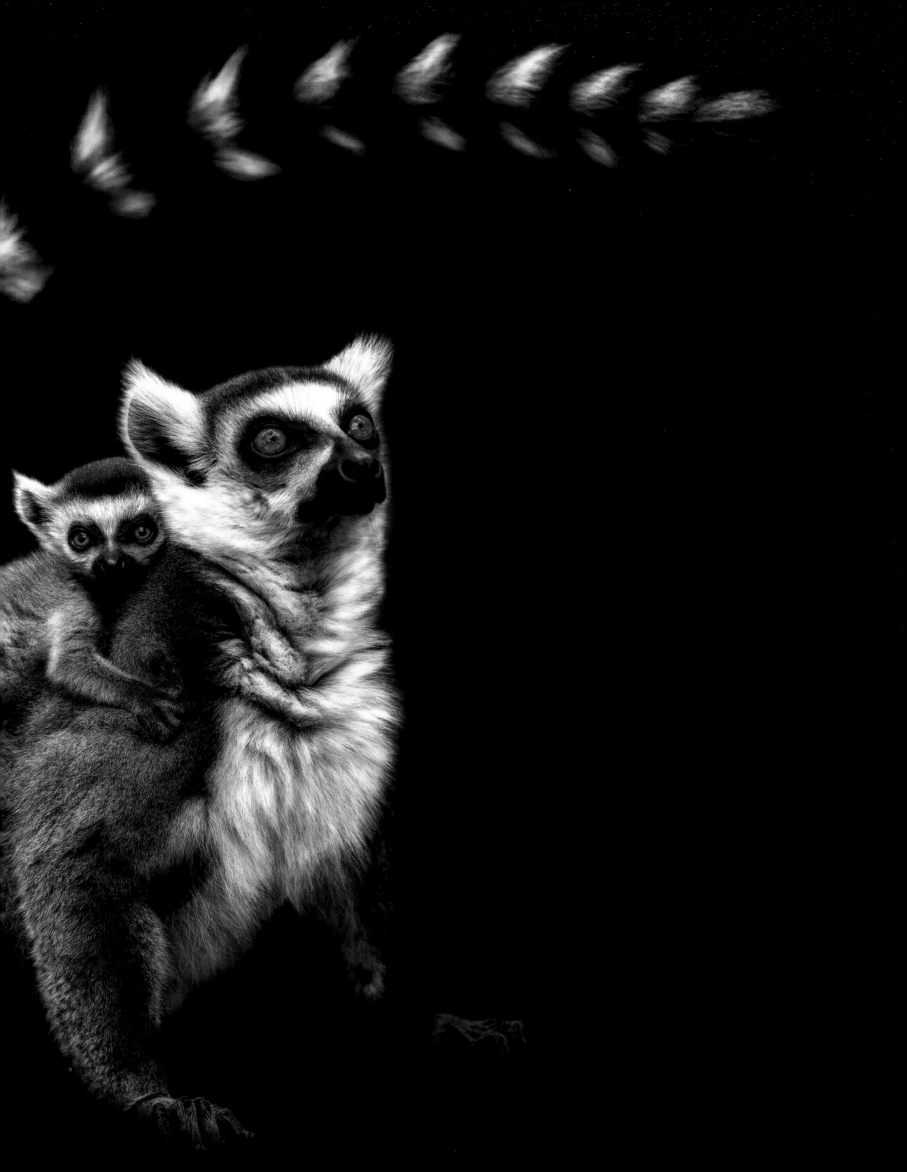

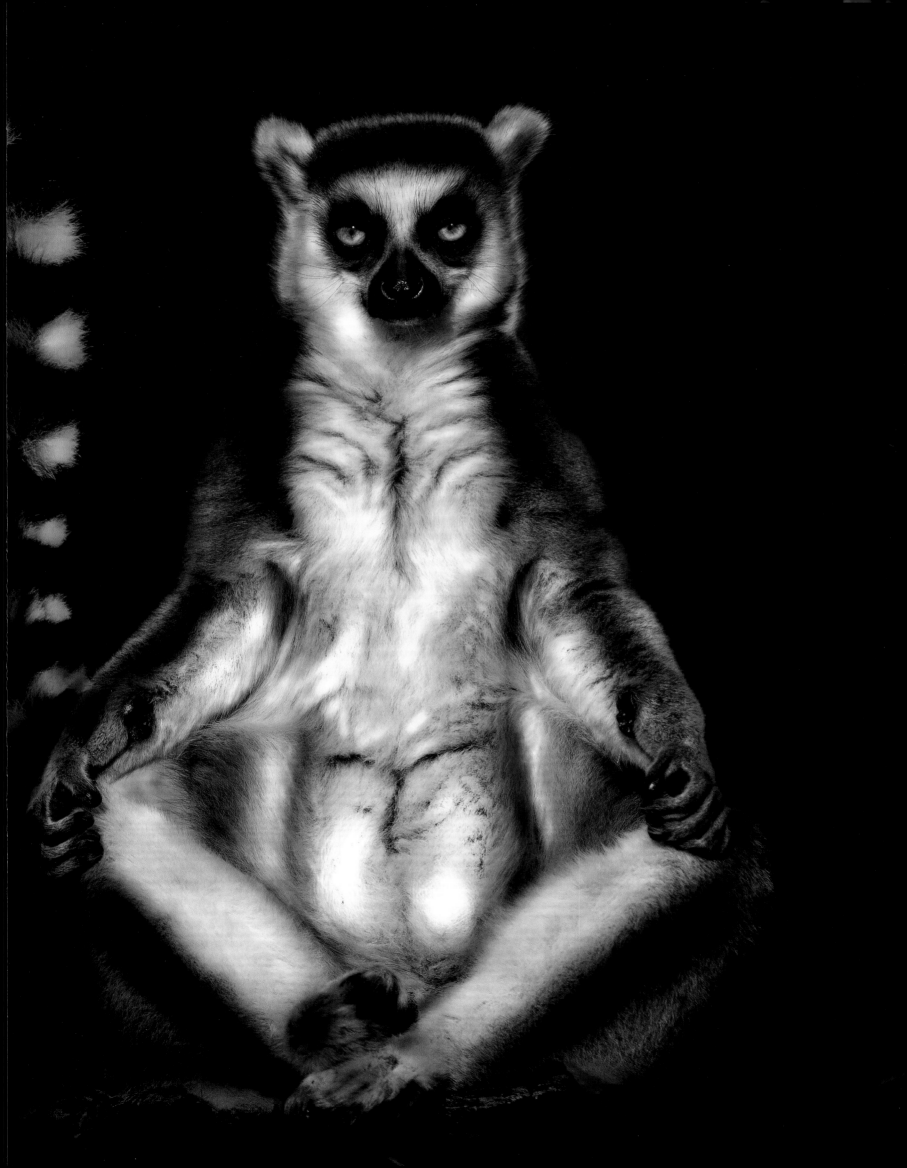

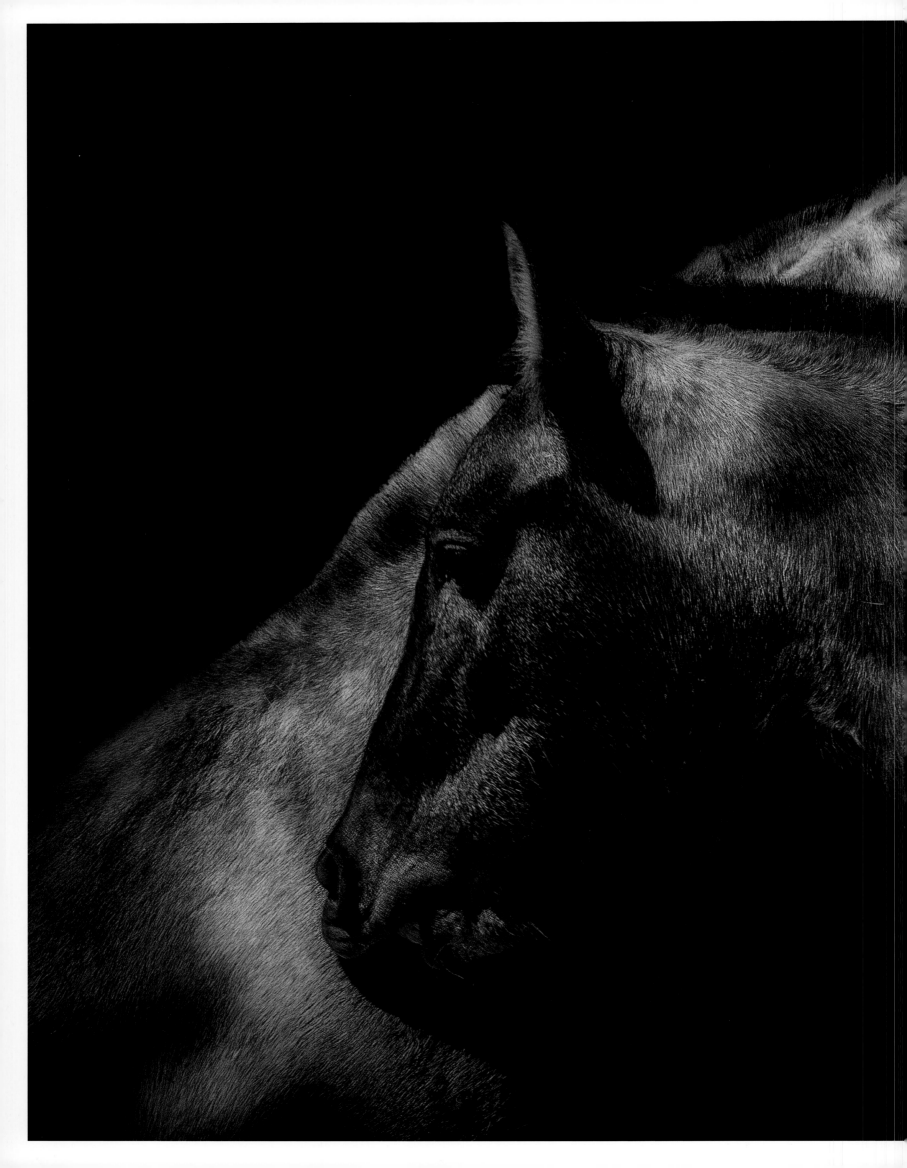

Horse
Equus caballus, 1758

Since its domestication some 5,000 years ago, the horse has played an important part in human history and contributed profoundly to human development. The horse has been used as a draft animal, as a means of transport, as a source of meat, as a work horse, and as a war horse. The first ever animal protection legislation was passed in 1635 against abuse and cruelty to horses.

Seit seiner Domestizierung vor 5000 Jahren hat das Pferd den Menschen über die Geschichte hinweg begleitet und entscheidend zu seiner Entwicklung beigetragen. Pferde dienten als Lasttiere und Transportmittel, als Fleischlieferant, für die Arbeit auf dem Feld und an der Front. Die ersten Gesetze gegen den Missbrauch und die Misshandlung von Pferden wurden im Jahr 1635 erlassen.

Desde su domesticación hace unos 5000 años el caballo ha acompañado al hombre a lo largo de su historia, contribuyendo de manera radical a su evolución. Se han usado tanto para la carga y el transporte, como para el consumo de carne o el trabajo en el campo y la guerra. Las primeras leyes de protección de los animales se promulgaron en 1635 en contra de los abusos y la crueldad hacia los caballos.

Depuis sa domestication il y a environ 5 000 ans, le cheval a accompagné l'homme tout au long de son histoire, contribuant à son évolution. Il a été utilisé aussi bien pour le transport de fret que le transport de passager, pour sa viande, pour l'agriculture ou comme monture de guerre. Les premières lois sur la protection des animaux ont été promulguées en 1635 pour endiguer les abus et les actes de cruauté envers les chevaux.

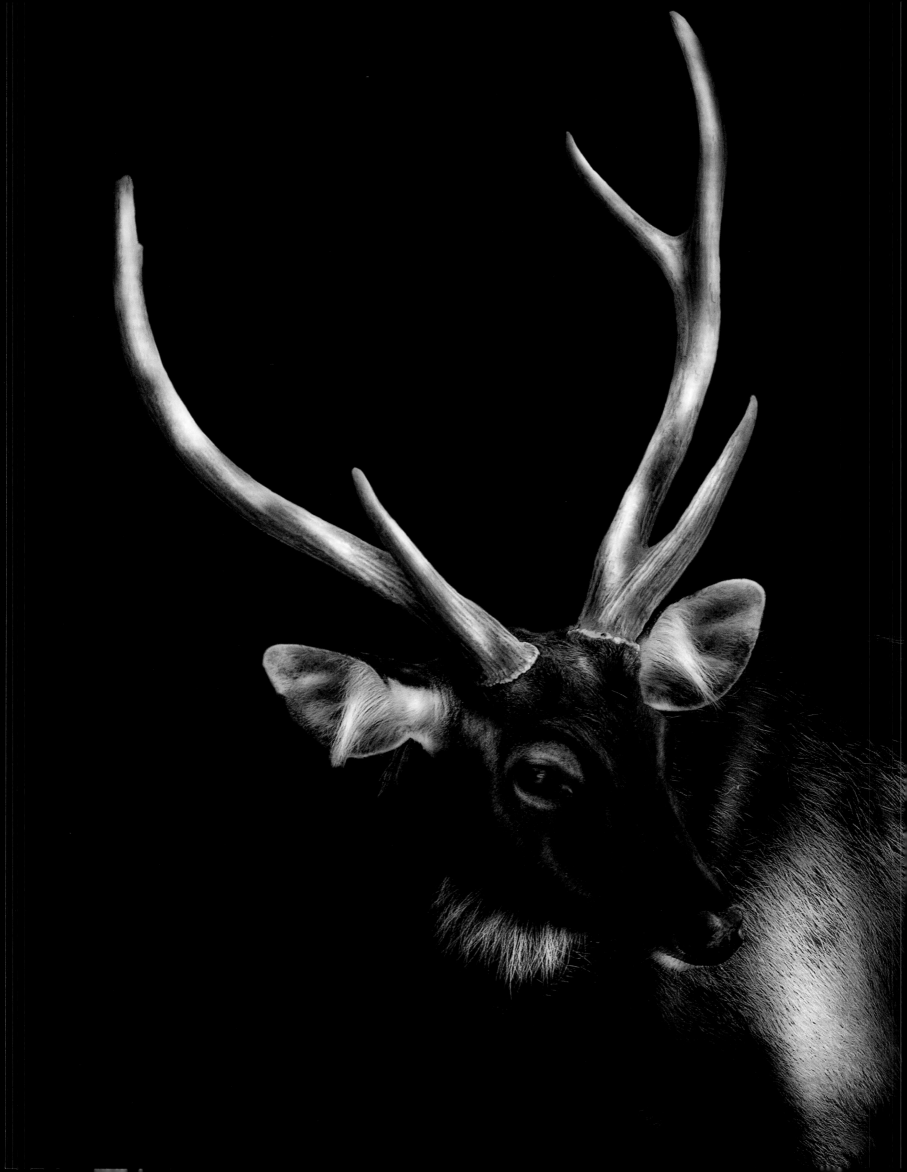

Hunting for food is an essential part of the life of many animals that allows them to survive. Primitive humans also had this need when they lived in small groups. Certain tribes would even beg the animals' forgiveness before killing them. Today, however, hunting is mainly considered a sport, and its consequences on ecosystems are more evident than ever in many cases, particularly on protected species, as a result of poaching or illegal hunting, or so-called "canned hunting," which is a source of controversy for ethical reasons.

Cazar para alimentarse es parte indispensable en la vida de muchos animales para su supervivencia. Y el ser humano primitivo no estaba exento de esta necesidad cuando vivía en pequeños grupos. En ciertas tribus pedían perdón al animal cazado, hoy en día, sin embargo, la caza se realiza sobre todo por deporte y en muchos casos sus consecuencias sobre el ecosistema son más evidentes que nunca, especialmente en especies protegidas, debido a la caza furtiva e ilegal, o a las llamadas «cacerías de encierro» que generan gran polémica por cuestiones éticas.

Jagen, um Beute zu machen, ist für viele Tiere überlebenswichtig. Auch die Urmenschen waren noch dazu gezwungen, als sie in kleinen Gruppen zusammenlebten. Bei manchen Völkern wurde das erlegte Tier sogar um Verzeihung gebeten. Heute hingegen wird die Jagd hauptsächlich als Sport betrieben. Vielfach hat dies eklatante Folgen für das Ökosystem, vor allem bei den geschützten Arten. Besonders groß ist die Zerstörung durch Wilderei und illegale Jagd. Aus ethischen Gründen kontrovers diskutiert werden die sogenannten *canned hunts,* für die Tiere extra gezüchtet werden.

La chasse pour se nourrir est indispensable à la vie de nombreux animaux. L'homme primitif y participait lui aussi par nécessité lorsqu'il vivait en petits groupes. Dans certaines tribus, on demandait pardon à l'animal chassé, mais de nos jours, la chasse est surtout un sport. Ses conséquences sur l'écosystème sont plus évidentes que jamais, surtout pour les espèces protégées, en raison du braconnage et de la chasse dite « en boîte », qui suscite une polémique et est éthiquement très discutable.

Red deer
Cervus elaphus, 1758

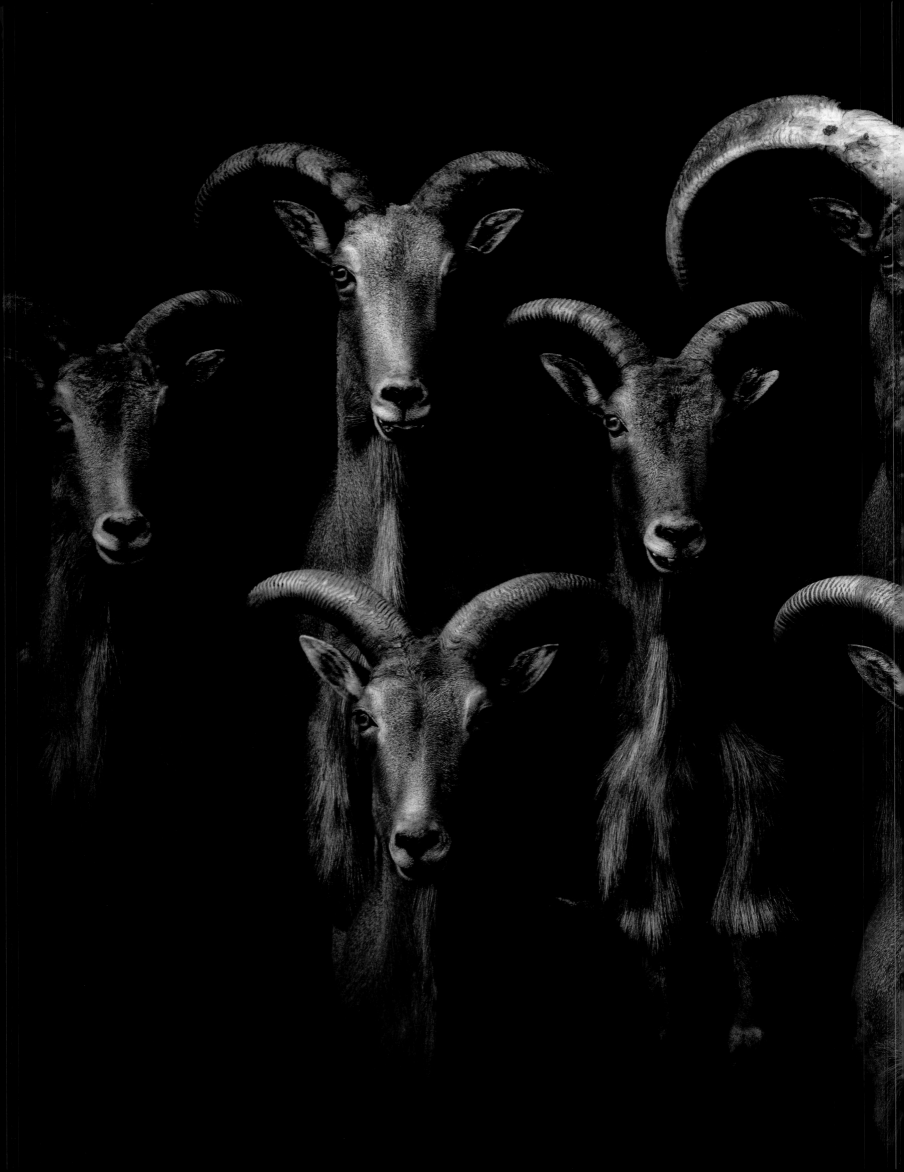

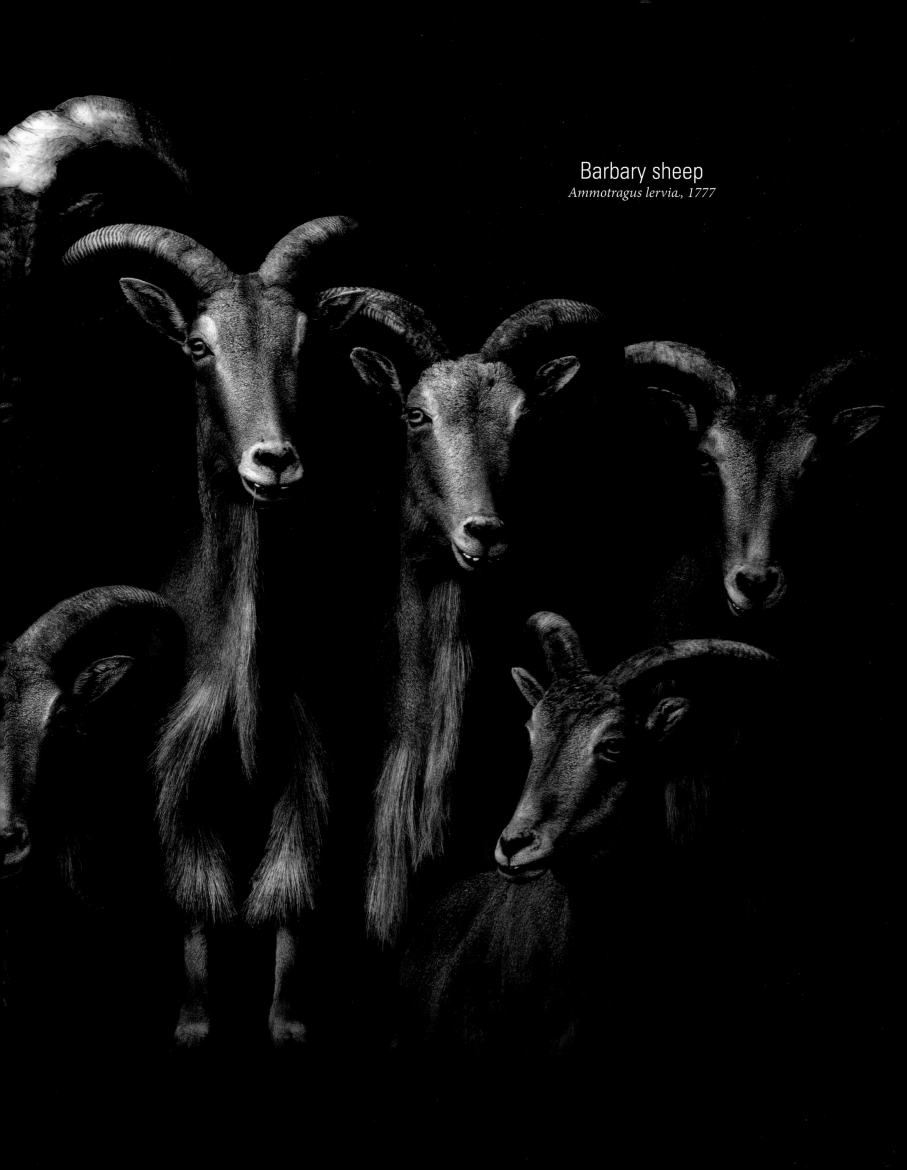

Barbary sheep
Ammotragus lervia, 1777

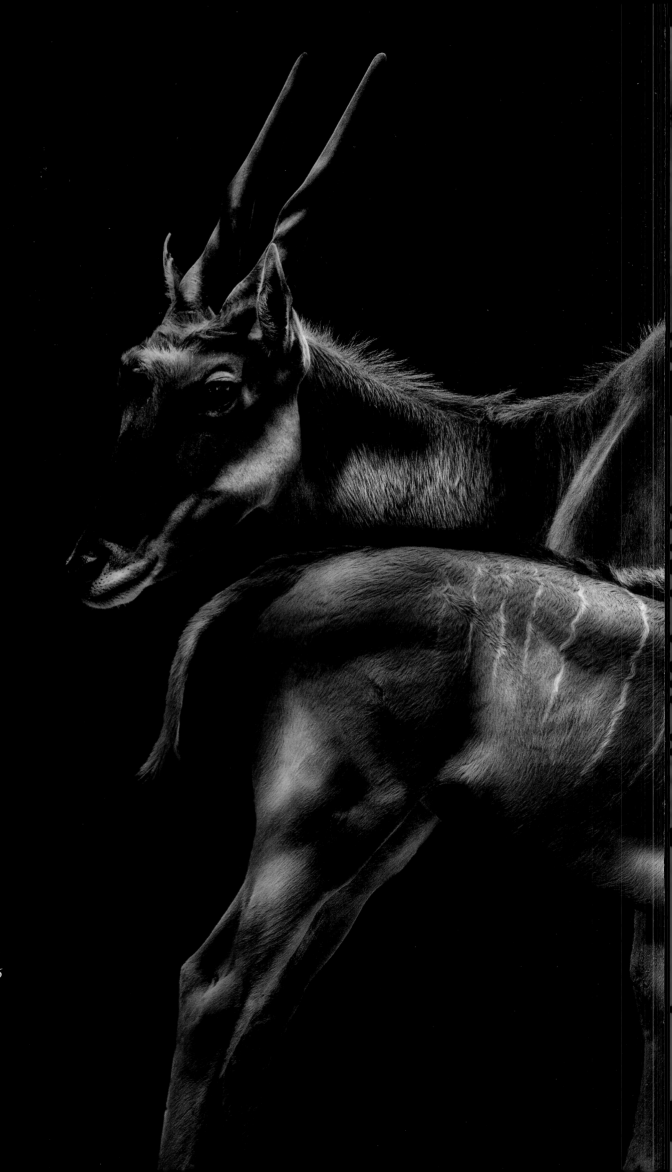

Common eland
Taurotragus oryx, 1766

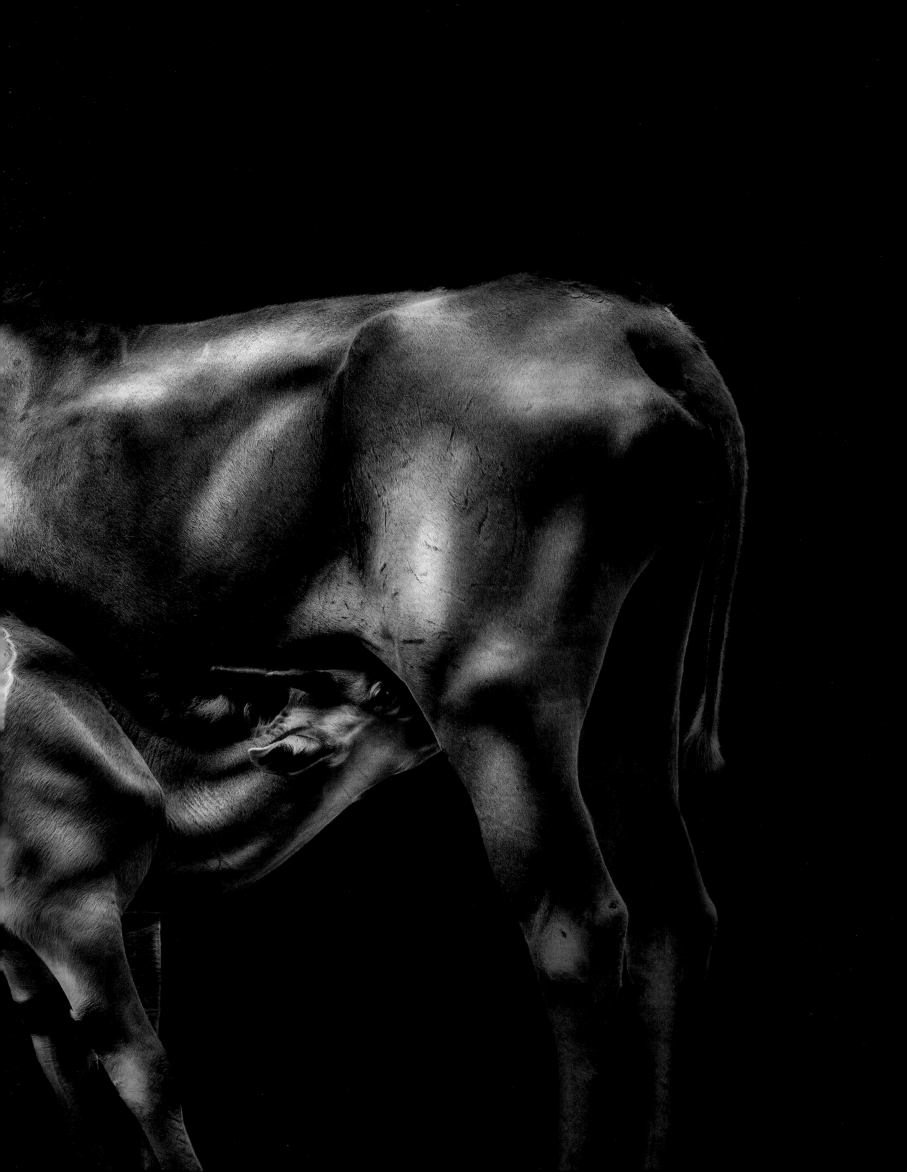

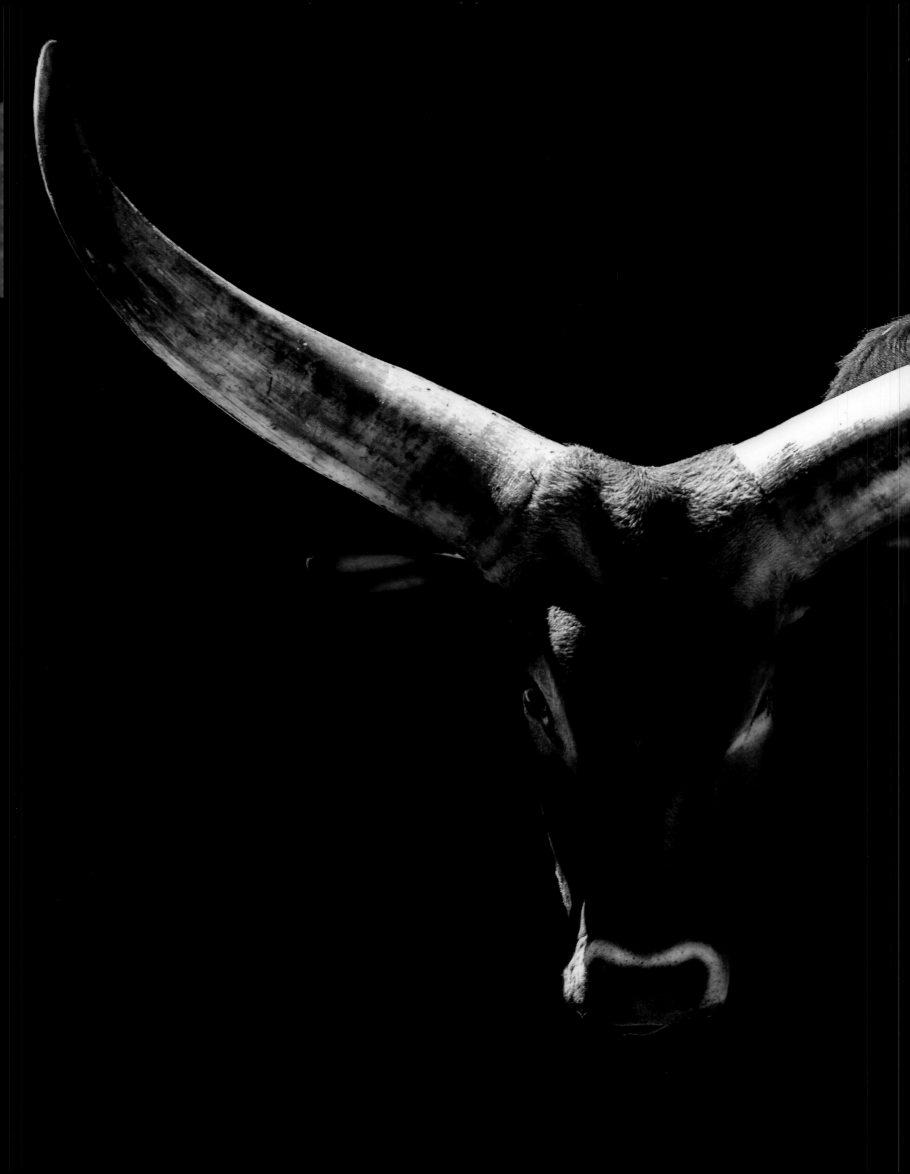

Ankole-Watusi
Bos taurus, 1758

Ankole-Watusi is an African breed of cattle characterized by their long horns, compared to those of European breeds that have been unable to adapt to the African climate. They are considered sacred animals, and their very low productivity has meant they have largely escaped intensive commercial exploitation. They are mainly ornamental animals and are often exhibited in zoos.

Das Watussirind, eine Hausrindrasse Ostafrikas, fällt durch seine überdimensionalen Hörner auf – besonders im Vergleich zu europäischen Rindern, die im afrikanischen Klima nicht heimisch werden konnten. Watussirinder gelten als heilig. Da sie nicht für die Fleischgewinnung gezüchtet werden, sind sie von der kommerziellen Ausbeutung verschont geblieben. Sie dienen als Kult- und Statusobjekt und werden in Zoos ausgestellt.

El watusi, raza bovina del continente africano, se caracteriza por su cornamenta de gran tamaño, comparada con la de otros bóvidos europeos que no han logrado adaptarse al clima africano. Se le considera un animal sagrado y su escasa productividad ha evitado su explotación comercial intensiva. Su uso ha sido sobre todo ornamental y de exhibición en zoológicos.

Le watusi est une race bovine du continent africain. Elle se caractérise par ses cornes démesurées par rapport aux autres bovins européens qui n'ont pas réussi à s'adapter au climat africain. Il est considéré comme sacré et sa productivité limitée a empêché son exploitation commerciale intensive. Son utilisation a été principalement ornementale et éducative dans les zoos.

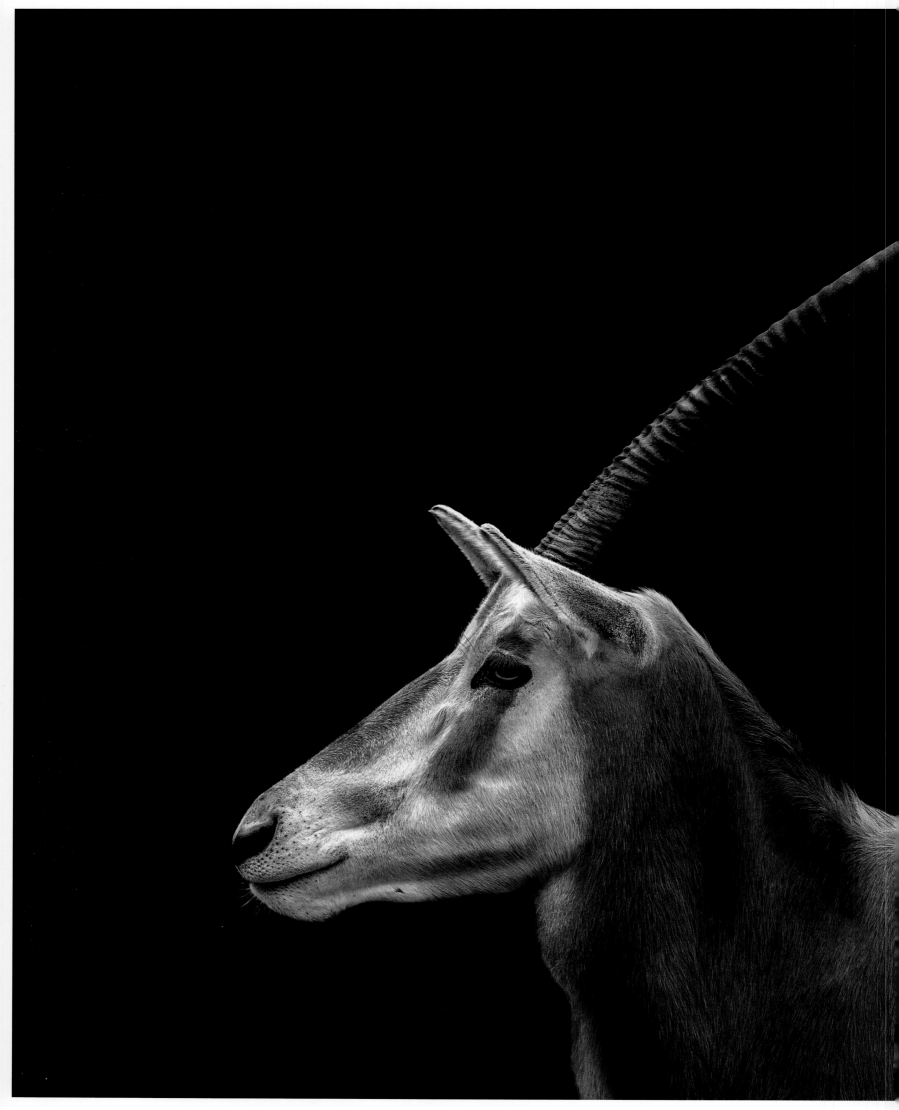

fragile

Scimitar oryx
Oryx dammah, 1827

The oryx dammah or scimitar-horned oryx is an African antelope that was declared to be officially extinct in the wild in 2008 as a result of overhunting for their horns. The only specimens still left are in captivity and in zoos. Current efforts are underway to reintroduce the species into protected areas and increase its numbers.

Die einst in der Sahara beheimatete Säbelantilope mit den nach hinten gebogenen Hörnern gilt seit 2008 offiziell als in der Natur ausgerottet. Grund ist die exzessive Jagd auf die Tiere, um an ihre Hörner zu gelangen. Die einzigen noch erhaltenen Exemplare leben in Gefangenschaft und Zoos. Aktuell gibt es Bestrebungen, die Säbelantilope in geschützten Gebieten wieder auszuwildern.

El oryx de cuernos de cimitarra es un antílope africano que fue declarado oficialmente extinto en estado salvaje en 2008 debido a su caza excesiva para obtener su cornamenta. Los únicos ejemplares que se conservan se encuentran en cautividad y en parques zoológicos. Actualmente se están realizando intentos para reintroducir y repoblar esta especie en zonas protegidas.

L'oryx algazelle est une antilope d'Afrique qui a été officiellement déclarée « espèce éteinte à l'état sauvage » en 2008 en raison d'une chasse excessive pour ses magnifiques cornes. Les seuls spécimens se trouvent en captivité et dans les parcs zoologiques. Des programmes ont été mis en place pour réintroduire cette espèce dans des régions protégées et favoriser leur reproduction.

European bison
Bison bonasus, 1758

European bison became extinct in the wild after the First World War, killed for their meat. Thanks to the existence of 54 specimens in different zoos, a "resurrection" of the species could be undertaken, but only using four males and three females. The little genetic diversity and problems caused by inbreeding continue to threaten the European bison with its definitive extinction.

Der Wisent ist in freier Natur bereits nach dem Ersten Weltkrieg ausgestorben, da man sich von seinem Fleisch ernährte. Zum Glück hatten in einigen Zoos noch 54 Exemplare überlebt, und so konnte man die Art »wiederauferstehen« lassen. Allerdings gehen diese Nachkommen auf nur vier Männchen und drei Weibchen zurück. Die niedrige genetische Variabilität und die Inzucht stellen daher weiterhin eine große Gefahr für den langfristigen Erhalt der Art dar.

Los bisontes europeos se extinguieron en estado salvaje tras la Primera Guerra Mundial debido al consumo de su carne. Gracias a la existencia de 54 ejemplares en diversos zoológicos se pudo llevar a cabo una «resurrección» de la especie, pero solo se utilizaron cuatro machos y tres hembras. La poca diversidad genética y los problemas de endogamia siguen amenazando con su extinción definitiva.

Le bison d'Europe s'est éteint à l'état sauvage après la Première Guerre mondiale, car il était recherché pour sa viande. Grâce à 54 spécimens présents dans plusieurs zoos, l'espèce a été sauvée de la disparition, mais seulement quatre mâles et trois femelles ont été utilisés. La faible diversité génétique et les problèmes de consanguinité risquent cependant de provoquer leur extinction définitive.

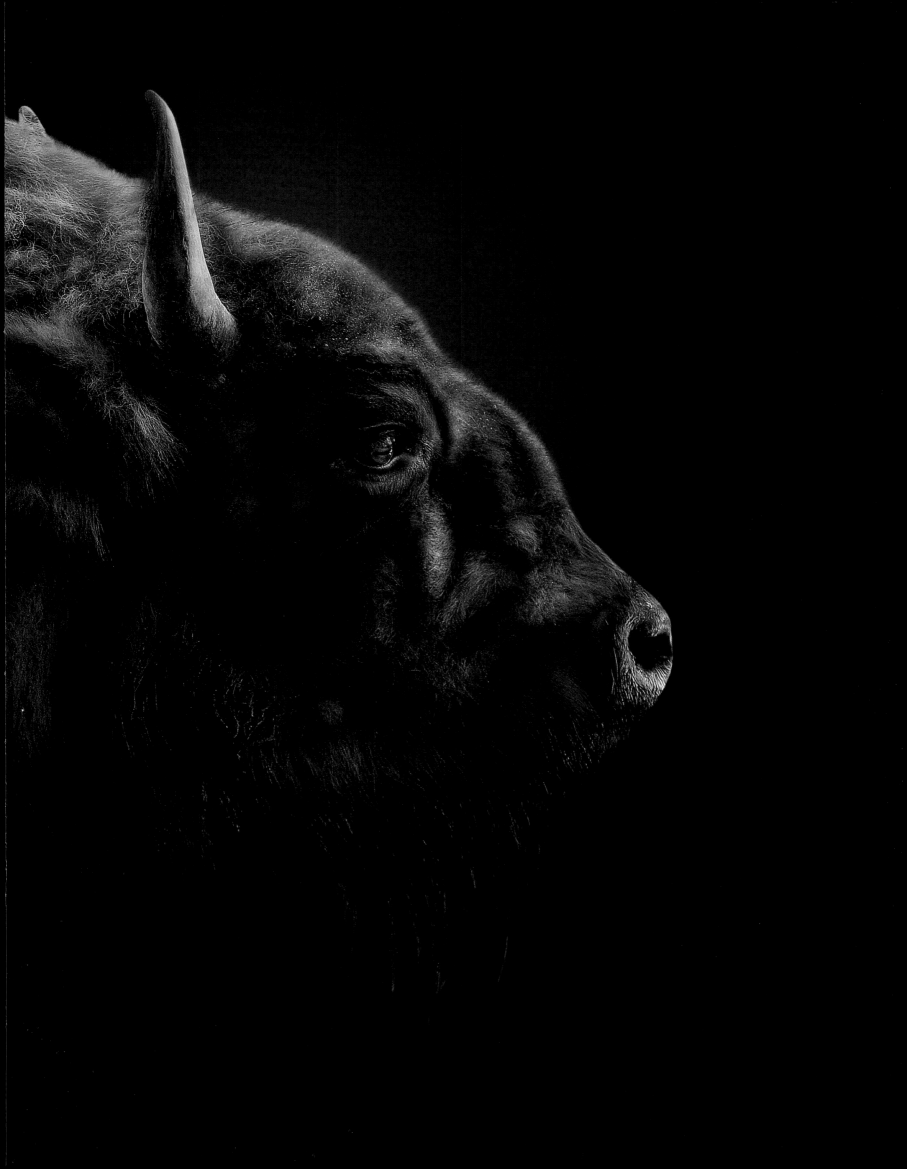

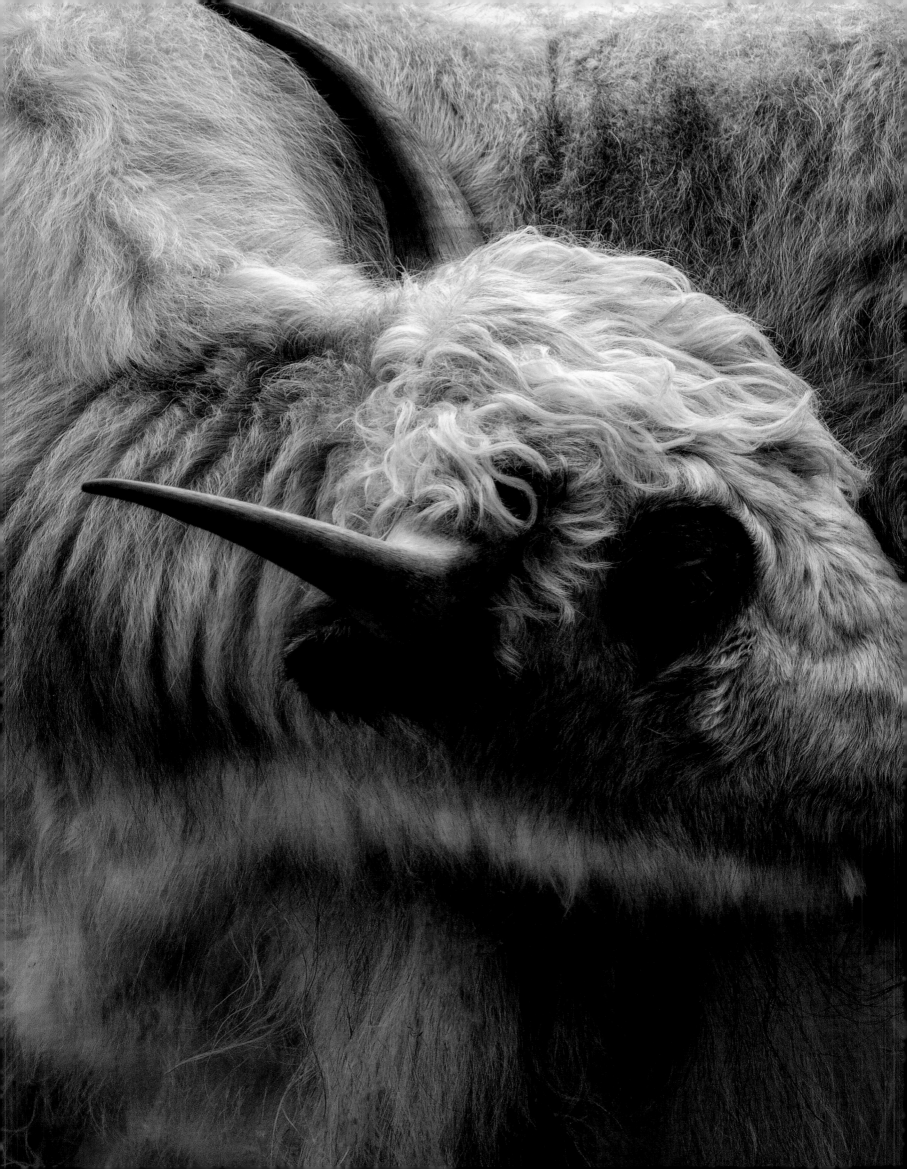

Domestic yak
Bos grunniens, 1883

A faithful friend to the inhabitants of the remote regions of the Himalayas, the domestic yak is an animal that coexists well with humans owing to its great usefulness, and because use is made of the entire animal—meat, horns, coat, and even their droppings, used as fuel. However, increasingly fewer yak are found in the wild as a result of overhunting for human consumption.

Der Yak ist der große Verbündete der Menschen, die in abgelegenen Gebieten des Himalaya leben. Er leistet dem Menschen gute Dienste, weil er sich als Last- und Reittier nutzen lässt sowie Fleisch, Horn, Leder und mit seinem Kot sogar noch Brennmaterial liefert. Doch in der freien Natur sind aufgrund der exzessiven Jagd nur noch wenige Exemplare vorhanden.

Gran aliado de las poblaciones que habitan zonas remotas del Himalaya, el yak doméstico es un animal que se compenetra bien con el ser humano debido a su gran utilidad para el trabajo y porque se aprovecha en su totalidad: carne, cuernos, pelaje e incluso excrementos, empleados como combustible. Sin embargo, en estado salvaje quedan menos ejemplares debido a la caza excesiva destinada al consumo.

Fidèles compagnons des habitants des régions reculées de l'Himalaya, le yack domestique est un animal qui cohabite très bien avec l'homme. Particulièrement utile comme bête de somme, on utilise sa viande, ses cornes, sa laine et même ses excréments comme carburant. Cependant, à l'état sauvage, il reste peu de spécimens en raison d'une chasse excessive.

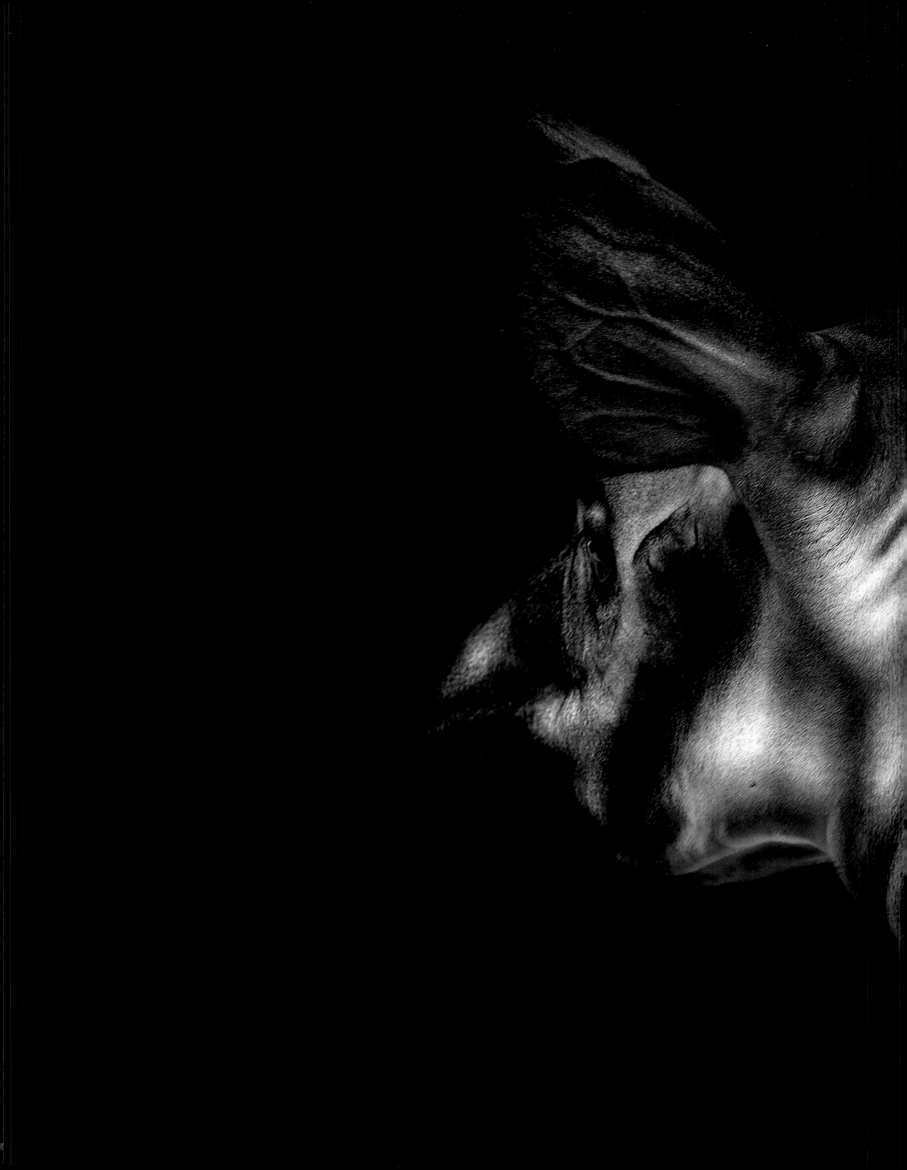

Okapi

Okapia johnstoni, 1901

The okapi or forest giraffe, undiscovered
before the twentieth century, is severely threatened with
extinction. Its numbers have been diminished by
poaching and habitat loss.

Das Okapi, auch Waldgiraffe genannt, wurde
erst im 20. Jahrhundert entdeckt und gilt als stark gefährdet.
Der Bestand wurde durch Wilderei und Zerstückelung
des Lebensraums dezimiert.

El okapi, o jirafa del bosque, un animal desconocido
antes del siglo xx, se encuentra en grave peligro de
extinción. Su población se ha visto reducida por la caza
furtiva y la reducción de su hábitat.

L'okapi, ou girafe des forêts, était
inconnu avant le xxe siècle. Cet animal est aujourd'hui
en danger d'extinction critique en raison du braconnage
et de la réduction de son habitat.

Giraffe

Giraffa camelopardalis
1762

Giraffes, very popular and loved animals owing to their peculiar features, are also a species under threat and have officially been declared vulnerable. Their numbers have fallen by 40 percent over the last 30 years. Deforestation, habitat loss due to farming and mining, armed conflicts, and sport hunting are largely responsible for the decline of this iconic species. Added to this is gross human ignorance, given that smoke from burning giraffe skin is considered to have healing properties for certain ailments.

Die Giraffen, allseits bekannt und beliebt wegen ihres grazilen Körperbaus, zählen inzwischen ebenfalls zu den bedrohten Arten. Sie sind offiziell als gefährdet eingestuft. Ihr Bestand ist in den letzten 30 Jahren um 40 Prozent zurückgegangen. Die Abholzung der Wälder, der Verlust des Lebensraums durch Bergbau und Landwirtschaft, die bewaffneten Konflikte und der Jagdsport sind die Hauptgründe für die Dezimierung dieser Tiere. Hinzu kommt noch der nicht auszumerzende Irrglaube, dass sich durch die Verbrennung ihres Fells Krankheiten heilen lassen.

Las jirafas, animales muy populares y queridos por sus particulares características, también son ahora una especie amenazada y oficialmente declarada como vulnerable. Su población se ha reducido en un 40 % en los últimos treinta años. La deforestación, la pérdida de su hábitat por la agricultura y la minería, los conflictos armados y la caza deportiva son las principales razones del declive de esta especie emblemática. A esto se suma la sempiterna ignorancia humana, pues a los humos de la quema de sus pieles se les atribuyen propiedades curativas para el tratamiento de enfermedades.

Les girafes sont des animaux très populaires et très appréciés. Elles apparaissent aujourd'hui également sur la liste des espèces menacées et sont officiellement déclarées vulnérables. Sa population a diminué de 40 % au cours des trois dernières décennies. La déforestation, la perte d'habitat par l'agriculture et l'exploitation minière, les conflits armés et la chasse sportive sont les principales causes du déclin de cette espèce emblématique. À cela s'ajoute l'éternelle ignorance humaine : on attribue à tort des vertus curatives aux fumées issues de la combustion de leur peau.

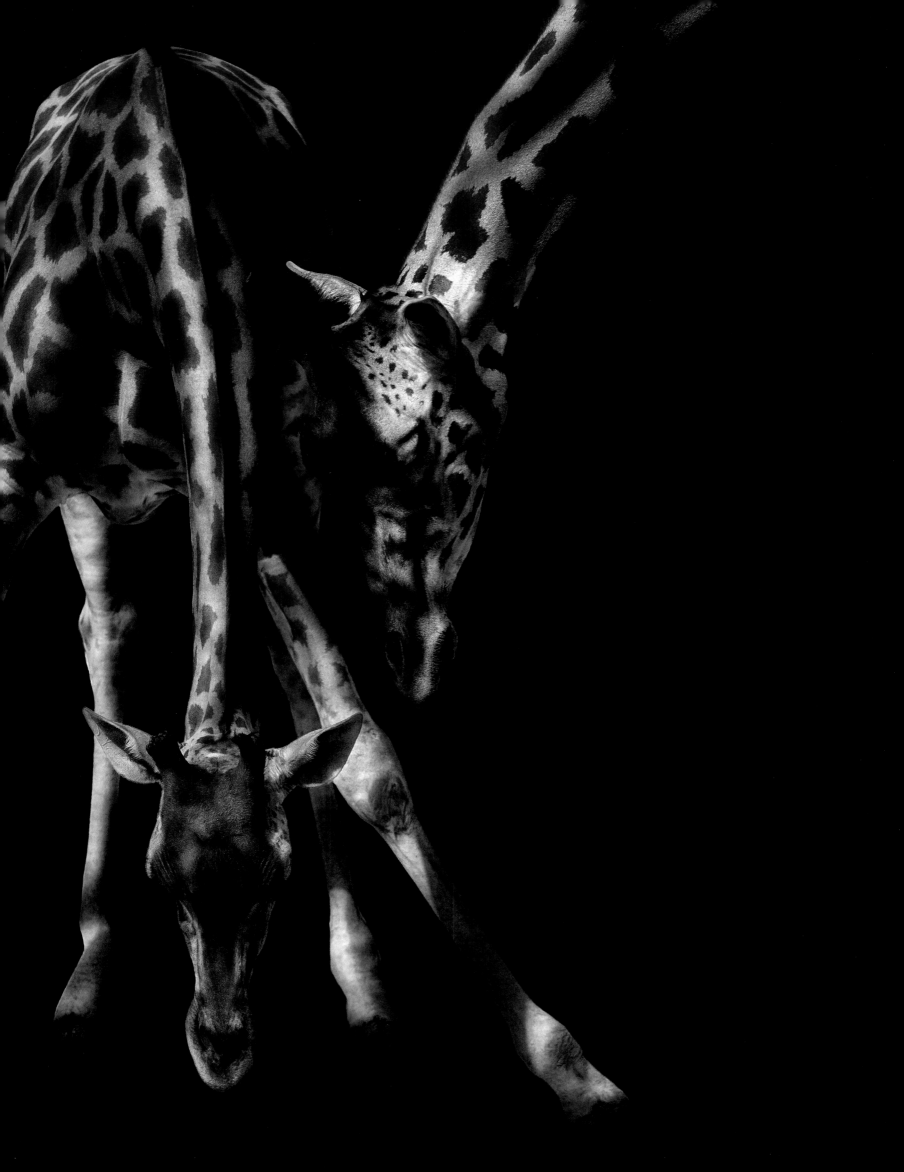

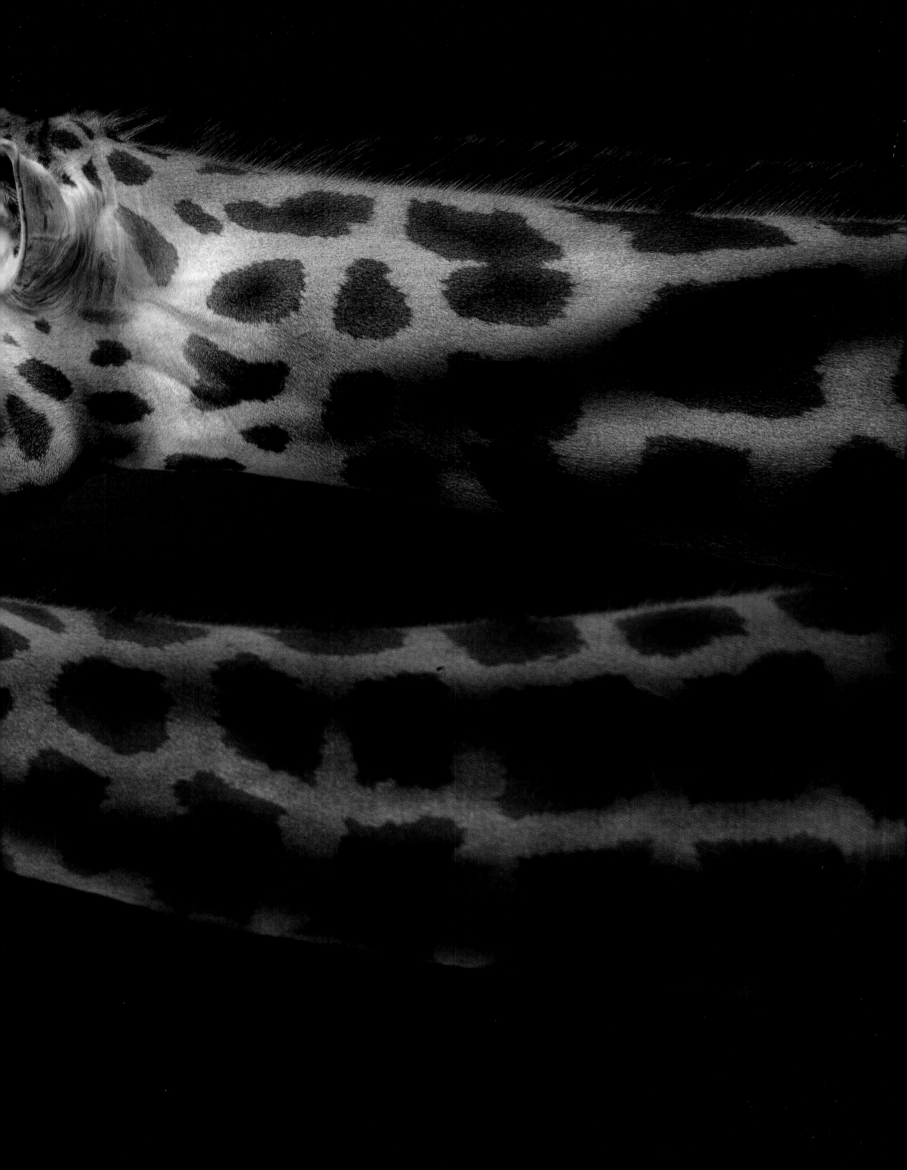

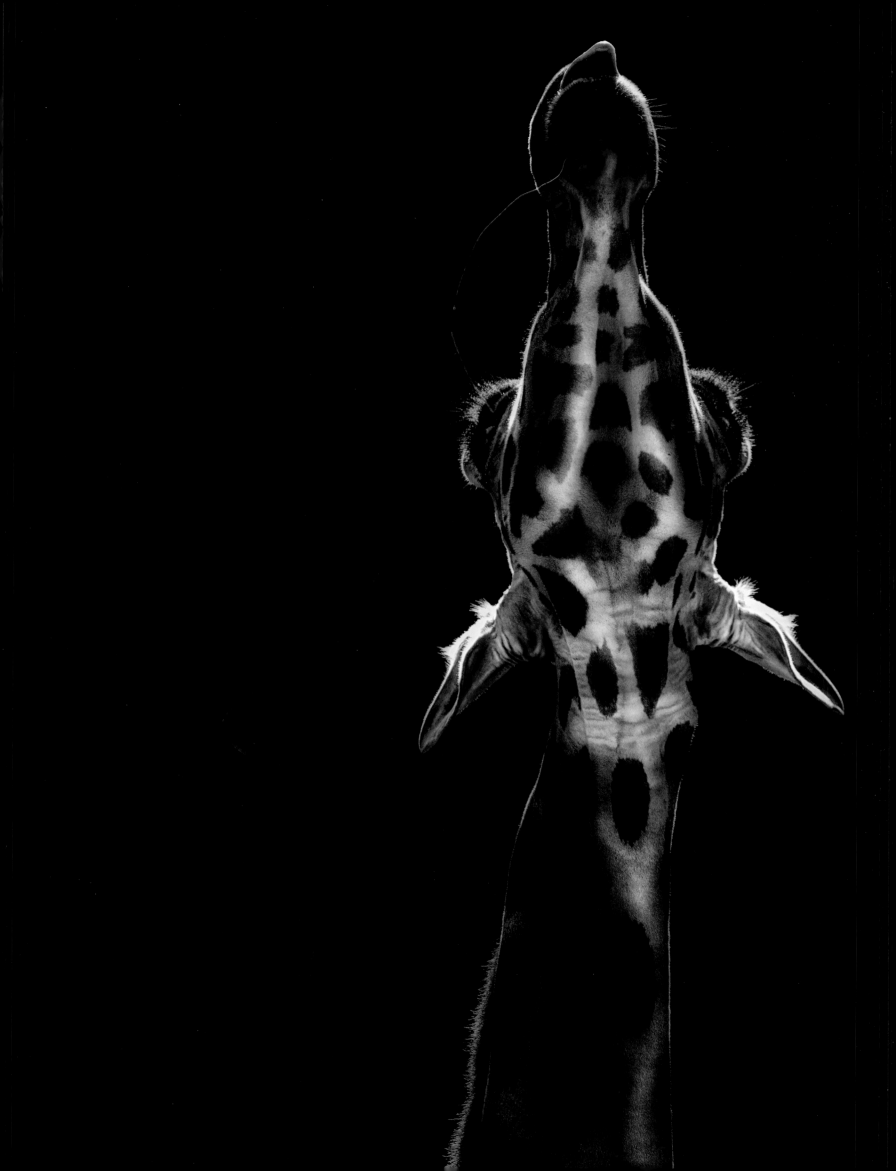

Camel
Camelus, 1758

Like many animals, a camel is able to show affection and loyalty. There was recently news from Pakistan that a camel fell into a deep depression after its master's death, causing it to reject food and water. Just like horses, camels enjoy great popularity among the people of Saudi Arabia, some of whom will pay millions of dollars for the most attractive specimens.

Wie viele andere Tiere ist auch das Kamel in der Lage, Zuneigung und Treue zu zeigen. Kürzlich war die Nachricht zu lesen, dass in Pakistan ein Kamel nach dem Tod seines Herrn so sehr trauerte, dass es Nahrung und Wasser verweigerte. Kamele sind ebenso wie Pferde bei den Menschen in Saudi-Arabien sehr beliebt. Für außergewöhnlich schöne Exemplare werden nicht selten Millionenbeträge gezahlt.

Como muchos animales, un camello es capaz de dar muestras de afecto y fidelidad. Recientemente trascendió la noticia de que en Pakistán un camello se sumió en una gran depresión tras la muerte de su amo, rechazando alimentos y bebida. Al igual que los caballos, los camellos gozan de gran popularidad entre las poblaciones saudíes que llegan a pagar sumas millonarias por los más atractivos.

Comme de nombreux animaux, le chameau est capable de faire preuve d'affection et de loyauté. Récemment au Pakistan, un chameau a été atteint de dépression après la mort de son maître, refusant de boire et de s'alimenter. Comme les chevaux, les chameaux sont très prisés en Arabie Saoudite, certains paient des millions de dollars pour les plus beaux spécimens.

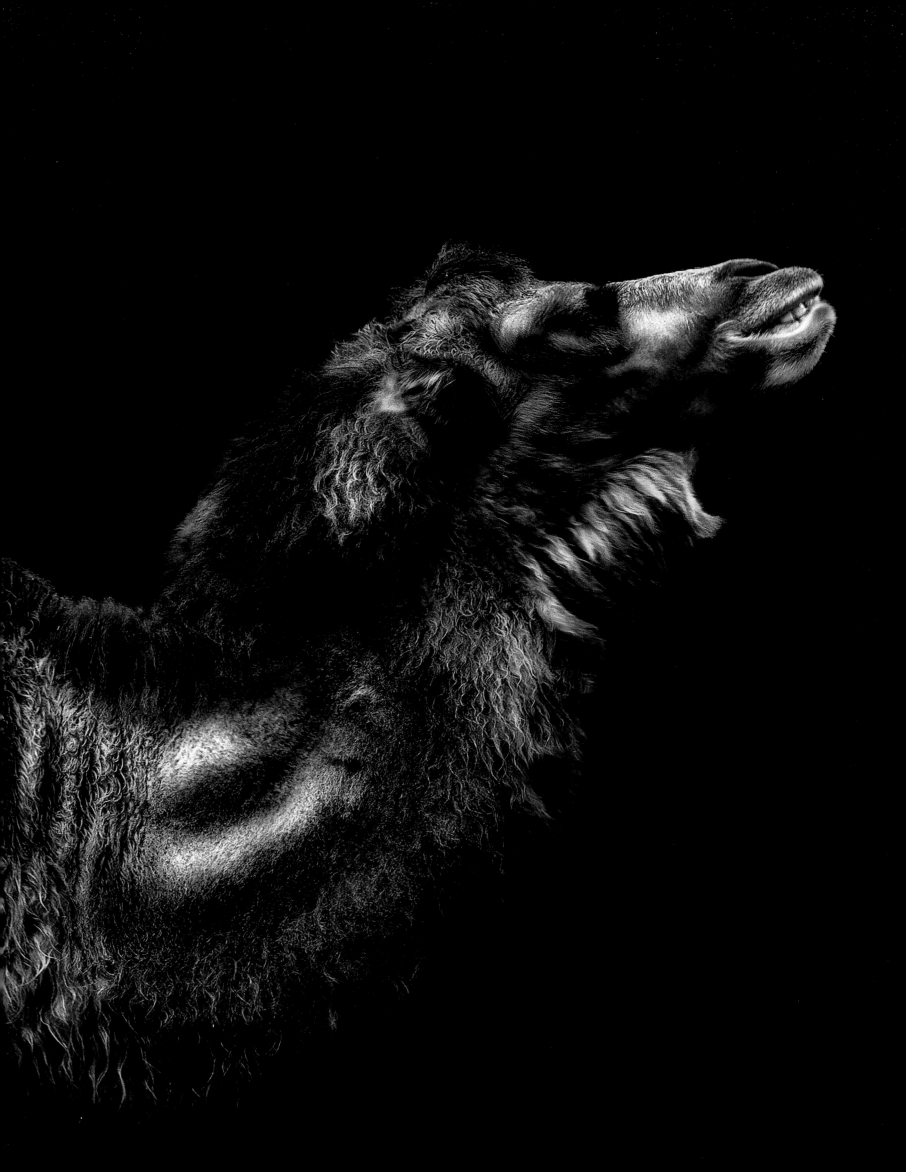

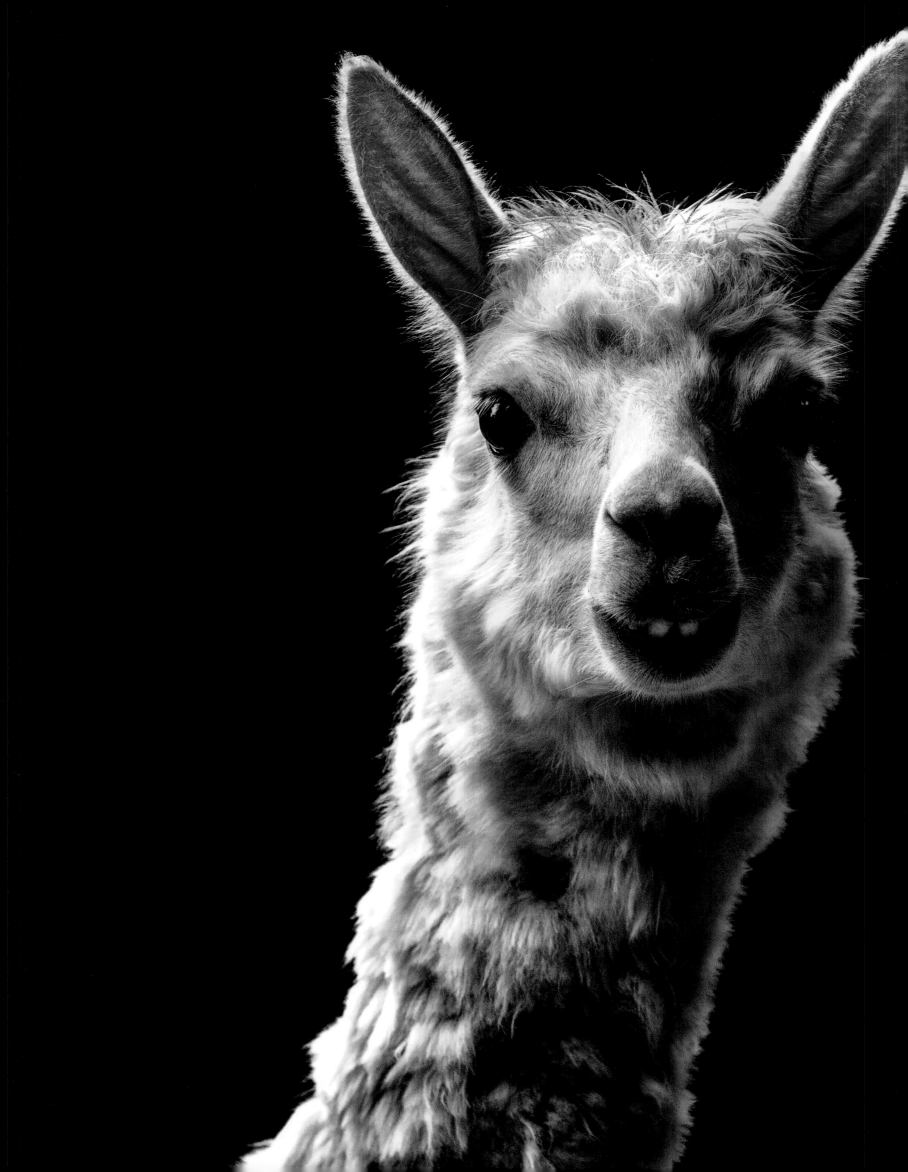

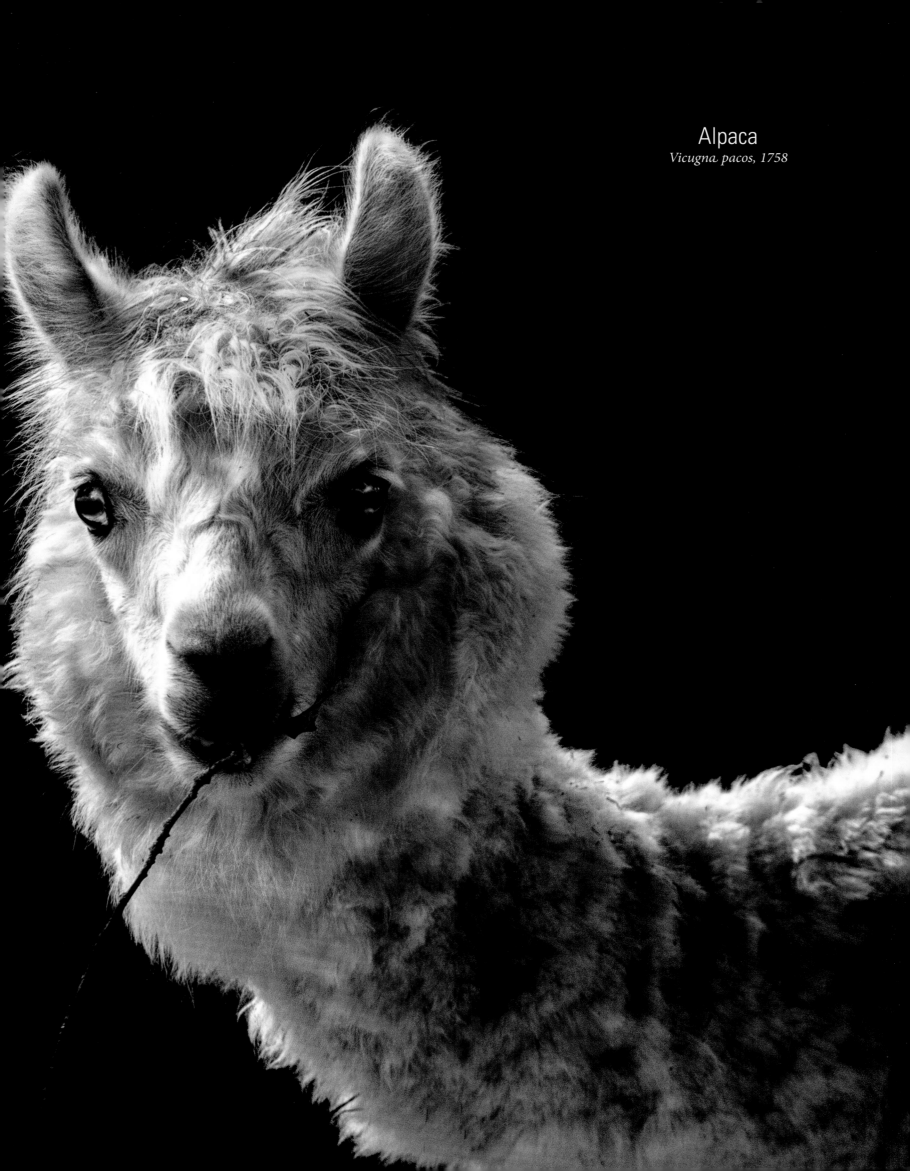

Alpaca
Vicugna pacos, 1758

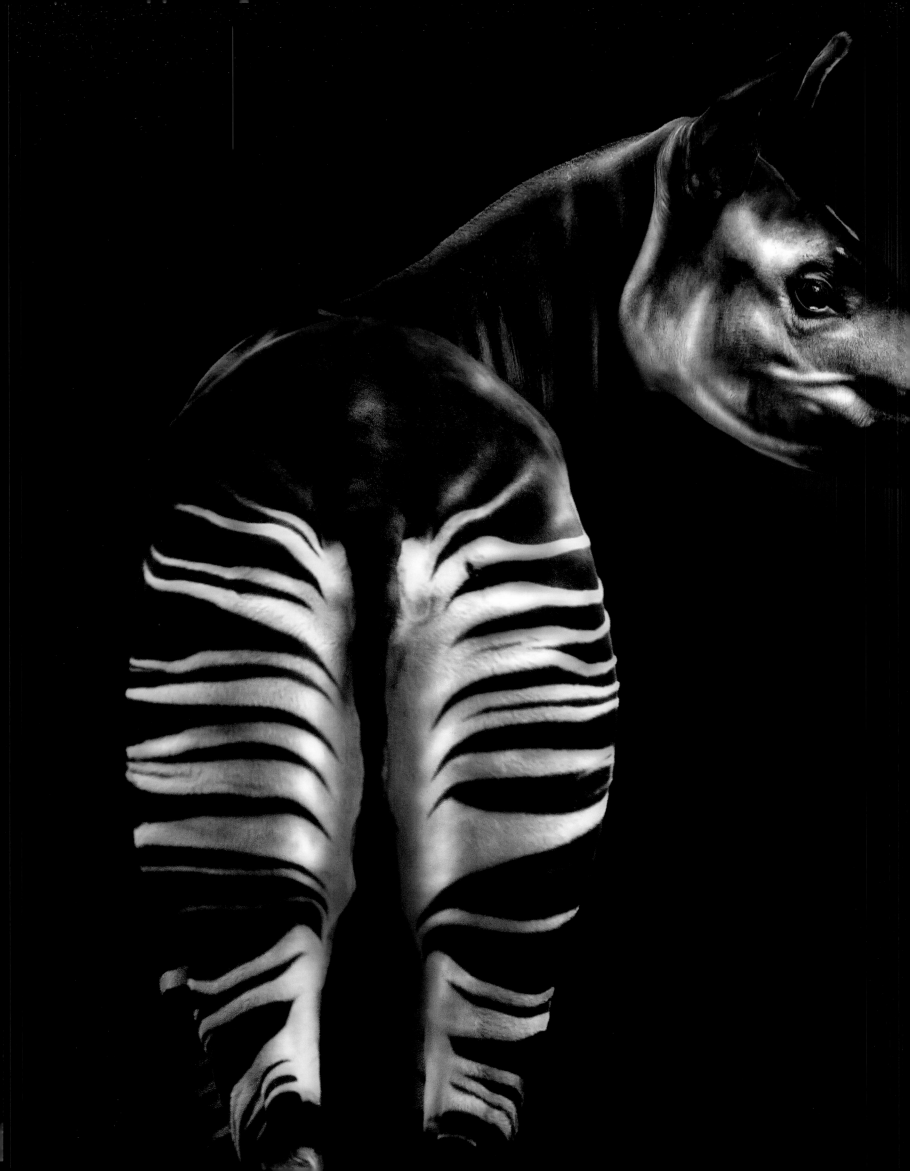

Okapi

Okapia johnstoni, 1901

The okapi is a unique animal that looks like a cross between a zebra and giraffe with the body of a horse. Discovered in the early twentieth century, it was considered to have become extinct for 50 years, before being seen again in 2006 in its natural habitat. Because it only has one offspring per year and its habitat is being reduced, it has become a critically endangered species. It is only found in the wild in the Democratic Republic of the Congo.

Das Okapi ist ein einzigartiges Tier, das wie eine Mischung aus Zebra und Giraffe im Körper eines Pferdes aussieht. Anfang des 20. Jahrhunderts entdeckt, galt es 50 Jahre lang als ausgestorben. Erst 2006 wurde es in seinem Habitat erneut gesichtet. Da Okapis nur ein Junges pro Jahr gebären und ihr Lebensraum begrenzt ist, sind sie vom Aussterben bedroht. In der freien Natur findet man sie nur noch in der Republik Kongo.

El okapi es un singular animal que parece mitad cebra, mitad jirafa y con cuerpo de caballo. Descubierto a principios del siglo xx, se consideró extinto durante cincuenta años hasta que volvió a ser visto en 2006 en su hábitat natural. Debido a que solo tienen una cría por año y a su reducido hábitat es una especie en estado crítico. Solo se le encuentra en estado salvaje en la República del Congo.

L'okapi est un animal au corps de cheval et à la robe moitié zèbre, moitié girafe. Découvert au début du xxe siècle, il a été considéré comme éteint pendant un demi-siècle avant d'être redécouvert dans son habitat naturel en 2006. Étant donné qu'ils n'ont qu'un seul petit par année et que son habitat est réduit, cette espèce est en danger. Il vit à l'état sauvage en République démocratique du Congo.

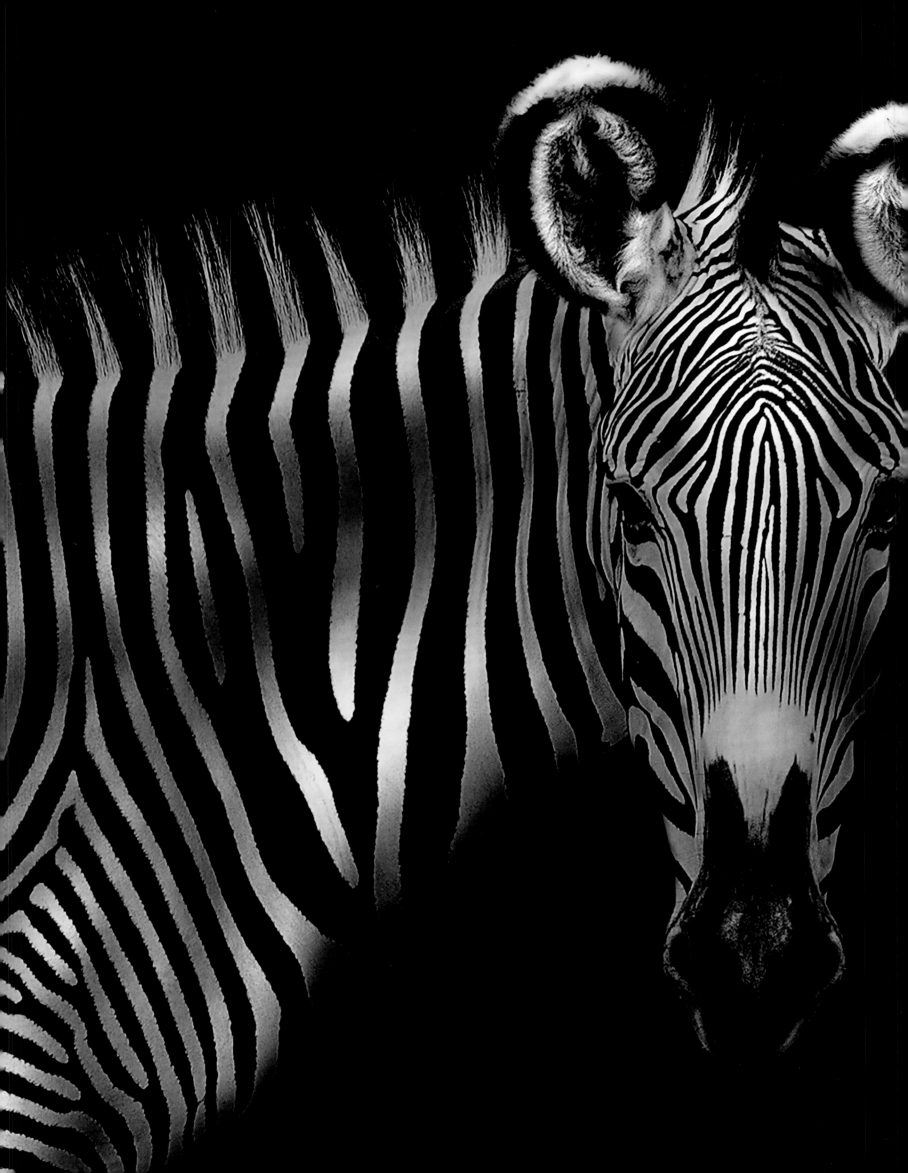

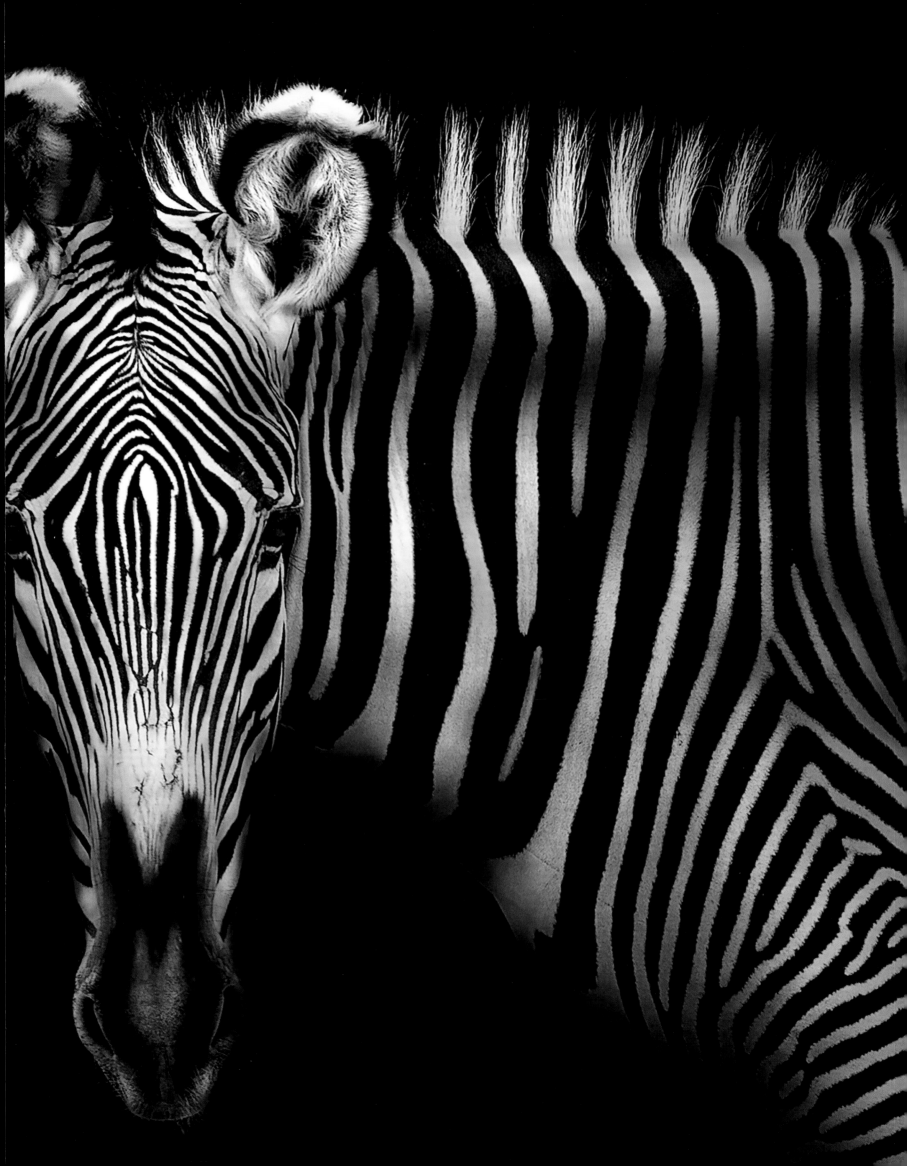

Zebra

Equus quagga, 1785

While Westerners believe that zebras are white with black stripes, Africans believe they are black with white stripes. Studies have concluded that in their fetal stage, their pigmentation is totally black, which they later lose in the areas where the white stripes appear. There are three zebra species with nine subspecies. One of these, the quagga, had uniform coloring with stripes only on the head and neck. It became extinct in the nineteenth century as the result of overhunting. Attempts to use zebras in the same way as horses failed because of their nervous and flighty nature.

En occidente se cree que las cebras son blancas con rayas negras mientras que en África se piensa que son negras con rayas blancas. Los estudios concluyen que en estado embrionario su pigmentación es totalmente negra y luego la van perdiendo en las zonas donde aparecerán las rayas blancas. Existen tres especies de cebra con nueve subespecies. Una de ellas, la quagga, que tenía el cuerpo de color uniforme y con rayas en la cabeza y en el cuello, se extinguió en el siglo XIX por la caza excesiva. Los intentos por utilizar cebras como caballos han fracaso debido a su carácter nervioso.

Im Westen glaubt man, Zebras seien weiß mit schwarzen Streifen, während man in Afrika denkt, sie seien schwarz mit weißen Streifen. Studien gelangten zu dem Schluss, dass sie im Embryonalstadium vollständig schwarz sind und später an den Stellen, an denen die weißen Streifen entstehen, die Pigmentierung verlieren. Es gibt drei Zebra-Arten mit neun Unterarten. Eine davon, das Quagga, ist im 19. Jahrhundert durch exzessive Jagd ausgestorben. Die Versuche, Zebras wie Pferde zu nutzen, scheiterten – die Tiere sind einfach zu nervös.

En Occident, on croit que les zèbres sont blancs avec des rayures noires, alors qu'en Afrique, on les dit noirs avec des rayures blanches. Les études concluent qu'à l'état embryonnaire, sa pigmentation est totalement noire et qu'elle se perd dans les zones où apparaissent les rayures blanches. Il existe trois espèces et neuf sous-espèces de zèbres. L'un d'eux, le quagga, avait une robe uniforme avec des rayures sur la tête et le cou. Il s'est éteint au xixe siècle, victime d'une chasse excessive. Quant aux tentatives d'utiliser les zèbres comme chevaux, elles ont échoué en raison de leur nervosité.

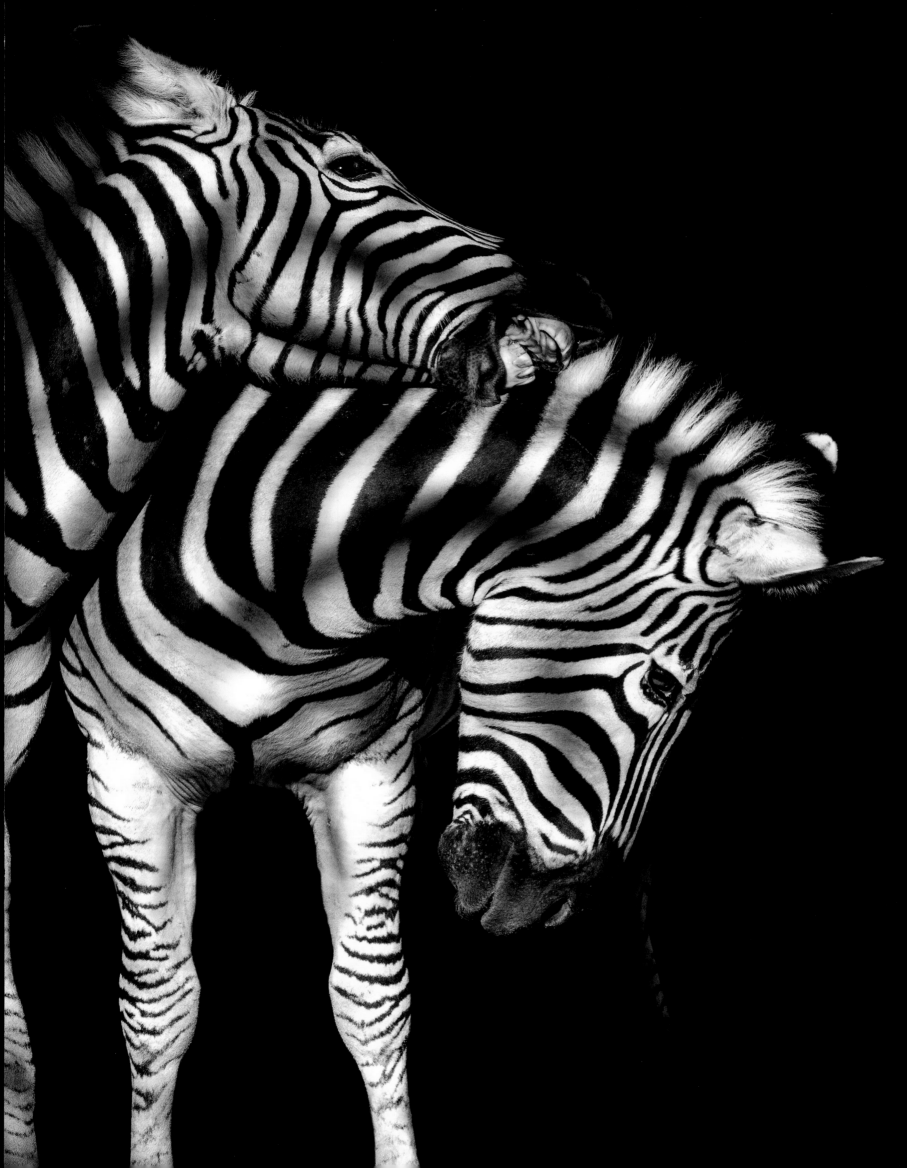

Domestic sheep
Ovis aries, 1758

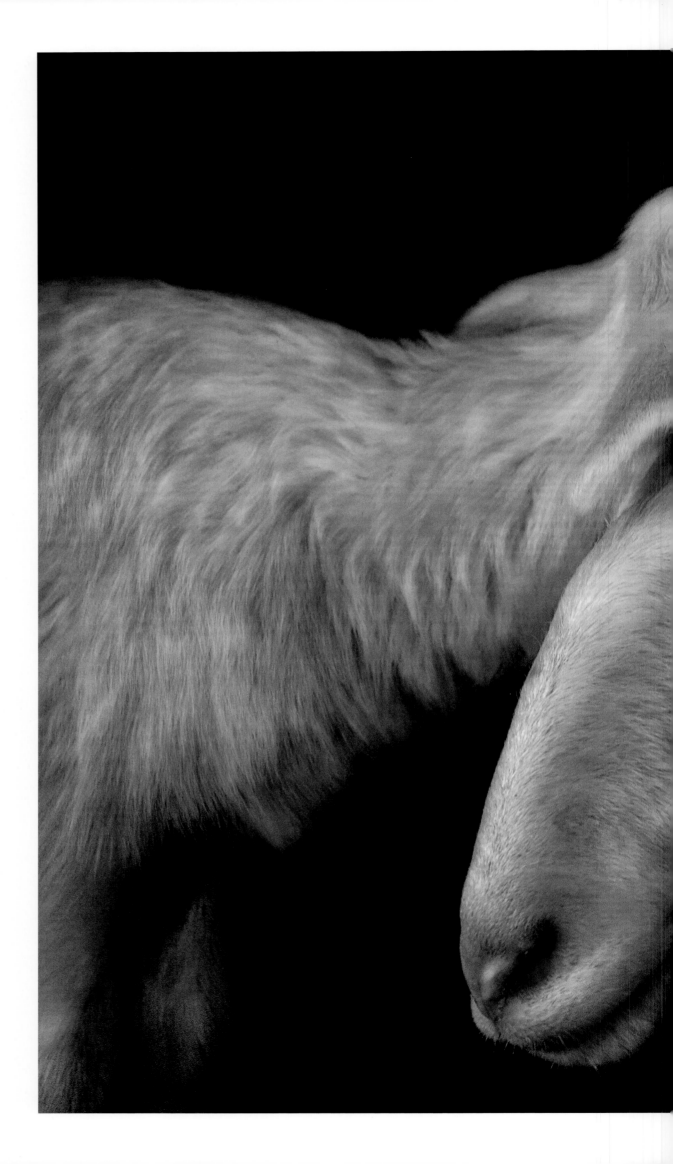

fragile

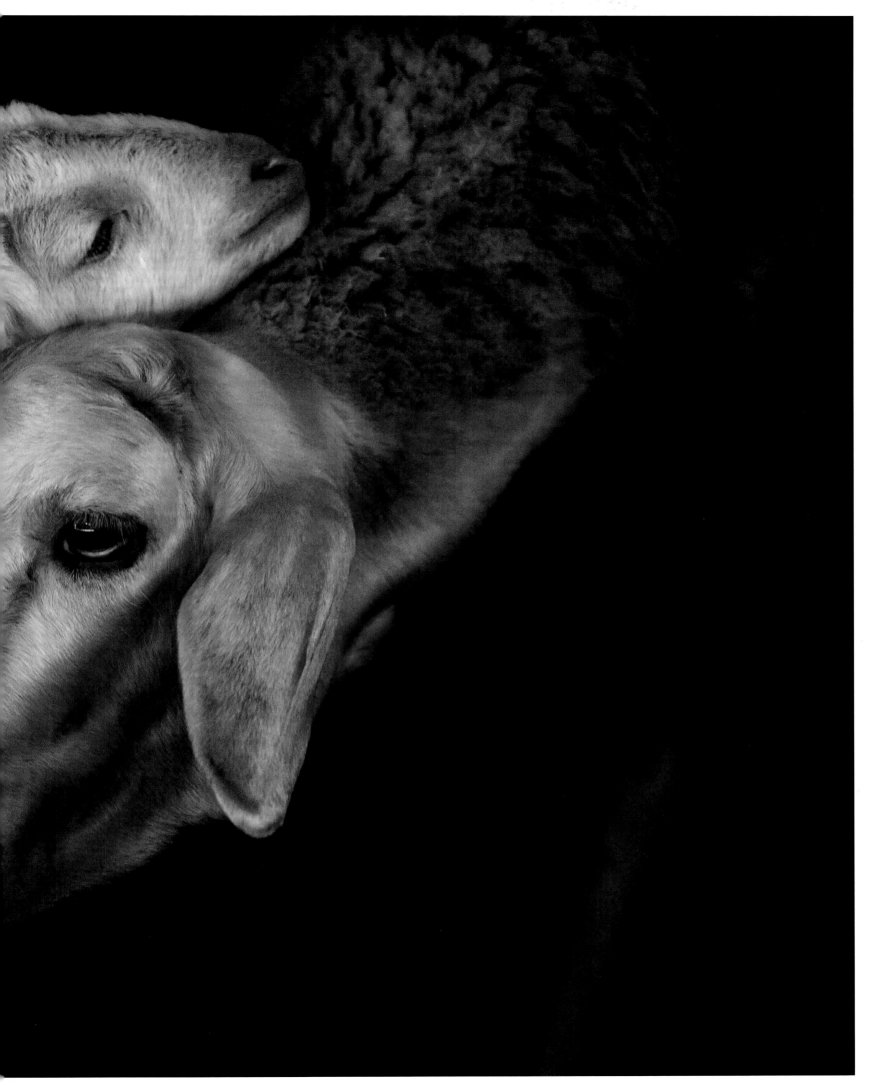

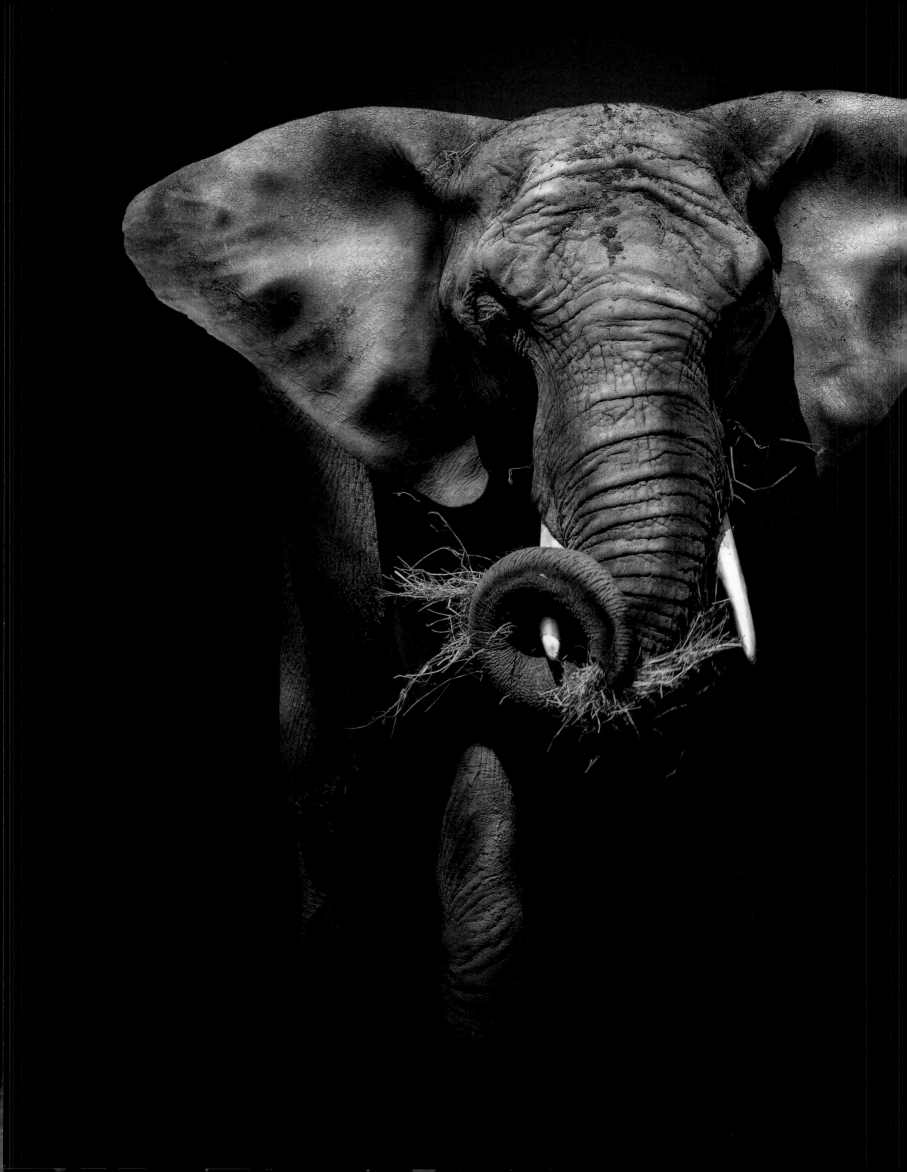

African elephant

Loxodonta africana, 1797

The African elephant is the world's largest land-dwelling animal, and its brain has three times as many neurons as a human brain. Humans are its only predator, and one elephant is killed every 15 minutes for its ivory tusks. Its numbers have fallen by 30 percent in only seven years. Its population has even fallen by 95 percent in some areas of Central Africa. China, the leading importer of ivory, banned its trade outright in 2018, but poaching continues in Africa to supply the black market. If the demand for ivory is not stopped, the African elephant may become extinct in the next 15 years.

Der Afrikanische Elefant ist das größte Landtier. Sein Gehirn hat dreimal mehr Neuronen als das des Menschen. Sein einziger Feind ist der Mensch. Alle 15 Minuten stirbt ein Elefant wegen der Gier nach Elfenbein. In nur sieben Jahren ist der Bestand um 30 Prozent zurückgegangen, in Zentralafrika sogar um 95 Prozent. China, der Hauptimporteur von Elfenbein, hat 2018 den Handel vollkommen untersagt, doch die Wilderei in Afrika geht weiter, um den Schwarzmarkt zu bedienen. Wenn die Nachfrage nach Elfenbein nicht nachlässt, könnte der Afrikanische Elefant in 15 Jahren ausgestorben sein.

El elefante africano es el animal terrestre más grande y su cerebro tiene tres veces más neuronas que el del hombre. Su único depredador es el ser humano y cada quince minutos muere un elefante, cazado por su marfil. En solo siete años su población ha disminuido un 30 %. En zonas de África Central la población ha llegado a disminuir hasta un 95 %. China, principal importador de marfil, prohibió totalmente su comercio en 2018, pero la caza furtiva en África continúa para abastecer al mercado negro. Si la demanda de marfil no se detiene, el elefante africano podría extinguirse en los próximos quince años.

L'éléphant d'Afrique est le plus gros animal terrestre et son cerveau possède trois fois plus de neurones que le nôtre. Son seul prédateur est l'être humain et toutes les quinze minutes, un éléphant meurt, chassé pour son ivoire. En seulement sept ans, sa population a diminué de 30 %. Dans certaines régions d'Afrique centrale, la population a chuté de près de 95 %. La Chine, principal importateur d'ivoire, a complètement interdit son commerce en 2018, mais le braconnage en Afrique continue à alimenterle marché noir. Si la demande en ivoire ne cesse pas, l'éléphant d'Afrique pourrait disparaître dans les quinze années à venir.

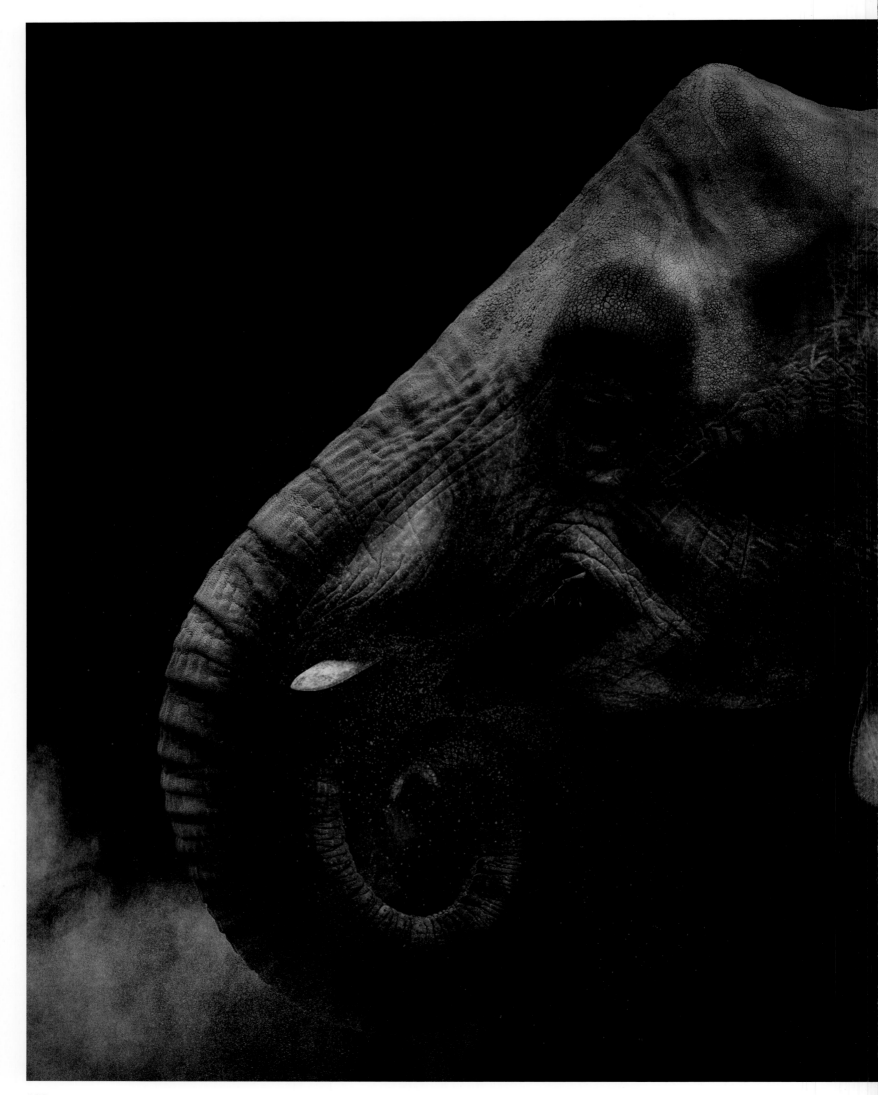

fragile

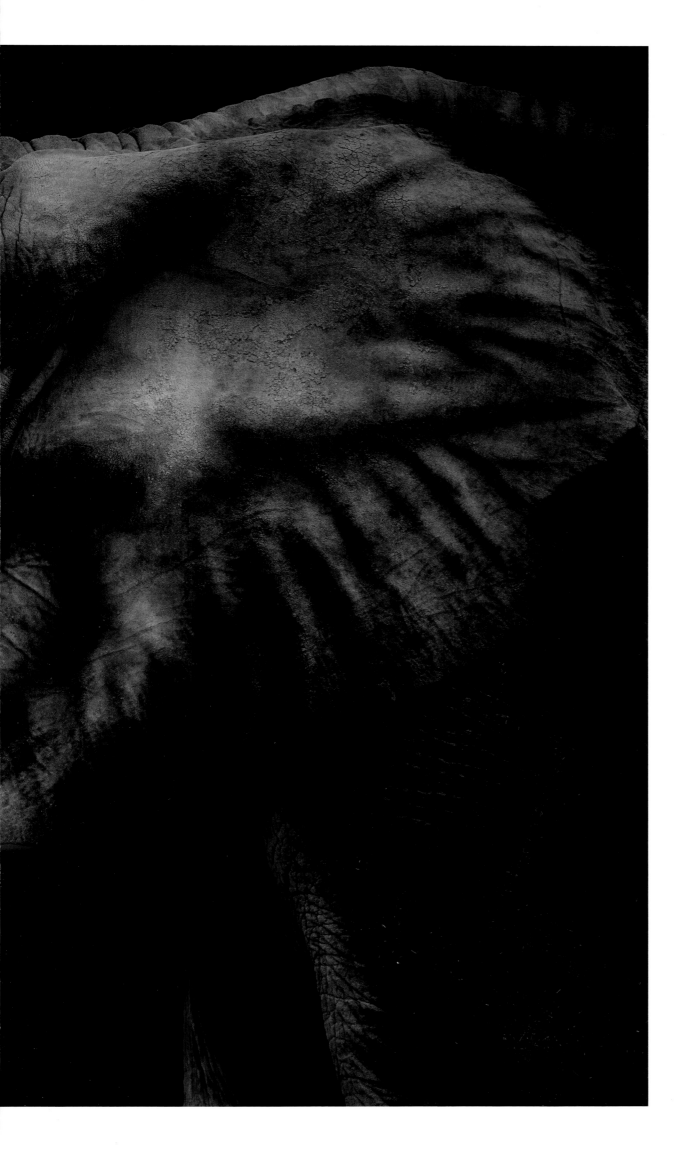

Asian elephant
Elephas maximus, 1758

The Asian elephant is severely endangered. Its numbers are estimated at fewer than 50,000 specimens. Hunting and conflict with humans over land are its main threats.

Der Asiatische Elefant ist stark vom Aussterben bedroht. Seine Population wird auf weniger als 50 000 Exemplare geschätzt. Jagd und territoriale Konflikte mit dem Menschen stellen die Hauptbedrohungen dar.

El elefante asiático está en grave peligro de extinción. Su población se estima en menos de 50 000 ejemplares. La caza y los conflictos territoriales con los humanos son sus principales amenazas.

L'éléphant d'Asie est en danger d'extinction. Sa population est estimée à moins de 50 000 spécimens, décimée par le braconnage et les conflits territoriaux avec l'homme.

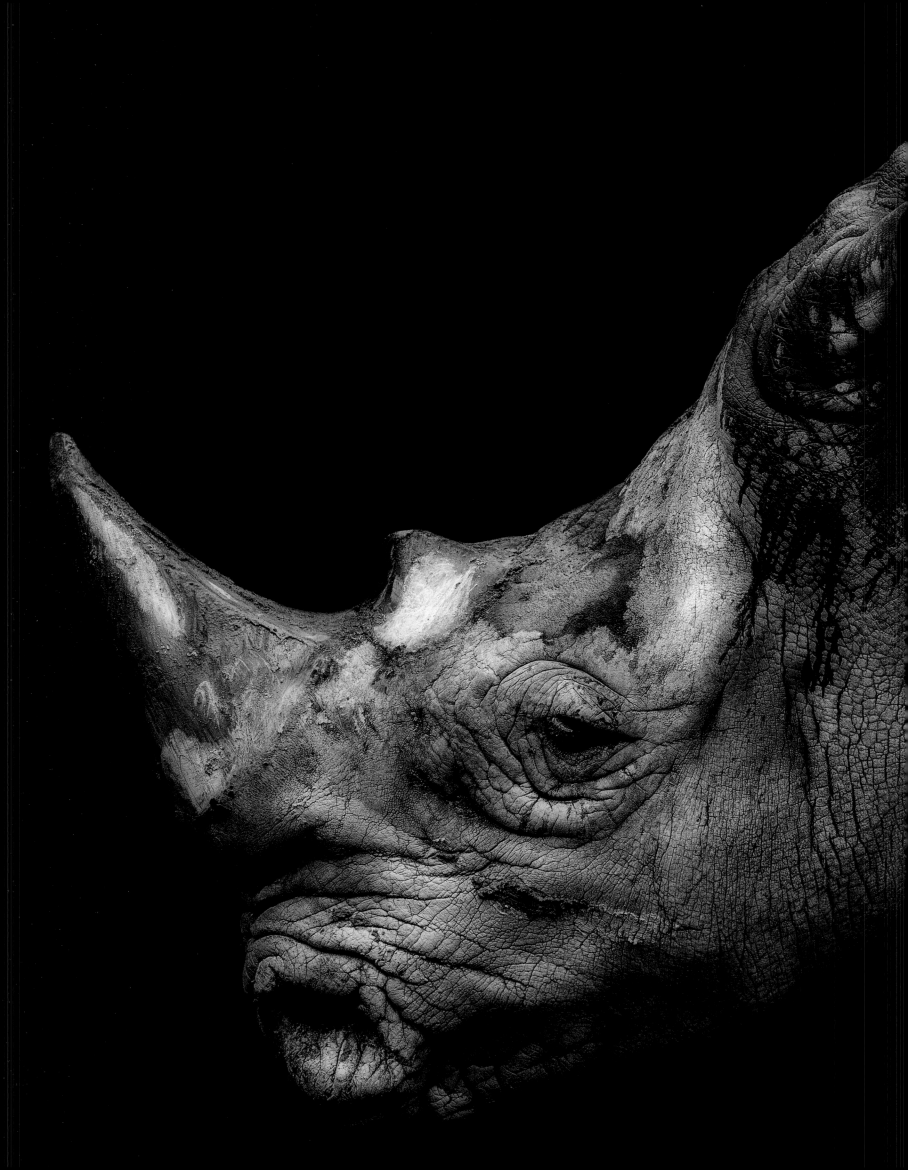

Southern white rhinoceros
Ceratotherium simum simum, 1817

The world's last male northern white rhinoceros died in March, 2018. An attempt at in vitro fertilization is being made using oocytes from the last two females in order to save the species from extinction. The southern white rhinoceros, on the other hand, offers hope. Its numbers have grown from less than 1,000 specimens in the early twentieth century to more than 20,000 today, as a result of the protective measures taken, although it is still considered to be critically endangered. Poaching for its horn (made of keratin, like finger nails), considered to have healing properties, is its greatest threat.

Im März 2018 starb das letzte männliche Exemplar des Nördlichen Breitmaulnashorns. Nun versucht man, durch In-vitro-Fertilisation mit den Eizellen der letzten beiden noch lebenden Weibchen die Art zu retten. Das Südliche Breitmaulnashorn hingegen gibt Anlass zur Hoffnung. Sein Bestand stieg dank Schutzmaßnahmen von weniger als 1000 Tieren Anfang des 20. Jahrhunderts auf aktuell 20 000 an. Dennoch gilt es nach wie vor als gefährdet. Die verbotene Jagd auf das Horn (das wie die Hufe aus Keratin besteht), dem heilende Wirkung zugeschrieben wird, stellt die größte Bedrohung dar.

En marzo de 2018 murió el último ejemplar macho de rinoceronte blanco del norte. Se está intentando la fecundación in vitro con ovocitos de las últimas dos hembras para salvar a la especie de la extinción. El rinoceronte blanco del sur, en cambio, supone una esperanza, pues su población pasó de menos de 1000 ejemplares a principios del siglo xx a casi 20 000 en la actualidad, gracias a medidas de protección, aunque aún se le considera en estado crítico. La caza furtiva para obtener su cuerno (formado por queratina, como las uñas), al que se le atribuyen propiedades curativas, es su mayor amenaza.

En mars 2018, le dernier rhinocéros mâle blanc du Nord est mort. Un programme de fécondation in vitro à partir des ovocytes des deux dernières femelles a été lancé pour sauver l'espèce de l'extinction. Il reste cependant un espoir pour le rhinocéros blanc du Sud. Grâce à des mesures de protection, sa population est passée de moins de 1 000 individus au début du xxᵉ siècle à près de 20 000 aujourd'hui, bien qu'il soit encore classé comme espèce en danger critique d'extinction. Il est menacé par le braconnage, car sa corne en kératine est très recherchée pour ses vertus thérapeutiques.

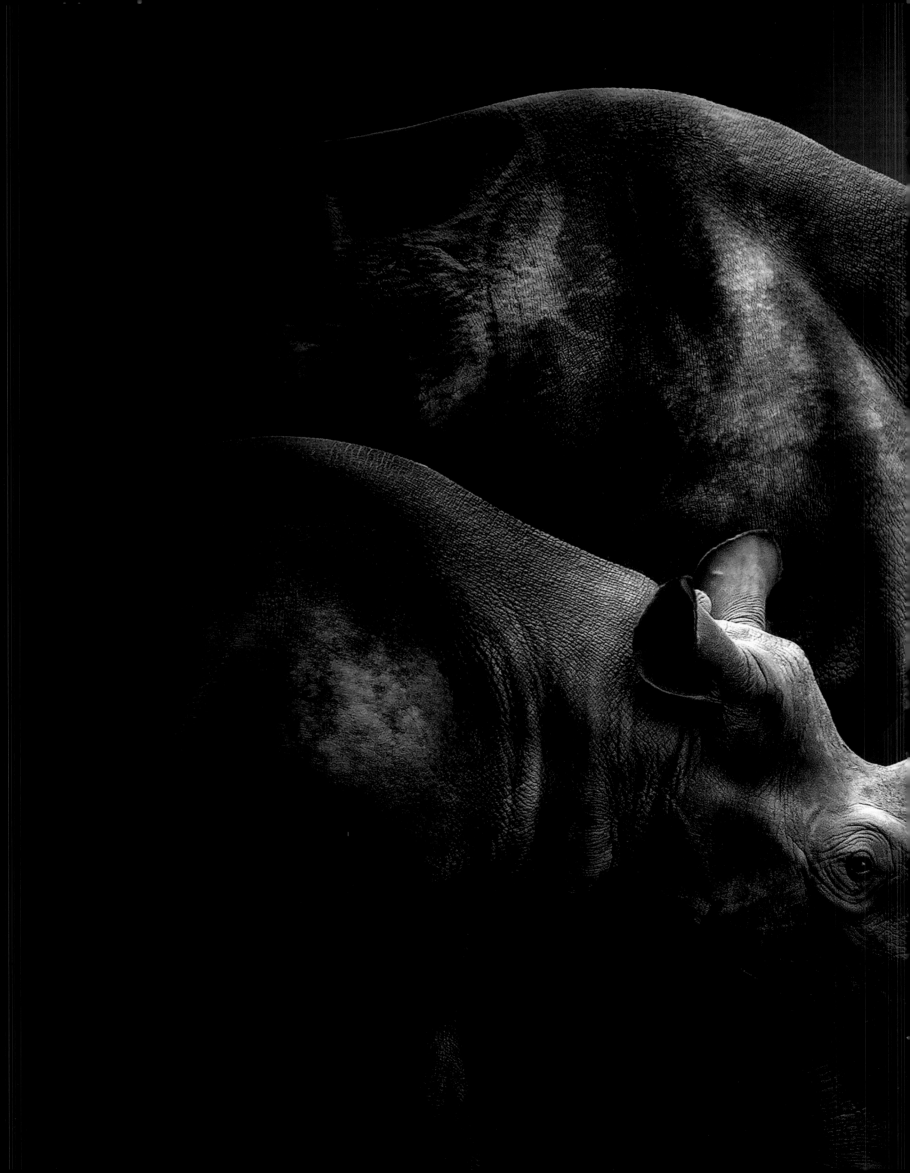

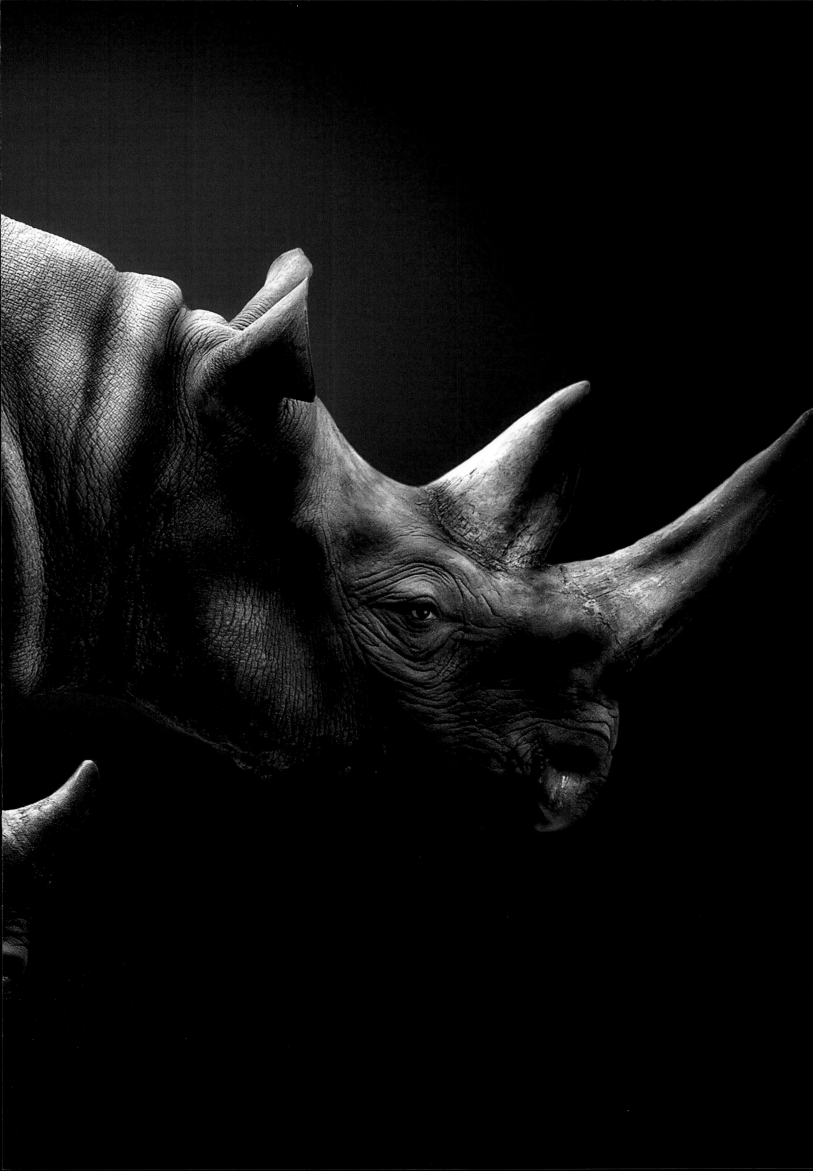

Common warthog

Phacochoerus africanus
1788

The warthog is a wild pig that lives on the African savanna. It lives in groups comprising females with their young, while a male will only join the group to mate. Each offspring has a teat reserved for its exclusive use, and even if it dies, it will not be used by its siblings. With each new litter, the mother will expel her oldest offspring, which will have to form their own groups.

Warzenschweine leben in der afrikanischen Savanne in Gruppen zusammen, die aus den Weibchen und den Jungtieren bestehen. Die Männchen finden sich nur für die Paarung ein. Jedes Jungtier hat eine feste Zitze, die ausschließlich von ihm genutzt wird. Selbst wenn es stirbt, wird diese Zitze von den Geschwistern ignoriert. Bei einem neuen Wurf werden die älteren Jungtiere von der Mutter vertrieben, damit sie ihre eigenen Rudel bilden.

El facóquero es un cerdo salvaje que habita en la sabana africana. Vive en grupos formados por hembras con sus crías y el macho solo se une al grupo para aparearse. Cada cría tiene una tetina reservada para su uso exclusivo, e incluso si muere no será usada por ninguno de sus hermanos. Con una nueva camada, la madre expulsará a sus crías mayores que tendrán que crear sus propios grupos.

Le phacochère est un porc sauvage vivant dans la savane africaine. Il évolue en groupes formés par des femelles et leur progéniture. Le mâle se joint au troupeau uniquement pour s'accoupler. Chaque marcassin a un téton attribué : s'il venait à mourir, il ne serait utilisé par aucun de ses frères et sœurs. À chaque nouvelle portée, la mère chasse sa progéniture plus âgée qui forme alors son propre groupe.

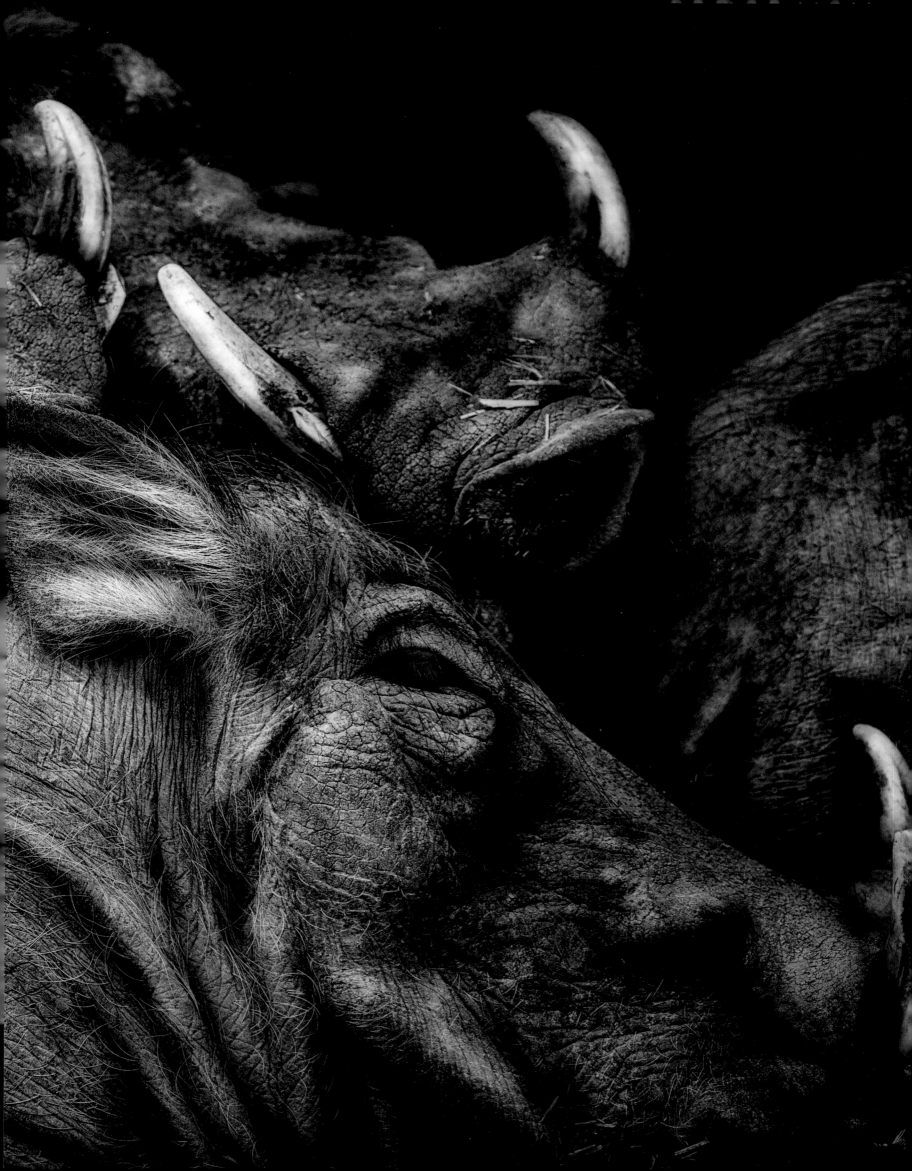

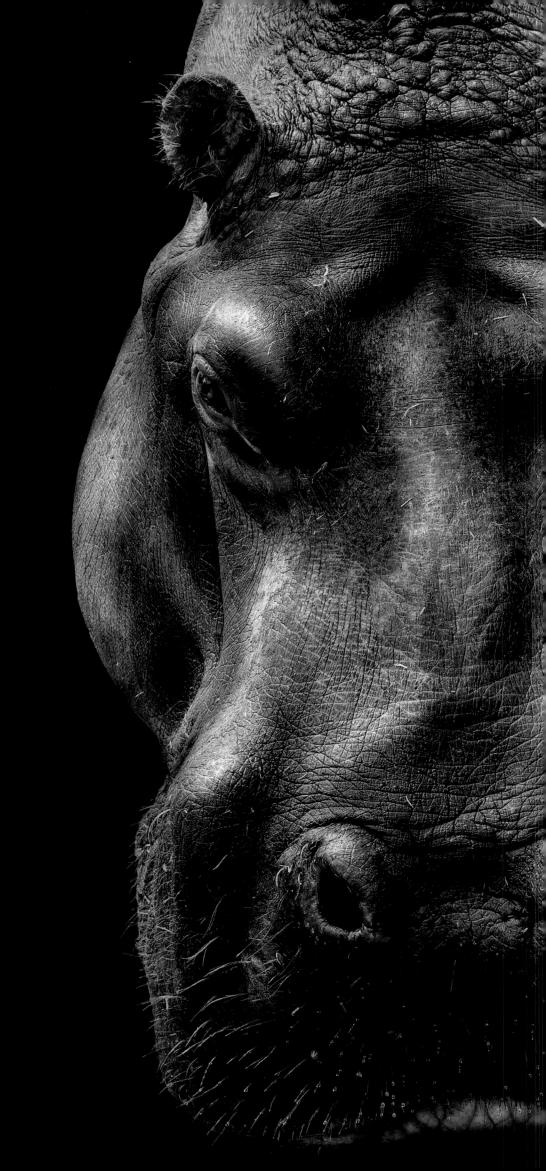

Hippopotamus
Hippopotamus amphibius
1758

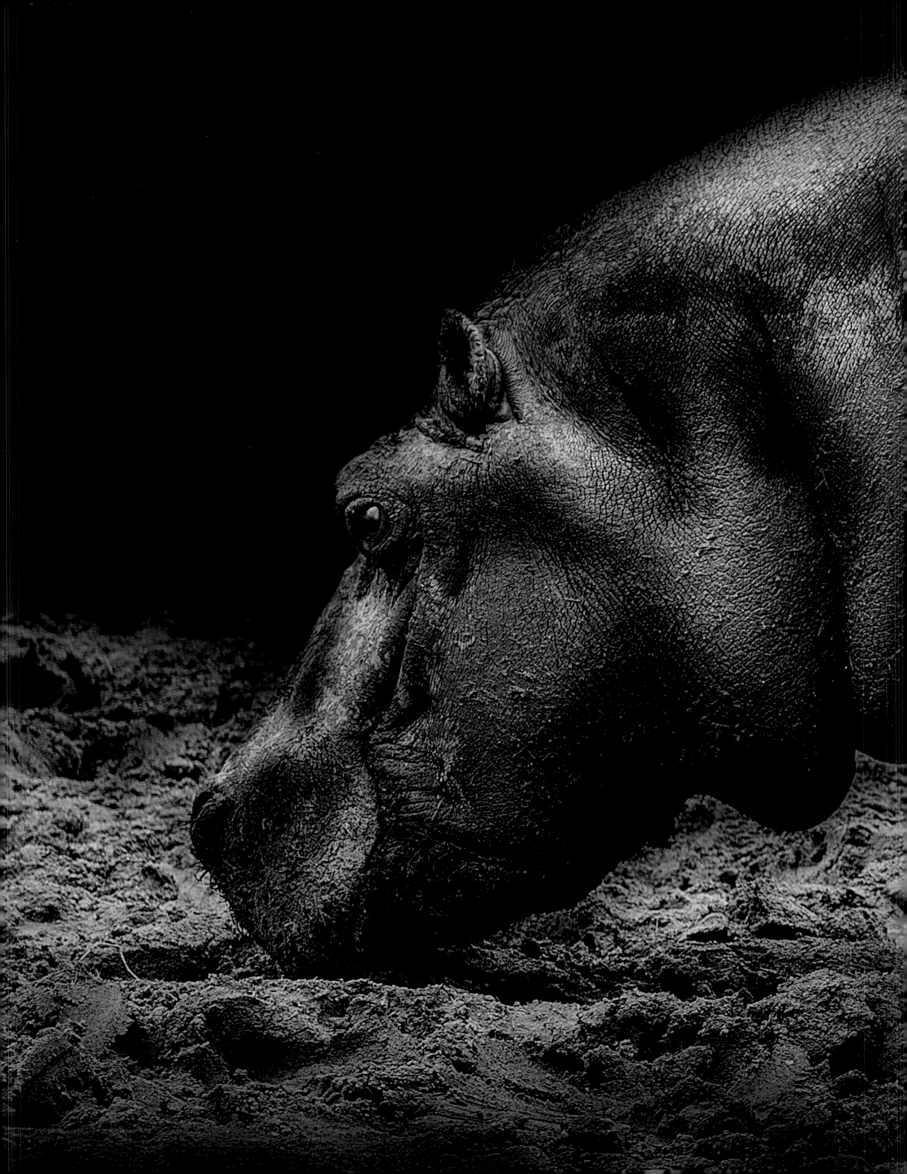

Africa is the cradle and last refuge of a large number of unique mammals. The growth and development of human settlements implies the destruction of the habitats of many of these species, and their subsistence will be threatened. This is the case of the hippopotamus, which until a few decades ago was not endangered. Its numbers have now fallen by between 10 and 20 percent.

Afrika ist die Wiege und der letzte Zufluchtsort einer Vielzahl einzigartiger Säugetiere. Das Anwachsen und die Entwicklung der Bevölkerung werden die Zerstörung des Lebensraums vieler dieser Arten mit sich bringen, sodass ihr Überleben bedroht ist. Ein Beispiel ist das Flusspferd, das vor zwei Jahrzehnten noch nicht als bedroht galt. Mittlerweile hat sein Bestand um 10 bis 20 Prozent abgenommen.

África es la cuna y el último refugio de una gran cantidad de mamíferos únicos. El crecimiento y desarrollo de las poblaciones humanas implicará la destrucción del hábitat de muchas de estas especies y su subsistencia se verá amenazada. Es el caso del hipopótamo, que hace un par de décadas no estaba amenazado, pero cuya población se ha reducido en la actualidad entre un 10 y un 20 %.

L'Afrique est le berceau et le dernier refuge d'un grand nombre de mammifères uniques. La croissance et le développement des populations humaines entraînent la destruction de l'habitat d'un grand nombre de ces espèces et leur survie est menacée. C'est le cas de l'hippopotame, qui n'était pas en danger il y a quelques décennies, mais dont la population a diminué de 20 à 10 %.

The hippopotamus has been collateral damage of the ban on the elephant ivory trade, and its large teeth have been used as a replacement to supply the black market. Because they are not protected like elephants, they easily fall prey to poachers, and there are currently no laws to protect them. This is leading them to the brink of extinction at an alarming rate. In 2002, 5 tonnes of hippopotamus teeth from Uganda, the equivalent of 2,000 dead hippos, were seized. This is only a fraction of the actual size of the ivory trade.

Das Flusspferd ist ein Kollateralopfer des Handelsverbots mit Elfenbein von Elefanten: Seine langen Hauer dienten als Ersatz zur Belieferung des Schwarzmarkts. Weil die Flusspferde nicht so überwacht werden wie die Elefanten, sind sie leichte Beute für Wilderer. Es gibt aktuell kein Gesetz, das sie unter Schutz stellt, sodass diese Art mit rasanter Geschwindigkeit auf ihre Ausrottung zusteuert. 2002 wurden fünf Tonnen Flusspferdzähne aus Uganda beschlagnahmt. Das entspricht etwa 2000 toten Tieren – und das ist nur ein Bruchteil des tatsächlichen Elfenbeinhandels.

El hipopótamo es una víctima colateral de la prohibición del comercio de marfil de elefantes, ya que sus largos dientes han servido como sustituto para alimentar el mercado negro. Al no estar vigilados como los elefantes, son presa fácil de cazadores furtivos y actualmente no existe ninguna legislación que los proteja, lo que está llevando a esta especie a su extinción a un ritmo acelerado. En 2002 se incautaron 5 toneladas de dientes de hipopótamo procedentes de Uganda, correspondientes a unos 2000 hipopótamos muertos. Y esto es solo una fracción de la cantidad real del tráfico de marfil.

L'hippopotame est une victime collatérale de l'interdiction du commerce de l'ivoire des éléphants, car ses longues dents ont servi de substitut sur le marché noir. N'étant pas surveillés comme les éléphants, ce sont des proies faciles pour les braconniers. Il n'existe actuellement aucune loi pour les protéger, ce qui mène cette espèce à l'extinction à un rythme accéléré. En 2002, cinq tonnes de dents d'hippopotames ont été saisies en Ouganda, ce qui représente quelques 2 000 individus tués. Et ce n'est qu'une fraction de la quantité réelle du trafic de l'ivoire à l'échelle mondiale.

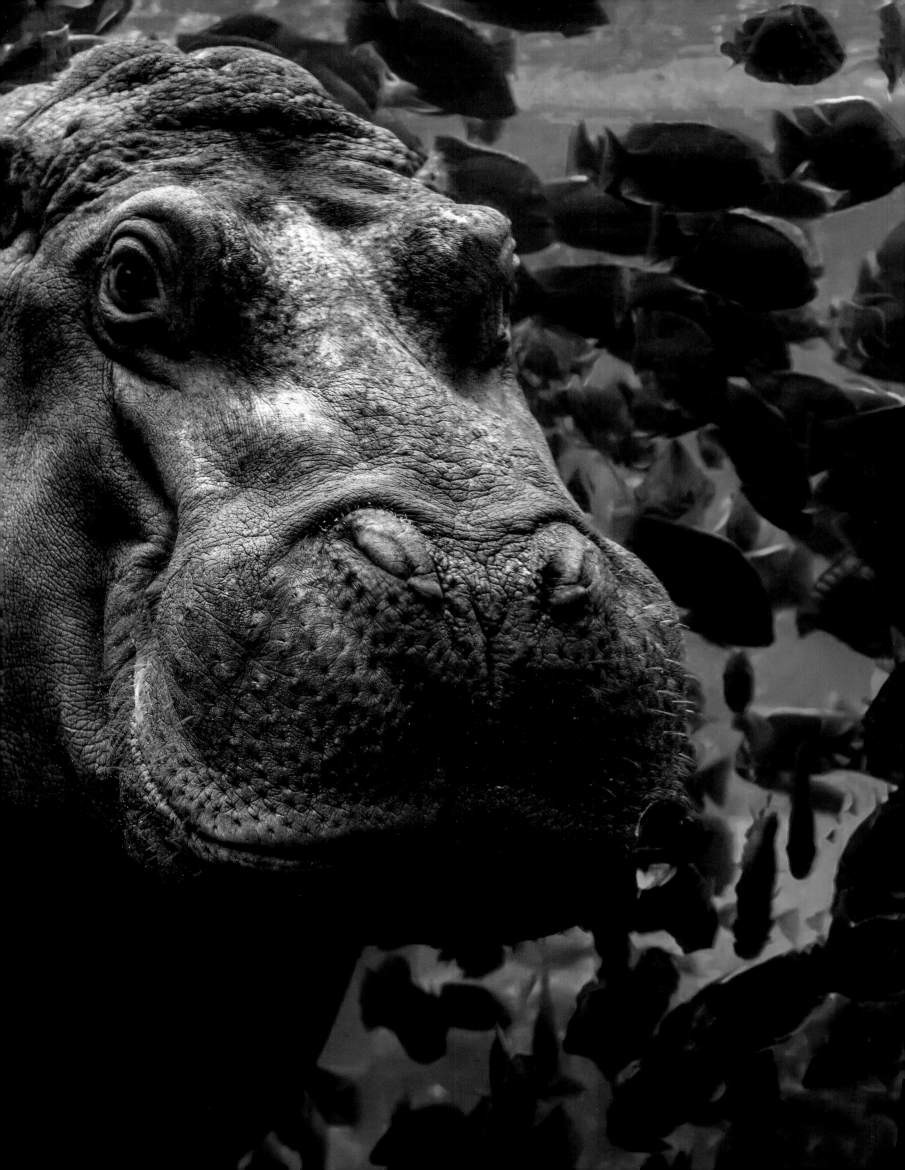

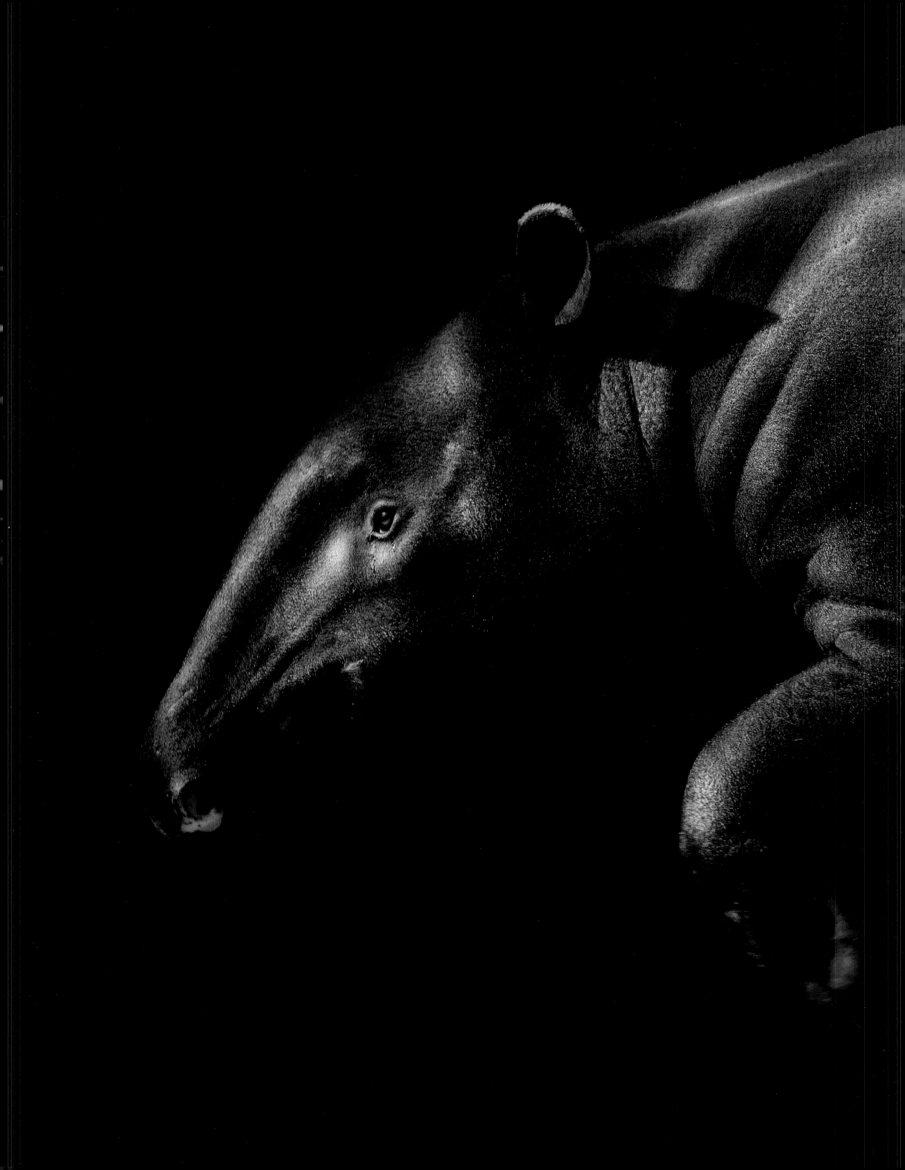

Malayan tapir
Tapirus indicus, 1819

The Malayan tapir is a shy and inoffensive animal that is also endangered as a result of habitat destruction, the consequence of deforestation and the illegal trade in exotic species, because its young are particularly prized on the black market. After 55 million years of evolution, this species is facing extinction in a few decades as a result of human greed.

Der Schabrackentapir ist ein friedfertiges, scheues Tier, das durch die Zerstörung seines Lebensraums infolge von Abholzung und illegalem Handel mit exotischen Arten ebenfalls stark gefährdet ist. Besonders nach den Jungtieren herrscht eine rege Nachfrage auf dem Schwarzmarkt. Nach 55 Millionen Jahren der Evolution könnte diese Art durch die Gier des Menschen in wenigen Jahrzehnten ausgerottet sein.

El tapir malayo es un animal tímido e inofensivo que también se encuentra amenazado por la destrucción de sus hábitats como consecuencia de la deforestación y el tráfico ilegal de especies exóticas, ya que sus crías son especialmente demandadas en el mercado negro. Tras 55 millones de años de evolución, esta especie se enfrenta a la extinción en pocas décadas por la codicia humana.

Le tapir de Malaisie est un animal timide et inoffensif qui souffre de la destruction de son habitat. Victime de la déforestation et du trafic illicite d'espèces exotiques, sa progéniture est particulièrement recherchée sur le marché noir. Après 55 millions d'années d'évolution, cette espèce est menacée d'extinction en quelques décennies à cause de la cupidité humaine.

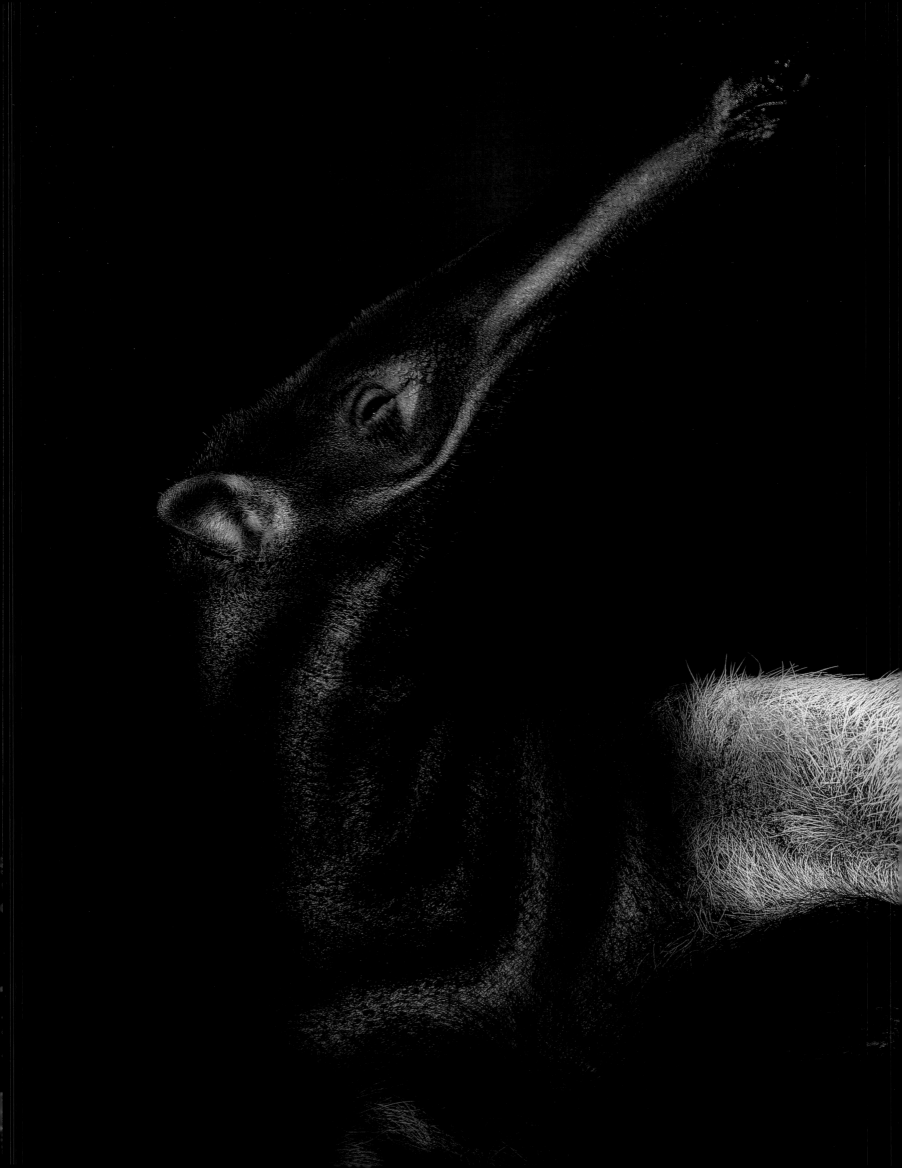

Giant Anteater
Myrmecophaga tridactyla
1758

As a pet or as a trophy, the giant anteater is under serious threat from poaching. 30 percent of its numbers have been lost over the last ten years.

Ob als Haustier oder Trophäe, der Große Ameisenbär ist durch Wilderei ernsthaft bedroht. In den letzten zehn Jahren ist der Bestand um 30 Prozent zurückgegangen.

Mascota o trofeo, el oso hormiguero gigante está seriamente amenazado por la caza furtiva. En los últimos diez años se ha perdido el 30 % de su población.

Mascotte ou trophée, le fourmilier géant est gravement menacé par le braconnage. Au cours de la dernière décennie, 30 % de sa population a disparu.

Sea lion
Otaria flavescens, 1800

South American sea lions live along the coasts of Central and South America, where they play an essential part in the ecosystem. Although similar to seals, they can be told apart by their small external ear flaps. Their numbers are diminishing, largely as a result of the presence of waste and plastic packing bands, in which they become entangled.

Die südamerikanischen Mähnenrobben leben an den Küsten Zentral- und Südamerikas, wo ihnen eine wesentliche Funktion im Ökosystem zukommt. Sie gehören zur Gruppe der Ohrenrobben. Diese unterscheiden sich von den Seehunden unter anderem durch die kleinen Ohren. Der Bestand der Mähnenrobben ist vor allem durch die vermüllten Meere und die Kunststoffleinen gefährdet, in denen sich die Tiere verheddern.

Los lobos marinos sudamericanos habitan en las costas de América Central y del Sur donde cumplen una función esencial en el ecosistema. Parecidos a las focas, se diferencian de estas, entre otras cosas, por sus pequeñas orejas exteriores. Su población se está reduciendo sobre todo por la presencia en el mar de residuos y zunchos de plástico, en los que quedan enredados.

Les lions de mer vivent sur les côtes d'Amérique centrale et du Sud, où ils jouent un rôle essentiel dans l'écosystème. Bien que ces otaries ressemblent aux phoques, elles se distinguent notamment de ces derniers par leurs petites oreilles extérieures. La population de lions de mer a diminué en raison de la présence de déchets et de lanières de plastique dans lesquels ils meurent piégés.

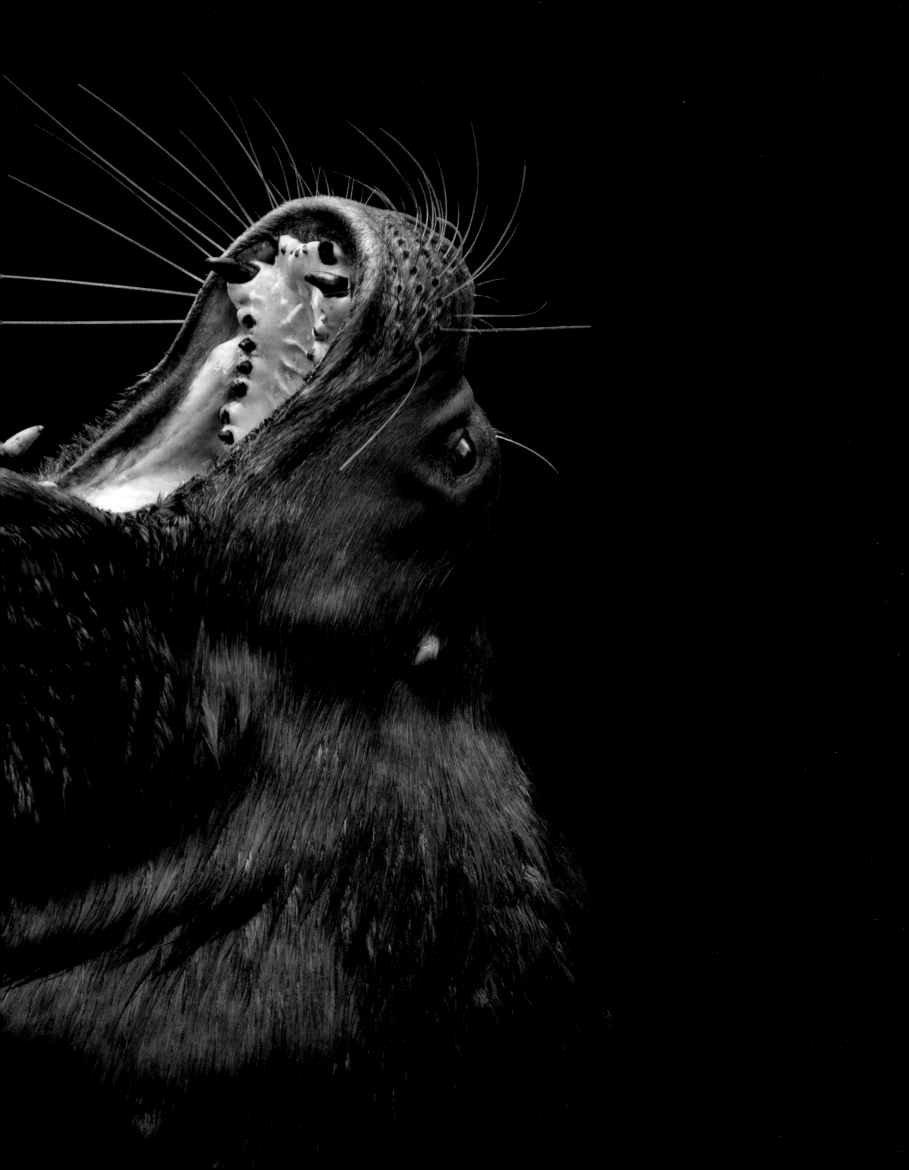

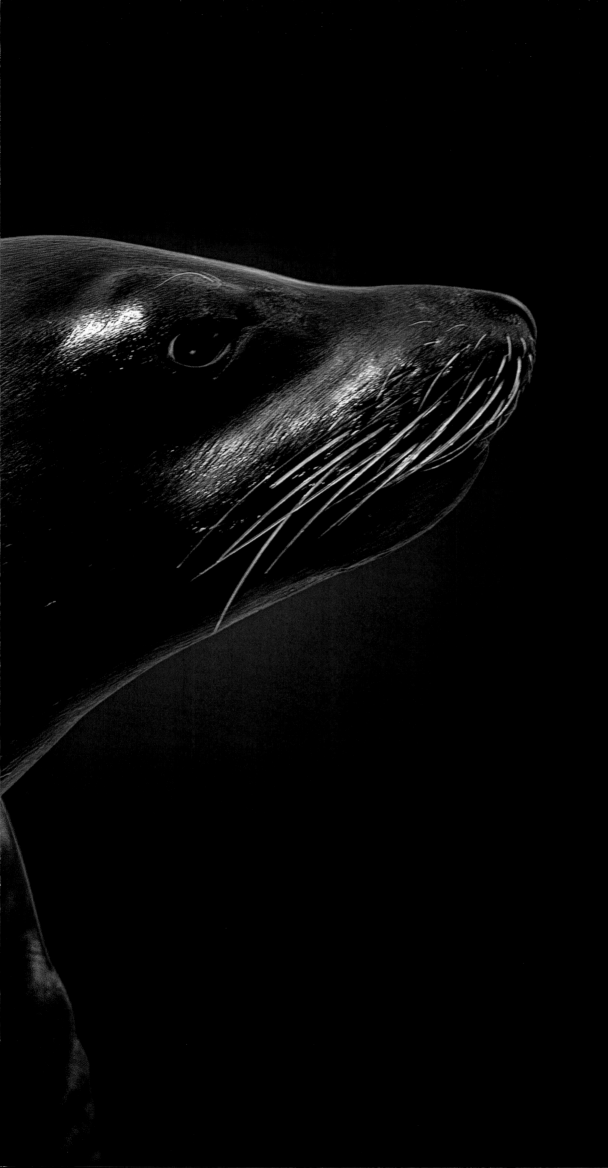

The oceans are home to 80 percent of the planet's living beings. It is estimated that there will be more plastic in the oceans than fish by 2050. Many species, such as sea lions, eat plastic and die from this or from becoming entangled in plastic debris. Plastic is also worn down into microparticles that pass down the food chain and end up in our own stomachs.

In den Ozeanen leben 80 Prozent aller weltweit verbreiteten Tiere. Schätzungen zufolge wird es im Jahr 2050 jedoch mehr Plastik im Meer geben als Fische. Viele Arten, wie die Mähnenrobben, fressen es und sterben daran. Oder sie bleiben im Müll hängen. Zudem zersetzt sich das Plastik zu Mikropartikeln, die auf diese Weise in die Nahrungskette geraten und schließlich auch in unserem Magen landen.

Los océanos albergan al 80 % de los seres vivos del planeta. Se estima que en 2050 habrá más plásticos que peces en los océanos. Muchas especies, como los leones marinos, lo consumen y mueren a consecuencia de ello o al quedar atrapadas en estos desechos. El plástico se convierte además en micro-partículas que pasan a la cadena alimenticia y terminan en nuestro propio estómago.

Si aujourd'hui, 80 % des êtres vivants de la planète vivent dans les océans, on estime qu'en 2050, on y trouvera plus de plastique que de poissons. De nombreuses espèces, comme les lions de mer, meurent en absorbant des déchets ou en y étant pris au piège. Le plas-tique se décompose en micro-particules qui passent dans la chaîne alimentaire pour finir dans notre estomac.

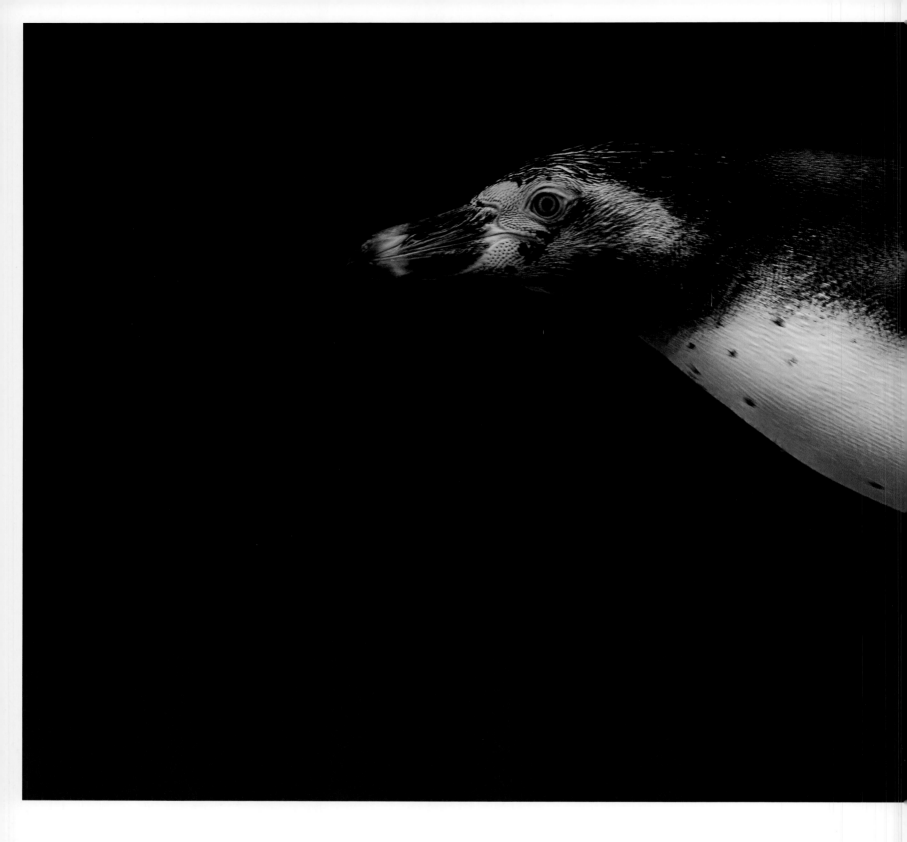

Humboldt penguin
Spheniscus humboldti, 1834

fragile

Once found in large numbers along the coasts of Peru and Chile, the Humboldt penguin today is seriously threatened by pollution, climate change, the arrival of invasive species, and accidental capture, but mainly by overfishing, which makes it hard for them to feed. Their current numbers stand at less than 50,000, less than half of what they were ten years ago.

Der Humboldt-Pinguin kam früher an den Küsten Perus und Chiles zahlreich vor, doch heute ist er ernsthaft bedroht. Gründe dafür sind Umweltverschmutzung, Klimawandel, invasive Arten oder Beifang, aber vor allem Überfischung. Sie führt dazu, dass der Pinguin kaum noch Nahrung findet. Aktuell liegt der Bestand bei knapp 50 000 Tieren – weniger als die Hälfte als noch vor zehn Jahren.

Antaño muy abundante en las costas de Perú y Chile, hoy en día el pingüino de Humboldt está seriamente amenazado por la contaminación, el cambio climático, la llegada de especies invasoras o la captura accidental, pero sobre todo por la sobrepesca que le dificulta la búsqueda de alimento. En la actualidad la población no supera los 50 000 ejemplares, menos de la mitad que hace diez años.

Autrefois très nombreux sur les côtes du Pérou et du Chili, les manchots de Humboldt sont aujourd'hui gravement menacés par la pollution, le changement climatique, l'arrivée d'espèces envahissantes et la capture accidentelle, mais surtout par la surpêche qui les prive de poissons. Aujourd'hui, on ne compte plus que 50 000 spécimens, soit moins de la moitié de la population d'il y a dix ans.

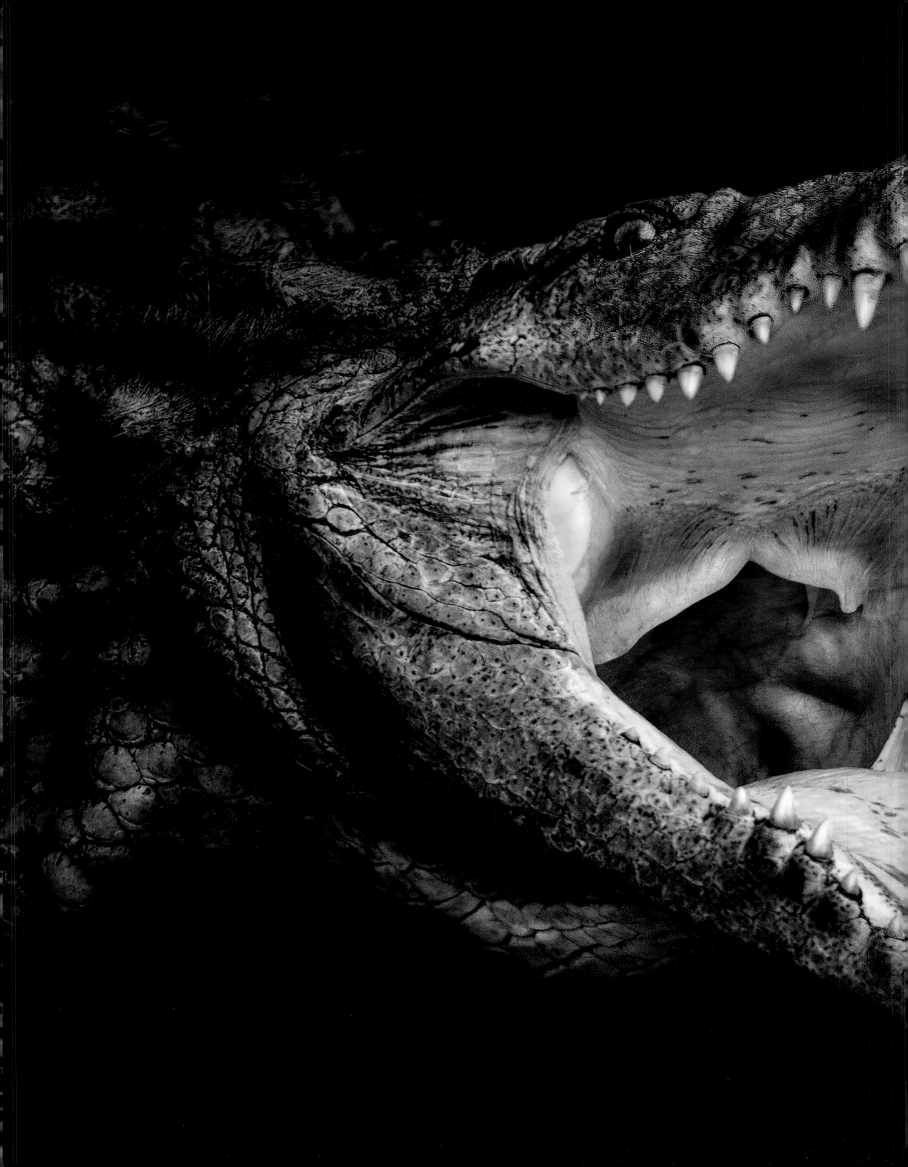

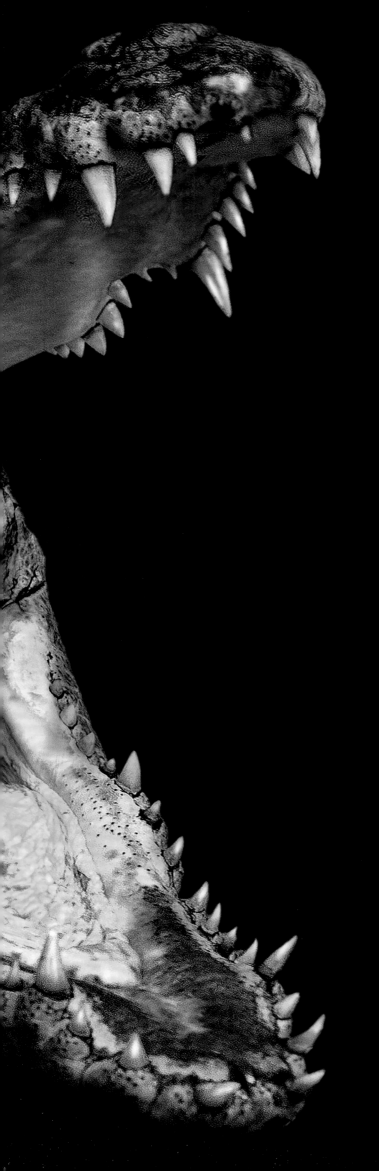

Nile crocodile
Crocodylus niloticus, 1768

The association between Egypt and crocodiles is a very close one; already in ancient times they were feared and venerated. Faced with the risk of their extinction, the country has embarked on recovery programs to save the species and their success has allowed the crocodile to shift from the Appendix I list of the most endangered species to the Appendix II list of species that are not now threatened with extinction but whose trade must be closely controlled.

Die Verbindung zwischen Ägypten und den Krokodilen ist sehr eng, da die Tiere schon im Altertum gefürchtet waren und verehrt wurden. Angesichts des drohenden Aussterbens hat das Land Programme zur Arterhaltung umgesetzt. Dadurch konnte das Krokodil von der Liste der vom Aussterben bedrohten Arten in die Liste der Arten wechseln, die nicht akut bedroht sind, deren Handel aber überwacht werden sollte.

El vínculo entre Egipto y los cocodrilos es muy estrecho, ya que en la antigüedad eran animales temidos y venerados. Ante el peligro de su extinción, este país ha llevado a cabo programas de recuperación de la especie y su éxito ha permitido al cocodrilo pasar del Apéndice I de especies en peligro de extinción al Apéndice II de especies no amenazadas pero cuyo comercio debe ser controlado.

Le lien entre l'Égypte et les crocodiles est très étroit. Dans l'Antiquité, ces reptiles étaient craints et vénérés. Face à la menace d'extinction, l'Égypte a mis en place des programmes de réintroduction de l'espèce. Son succès a permis au crocodile de passer de l'Annexe I des espèces en danger d'extinction à l'Annexe II des espèces non menacées, mais dont le commerce doit impérativement être contrôlé.

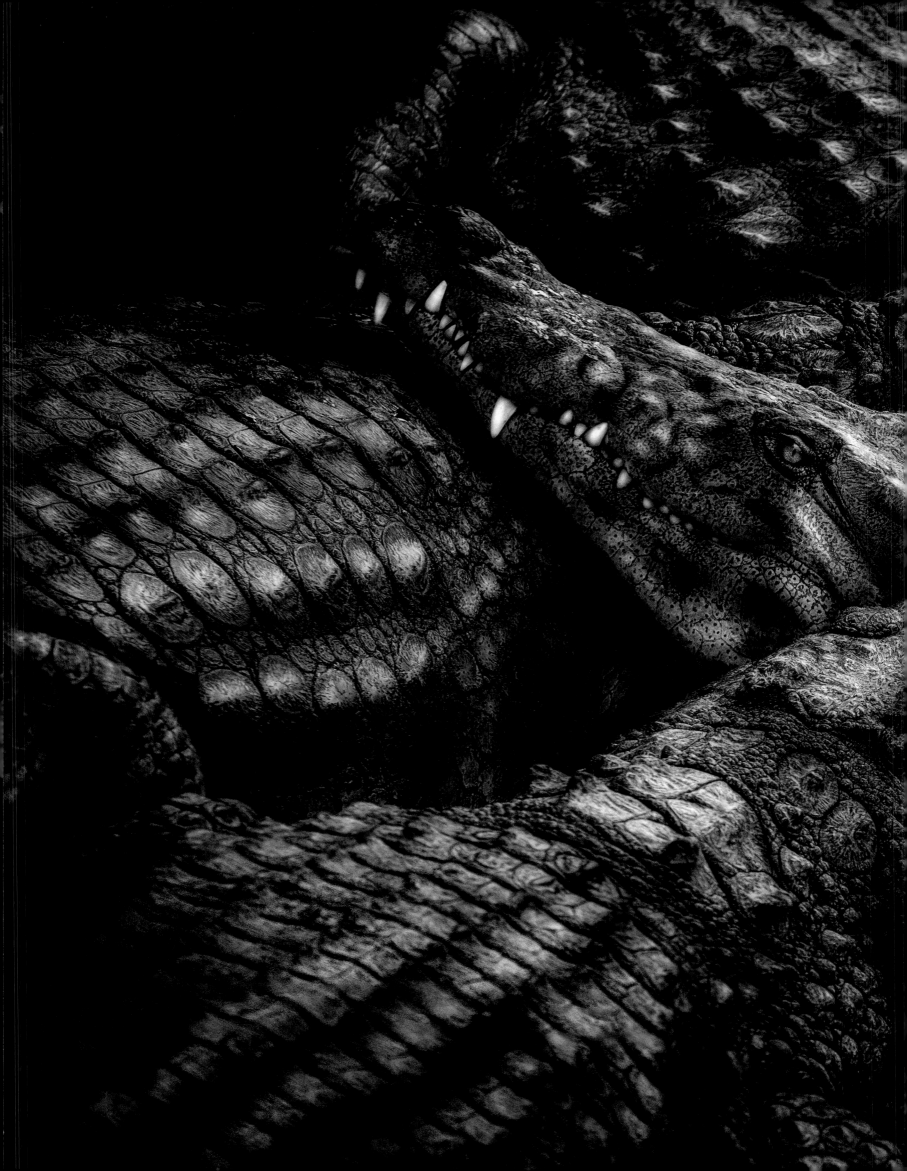

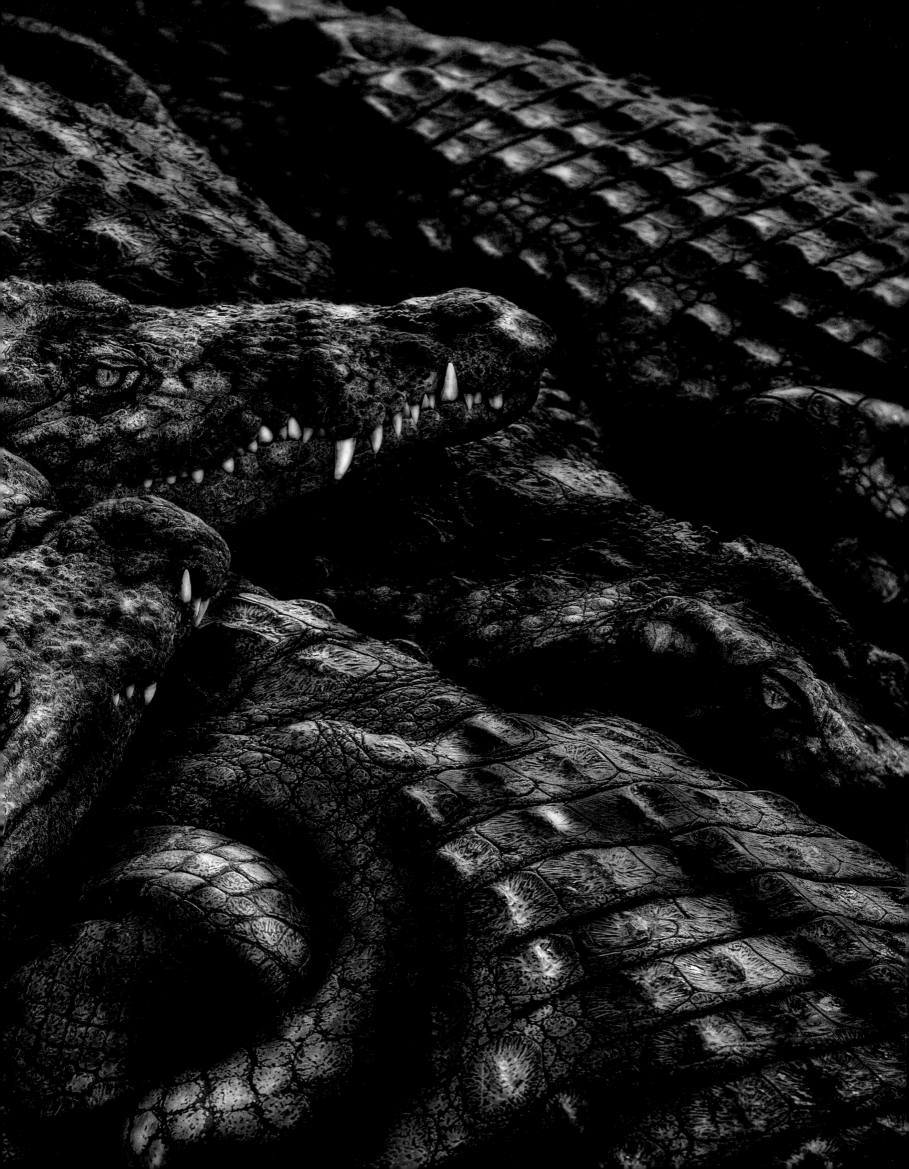

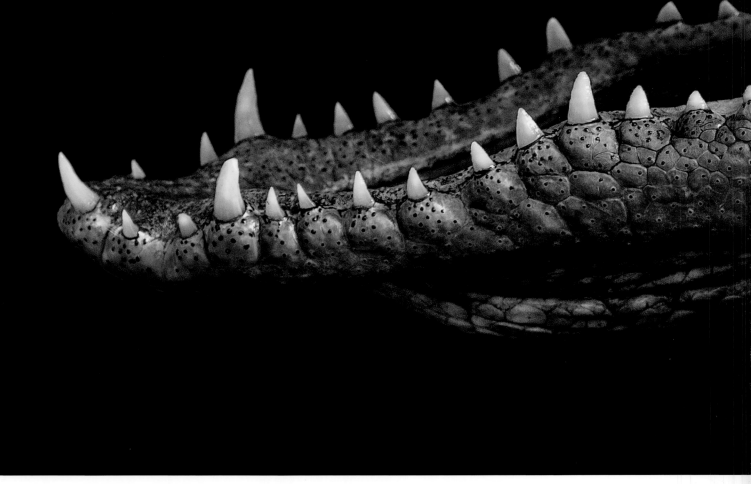

fragile

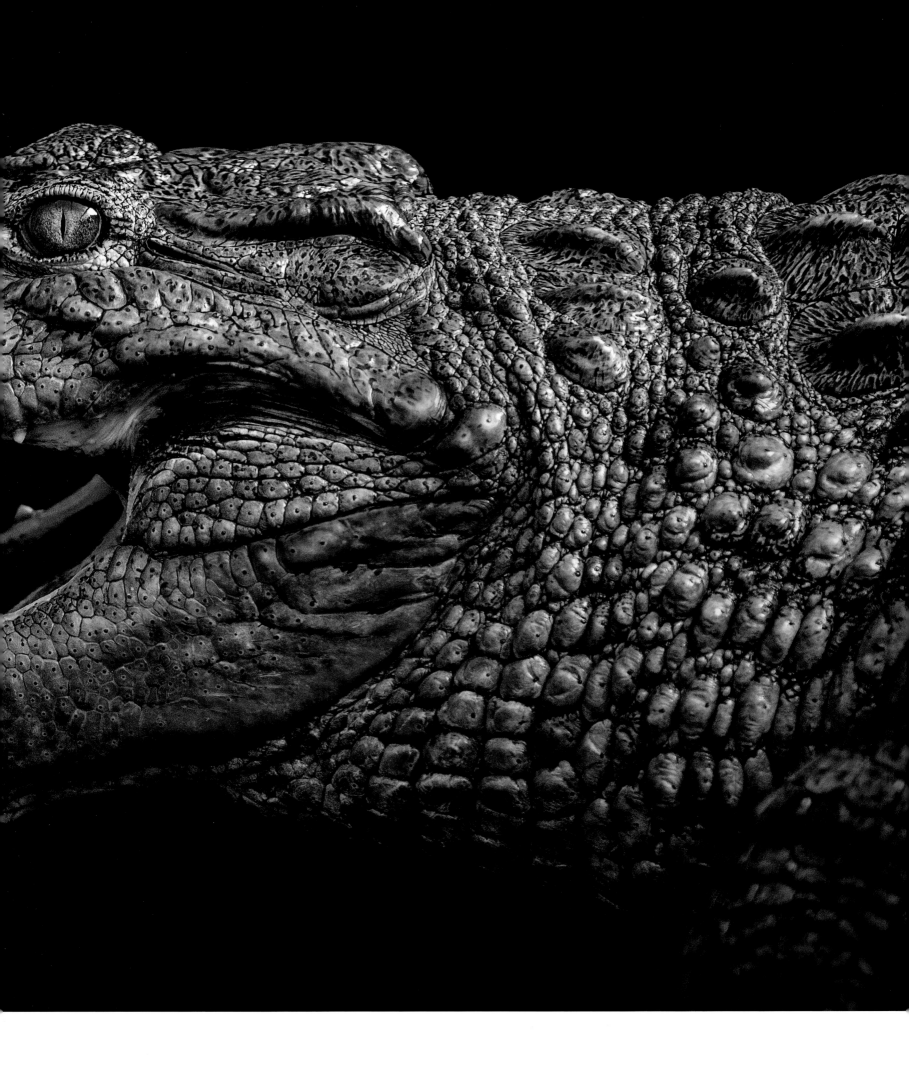

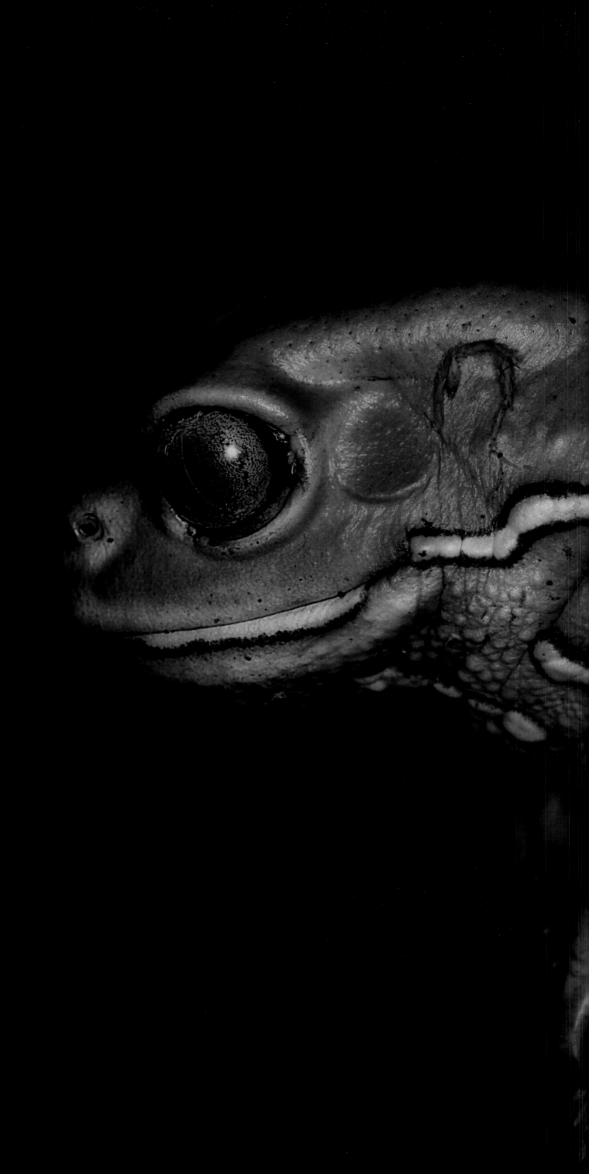

Waxy monkey
tree frog

Phyllomedusa sauvagii
1882

The impact of the drastic
decline in biodiversity is
most evident in species like
amphibians, where plum-
meting numbers are reaching
dramatic extremes. More
than half are on the brink of
vanishing forever on a silent
and unstoppable road to
extinction. Growing urban-
ization, pollution, and climate
change have taken a heavy
toll, particularly among these
fragile species.

Der drastische Rückgang
der Artenvielfalt zeigt
sich besonders bei empfind-
lichen Tieren wie den Am-
phibien. Gerade bei ihnen
erreicht die Dezimierung des
Bestands dramatische Aus-
maße. Mehr als die Hälfte
der Amphibien weltweit steht
kurz vor einer unaufhaltsamen
Auslöschung. Verstädterung,
Umweltverschmutzung und
Klimawandel haben diesen
hochsensiblen Tieren beson-
ders stark zugesetzt.

El impacto de la drástica
reducción de la biodiver-
sidad es más evidente en espe-
cies como los anfibios, en las
que el colapso de la población
alcanza extremos dramáticos.
Más de la mitad está a punto
de desaparecer para siempre
en una silenciosa e imparable
extinción. La expansión de la
urbanización, la contamina-
ción y el cambio climático se
han cebado especialmente en
estas frágiles especies.

La réduction drastique de la
biodiversité est particuliè-
rement évidente sur des espèces
telles que les amphibiens, dont
les populations ont été déci-
mées. Plus de la moitié est sur
le point de disparaître à jamais,
happé par un lent processus
d'extinction silencieux et
inexorable. L'expansion de l'ur-
banisation, la pollution et les
changements climatiques ont
eu un impact tragique chez
ces espèces fragiles.

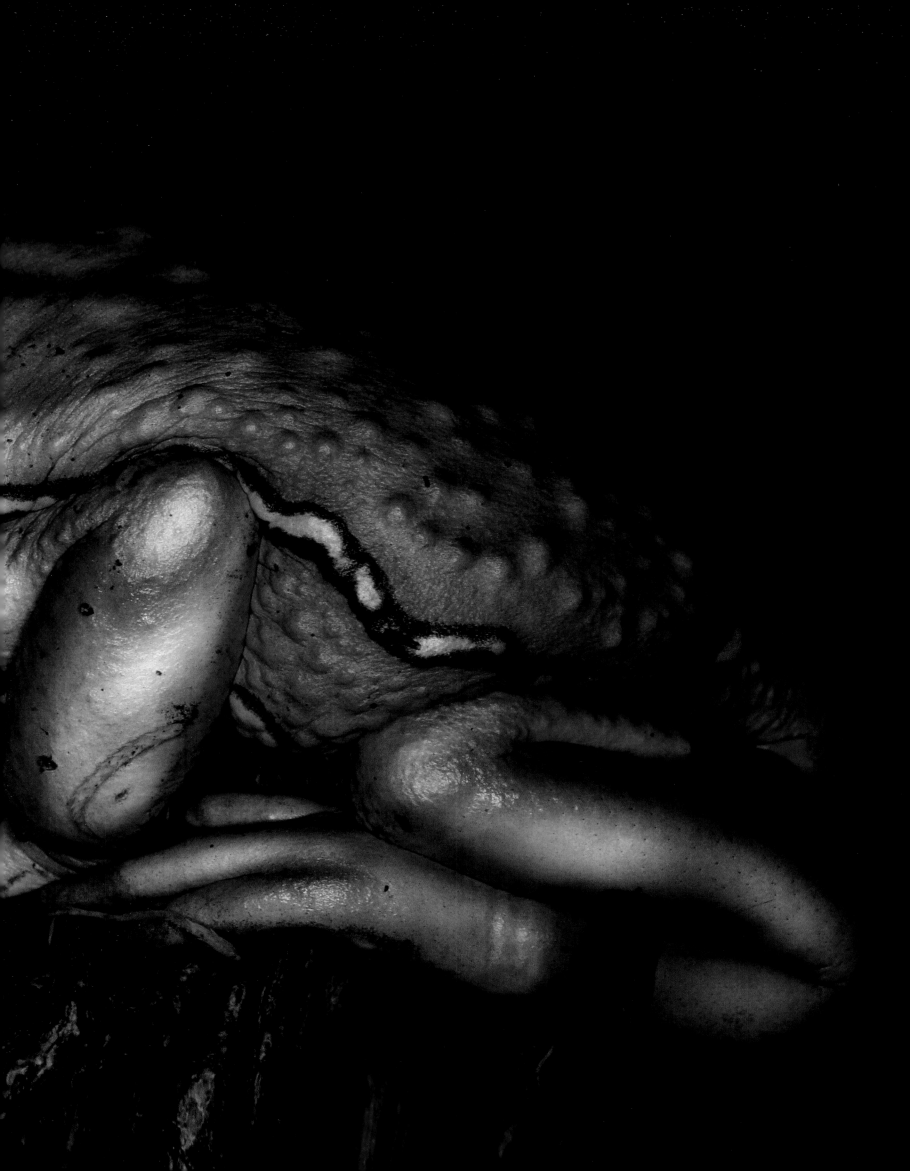

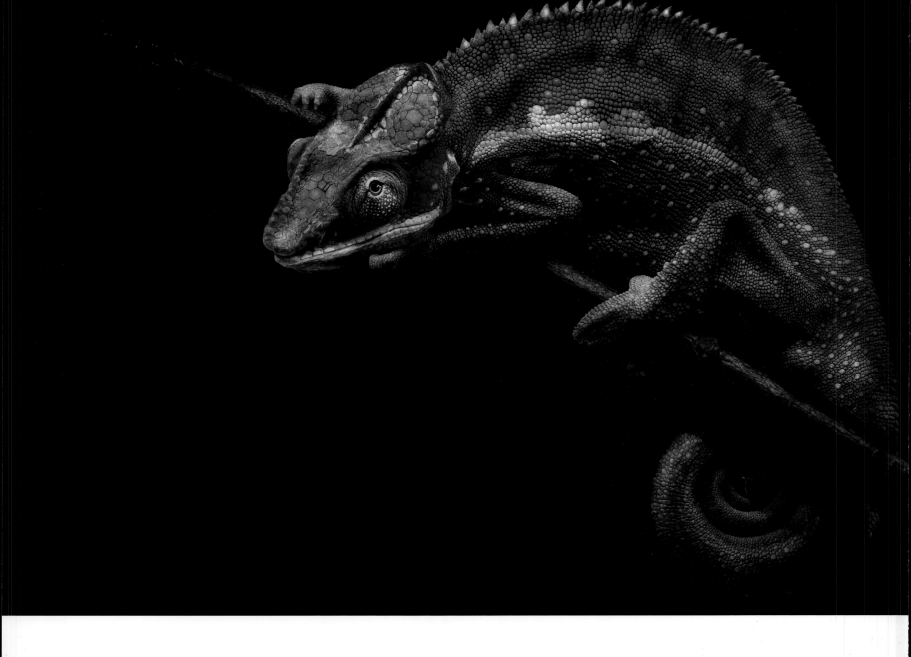

Panther Chameleon
Furcifer pardalis, 1829

The panther chameleon is one of the most colorful of all the chameleons, which vary their color and pattern depending on their place of origin on the island of Madagascar. Researchers have discovered that their changing color is caused by light reflecting off microscopic crystals that move over the animals' skin. Each chameleon has a personality of its own.

Das Pantherchamäleon zählt zu den farbenprächtigsten Chamäleons weltweit. Farbe und Muster variieren je nach seinem Verbreitungsgebiet auf Madagaskar. Forscher haben entdeckt, dass die Farbveränderung durch lichtreflektierende Nanokristalle in der Haut entsteht. Jedes Chamäleon hat seine eigene individuelle Zeichnung und ist so unverwechselbar.

El camaleón pantera es uno de los más coloridos de todos los camaleones y varía su color y patrón según su lugar de origen en la isla de Madagascar. Los investigadores han descubierto que el cambio de color se produce por el reflejo de la luz de cristales microscópicos que se mueven sobre la piel de los animales. Cada camaleón tiene su propia personalidad.

Le caméléon panthère est un des caméléons les plus colorés. La couleur et le motif de sa peau varient en fonction de son origine sur l'île de Madagascar. Les chercheurs ont découvert que le changement de couleur est dû à la réflexion de la lumière de cristaux microscopiques qui se déplacent sur son épiderme. Ainsi, chaque caméléon a sa propre personnalité.

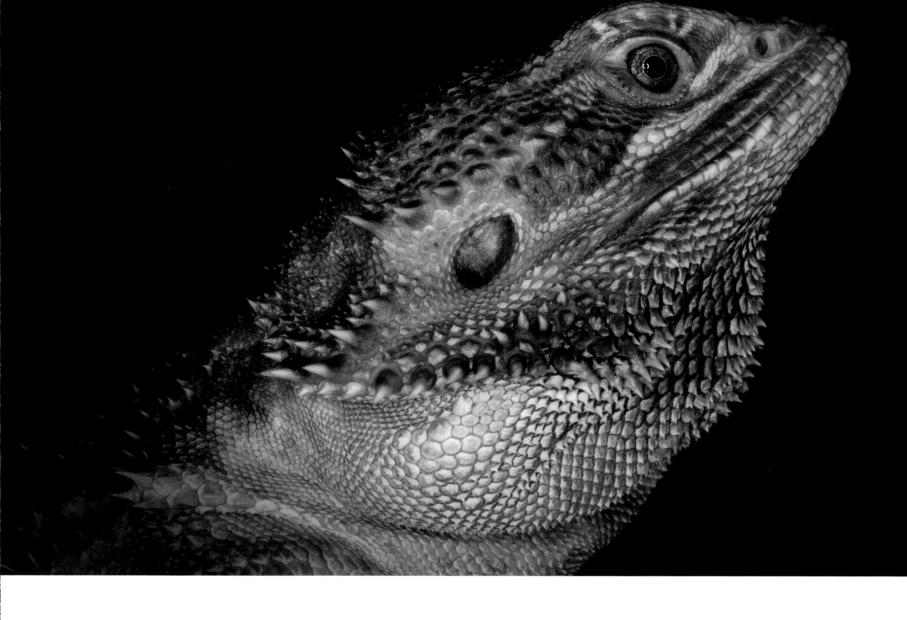

Bearded dragon
Pogona vitticeps, 1926

Like many other reptiles, the bearded dragon is often kept as a pet. Even so, one in every five reptiles is endangered. The conversion of their habitats into farmland and the fact that they are particularly vulnerable to environmental change are the main causes of their decline. Reptiles are some of the most ancient of land animals.

Die Streifenköpfige Bartagame wird, wie viele Reptilien, gern als Haustier gehalten. Trotzdem ist eine von fünf Reptilienarten vom Aussterben bedroht. Die Umwandlung ihrer Lebensräume zu landwirtschaftlichen Nutzflächen und die Tatsache, dass sie besonders sensibel auf Umweltveränderungen reagieren, sind die Hauptursachen für ihren Niedergang. Die Reptilien zählen zu den ältesten Landtieren.

El dragón barbudo o pogona, al igual que muchos reptiles, se ha empleado mucho como mascota. Aún así, uno de cada cinco reptiles está en peligro de extinción. La conversión de sus hábitats para usos agrícolas y el hecho de ser particularmente vulnerables a los cambios ambientales son las principales causas de su declive. Los reptiles son uno de los animales terrestres más antiguos.

Le dragon barbu ou pogona, a été adopté comme animal de compagnie. Pourtant, un reptile sur cinq est en danger d'extinction. La conversion de leurs habitats à des fins agricoles et le fait qu'ils soient particulièrement vulnérables aux changements environnementaux sont les principales causes de leur déclin. Les reptiles comptent parmi les plus anciens animaux terrestres.

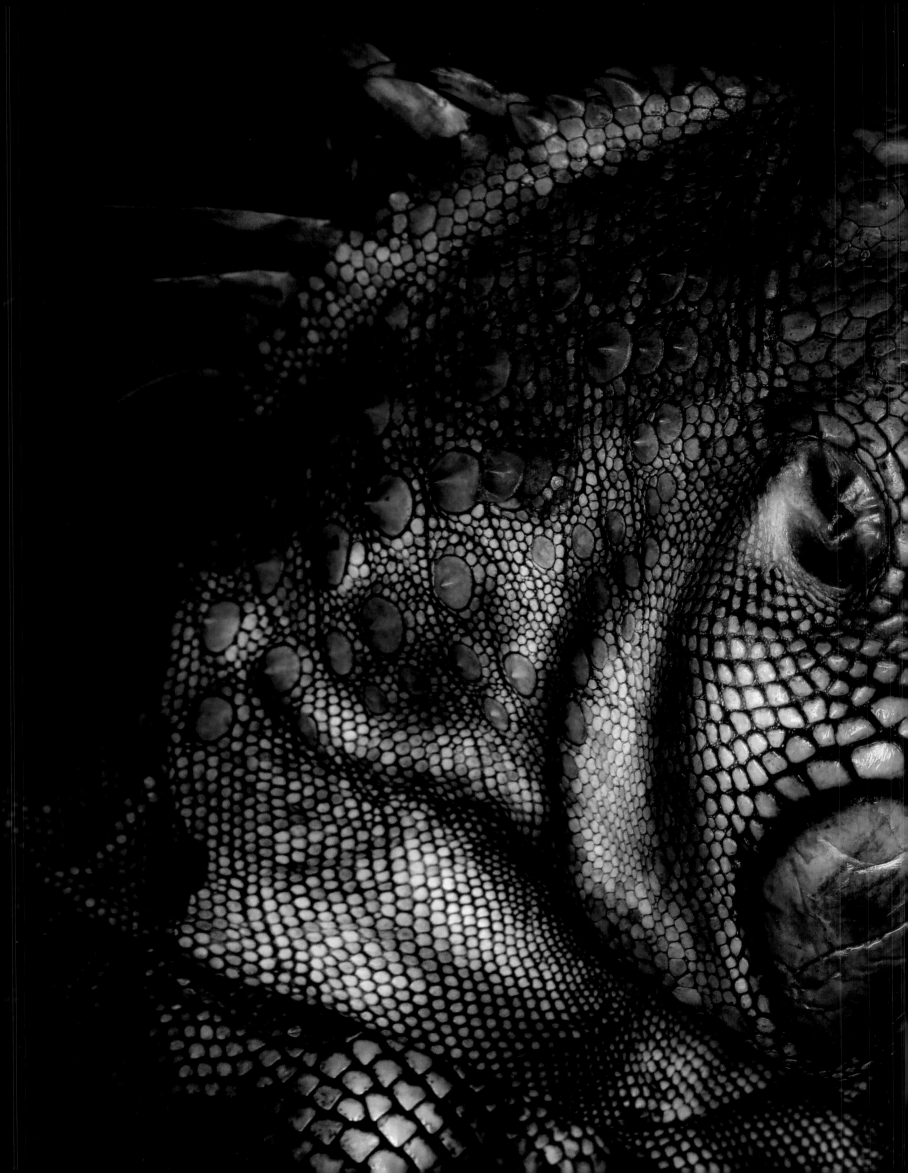

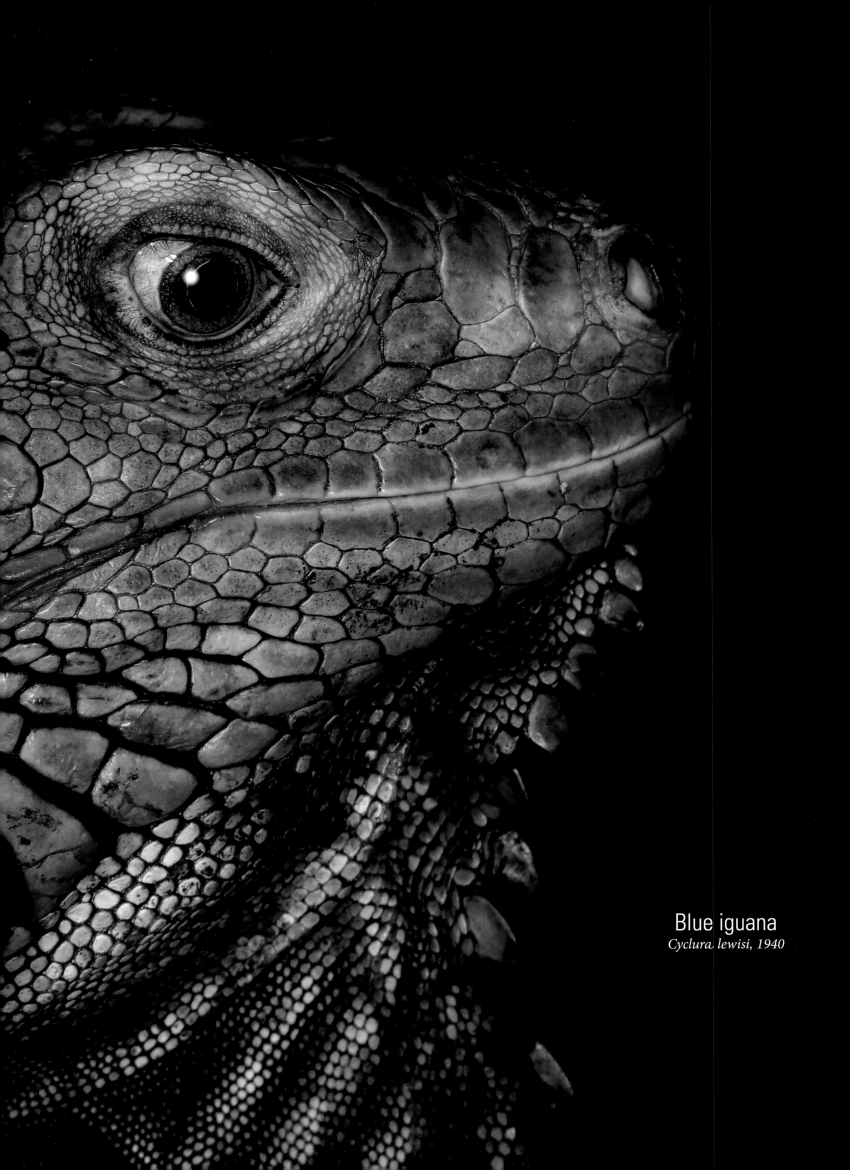

Blue iguana
Cyclura lewisi, 1940

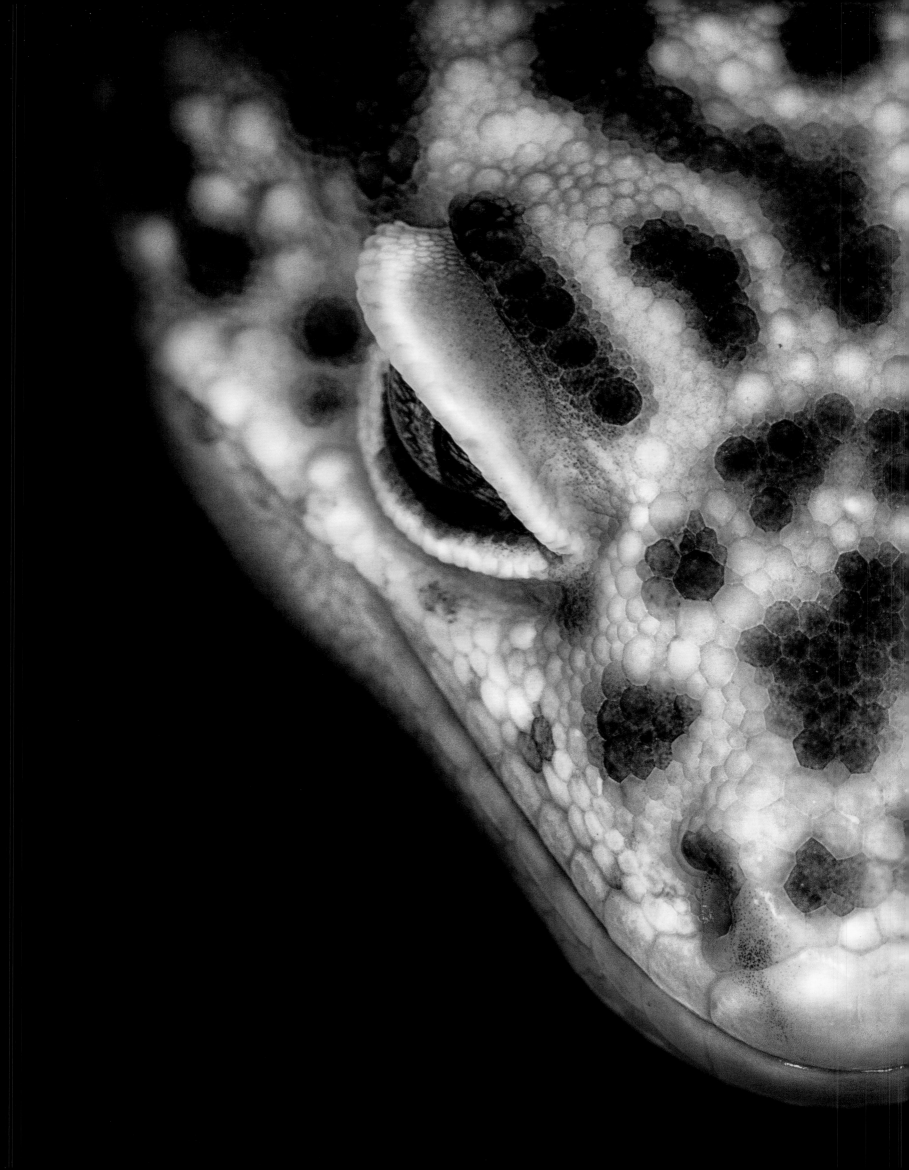

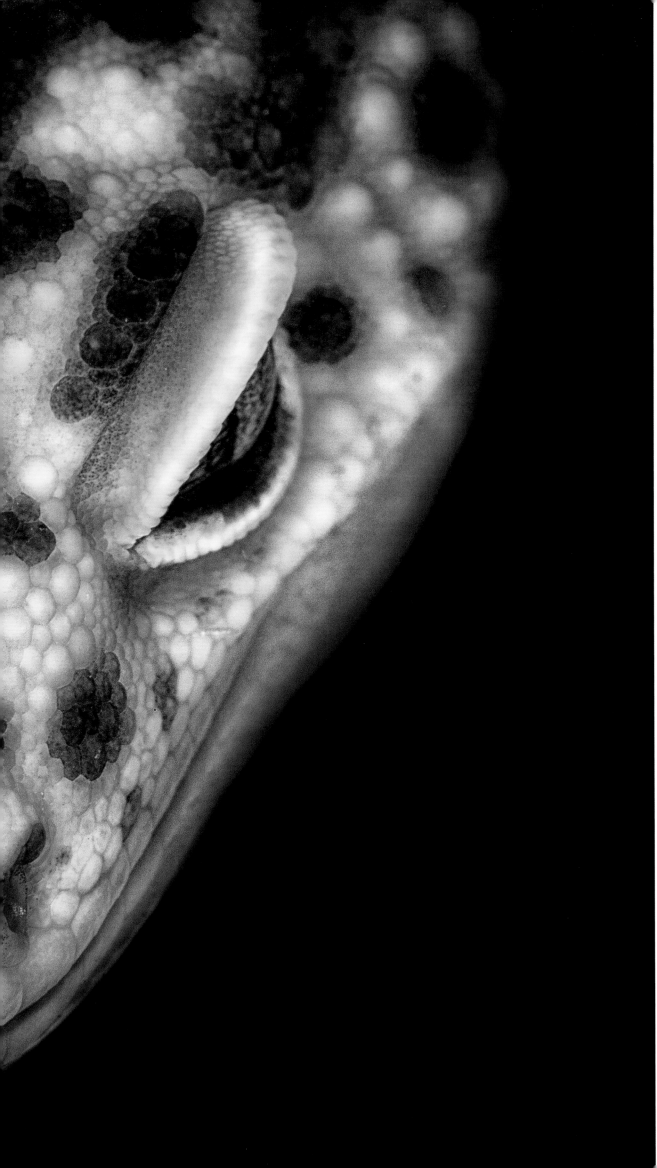

Common leopard gecko
Eublepharis macularius
1854

In Western countries, the leopard gecko has become a very popular pet among reptile lovers because of their relatively easy care. Owing to local superstitions, these natives of Southwest and Central Asia do not enjoy a very good reputation in their natural habitats, where they are thought to be venomous and to bring bad luck, and are often killed.

Im Westen erfreut sich der Leopardgecko unter Reptilienliebhabern großer Beliebtheit, weil er relativ pflegeleicht ist. In seiner Heimat in Südost- und Zentralasien genießt er aufgrund von lokalem Aberglauben keinen besonders guten Ruf: Er wird dort häufig getötet, weil man glaubt, er sei giftig und würde Unglück bringen.

En occidente, el gecko leopardo se ha convertido en una mascota muy popular entre los amantes de los reptiles por su relativamente fácil cuidado. Originarios del sudoeste y centro asiático, en sus hábitats naturales no gozan sin embargo de muy buena reputación debido a las supersticiones locales; con frecuencia se les mata ya que se piensa que son venenosos y que traen mala suerte.

En Occident, le gecko léopard est devenu un animal de compagnie très populaire chez les amateurs de reptiles en raison de sa facilité d'entretien. Dans leurs pays d'origine, en Asie du Sud-Ouest et en Asie centrale, les superstitions locales ne sont pas à leur avantage : on les tue, car on les considère à tort comme venimeux ou porteurs de malchance.

Axolotl
Ambystoma mexicanum
1798

The axolotl is an amphibian endemic to the Valley of Mexico. Also known as the water monster, it was once used for food and in medicine. Its most peculiar characteristic is its ability to regenerate its limbs, and even its brain. It has the largest genome of all living beings, a potential treasure of biological knowledge. It is nearly extinct in the wild.

Der Axolotl war früher im Xochimilco-See in Mexiko häufig anzutreffen. Sein Name bedeutet »Wassermonster«. Sein besonderes Merkmal ist die Fähigkeit, Gliedmaßen, Organe und sogar Teile des Gehirns wiederherzustellen. Außerdem besitzt er von allen Lebewesen das größte Genom, ein wahrer Schatz an biologischem Wissen. Leider diente diese Amphibie lange Zeit als Nahrung oder Medizin. In freier Natur ist der Axolotl inzwischen so gut wie ausgestorben.

El ajolote es un anfibio endémico del valle de México. Su nombre significa monstruo del agua y se utilizaba como alimento o medicamento. Su característica más peculiar es su capacidad para regenerar sus miembros e incluso el cerebro, y tiene el genoma más grande de todos los seres vivos, un tesoro potencial de conocimientos biológicos. En estado salvaje se encuentra casi extinto.

L'axolotl est un amphibien endémique de la vallée du Mexique. Son nom signifie « monstre d'eau » et on le consommait principalement comme plat ou médicament. Il est connu pour la capacité exceptionnelle de régénération de ses membres et de son cerveau. Il possède le plus grand génome de tous les êtres vivants, un trésor potentiel de connaissances biologiques. À l'état sauvage, il est quasiment en état d'extinction.

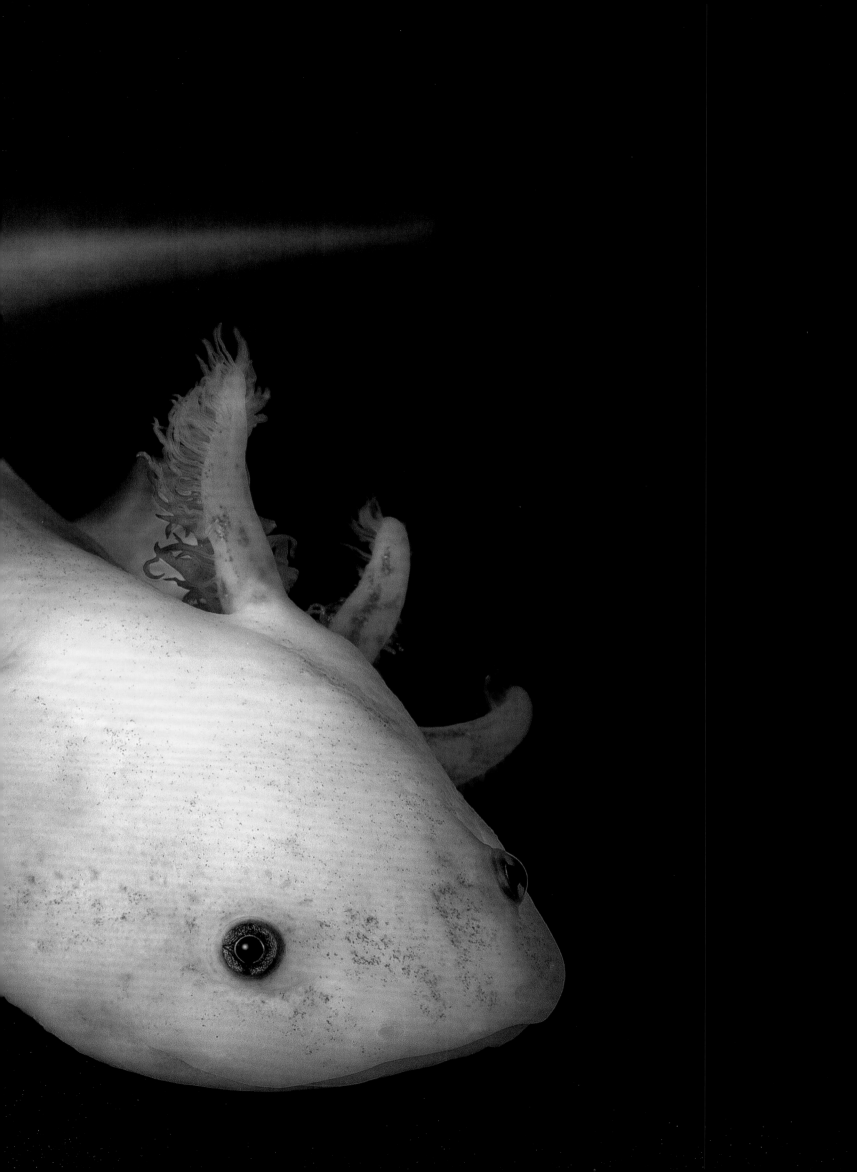

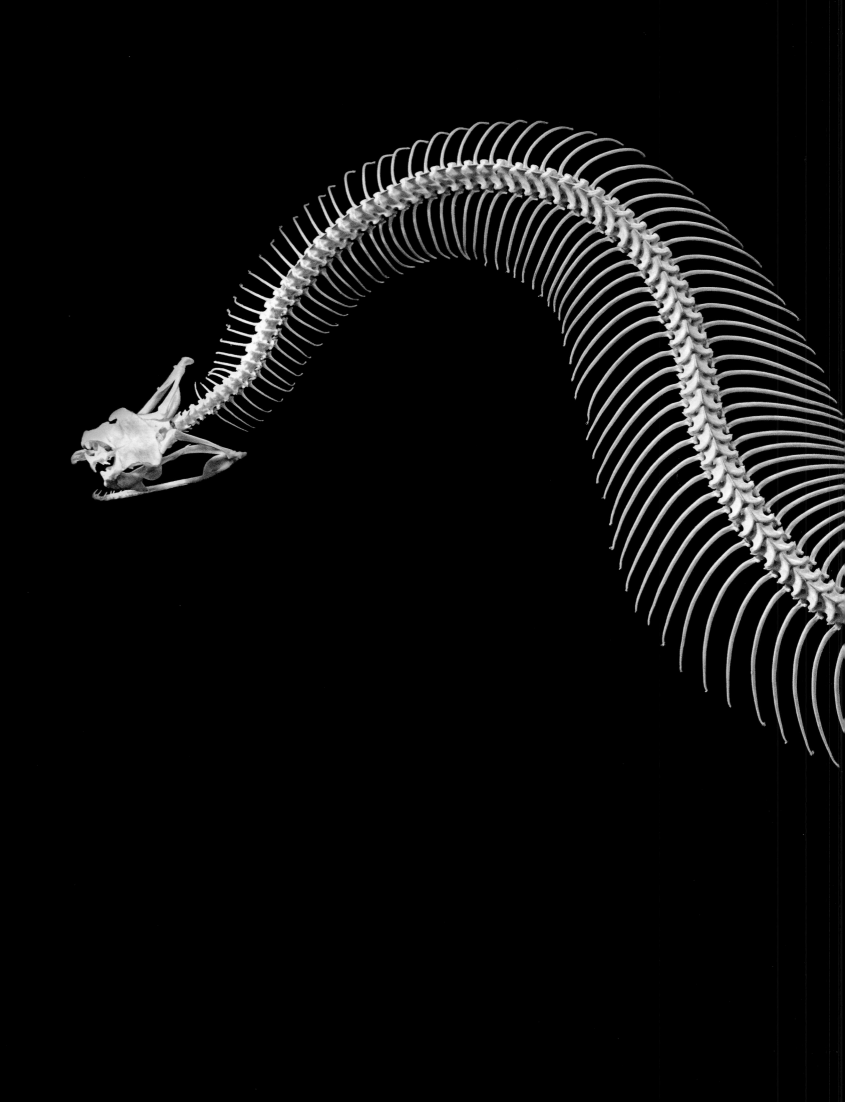

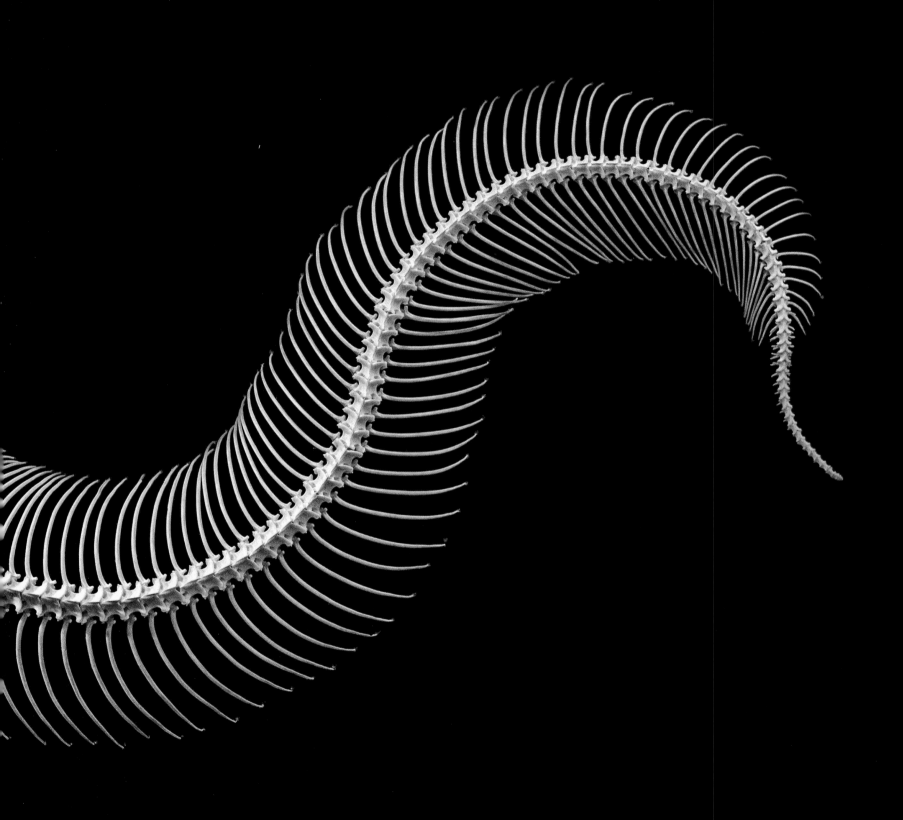

Boa constrictor
Boa constrictor, 1758

Index

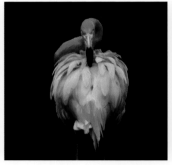

American flamingo
Phoenicopterus ruber, 1758
4

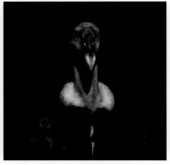

Griffon vulture
Gyps fulvus, 1783
10

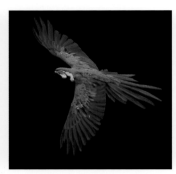

Blue-and-yellow macaw
Ara ararauna, 1758
12

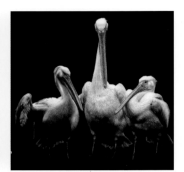

Great white pelican
Pelecanus onocrotalus, 1758
14

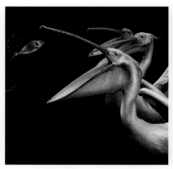

Great white pelican
Pelecanus onocrotalus, 1758
16

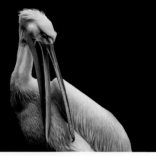

Great white pelican
Pelecanus onocrotalus, 1758
18

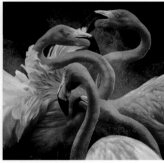

American flamingo
Phoenicopterus ruber, 1758
20

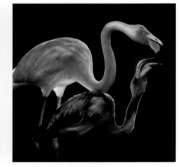

American flamingo
Phoenicopterus ruber, 1758
22

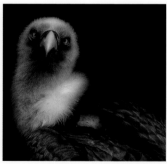

Griffon vulture
Gyps fulvus, 1783
24

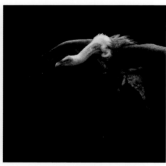

Griffon vulture
Gyps fulvus, 1783
26

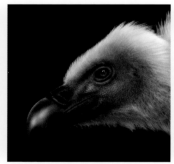

Griffon vulture
Gyps fulvus, 1783
28

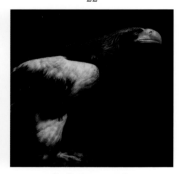

Steller's sea eagle
Haliaeetus pelagicus, 1811
30

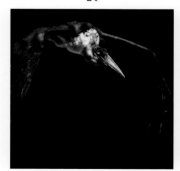

Marabou stork
Leptoptilos crumeniferus, 1831
32

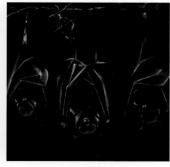

Large flying fox
Pteropus vampyrus, 1758
34

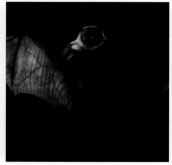

Large flying fox
Pteropus vampyrus, 1758
36

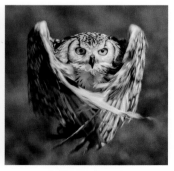

Indian eagle-owl
Bubo bengalensis, 1831
38

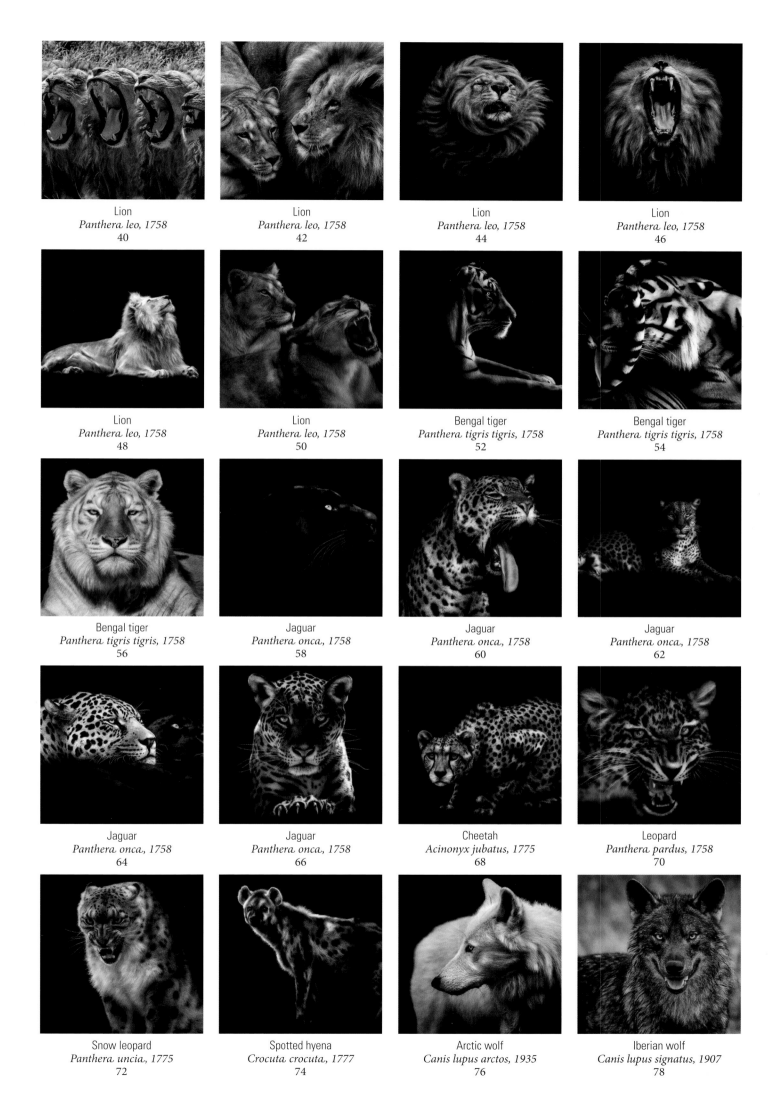

Lion
Panthera leo, 1758
40

Lion
Panthera leo, 1758
42

Lion
Panthera leo, 1758
44

Lion
Panthera leo, 1758
46

Lion
Panthera leo, 1758
48

Lion
Panthera leo, 1758
50

Bengal tiger
Panthera tigris tigris, 1758
52

Bengal tiger
Panthera tigris tigris, 1758
54

Bengal tiger
Panthera tigris tigris, 1758
56

Jaguar
Panthera onca, 1758
58

Jaguar
Panthera onca, 1758
60

Jaguar
Panthera onca, 1758
62

Jaguar
Panthera onca, 1758
64

Jaguar
Panthera onca, 1758
66

Cheetah
Acinonyx jubatus, 1775
68

Leopard
Panthera pardus, 1758
70

Snow leopard
Panthera uncia, 1775
72

Spotted hyena
Crocuta crocuta, 1777
74

Arctic wolf
Canis lupus arctos, 1935
76

Iberian wolf
Canis lupus signatus, 1907
78

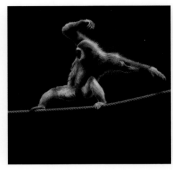

Lar gibbon
Hylobates lar, 1771
80

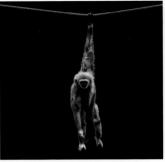

Lar gibbon
Hylobates lar, 1771
82

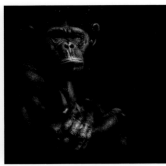

Chimpanzee
Pan troglodytes, 1775
84

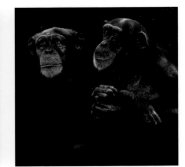

Chimpanzee
Pan troglodytes, 1775
86

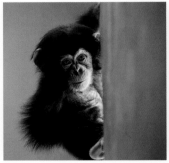

Chimpanzee
Pan troglodytes, 1775
88

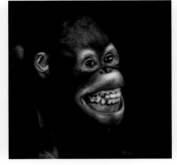

Chimpanzee
Pan troglodytes, 1775
90

Bornean orangutan
Pongo pygmaeus, 1760
92

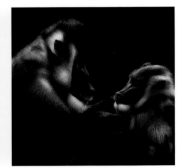

Drill
Mandrillus leucophaeus, 1807
94

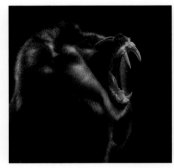

Drill
Mandrillus leucophaeus, 1807
96

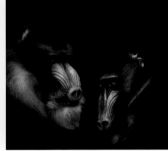

Mandrill
Mandrillus sphinx, 1758
98

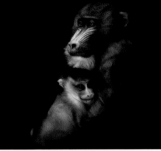

Mandrill
Mandrillus sphinx, 1758
100

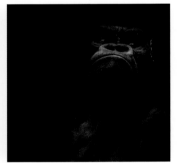

Western gorilla
Gorilla gorilla, 1847
102

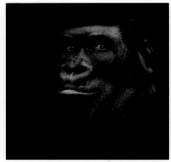

Western gorilla
Gorilla gorilla, 1847
103

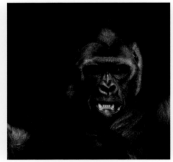

Western gorilla
Gorilla gorilla, 1847
104

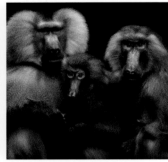

Hamadryas baboon
Papio hamadryas, 1758
106

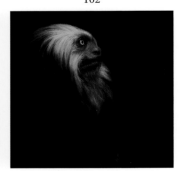

Golden Lion tamarin
Leontopithecus rosalia, 1766
108

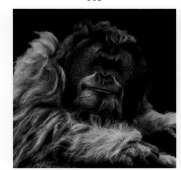

Bornean orangutan
Pongo pygmaeus, 1760
110

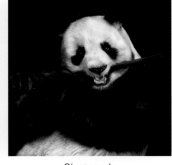

Giant panda
Ailuropoda melanoleuca, 1869
112

Brown bear
Ursus arctos, 1758
114

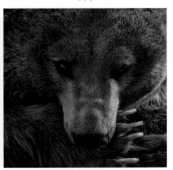

Brown bear
Ursus arctos, 1758
116

Polar bear
Ursus maritimus, 1774
118

Red kangaroo
Macropus rufus, 1822
120

Wallaby
Macropus rufogriseus, 1817
122

Meerkat
Suricata suricatta, 1776
125

Lemur
Lemuroidea, 1821
126

Lemur
Lemuroidea, 1821
128

Horse
Equus caballus, 1758
130

Red deer
Cervus elaphus, 1758
132

Barbary sheep
Ammotragus lervia, 1777
134

Common eland
Taurotragus oryx, 1766
136

Ankole-Watusi
Bos taurus, 1758
138

Scimitar oryx
Oryx dammah, 1827
140

European bison
Bison bonasus, 1758
142

Domestic yak
Bos grunniens, 1883
144

Okapi
Okapia johnstoni, 1901
146

Giraffe
Giraffa camelopardalis, 1762
148

Giraffe
Giraffa camelopardalis, 1762
150

Giraffe
Giraffa camelopardalis, 1762
152

Camel
Camelus, 1758
154

Alpaca
Vicugna pacos, 1758
156

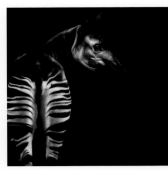

Okapi
Okapia johnstoni, 1901
158

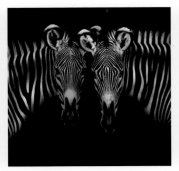

Zebra
Equus quagga, 1785
160

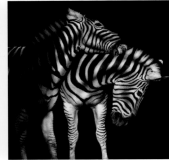

Zebra
Equus quagga, 1785
162

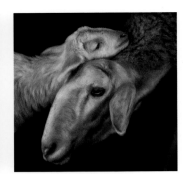

Domestic sheep
Ovis aries, 1758
164

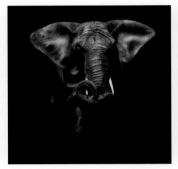

African elephant
Loxodonta africana, 1797
166

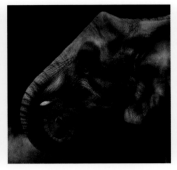

African elephant
Loxodonta africana, 1797
168

Asian elephant
Elephas maximus, 1758
170

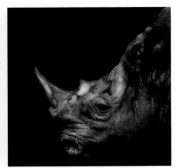

Southern white rhinoceros
Ceratotherium simum simum
1817 | 172

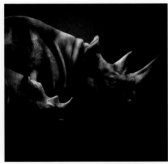

Southern white rhinoceros
Ceratotherium simum simum
1817 | 174

Common warthog
Phacochoerus africanus, 1788
176

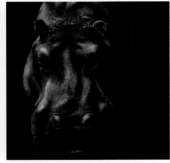

Hippopotamus
Hippopotamus amphibius, 1758
178

Hippopotamus
Hippopotamus amphibius, 1758
180

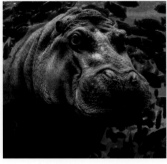

Hippopotamus
Hippopotamus amphibius, 1758
182

Malayan tapir
Tapirus indicus, 1819
184

Giant Anteater
Myrmecophaga tridactyla, 1758
186

Sea lion
Otaria flavescens, 1800
188

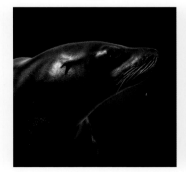

Sea lion
Otaria flavescens, 1800
190

Humboldt penguin
Spheniscus humboldti, 1834
192

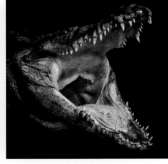

Nile crocodile
Crocodylus niloticus, 1768
194

Nile crocodile
Crocodylus niloticus, 1768
196

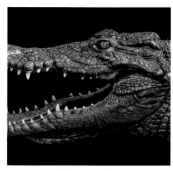

Nile crocodile
Crocodylus niloticus, 1768
198

Waxy monkey tree frog
Phyllomedusa sauvagii, 1882
200

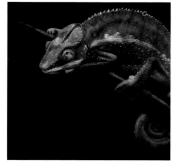

Panther Chameleon
Furcifer pardalis, 1829
202

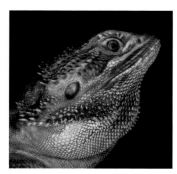

Bearded dragon
Pogona vitticeps, 1926
203

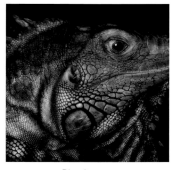

Blue iguana
Cyclura lewisi, 1940
204

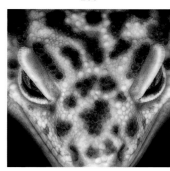

Common leopard gecko
Eublepharis macularius, 1854
206

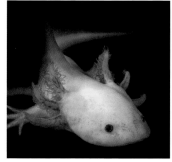

Axolotl
Ambystoma mexicanum, 1798
208

Boa constrictor
Boa constrictor, 1758
210

About Pedro Jarque Krebs

Pedro Jarque Krebs is a photographer who was born in Lima, Peru, and specializes in animal portraits. He graduated from the Sorbonne University in Paris with a degree in Philosophy of Science, and took courses in Art History and Archeology. In 1984, he won the Municipality of Lima award for black and white photography. Since that time, Pedro Jarque has received more than 110 prizes and recognitions, 31 gold medals, 10 silver medals, and 6 bronze medals, in addition to many honorable mentions, and has been a finalist of the most important international photography competitions. Among these are the Sony World Photography Awards, whose Peru National Award he won two years in a row, in 2018 and 2019; the 2018 Bird Photographer of the Year competition (United Kingdom), where he was the overall winner; Montier Festival Photo (France) in 2018, Oasis Photo Contest (Italy) in 2017; the Sente-Antu Cup (China) in 2018, and the Trierenberg Super Circuit (Austria) in 2018. He was a finalist four years in a row of the Smithsonian Annual Photo Contest (United States). In October 2016, he was named photographer of the month by *National Geographic*, France. He has taken part in a large number of collective and individual exhibitions around the world.

Pedro Jarque Krebs ist ein peruanischer Fotograf, geboren in Lima, der sich auf Tierfotografie spezialisiert hat. Er hat Kunstgeschichte und Archäologie studiert und einen Abschluss in Wissenschaftsphilosophie der Sorbonne Université Paris. Im Jahr 1984 hat er den ersten Preis der Stadt Lima in Schwarz-Weiß-Fotografie gewonnen. Inzwischen hat Pedro Jarque mehr als 110 Preise und Auszeichnungen erhalten. Er bekam 31-mal den ersten, zehnmal den zweiten und sechsmal den dritten Preis, dazu zahlreiche ehrenvolle Erwähnungen. Außerdem kam er in zahlreiche Endausscheidungen bei bedeutenden internationalen Fotowettbewerben, darunter der internationale Wettbewerb Sony World Photograph Awards, dessen Nationalpreis von Peru er zwei Jahre in Folge, 2018 und 2019, gewann. Zudem erhielt er 2018 den ersten Preis als Bird Photographer of the Year (Großbritannien) sowie weitere erste Preise 2018 beim Montier Festival Photo (Frankreich), 2017 beim Oasis Photo Contest (Italien), 2018 beim Sent-Antu Cup (China) und ebenfalls 2018 beim Trierenberg Super Circuit (Österreich). Er kam vier Jahre hintereinander in die Endausscheidung beim jährlichen Fotowettbewerb der Smithsonian Institution (Vereinigte Staaten). Im Oktober 2016 wurde er von der Zeitschrift *National Geographic* (Frankreich) zum Fotografen des Monats gekürt. Er hat an zahlreichen internationalen Einzel- und Gruppenausstellungen teilgenommen.

Pedro Jarque Krebs es un fotógrafo peruano nacido en Lima, Perú, especializado en retratos de animales. Se graduó en la Universidad de la Sorbona de París en Filosofía de las Ciencias, y cursó estudios de Historia del Arte y Arqueología. En 1984 ganó el primer premio de la Municipalidad de Lima de fotografía en blanco y negro. Desde entonces, Pedro Jarque ha recibido más de 110 premios y reconocimientos, treinta y una medallas de oro, diez de plata y seis de bronce, así como múltiples menciones, y ha sido finalista en los concursos internacionales de fotografía más importantes. Entre ellos destacan el concurso internacional *Sony World Photography Awards*, cuyo primer Premio Nacional del Perú ha ganado dos veces consecutivas en 2018 y 2019, el premio absoluto *Bird Photographer of the Year* (Reino Unido) en 2018, *Montier Festival Photo* (Francia) en 2018, *Oasis Photo Contest* (Italia) en 2017, *Sente-Antu Cup* (China) en 2018 y *Trierenberg Super Circuit* (Austria) en 2018. Ha sido finalista cuatro años consecutivos en el concurso fotográfico anual de la Smithsonian Institution (Estados Unidos). En octubre de 2016 fue nombrado fotógrafo del mes por la revista *National Geographic* (Francia). Ha participado en numerosas exposiciones colectivas e individuales a nivel internacional.

Pedro Jarque Krebs est un photographe animalier péruvien né à Lima au Pérou. Titulaire d'une licence en philosophie des sciences à l'Université Paris-Sorbonne, il a également étudié l'histoire de l'art et l'archéologie. En 1984, il a été décoré pour la première fois en remportant le premier prix de la photographie noir et blanc de la ville de Lima. Depuis, le travail de Pedro Jarque a été salué par plus de 110 prix et distinctions – trente-et-une médailles d'or, dix médailles d'argent et six médailles de bronze –, ainsi que de multiples mentions. Il a également été finaliste de grands concours internationaux de photographie animalière, notamment les Sony World Photography Awards, dont il a remporté le premier Prix national au Pérou en 2018 et 2019 ; le Bird Photographer of the Year (Royaume-Uni), le Montier Festival Photo, festival international de la photo animalière et de nature (France), le Sente-Antu Cup (Chine) et le Trierenberg Super Circuit (Autriche) en 2018 ; l'Oasis Photo Contest (Italie) en 2017. De 2016 à 2019, il a été finaliste du concours de photographie annuel de la Smithsonian Institution (États-Unis). En octobre 2016, il a été nommé photographe du mois par le magazine *National Geographic* (France). Pedro Jarque a participé à de nombreuses expositions collectives et individuelles à travers le monde entier.

Imprint

© 2019 teNeues Media GmbH & Co. KG, Kempen
Photographs © 2018 Pedro Jarque Krebs. All rights reserved.

Translations by Cillero & de Motta:
John Ripoll and Louise Wilson (English)
Sabine Giersberg für bookwise GmbH (German)
Sabrina Ducrocq-Poirier and Book-sitter (French)
Art direction, Design & Layout by Robin John Berwing
Editorial coordination by Roman Schmid
Production by Dieter Haberzettl
Color separation by Jens Grundei

ISBN 978-3-96171-222-9

Library of Congress Number: 2019939504

Printed in Italy

Bibliographic information published by
the Deutsche Nationalbibliothek
The Deutsche Nationalbibliothek lists this publication in the
Deutsche Nationalbibliografie; detailed bibliographic data are
available on the Internet at http://dnb.dnb.de.

Published by teNeues Publishing Group

teNeues Media GmbH & Co. KG
Am Selder 37, 47906 Kempen, Germany
Phone: +49-(0)2152-916-0
Fax: +49-(0)2152-916-111
e-mail: books@teneues.com

Press department: Andrea Rehn
Phone: +49-(0)2152-916-202
e-mail: arehn@teneues.com

Munich Office
Pilotystraße 4, 80538 Munich, Germany
Phone: +49-(0)89-443-8889-62
e-mail: bkellner@teneues.com

Berlin Office
Kohlfurter Straße 41–43, 10999 Berlin, Germany
Phone: +49-(0)30-4195-3526-23
e-mail: ajasper@teneues.com

teNeues Publishing Company
350 7th Avenue, Suite 301, New York, NY 10001, USA
Phone: +1-212-627-9090
Fax: +1-212-627-9511

teNeues Publishing UK Ltd.
12 Ferndene Road, London SE24 0AQ, UK
Phone: +44-(0)20-3542-8997

teNeues France S.A.R.L.
39, rue des Billets, 18250 Henrichemont, France
Phone: +33-(0)2-4826-9348
Fax: +33-(0)1-7072-3482

www.teneues.com

teNeues Publishing Group
Kempen
Berlin
London
Munich
New York
Paris

teNeues

YellowKorner
éditions